HOPPER
DAVIS
POLLOCK
DE KOONING
ROTHKO
RAUSCHENBERG
WYETH
CORNELL

AMERICAN

The Voice and the Myt

Photographed by Hans Namut

MASTERS

y Brian O'Doherty

A Ridge Press Book | Random House, New York

Contents

Editor-in-Chief: Jerry Mason
Editor: Adolph Suehsdorf
Art Director: Albert Squillace
Project Art Director: Harry Brocke
Associate Editor: Moira Duggan
Associate Editor: Barbara Hoffbeck
Associate Editor: Jean Walker
Art Associate: Mark Liebergall
Art Associate: David Namias
Art Production: Doris Mullane

Photographs on pages 47 and 60, courtesy of
Mrs. Stuart Davis. Photographs on pages 98 (*Pasiphaë*), 178, 179, 181, 184,
and 185, courtesy of the Marlborough Gallery, New York.

First printing. All rights reserved.
Published in the United States by Random House, Inc., New York,
and simultaneously in Canada
by Random House of Canada, Limited, Toronto.
Prepared and produced by The Ridge Press, Inc.
Library of Congress Cataloging in Publication Data
O'Doherty, Brian
 American masters.
 "A Ridge Press book."
 1. Painters—United States. 2. Painting, Modern—
20th century—United States. I. Title.
ND212.036 759.13 73-4867
ISBN 0-394-46423-0
Printed in Italy by Mondadori Editore, Verona.

ROTHKO
RAUSCHENBERG
WYETH
CORNELL

or B.J.N.

Introduction

This book attempts to recognize and clarify a dialogue inseparable from modernism: that between an artist and his work on the one hand, and the audience on the other. There are large areas here for misunderstanding. The artist's intention does not always guide his work into its most worthwhile context. The work itself offers different complexions to contemporary—and succeeding—audiences.

In speaking of an artist's voice, I am borrowing a device from literature, where a writer's habits of locution, his tone, make his "voice" a profitable short-term idea. The artist, however, while he may incorporate words into his work (five of the eight artists in this book do so), has a wordless medium. Reading a voice into it establishes a convention; one gains a device, but it must be used carefully for what it may yield. This convention makes us aware of modes of presentation, motifs that recur like habits of speech, and an idea of the artist given by the sum of these.

This idea of the artist has its more formal literary equivalent in the persona. The image of the artist composed by the sum total of his strategies is very different from the secular figure painting the picture. This connoisseurship of self-images has resulted in a large bibliography in literature, but none in visual art, perhaps because of the persistence of formalist criticism. The image of the artist that is included, dismantled, or denied in his work is part of its content, as is the other implied—and ignored—figure, the observer who stands for the audience. It has not been customary to pay any attention to either of these shadowy but significant figures. But they are incorporated to varying degrees in every artist's work, and as modernism draws to a close they take on more substance.

The figure that stands for the audience leads us to consider modes of reception, some of which the artist has already anticipated and made part of his work's content. The expectation of his specialized audience is, in modernist art, one of the artist's indispensable frames of reference. The broader reception of the work brings us to cultural needs and expectations, ideas of what constitutes an artist and, indeed, art. The resulting myth of the artist is very different from the artist himself and, usually, from the persona or voice his work implies.

The artist's myth, then, is a social armature that stabilizes a body of work and an image of

an artist, making both comprehensible on the level of imaginative gestalts rather than on visual terms. The work tends to be read as an illustration of this. At times voice and myth are so entangled as to be impossible to separate; that is, the myth amplifies and coarsens the voice, but does not otherwise distort it. The myth of the artist can be helpful in investigating the fate of art. It also allows us to read the vagaries of taste and fashion and, indeed, the cultural temperature at any particular time. Myths, though they embalm the artist and his work, sound the aspirations and spiritual life of the public.

The eight artists here exemplify the dialogue between the voice and the myth in many of its aspects. Each artist stands for a set of problems and for particular postures adapted to meet them. It is hoped that they afford a kind of shorthand view of the history of modern art in America up to the sixties. Davis and Hopper are, to my mind, along with Arthur Dove, the major figures of the first part of the century. De Kooning, Pollock, and Rothko sketch Abstract Expressionism's main parameters. Rauschenberg stands for solutions to the problems bequeathed by that generation. Wyeth and Cornell, outside the historical sequence implied by the other names, illuminate that darker territory in singular fashion, but also stand for attitudes toward the mainstream that, particularly in Cornell's case, distinguish some of the best American art.

II

The approach to each artist has been instructed by the available literature. Hopper needed to be recovered from that silence which has camouflaged his formidable intelligence. Hopper's voice has been almost stifled by an oppressive myth; and the issues raised by his method and modes of observation have hardly been touched.

Davis' myth, like Hopper's, has retarded an exact appreciation of his achievement. A main purpose here is to propose both artists as major figures. Since their presence is not easily disposable, their status has been tacitly acknowledged, but the idea that American painting began with the forties still undercuts their reputations. The intent is to open the way to further studies. Hopper's voice is dealt with more than his well-codified myth. Davis' reputation is blurred by a misunderstanding of the relationship between modernism and the vernacular tradition in his work, and an attempt is made to clarify this.

Pollock has been studied so abundantly that there is little to add formally at this time, beyond pointing out that the art after 1951 still has some unrecognized climaxes. But Pollock's myth, a formidable fiction, has been misused to authenticate or devalue his art or seen as an embarrassment to be removed before making intense formal readings. This myth, however, is essential to understanding Pollock's achievement; indeed, has a great deal to do with that achievement. It provides insight not only into the art and criticism that followed, but into persistent themes in American culture.

Rothko and de Kooning share themes found in Pollock. De Kooning is examined from that moment in the mid-fifties when his ambitions and rhetoric were at their height. Voice and myth here interact, since the artist chose to see himself as a myth, and included that myth in his thinking. Rothko, of course, does not inhabit his art in a similar way, but is expelled from it to become just another witness.

The tragic and transcendental themes found in these three artists define the climate and much of the art of their period—the forties and fifties. As romantic artists bringing Romanticism to a close, they recapitulate ideas that early Romanticism dramatized. These are summarized in two concepts: the quest—the search for transcendence which, with failure, assumes a tragic cast; and the void, occupied in part by modernism's self-referential tactics. The status of all three artists is hardly in doubt.

Rauschenberg brings many of the opposing concerns of the Abstract Expressionist generation together with an informal panache that hasn't helped his reputation. Perhaps because of his somewhat unfocused myth, his art has not received the sustained re-evaluation it clearly needs. This neglect (not of attention but of serious examination) is partly because Jasper Johns' work submits to critical disquisitions more tractably. Johns, by the way, is the ninth artist in this book—distributed through it in properly elusive fashion. Rauschenberg's finest work has been spun off in transit and has not been framed by theories deduced from it. This has encouraged superficial readings of the artist, who, in my opinion, may eventually be the dominating figure of the late fifties and sixties.

Wyeth is presented here without apology because he exemplifies a conservative American strain—a provincialism that, however disguised, makes contact with nineteenth-century values and with the

rural myth his art illustrates. Like Rothko and Pollock, whose art keeps up a discreet dialogue with nature, Wyeth touches on the tragic and the transcendental through his subject. The urban hostility to the rural myth and to Wyeth's politics has not allowed his art to define itself—any more than has the popular success which exposes its weaknesses by bringing it into the area of mass amiabilities. This is unfortunate, for his work has something to add to the fabric of American art. While no claim is made for major status, the idea is put forward that Wyeth is often a maker of great images—an act of social value.

No such reservations apply to Joseph Cornell, whose marvelous singularity is hardly at issue. He represents a way of coping with Europe by seeing himself as an exile in America, again a persistent strain in our culture. As with Hopper, Cornell's conversation is included, since so little of it has been overheard. His myth and voice coincide with an unexpected purity, but at a certain cost. The deceptive childlikeness of his art gives it a kind of "junior" status when one contemplates the strenuous issues raised by, say, de Kooning or Rothko. But Cornell is an artist of not dissimilar magnitude.

III

Since this book is in part devoted to inscribing imaginative patterns among eight artists, some themes recur. The use of the vernacular tradition is of significance in American art of all periods, particularly the modernist era. The relationship between Europe and America, about which American art has always been self-conscious, is an important subtheme. Questions of audience and spectator, and of the voice and the myth, have already been mentioned here as major themes. Which brings me to a final word of explanation.

The text is illustrated by Hans Namuth's photographs. His photographs of Pollock, an invaluable record, have already played a part in generating Pollock's myth. Namuth's other photographs in this book engage each artist's myth in a dialogue that is handled with great sophistication. The illustrations of the artists' work—or more truly their mode of presentation—fit, more often than not, into the mythic interpretation of the artist and may be read as such. For this book, in its format, is part of the myth-making apparatus, and to that degree is an illustration of it. Just as the text of this book is, hopefully, its voice.

New York, N.Y. —Brian O'Doherty

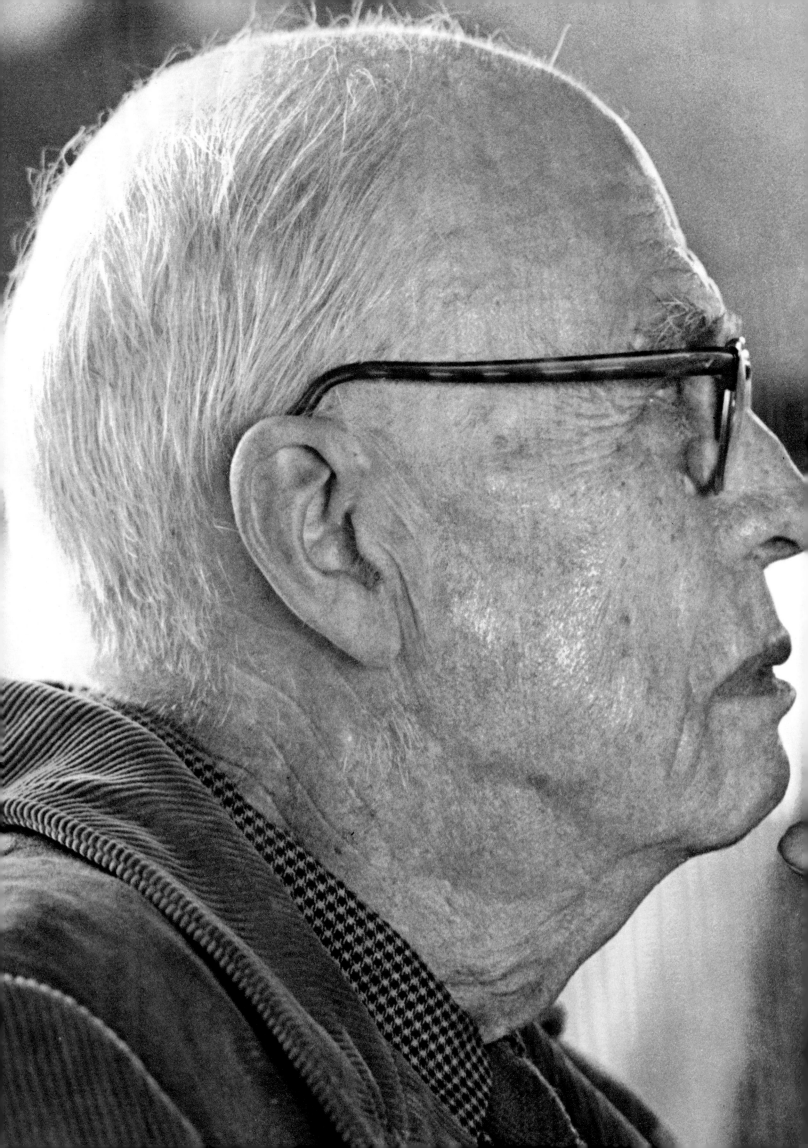

HOPPER

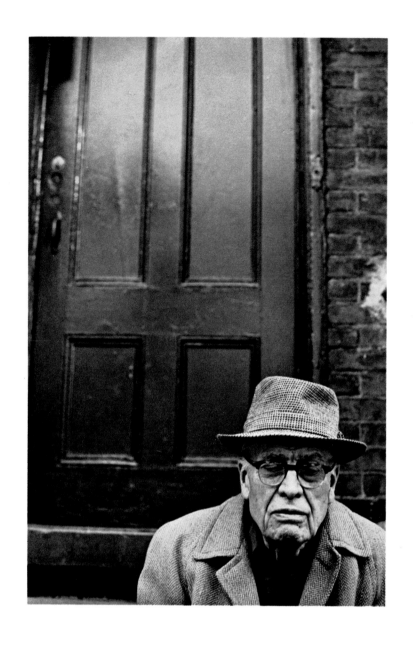

Edward Hopper's Voice

The stove, vintage 1913, stood on bulldog legs, its pipe genuflecting into the wall a foot from the ceiling. Mrs. Hopper was obviously very fond of it and it frequently appeared in her pictures. She chattered against her husband's silence, a silverpoint writing against a boulder.

Edward Hopper sat back from the animation. Mostly, his wife did the talking for him, and he watched her curiously as if to discover what she thought he thought. When he disagreed with something she said, he spoke in a flat monotone that fell across the conversation like a roadblock which had to be removed before further progress could be made. He was an economical man, exactly fitting the word to the idea. Anything more was conceit, artificiality, rhetoric.

His art and his life were a taciturn denial of all three. He was hard to impress, so hard, in fact, that he didn't even impress himself. Everyone told him he was a great artist. He didn't believe it: "Ninety percent of them are forgotten ten minutes after they're dead."

The apartment, which the Hoppers had occupied since their marriage in 1924, was bare and clean. In the back room—Mrs. Hopper's studio—the north light angled in through a great window, moving around the wall and floor each day to the door, outside of which four flights of stairs plunged down, in seventy-four steps, to Washington Square. Mrs. Hopper mounted those steps in spurts and starts through a flutter of conversation, looking back to see her husband climbing slowly and methodically, occasionally stopping and raising his head to see how much farther he had to go.

The front room was Hopper's studio. It had some of the asceticism of a tidied-up carpenter's workroom. Beside the stove was a printing press; Hopper's hat usually hung on one of its four spokes. In front of the press stood an easel he had made himself. There was no art to be seen—only a mirror on the wall. Above, a skylight. Through the two windows, across the Square, could be seen the campanile of New York University and, below, a fringe of weak city trees. The apartment and the house were under threat for years from one of Mrs. Hopper's enemies, New York University, which wanted to engulf it, and its history, which is quite sizable. "They say Henry James was born next door in Number Two," Hopper said.

"Two of the Eight lived here," said Mrs. Hopper. "Ernest Lawson and William Glackens."

"Frank Harris was here on the first floor for a while."

"Edmund Wilson was married to Mary Blair at that time."

"*The Dial* was born here."

"E. E. Cummings was here."

"John Dos Passos lived here. I think he wrote *Three Soldiers* here."

"Rockwell Kent had the back apartment—my studio."

"Eakins did President Hayes and Frederick Stokes' mother in Number Three."

"Stokes of Philadelphia—he looked like a mountain goat," said Mrs. Hopper. "He went to the North Pole with Peary."

"Not all the way," said Hopper. "Peary and the Negro were the ones who got to the North Pole."

"I don't know if Hayes liked his portrait," he went on. "Probably didn't. They say the wall behind the easel was full of geometric designs and perspective. One of my paintings was swapped for an Eakins recently."

There was a long pause.

"That's coming up!" he said. Eakins was one of his heroes: "Greater than Manet." When this conversation took place, in 1963, he was eighty-one. By that time he usually did two pictures a year, in spring and fall. In 1960, *People in the Sun* and *Second Story Sunlight*; in 1961, *A Woman in the Sun*; in 1962, *New York Office* and *Road and Trees*; and in 1963, *Intermission* and *Sun in an Empty Room*—the latter his fall picture, done at his house near Wellfleet on Cape Cod.

II

The woman in the theater in *Intermission* sits prosaically across a deserted aisle, under a balcony.

"Her name is Norah," said Mrs. Hopper. "We name them, you know."

"Why Norah?" she was asked.

"Maybe she's Irish," said Hopper.

"She's a maid or something on her night out," said Mrs. Hopper.

"She's a coming egghead," said Hopper.

"There's half another person in the picture," he added. "I got the idea in one of the movies around here. I had it for a year. I think it's pretty good. Maybe it's too complete, not suggestive enough. The figure—maybe the finish has ignored the feeling. I don't know." A year later he said: "I think I lost sight of the mood in finishing the figure so minutely." Everything he said or painted had this delay, as if thinking were a form of hibernation. Like his pictures, he often communicated by reserving comment. His silence invited siege, which he found surprising, for he had nothing to hide—no magic, no secrets. He invited one in to probe it and then left one outside again, the drawbridge up, looking in, unconvinced.

His mind was composed of fatalism, detachment, and a steady curiosity. Frequently he looked quite baffled. Sometimes one had the impression he was surprised to find himself inside his own body, as if it had grown up, a separate object, around him.

His pessimism was so deep one could easily get him to agree, thus stopping conversation short of any illumination. For all his appearance of durability and strength, he was an elusive poet who stated a fact with the utmost conviction, then doubtfully contemplated it. No one was more secure in his knowledge of the facts and less convinced of their worth.

From all this one could easily—as many have done— make a myth of his loneliness and isolation, finding plenty to support it. It would have, and has, a certain truth, but for the wrong reasons. He felt the critics' emphasis on the isolation of his figures was a sentimental distortion of the facts as he presented them.

"The loneliness thing is overdone. It formulates something you don't want formulated. Renoir says it well: 'The most important element in a picture cannot be defined' . . . cannot be explained, perhaps, is better." In trying to explain this inexplicable, he denied influences: "I have no influences really. I don't mean that in a conceited way. Every artist has a core of originality— a core of identity that is his own."

Identity and originality were for him closely connected. "The main thing," he wrote once, "is the natural development of a personality." He agreed, not far from Zola, that art is fact seen through a personality. For such a seemingly objective man this preoccupation with the self was a bit of a paradox until one realized that all his work is a kind of self-portrait, that the solidity of each scene was based on steadily confronted ambivalence and doubt. His art is a sort of self-reassurance. He sent out soundings whose echoes rebound from the facts, via the picture, to define and prove the existence of the self. "The interior life of any human being is a vast and varied realm," he once wrote. His paintings helped him chart it, halfway stations in a traffic between the fact and the self, between observer and observed.

That dualism—and that unity—is best expressed by something he carried around in his wallet, a quotation from Goethe that goes: "The beginning and end of all literary activity ['For literary substitute artistic. It works for that, too'] is the reproduction of the world that surrounds me by means of the world that is in me, all things being grasped, related, re-created, molded, and reconstructed in a personal form and an original manner."

Hopper's pictures embody this reversal: object becoming subject, subject becoming object, the architecture animate, the people inanimate. This need to establish his own identity through painting was a sort of pragmatic anxiety that stopped him from painting and started him again, like a built-in regulator. He painted one self-portrait. He had a lot of trouble with it and didn't think it very good. (His wife didn't like it either and said she had destroyed it. But it appeared in the Hopper bequest to the Whitney Museum after their deaths.)

I returned six months later to the subject of isolation. Our conversations, especially in the first few years, were often seasonal, months between sentences, picking up where we had left off. He was sitting in the same chair, leaning forward. I asked him if he really thought the loneliness thing was overdone. His eye unlatched

from me and went off to stare at the wall. He said nothing. Pressed a little further he broke his silence. "Maybe they're right," he said at last, meaning the critics, and everything receded into the yawn of his pessimism.

"A pessimist?" he said. This was a few months later, just before he and his wife went up to Cape Cod to their summer place. The floor was covered with crates and bundles. They drove up each year in their 1956 Buick sedan. "A pessimist? I guess so. I'm not proud of it. At my age don't you get to be? When I see all those students running around painting—studying like mad— I say, 'What's the use? It all ends the same place.' At fifty you don't think of the end much, but at eighty you think about it a lot. Find me a philosopher to comfort me in my old age," he said, half joking.

"Marcus Aurelius?" He thought he had the *Meditations* somewhere. "I like Renan's *Life of Jesus*," he said.

"No miracles," said the no-nonsense Mrs. Hopper approvingly. "They only place these impediments in the way of intelligent people." Obviously she thought miracles shouldn't be allowed.

"Emerson's a very shrewd New Englander," said Hopper, "but he's no help." He read a lot of Emerson.

Later I wrote to him at the Cape, curious if he'd got to Marcus Aurelius. He wrote back, as laconically as he talked: "I have not yet begun on Marcus Aurelius. I have been rereading the short stories of Thomas Mann. They do not induce in one, a gleeful outlook." He had a comma in the last sentence, breaking it as if he were talking.

When I saw him again he talked more about Thomas Mann. "Rough going. Well, depressing. Freudian. A great writer of fiction. I've been reading E. B. White. He has a short sketch on leaving a house. And cleaning it out 'he encountered the stale odor of success.'" He jerked his head around. "Not wordy, but good," he said, a mistruster of words who had found some he could trust.

III

It is hard to prevent the Hopper myth from taking over when talking about him. His fatalism, his prosaic con-templation of mystery, left him open to the clichés that destroy truth by coming close to it. The legend made Hopper a Great Stone Face.

We talked about this embarrassment, leading to a cover story *Time* magazine did in the issue of December 24, 1956, an excellent job that apparently got jazzed up. Mrs. Hopper was furious about the cover, let alone the cover story. "They made him look like a leering, lascivious Santa Claus! And lascivious—that's one thing he's not!"

"How do you know?" said Hopper. We looked at the *Time* cover, which appeared quite benign.

"I objected strenuously," he said, talking about the story, which had him going around the country like some hick who happened to be a genius. The story even said he cracked his knuckles.

"You don't crack your knuckles," he was reassured.

"Nobody connected with us on either side!" said Mrs. Hopper, sitting up very straight.

Attempts to turn him into a cracker-barrel All-American aroused Hopper to rare anger. "The thing that makes me so mad is the 'American Scene' business. I never tried to do the American scene as Benton and Curry and the midwestern painters did. I think the American Scene painters caricatured America. I always wanted to do myself. The French painters didn't talk about the 'French Scene,' or the English painters about the 'English Scene.' It always gets a rise out of me. The American quality is *in* a painter. He doesn't have to strive for it."

Physically Hopper was made, like Lincoln, for myth. Both he and his wife were exceptionally handsome people. Hopper had a magnificent head, grandly bald, almost geologically weathered. His blue eyes were set firmly and deep. They stared easily, then slipped away deliberately when they had provided the necessary information. His mouth was wide-lipped and generous, connected to a blunt nose by two deep wrinkles that in the other direction zigzagged into two spare jowls framing a square, definite chin. He usually sat on a low, straight-backed chair, leaning forward, his knees high (since he was very tall), his shoulders draped

around him like a cape, elbows sticking out over the arms of the chair like rudimentary wings, his fingertips lightly touching. In motion he was purposeful and economical. He didn't waste a thing—a gesture, a brushstroke, a word, a thought. He moved so deliberately that he thought other people moved fast, especially in the movies. "Normal people don't hop and jump like movie actors; their rhythms are slower," he said once, which surprised me since I felt that actors' movements in film, stylized by an easy naturalism, were much more economical than in real life. He saw it the other way around. His pictures show no action; the people do nothing; they are passing time.

Unless he knew one well, that is, for years, he didn't talk much. At first I had the impression I was sending words to him across a vast distance, like a wireless operator who had no way of knowing if they had been received—an image with which Mrs. Hopper agreed. When one asked a question there was a long moment of silence before the voice began to quarry words and a few verbs to carry them. Sentences were short, sometimes phrases without verbs, a further development or qualification of what had gone before. Sometimes his response rolled over a question so completely one was chastened for having asked it at all. Any argumentative pursuit of a point was aborted by agreement or sudden indifference. His writings have the same spare and solid character. Words are few, constructions simple, movement unhurried. His article on one of the few contemporaries he admired, Charles Burchfield,[1] though a meditation on another painter, is his surest portrait of himself as artist. As in his paintings, there is the same fixation of the mind on facts, guided by the imagination into areas of uncertainty, and then contemplated steadily.

IV

An only boy (he had one sister), Hopper spent a lot of time at the Nyack, New York, shipyards, watching the boats. He had some vague idea of being a naval architect, but eventually he found himself in New York, working three days a week as an illustrator.

[1]The Arts, July, 1928.

"Illustration didn't really interest me. I was forced into it in an effort to make some money. That's all. I tried to force myself to have some interest in it. But it wasn't very real."

"He never could do pretty girls," said Mrs. Hopper.

He also studied at the New York School of Art under Robert Henri, a man as flamboyant as Hopper was reserved. A slow developer, he found himself in some fast company: Guy Pène du Bois, Rockwell Kent, Eugene Speicher, and George Bellows.

"Henri wasn't a very good painter," said Hopper. "At least I don't think so." (He often qualified an opinion with a disclaimer, just as his art qualifies a strong image as you continue to look at it.) "He was a better teacher than painter. His wife was an Irish woman with red hair. Beautiful and tough."

After finishing at the New York School he went to Paris in 1906, returning twice in the next four years, earning the travel money by illustration. "In my day you had to go to Paris. Now you can go to Hoboken. It's just as good."

In Paris he stayed on the Rue de Lille, near the Rue de Bac. "I could just go a few steps and I'd see the Louvre across the river. From the corner of the Rues de Bac and Lille you could see Sacré-Coeur. It hung like a great vision in the air above the city. Whom did I meet? Nobody. I'd heard of Gertrude Stein, but I don't remember having heard of Picasso at all. I used to go to the cafés at night and sit and watch. I went to the theatre a little. Paris had no great or immediate impact on me.

"I went to Paris when the pointillist period was just about dying out. I was somewhat influenced by it. Perhaps I thought it was the thing I should do. So the things I did in Paris—the first things—had decidedly a rather pointillist method. But later I got over that and the later things done in Paris were more the kind of thing I do now."

Americans can be divided into those who have their crisis when they get to Europe and those who have it when they come back. "It seemed awfully crude and raw here when I got back. It took me ten years to get over Europe." But in those ten years the painter was

recognizing his subject, the tawdry urban landscape—already a wilderness comparable to the nineteenth-century American landscape. His first act, typically fatalistic, was to accept it. Then he transformed it with what seems almost an act of will.

In 1912 he spent his first summer at Gloucester in Massachusetts, that Barbizon of American art, where a decade later he was to turn out some of his greatest watercolors. Nineteen-thirteen was the year of the Armory Show, and he exhibited a painting called *The Sailboat.* It looks a bit like an Eakins done over in plumper, richer paint. *The Sailboat* sold. It was his first sale; he was thirty-one. The next time he sold a painting was ten years later, when the Brooklyn Museum bought a watercolor.

During those ten years he illustrated for a living and painted during the summer in Gloucester and Ogunquit, Maine. According to a legend apparently started by Alfred Barr's introduction to the catalogue for the 1933 retrospective at the Museum of Modern Art, he withdrew from the artistic scene, rarely saw his friends, and went through some sort of emotional crisis eventually resolved when he took up etching, which opened the future to him.

"The idea that I gave up painting is completely wrong. I painted in Gloucester and Ogunquit. I improvised pictures in the studio. Nor did I withdraw from the art world—whatever the hell that is. Etching? I don't know why I started. I wanted to etch, that's all."

The etchings, begun with the help of Martin Lewis, foretell all the clearsighted power and simplicity of his later work; they still await serious study. In them he laid claim to what would become inevitable Hopper country—the houses, the railway tracks, the windows.

The etchings mass thickly matted shadows and darks against cloudless light. They are handled with a hard force that expends itself to produce the effect and then departs. It's not surprising that one of the few artists he admired was Charles Méryon, the etcher of Paris. Both have the same obsession with architecture and light.

"One called *The Street of the Weavers*," he said once. "Marvelous rendition of sunlight. To me. Romantic sunlight. He had a terrible life. He was a little bastard. Father was English. Was a doctor—related to Hester Stanhope, that crazy woman who went to the Orient."

He stopped etching sometime before 1924. By then he was on his way. In 1933 the Museum of Modern Art gave him a retrospective. The Whitney Museum had retrospectives in 1950 and 1964. He won prizes and awards, was elected to the Institute of Arts and Letters in 1945. After it all, without sourness, but with fatalism, he said, "Recognition never comes when you need it." If it came in any particular year, it was in 1924, his *annus mirabilis.* He showed some of his watercolors to Frank Rehn of the Rehn Gallery. Rehn gave him an exhibition, which sold well. He was forty-two and his best work was ahead of him. And the same year he married Mrs. Hopper.

V

Josephine Verstille Nivison Hopper was one of the most extraordinary women any artist ever married. She was handsome, small, vivid in thought and action, reacting totally to whatever happened around her. Her opinions were often violent: "I hate Caligula! Roosevelt? A monster!" She was very well-read and seemed to take both present and past personally. Her perceptions were frequently anarchic and marvelous. She reserved for herself the privilege of attacking her husband as energetically as she defended him, often surrounding his inertia with a dazzling series of provocations. He and she were so opposed to each other in temperament they were a continual source of life and dismay to each other. Opinions are much divided as to her role. One view holds that Mrs. Hopper persecuted her husband. Another claims that she stung him to life. It was an unusual marriage.

"Marriage," she said once, her hands clasped firmly in her lap, "is difficult. But the thing has to be gone through. I have been a very decided person and very difficult to get on with from the day I was born. My mother was well before the Freudians. One day a friend was visiting when I was one and a half and I put

on a show. At that age there could be no compromises. I yelled. 'What a temper,' said my mother's friend. 'You'll have to break that!' 'I'll do nothing of the sort,' said my mother. 'She may need it sometime.' "

"Freud says the devil is a woman," said Hopper.

"I didn't compromise," said Mrs. Hopper. "He wouldn't have liked me if I had. He had his spots you know. I haven't scratched around to take out his spots."

"Aristotle says women are undeveloped men," said Hopper.

"We met under Robert Henri's wing," said Mrs. Hopper. "It was a broad, spreading wing"—she lifted her elbows—"but a discriminating one."

"What did you think of Henri as a painter, Mr. Hopper?"

"I think he was moderately good."

"Oh!" said Mrs. Hopper. "It's so ungenerous. But you know men are not grateful creatures. It seems to me that women are the ones that show gratitude for the little things and big, who remember over the years." (Once Mrs. Hopper said: "I'm an elephant. I remember way back, prenatal, everything.")

They were married on July 9, 1924, at the Huguenot Church—the Eglise Evangélique—on West 16th Street. It was a sudden decision. Hopper wanted to go to Cape Ann. Mrs. Hopper wanted to go to Cape Cod. They got married the same day as the argument. They went to Cape Ann.

"He married a woman with a cat," said Mrs. Hopper, "not just a woman. I was taking out a maternity complex on a big warrior alley cat—the scourge of 9th Street. It was all right by the cat. He lapped it all up. Nothing he wanted more than an adoring mother. Think of all a child has been spared by all that went to the cat instead."

The cat, named Arthur, looms sizably in the mythos of the early Hopper household. "He and the cat," said Mrs. Hopper, "exchanged glances when there was something about me too utterly utter." The cat between husband and wife led to some Hopper caricatures and running comment on the domestic situation. They reveal a side of his character unseen except for the early carica-

tures done in Paris. They have a deadpan wit, a suppleness of imagination one would not suspect from the sober majesty of his painting. Before their marriage, he courted her with humorous drawings and cards inscribed and painted with tongue-in-cheek seriousness. None of these has appeared in the Hopper bequest and Mrs. Hopper may have destroyed them.

Among the drawings were some fantasies: a winged figure hovering between cliffs ("Nonsense. It's just nonsense," said Hopper); a "tough" Jesus, done after reading Renan; and, of course, lots of Arthur.

In *The Great God Arthur*, Mrs. Hopper sits tête-à-tête with a man-sized cat, while Hopper, shrunk and cringing on the floor, begs from the cat, who looks at him with a malevolent condescension. There is one of *Josie Leading Eddie to a More Spiritual Existence*, and *Mrs. Kit Hopper's One-Man Jury Show*, a mouse jurying an exhibition of cats. Another shows Mrs. Hopper's dream-boy, a pipe-smoking, tweedy type with a basket full of her favorite authors.

The caricatures became a way of criticism and complaint. "If he didn't like my clothes," said Mrs. Hopper, "he'd draw it to show how I looked, and accompany it with a drawing showing how I thought I looked." The most lethal of them is Hopper's judgment on women: Mrs. Hopper is wearing a halo, a moment later one discovers she is also wearing a barbed devil's tail.

"Living with one woman is like living with two or three tigers," he said.

"Can't you see why?" she said immediately. "This everlasting argument: He'd be up first to watch for the first thing I'd say in the morning and then be ready to disagree with it."

"That's a point of view," said Mr. Hopper.

"Like Carlyle with Jane: When he couldn't find anything else to complain about he complained about her *breathing*."

"I tear him," she went on, "because he's flesh of my flesh, bone of my bone."

Hopper's response, or nonresponse, to her thrusts was always underplayed, so much so that Mrs. Hopper once said accusingly, as if Hopper were not being fair,

"Sometimes in the middle of the row, I'd forget what it was about." Occasionally, Hopper replied through the written word. She was so slow to get ready, he said, that they caught only the third act of every play. On one occasion he was in such a hurry he pushed Mrs. Hopper against a subway turnstile as he put the token in. "But the mechanism must be free before the token works," she said, "so I was locked in and it needed two others to get me out and to the theater."

Hopper decided it was the turnstile's fault, and exonerated himself with a letter to the Transit Authority asking for better turnstiles:

Dear Sir:

We are uncertain whether to communicate directly with you in the matter of the turnstile in the subway or to try to prove our point by complete silence. Of course a wife whose every motion defies gravity and the common practice of the whole of humanity will not easily be turned aside from the unique and solitary ellipse in which she moves. Finally we doubt if she would not feel out of place and angry in the orbit which we by our horse sense be forced to follow. Our previous order for individual turnstiles must therefore be cancelled.

very truly yours,
Worm of worms.

VI

The mysteriousness of Hopper's pictures lies in the disparity between cause and effect. Sunlight falling across a floor amounts to an event, an empty street holds attention. How such scenes become important has engendered much critical speculation. "There is a sense of silence and detachment, as if one were looking at the scene through plate glass," wrote Alfred Barr of Hopper's interiors in 1933. Guy Pène du Bois, one of Hopper's more perceptive critics, wrote in 1931: "There is a definite static quality . . . a stillness that has its counterpart in the calm preceding the storm," and again, "His honesties carry considerable brutality with them." Robert Coates felt that "the source of his extraordinary evocativeness lies in the balance . . . between the rigidity

and monumentality of abstraction and the particularity of realism." Alexander Eliot wrote in 1948 that Hopper's work "is familiar vision without any of the dullness familiarity brings." Lloyd Goodrich wrote of Hopper's interiors in 1950 that "there is a sense of remote but observant viewpoint . . . glimpses of private life give a penetrating feeling of the vast impersonality of the city, of the loneliness that can be experienced most intensely among millions." William C. Seitz wrote in 1967 that Hopper's buildings "have a clarity and presence one experiences in actuality only in rare moments of heightened perception," and that his objects "have been projected into the realm of ideas, distilled to their essence by a mind that has scrutinized the world of artifacts again and again."

Hopper would have had a simple answer for his transmutation of facts into mysteries. The artist's personality stamps a scene with an intimacy that makes all of it—woods, houses, people, sky—an act of formal and private possession, as if he had passed through each object and space.

And if the artist's personality is as much a mystery to the artist as to the observer, as much an object of speculation and pursuit, the artist would in effect have chased himself out of the picture, leaving the observer to track down his passage. Hopper's scenes not only invite literal comments on the observer and observed, they play a game of hide-and-seek in which the artist's pursuit of his identity is pursued by the audience. The elements of such a game are part of the picture's content—disappearance, silence, stealth, suspense, bafflement, glimpses—but no denouement. As in such a pursuit, objects become dumb, eloquent, blank, mysterious; they assimilate a vocabulary and speak a language. This is the "voice" in Hopper's work and it has a great deal to do with what he called "the fact."

For years Hopper painted from the fact—what he saw. His concentration on a scene was such that his painting lifted it out of its natural continuum, so that one might say that for Hopper a fact was a snapshot of a process. In this way, meaning was made inaccessible but, as in an uncaptioned news photograph, still implied.

By denying meaning, his pictures provoke it; they pretend to a familiarity of recognition which they eventually frustrate. His art often has to be defined by negatives until something positive is forced into the open. This is appropriate for the reversals his pictures provoke—switching emptiness into fullness, isolation into spiritual richness, lack of emotion into feeling. His work ties a neat slipknot in time, revealing the transience in permanence, the permanence in transience. This traffic through opposites leads again into their apparent source: the separation and fusion of object and subject, signified further by the frequent traffic between inside and outside in his work, which can be extended to the observer and observed, the artist and his tracker, as described above. Hopper's "voice" has to do with these intimate detachments.

Facts, of course, are subjects. Hopper's art profited from the revolution in subject matter pioneered in American art by the Eight. He came out of Henri's circle, a circle that can perhaps be identified with a particular kind of picture: a landscape or cityscape seen with a bluff unsentimentality, displaying a painterly impetus as if painting were a "coats off, gentlemen" business. (This is perhaps exemplified by much of Rockwell Kent's work. Close to Hopper's sophisticated detachment is an almost forgotten figure, G. L. Chatterton, a few of whose works could be mistaken for Hoppers.) Hopper's attitude toward his subject matter, antiromantic and asentimental, was unmatched in twentieth-century American art until Pop art inserted its ironies between the artist and the banal.

Hopper mostly painted scenes of utter banality in the city, and his recognition of subjects amounted to a vision. He incidentally explained his own attitude to "unimportant" subjects in his essay on Burchfield: "This thing has been said by Emerson with incomparable clarity: 'In every work of genius we recognize our own rejected thoughts; they come back to us with a certain alienated majesty.' Great works of art have no more affecting lesson for us than this. They teach us to abide by our own spontaneous impression with good-humored inflexibility—most when the cry of voices is on the other side. Else tomorrow a stranger will say with masterly good sense precisely what we have thought and felt all the time, and we shall be forced with shame to take our opinion from another."

Writing further on Burchfield he said: "From what is to the mediocre artist and unseeing layman the boredom of everyday existence in a provincial community he has extracted a quality that we may call poetic, romantic, lyric, or what you will. By sympathy with the particular he has made it epic and universal. No mood has been so mean as to seem unworthy of interpretation; the look of an asphalt road as it lies in the broiling sun at noon, cars and locomotives lying in God-forsaken railway yards, the steaming summer rain that can fill us with such hopeless boredom, the blank concrete walls and steel constructions of modern industry, midsummer streets with the acid green of closecut lawns, the dusty Fords and gilded movies—all the sweltering tawdry life of the American small town, and behind all, the sad desolation of our suburban landscape. He derives daily stimulus from these that others flee from or pass with indifference."

This veritable paean to banality immediately brought one to the American realists in literature. But one didn't get very far with them. Theodore Dreiser? "He's all right." Sinclair Lewis? "A fathead." Sherwood Anderson? "Good writer." Hopper didn't like to be classified anywhere near them. ("His tastes were never small town"—Mrs. Hopper.) And if one reads the praise of America Deserta again, one finds oneself in the presence of a voice transforming the wasteland as it describes it.

For Hopper made boredom epic, baptized the raw scene with light, and measured it with a grave spatial geometry. His detached viewpoint, which has been compared to a lens, the eye of a voyeur, and the eye of God, hints at a moral bias one would not suspect unless one knew that his pessimism is often highly critical, and that his realism, like Zola's, is a sort of moral force. He despised anything that obscured the truth and it often led to harsh judgments on human nature. Mrs. Hopper reported he had said at Macy's: "Lord. Wouldn't

He drive the money changers out of this if He were here." Although Hopper said that Guy Pène du Bois always "treated me as if I were pure Anglo-Saxon, which I'm not at all," du Bois said the last word on Hopper's puritanism thirty years ago: "He has turned the Puritan in him into a purist, turned moral rigors into stylistic precisions."

The life of pictures in the mind is a subject that hasn't received much attention. The way one remembers an artist's work, and the dialogue between the remembered image and the work when actually seen again, involves perceptual revisions of a somewhat obscure nature. When the picture is part of our cultural image-bank, as many of Hopper's pictures are, I find that it is occasionally reversed in memory, its parts unequally emphasized, indeed sometimes adjusted to one's own aesthetic interests. Many things influence the way we remember works of art and so inflect our always tentative possession of them, particularly *where* they are seen. With a change in country, for instance, an artist's work often looks different; the new milieu has subjected it to another set of cultural cues. Sometimes the work refutes this subtle influence, firmly carrying its own idea of place with it.

When one speaks of memory it is often assumed that nostalgia, a corruption of memory, is involved. Nostalgia is the result of a process by which the lazy mind stocks itself with cozy furniture and has nothing to do with the process under discussion. Hopper, as we shall see later, was greatly concerned with a picture's conceptual formulation *before* he had painted it, and would have been greatly interested in its subsequent history in the observer's mind. Indeed, the way in which Hopper's pictures survive in the mind is an extension of the process whereby the artist is tracked down by the observer, where traces of the artist's passage provide intimations of intention that modify the image of the work during flashes of recall.

Hopper's images have, to my mind, a distinct relationship to another class of images which are less subject than ordinary images to the dynamics of remembering and forgetting. These are images with a strong

emotional tone, persisting from some experience, but often without memory of the experience. In retrospect, they seem quite irrelevant to our lives, and why they should be remembered is not clear. A face, seen momentarily years before among hundreds of anonymous faces, can assume an inexplicable importance in memory. There are those moments of *déjà vu* when we stop a car in a strange place, and move on again, haunted by a troubling sense of familiarity. The unimportant scene becomes important and a banality is transformed into a vision. Such moments, while depending on one's mood and on the psychological context, are deeply affected by atmosphere and light. Hopper's pictures, in their peculiar isolation from identifying contexts (his work by and large is placeless and unlocatable), have something in common with such images. And light, of course, his main preoccupation when painting, is the chief protagonist in his tableaux. He had a distinct preference for waxing and waning lights and for artificial light. His best work was not done in the midday glare.

If isolation is to be spoken of in Hopper's work, the isolation of the individuals from each other, or even from the environment, should not be emphasized. The *Nighthawks* inhabit a not unfriendly oasis; many of his people are not unaware of each other sexually and, as animals, they seem to be in their proper habitat. A more telling isolation is of two orders. One is the observer's distance from the scene. (Whose eye is watching?) The other is the isolation of the image from any easily accessible context that would make it psychologically available. (There is a massive abstraction to Hopper's realism.) These have hardly begun to be investigated, since Hopper studies have been delayed by another kind of isolation, the isolation of his oeuvre by "American Scene" misunderstandings and by his myth.

At this point it is necessary to correct another misunderstanding. Hopper himself talked about his devotion to the fact. This should not be taken literally. Though he started painting directly from life he eventually put his pictures together from notes and recollections. When he spoke of the fact he meant a

recognizable image from life, as distinct from abstraction. As William C. Seitz wrote: "His compositions arise from a synthesis of observations, impressions and thoughts, are carefully and intellectually planned, and take form within a preconceived pictorial language." The conceptual nature of the later pictures is very evident in their lack of detail. They are made up of a few broad generalized units. "It's hard to define how they come about," Hopper said of his pictures, "but it's a long process of gestation in the mind and a rising emotion." Of his quotation from Goethe[2] he said, "To me that applies to painting from the memory." Remembering and forgetting apparently collaborated in purging detail, emphasizing aspects of the unimportant, and depriving scenes of their specificity. By this process the generalized statement is disguised as a particular, and a conceptual rigor taps formal energies usually confined to abstraction. "It is very well to copy what one sees," wrote Degas. "It's much better to draw what one has retained in one's memory. It is a transformation in which imagination collaborates with memory. One reproduces only that which is striking, that is to say, the necessary. Thus one's recollections and invention are liberated from the tyranny which nature exerts."

Hopper's famous statement of 1930 is mainly concerned with the process by which the idea of the picture is translated to the canvas: "My aim in painting has always been the most exact transcription possible of my most intimate impressions of nature. . . . I have tried to present my sensations in what is the most congenial and impressive form possible to me. The technical obstacles of painting perhaps dictate this form. It derives also from the limitations of personality. Of such may be the simplifications that I have attempted."

The loaded words in Hopper's aesthetic are used here: "intimate," "sensations," "personality." The next part of the statement deals with his attempt to close the gap between fact and idea, between sensation and experience, between memory and the present: "I find, in working, always the disturbing intrusion of elements not a part of my most interested vision, and the inevitable obliteration and replacement of vision by the work

[2]See page 42.

itself as it proceeds. The struggle to prevent this decay is, I think, the common lot of all painters to whom the invention of arbitrary forms has lesser interest."

The idea that the birth of a picture involves a kind of death is not a new one. But why, of all words, had he used "decay"? "You start with the canvas and you have an idea up here," he said, tapping his head. "It isn't very clear, but it has definition. As soon as you start putting it on canvas every concrete element is driving it away from the idea. You can't project your mind onto the canvas because there are concrete things that interfere, technical things. It's *decaying* from your original idea. I think a great deal of contemporary painting doesn't have that element in it at all. It's all cerebral invention. Inventions not conceived by the imagination at all. That's why I think so much contemporary painting is false. It has no intimacy."

Hopper made a distinction between "invention" and "imagination." He associated invention generally with abstract painting, and by implication with the "new." He assumed, incorrectly, that abstract art limited the expression of a personality. Abstract painting could not draw on the powers of the imagination nurtured by the rich matrix of the real world. He felt strongly about this. Franklin Watkins remembers serving on a jury with Hopper when another member commented that a picture under review was "imaginative." Hopper corrected this to "inventive," launching into a discourse about the distinction. Abstract (that is, "inventive") painting for Hopper lacked "intimacy," a quality won, in his canon, by an obstinate rearguard action against the decay of the idea while realizing the picture. Hopper's conception of process was a highly sophisticated one, providing him with a sense of difficulty entirely appropriate to the ethical nature of his vision. The intimacy may have been connected with the reconciliation of the raw landscape with thought, a civilizing process that has troubled American artists from Washington Allston on. The subject was thus as important to him as the means of expression, which purged the subject of the anecdotal. At the same time the subject continued to define the means. ("If what you want to

express is literary, then you can come near achieving it. I was never able to paint what I set out to paint. That's a very crude statement in the popular mind.")

In this fusion between subject and means, Hopper made an important contribution to "realist" painting. For such a practice implies a realization (rather than a redefinition) of conventions each time around, and an anxiety that ranks with more glamorously publicized anxieties in modernist practice. And the emotional neutrality which gives Hopper's scenes that potential into which we can read our own scenarios is the result of a process not unlike de Kooning's having to make everything abstract before he can use it. Rothko was traveling in exactly the opposite direction, giving the abstract a content which it apparently precluded. If Rothko could appropriate a literary apparatus through abstraction, Hopper appropriated profound abstract energies through his variety of realism. Thus we cannot look to either, as we can to purer practitioners, for definitions of realism or abstraction. Their ambitions and performance went beyond such limits. I believe Hopper was an artist of comparable intelligence and sophistication to Rothko and de Kooning. He was pleased when someone told him that de Kooning liked his work, and he might well have enjoyed a contact with them that was cut off by his wife, on whom the word "abstraction" had much the same effect as a cross would have on a werewolf.

If through that process of decay, Hopper's personality was realized even as it eluded him, what was left behind after he had eluded himself, as it were, is a cluster of motifs. The conception of the painting descends through modes and habits of seeing that turn up repeatedly in his pictures. Like habits of movement or speech they indicate personality and character. These motifs are intimately connected with Hopper's "voice," that element in the picture that re-creates a figure distinct from the actual artist or the myth of his work. This fragile locution is difficult to recover from those modes of perception that close off the voice effectively or destroy it through assimilation into the social context. Since the voice is really a form of silence which

articulates for us what cannot be expressed, and is thus vulnerable, each generation has the responsibility to reconstruct it, and so give to works of art that life which is always being frozen by coarser public transactions. This complicated dialogue between the voice and the myth is far too easily abandoned to certain kinds of art history or to "smart" avant-garde thinking. The once-revolutionary and now fashionable view of the perishability of art—that its energies and moral force quickly expire—is a modish capitulation that ignores our capacities to engage the forces that vitiate and pervert the work of art. If the critical act is to have any meaning, it is part of its responsibility to resuscitate and recover the voice, stifled by neglect or overacceptance, that gives a work of art its permanent, and permanently elusive, value. In this way not only are art's potentially moral energies made accessible, but culture itself is preserved.

So Hopper's motifs, telescoping formal and psychological elements that in their own way subvert critical orthodoxies as surely as do Rothko's paintings, open a field for study that has hardly been explored. Some of these motifs are: aspects of the figures; the way edges edit his pictures; his magisterial horizontals; certain recurring geometric patterns produced by the dialogue of buildings and light; habits of handling paint; woods; and, of course, windows.

Hopper's figures (influenced slightly, as William Seitz has pointed out, by Guy Pène du Bois) embody a curious dialogue between the general and the particular. Irrespective of age or occupation they have an animal kinship, as if an alien eye had recognized the species but not learned to make fine discriminations. They move slowly, turn their blank faces to the light, relax, or are stilled in some transitory pose that has as part of its content a complete unawareness of being watched. This amounts to a cruelty, somewhat reminiscent in kind if not in pose of Degas, whom Hopper admired. (The only reproduction in either of the Hopper houses was a Degas nude in the bedroom at Truro.) The isolation of his people is perhaps due to the absence of any event or action that could give their presence some motivation.

They exist, to adapt Robert Lowell's phrase, in "a wilderness of lost connections." Such neutrality, however, returns to the observer a constant stream of suggestions, much as Rothko's powerful neutrality does. The figures measure not just the degree of our aesthetic perception, but of our wisdom—as if we were confronted by them in real life. For instance, the physiognomy of hands, particularly the women's, often summarizes personality in a flash (for example, the two fingers shot around a cigarette in *A Woman in the Sun*—1961). And the eloquence of many figures is hardly in the face, but in the tone and posture of the body. There is a depth of worldly knowledge camouflaged as simple observation. What Hopper wrote of another artist is more applicable to himself; his paintings are "stated with such simple honesty and effacement of the mechanics of art as to give almost the shock of the reality itself."

On occasion, when figures are absent, they were originally present and their traces remain, often in pentimenti, more often in the atmosphere, which remains inhabited—again perhaps a residue of the artist who has passed through the picture. In 1930 Hopper put a figure in one of the windows of *Early Sunday Morning* and then painted it out. The sketch for *Sun in an Empty Room* also had a figure which he took out.

Hopper's connoisseurship of "our native architecture with its hideous beauty, its fantastic roofs, pseudo-Gothic, French Mansard, Colonial, mongrel or what not . . ." is an unexplored subject. Tracking the fall of sunlight across its angularities is obviously one of his ruling passions. "Such easily ignored peripheral details as corners and right-angular intersections are of immense importance, and the geometric dividing edges between light and shadow areas are far more significant than they may at first appear" (Seitz). The geometry of shapes and shadows make two of his pictures look Cubist (*House on Pamet River* of 1934 and *Skylights* of 1925), but this is coincidence rather than intention. Frequently, long diagonals at the base of the picture (railway tracks, a road, a wall) are tilted in a way that underlines the scene and at the same time urges it to slide away, relieving the fairly consistent frontality.

"I hate diagonals," said Rothko, "but I like Hopper's diagonals. They're the only diagonals I like." His framing ("The frame? I consider it very forcibly") crops in ways that stimulate and frustrate attention, sometimes suggesting movement and change while fixing the subject so firmly that his best works appear like freeze-frames from a lifelong movie. Hopper's viewpoint, framing, and lighting frequently appropriate movie and theater conventions.

Hopper's art affords frequent glimpses of distant woods, often through windows. They are nearly always impenetrable and thus mysterious, and have a distinct organic force. By seeing the wood rather than the trees, he makes "the wood" a single idea which ties in with the conceptual mode of assembling his compositions in large units. The wood's silence is formidable, frequently accenting the sensations provoked by the man-made components: the gas stations, the houses, the road itself. This muffling of sound is emphasized by Hopper's method of painting. Though the early Paris pictures are confidently painterly, he later seems to have invented difficulties for himself, in a habit usually described as "American," but which may be primarily related to the increasing conceptualization of his vision. As time went on, the thick impastos gave way to a precisely controlled painterliness which softens the impact of his laconic subjects. This discreet painterliness turns hard in the memory, so that one tends to remember the image as more sharply defined than it really is.

This, indeed, is one of our more profitable dialogues: between the memory of Hopper's work and actually seeing it—undoubtedly, too, a part of that dialogue between the voice in the work and the myth that suppresses it. Hopper's painterliness, however, is a subject that has more than its share of surprises. Elements that demand a sophisticated painterly touch are not handled well. He told du Bois that it was years before he could bring himself to paint a cloud. The mutable always escaped him and numerous unsuccessful attempts to paint sea underline the conceptual nature of his approach. Water wouldn't stay still long enough, and he couldn't find a convincing rapprochement

between formula and perception. Yet occasional details, for example, the pastries under glass in *Tables for Ladies* (1930), are handled with a fluent painterliness which inserts into a picture a quota of surprise. Over the years the paint got thinner and more transparent and, like Rothko, he made corrections when painting. Indeed, the frank way Rothko often edges his rectangles is not unlike the way Hopper turns a corner or effects the transition from sunlight to shadow.

The mature art is more summary and selective. The intensification of the image, burning away all trivia, amounted to a quickening, a speeding up of his art, and a closer approximation of the idea whose decay he tried to subvert. After a lifetime in which small adjustments in his families of motifs indicate considerable interior changes, Hopper could express movement and transience more indirectly and yet more powerfully. The *Railroad Train* of 1908 hurtles out of the picture with the aid of dashing strokes and leaning effects. The train in *Dawn in Pennsylvania* (1942) hardly moves, but the eclipsing frame forces a realization of its imminent departure. The *Road with Trees* (1962) contains no moving object at all. But the road rushes past the darkening trees with a speed all the more urgent because the means producing it are more hidden. Thus Hopper engaged those problems of fixity and motion, of impact and recollection which can be identified with the preservation of the image, and its decay through process, which was his central concern.

These and other aspects of Hopper's art are exemplified by his most obvious and enigmatic motif: the window, which signifies most clearly those habits of observation that bring the distinctive "voice" into Hopper's work. The window as lens or eye, of course, monitors traffic between inside and outside. Within a picture, a window is a kind of inner eye through which the subject can flow either way, introducing a dialogue that Hopper frequently replicated by providing numerous vantage points of more distant observation, leading to such questions as: Who is it that sees the picture? Or, who is it that the picture itself "watches"? Hopper's voice is, to my mind, composed of three elements, each

of which can be distinctly separated: observer and observed, which can easily be translated into pursuer and pursued, and the further system of observation signified by the witness who watches this. The pursuer, the pursued, and the witness prompt recollections of the phantom traffic within Jasper Johns' paintings through which the artist escapes into silence, leaving only stealthy residues. But Johns' traffic is mediated by ironies Hopper never summons. In Hopper's work the window (as eye, as vacancy, as threshold, as silence, as labyrinth, as escape) is a common denominator to the elusive transactions of the pursuer, pursued, and witness, which, I believe, have hardly begun to be understood. Through them he avoided the Ping-Pong dialectics into which modernist game-playing often falls. Instead, he achieved a neutrality that made his pictures available to numerous readings, depending on the observer's capacities. Such an achievement leads to comparisons, not with other realists, but with his great colleagues—with Davis in terms of subject, with Rothko in terms of suggestive neutrality, with de Kooning in terms of those gaps between parts of the picture that Hopper, in assembling his conceptual structures, experienced in terms of subject.

VII

Riding toward Truro the pygmy trees hid the sea. Mrs. Hopper had written: "Our road in S. Truro—deep sand, steep, winding, one lane—is a menace by day and E. H. shouldn't go over it at night. He has been stuck there as often as I in broad daylight. Night here is solid black." A few days later she wrote: "It was bitter cold here yesterday. We came back from what used to be a *tea party*, and I want to insist you do not attempt our road, even for the first time, at night. Garages are closed and E. H. unable to haul you out of deep sand in the dark. We come get you at Truro P. O. on [Route] 6A Sunday AM when you phone from Wellfleet." It was September and hurricane season. "Flora decided to go elsewhere!" she went on. "Thank goodness for that. Coral took our garage and just missed our car that year."

The rendezvous point, the post office, was on a

hillock. On top of it Mrs. Hopper waved, her hair gathered into a ponytail. She wore black corduroy pants, white socks, an orange-yellow sweater, and a brick-colored jacket. She looked about sixteen. Hans Namuth and I went down the hill. Hopper, waiting below in the car, came into view. He wore his floppy wide-brimmed hat, a brown corduroy Norfolk jacket, and an open-necked shirt. They always dressed with care.

The road to the house lurched as if one were passing through a slow-moving python. The house tossed up and down and we moved toward it. It was built in 1930, the first one there. From the seaward view, it was a rectangular block with a V-lid, set on a hill, unadorned. It looked uncannily like a Hopper, as was right, since he designed it. There was a kitchen, bedroom, a huge studio with a great factory window in the gable facing north. Inland windows framed scrub and bearberry grass, and small white houses that had sprung up recently. Other windows framed the sand below.

The studio was austere: a floor of gray boards, a large grill puffing up hot air, a solid, red-bricked chimney, bureaus, chest of drawers, a long mirror, an armchair, window seat, chaise longue, a bare easel. Hopper spoke of what he was currently painting: "It's the interior of a room with sunlight coming in—not very successful so far. I'll have to do something with it."

Later he put it on the easel and looked at it. It was an empty room, two pillars of light rising off the floor onto the wall, which stepped back in an L between them into shadow. The light came through a window at the right, framing a tiny triangle of sky.

"What are you after in it?"

"I'm after ME," he said with a slightly exasperated smile.

"He set it up with no chair, no floorboards," said Mrs. Hopper.

"No mouse either!" he said. He kept staring at it. "It needs more white on the foliage outside."

"Did you do any sketches for it?"

"I had a figure in the sketch, but the figure was too big."

"Could I see it?"

"You bring trouble on yourself by mentioning the figure," said Mrs. Hopper. "Don't talk about it."

"Could I see it?" The sketch was in a manila envelope that Hopper held as he turned around. Mrs. Hopper snatched it and sat on the envelope, staring at us defiantly.

"The sketch is a piece of tripe," said Hopper, resigned. "I've always been intrigued by an empty room anyway. When we were at school, du Bois and Rockwell Kent and others debated what a room looked like when there was nobody to see it, nobody looking in even. Of course, there might be a mouse somewhere. I'd done so much with the figure I decided to leave the figure out.

"It needs more white on the foliage outside," he said again, nodding at the window in the painted wall. "There're problems of positive and negative areas here on the right that I have to think about. A negative window with a positive tree outside. They're opposed to each other right there. . . . It's hard to counteract each other. . . . It's hard to paint outside and inside at the same time," he said, expressing the dichotomy fundamental to his work in terms of a formal problem. He got out his palette, placed the colors on it in a neat half-circle, mixed the paint slowly, and made a few rubs of the brush against the olive-green wall in shadow.

The painting was simple and extraordinarily summary. The highlights were fairly thickly painted, but mostly the paint was thin, letting the canvas shine through in the darks. He hadn't measured anything out, making only one correction—at the top of the left pillar of light. Light and shadow, and the line of zone that separates them, were deep experiences for him. Coming out of Giulio's Restaurant in Cape Cod (he waited patiently for the waiter), he was stopped by some foliage lit by the restaurant window. "Do you notice how artificial trees look at night? Trees look like theater at night." He admired light for its capacity to create volume, density, power. Cézanne? "No. Many Cézannes are very thin. They don't have weight."

What did he mean by weight?

"It's concerned with saying something that's in the man. Courbet and Homer have physical weight. In

(continued on page 41)

Washington Square studio, 1964.

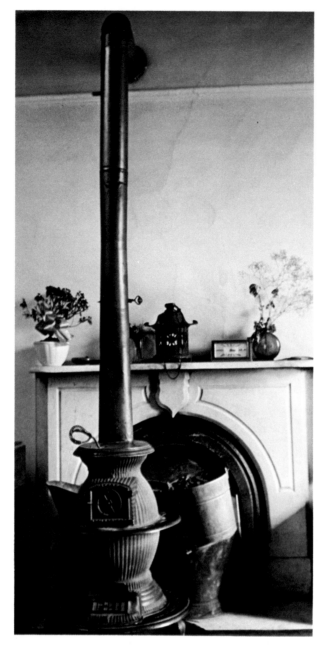

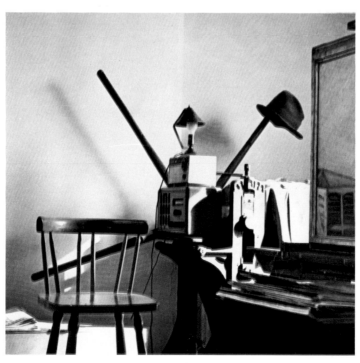

Washington Square studio, 1964.

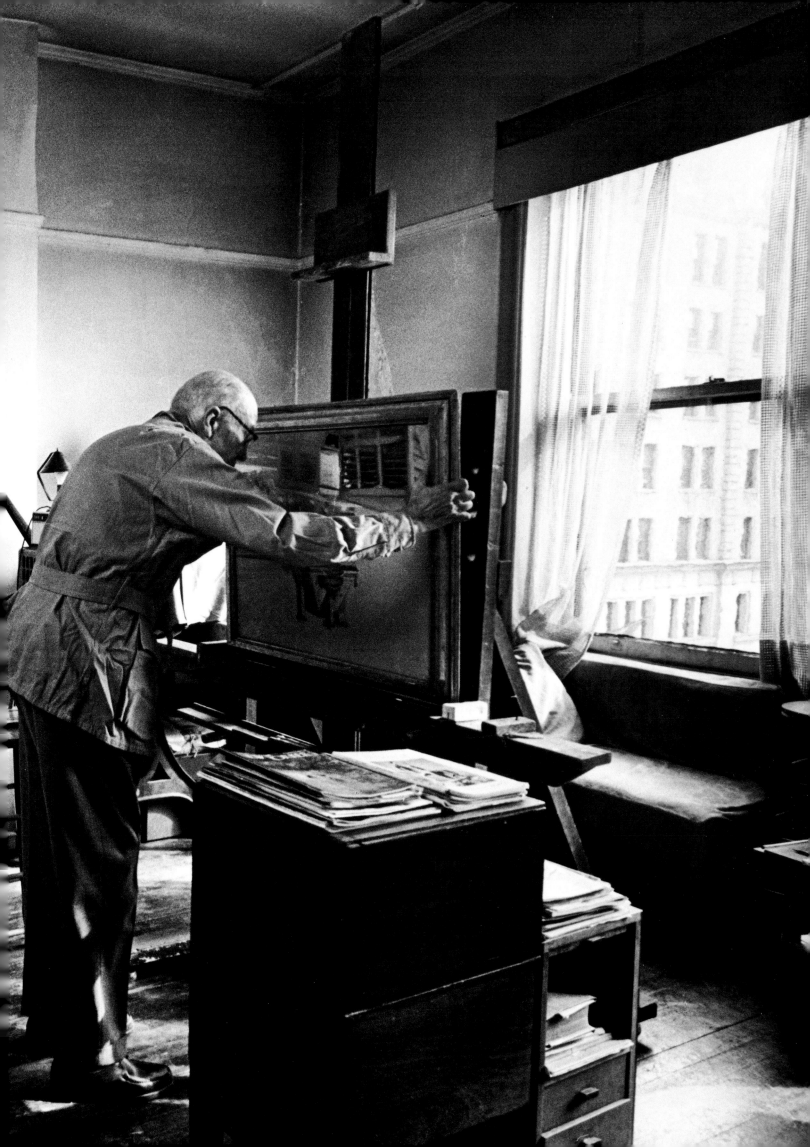

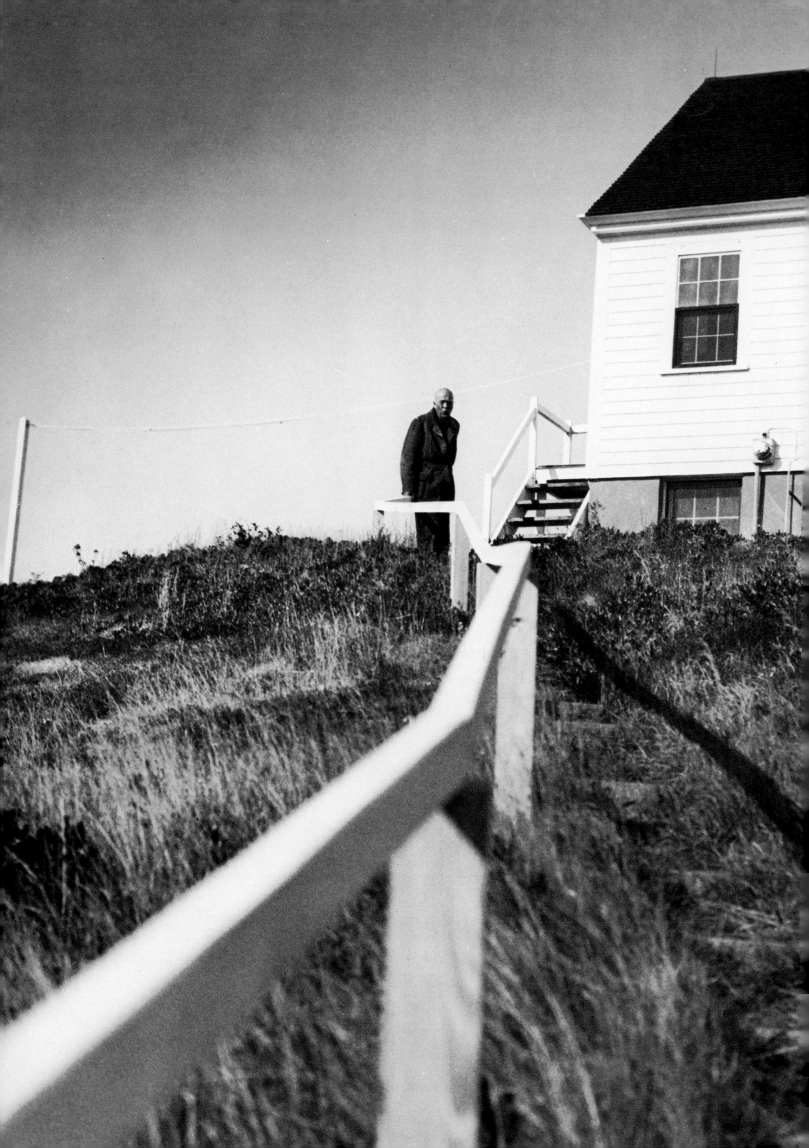

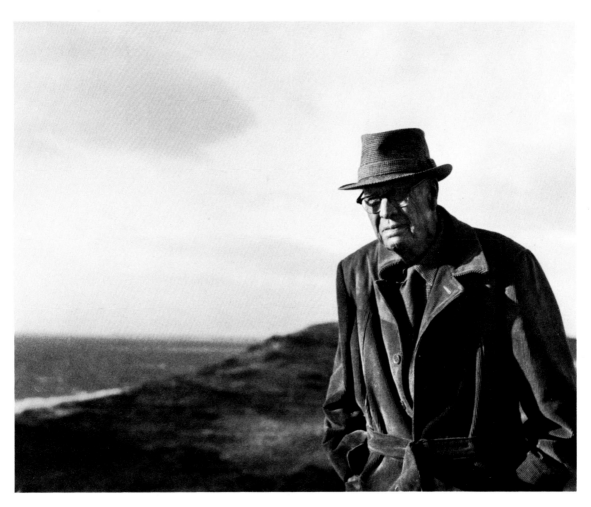

Truro, 1963.

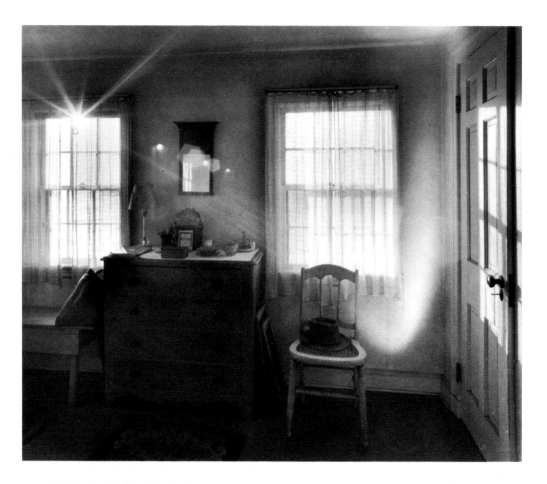

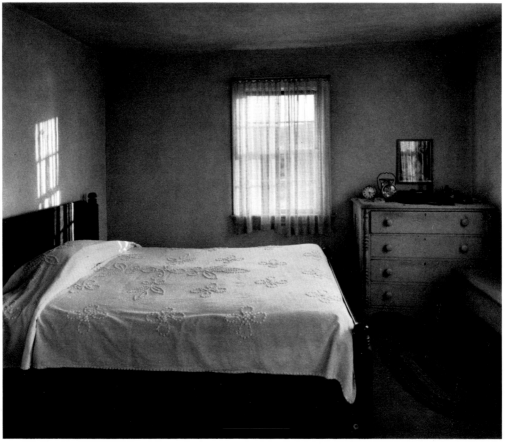

Truro, 1963: Hopper's bedroom
(this page) and studio (right). Foreground blur
is Mrs. Hopper moving in front of camera.

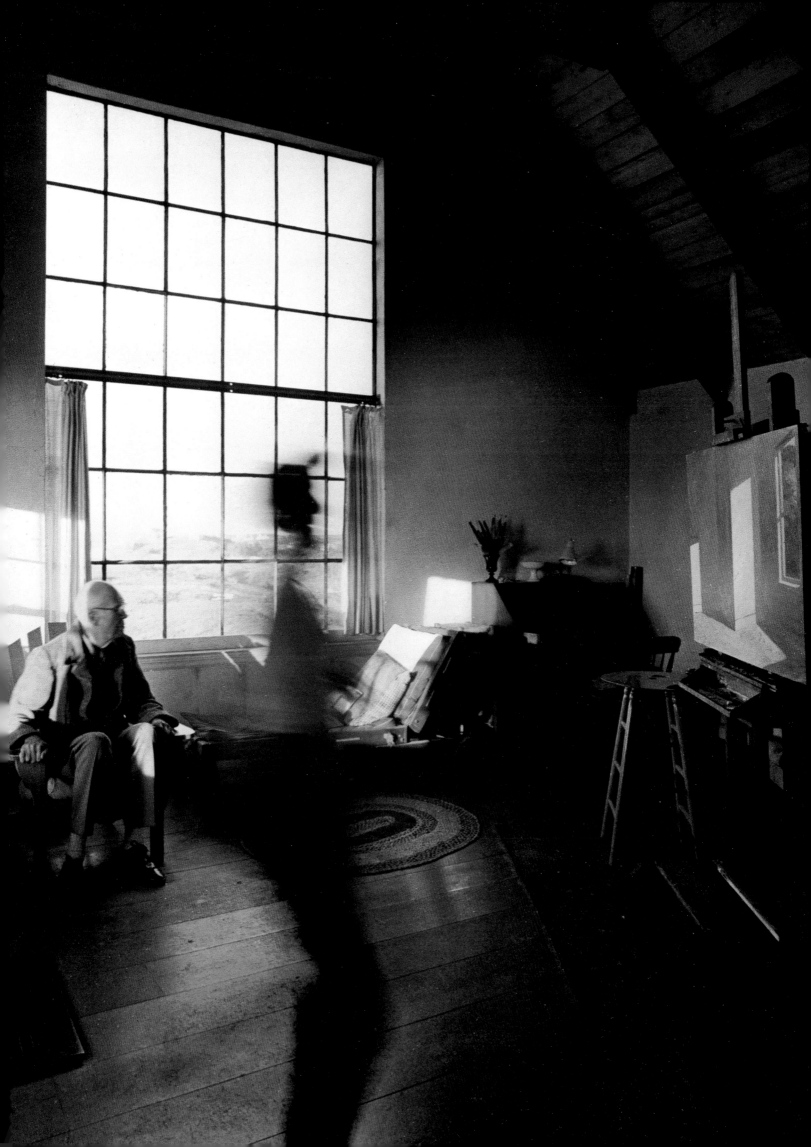

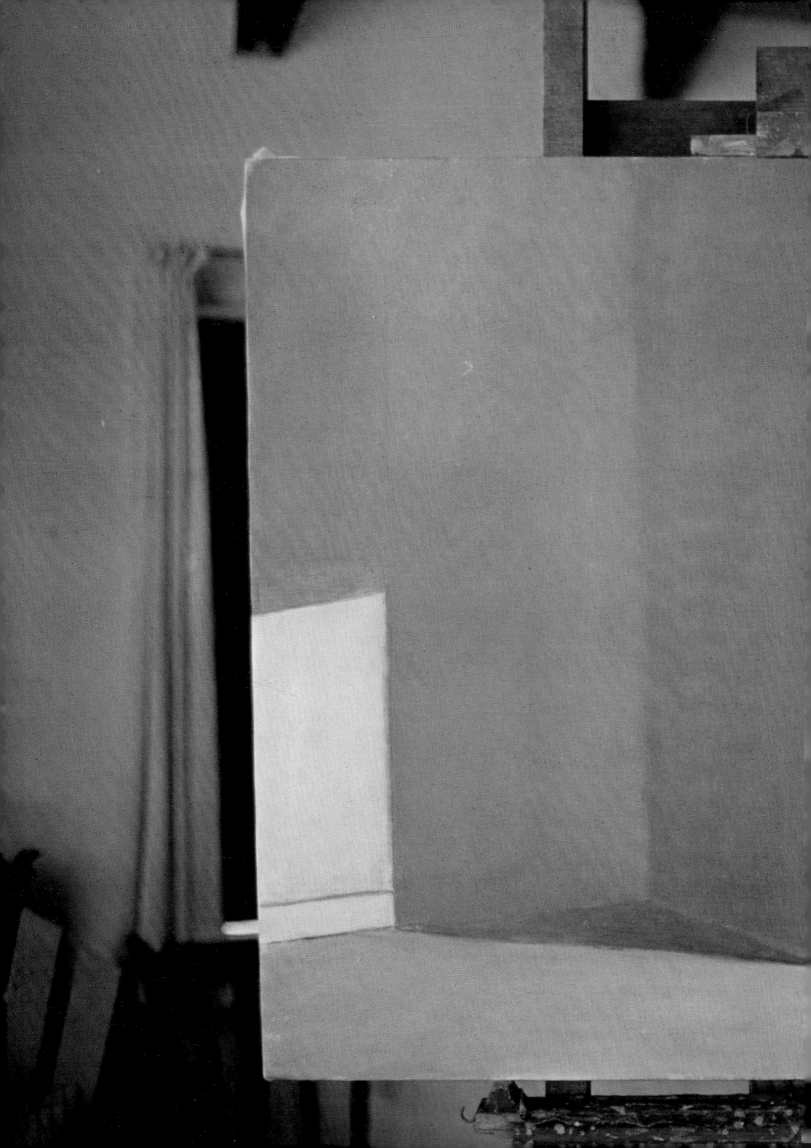

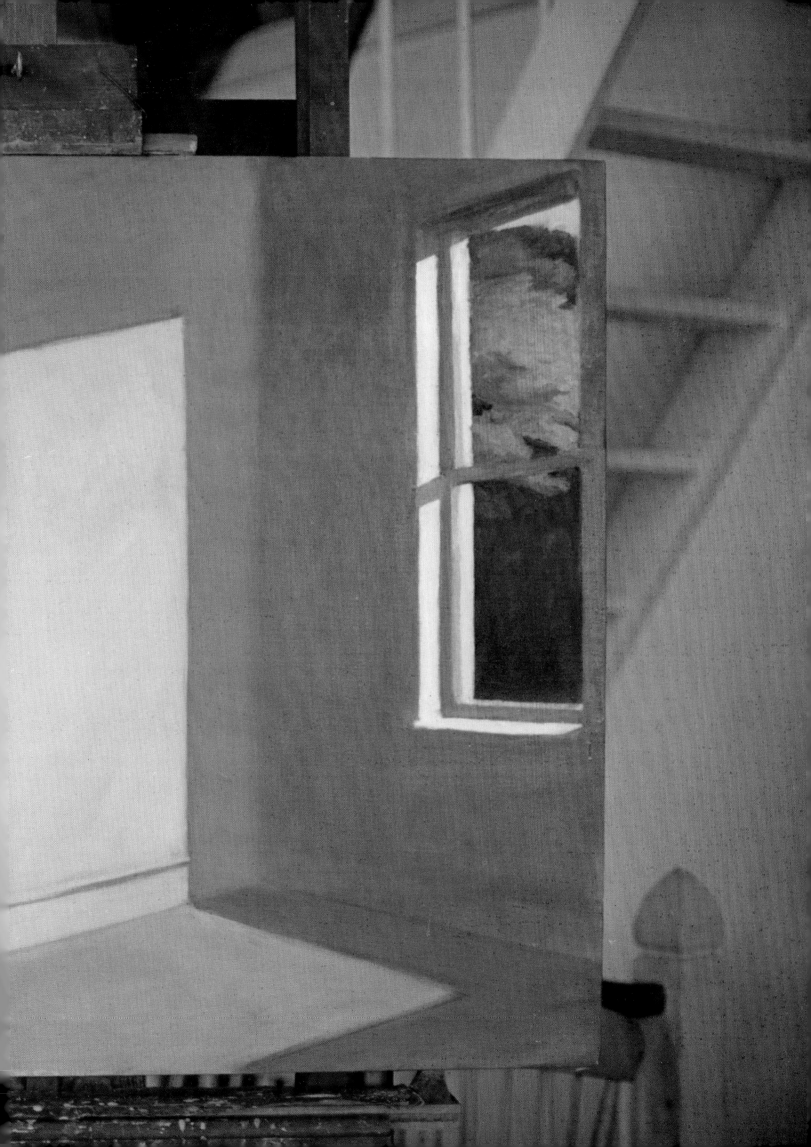

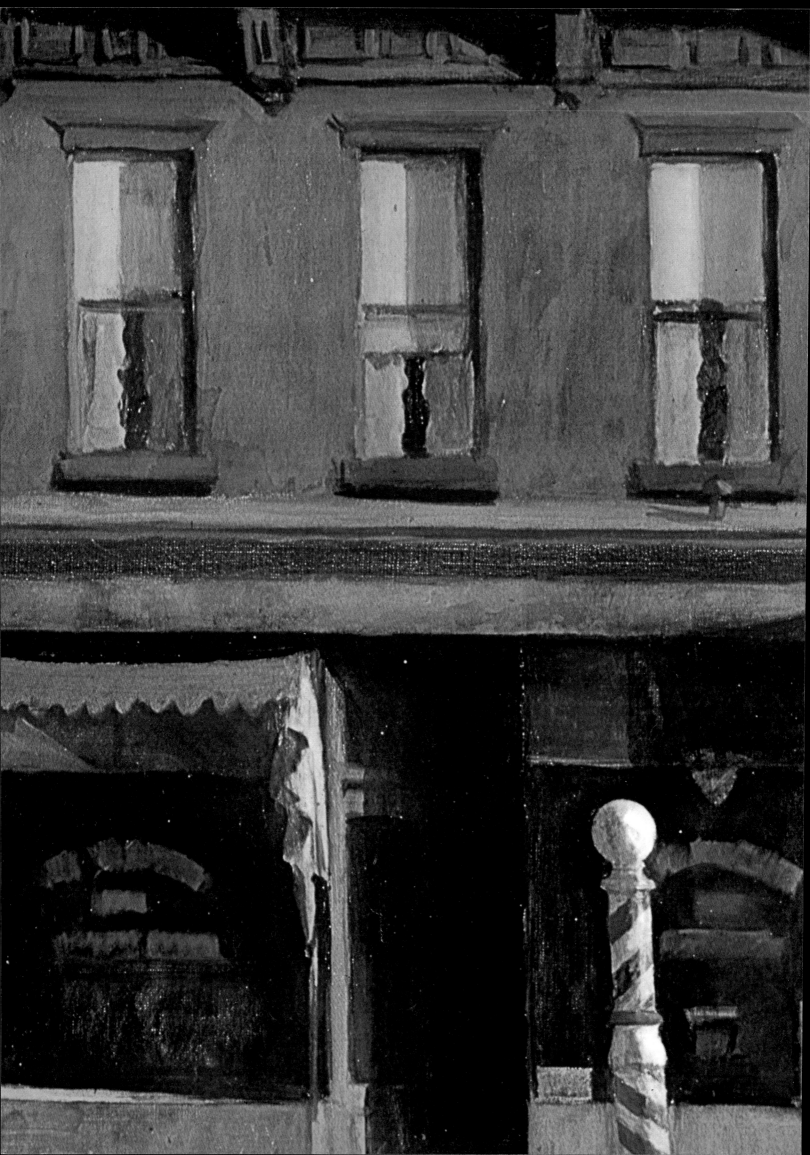

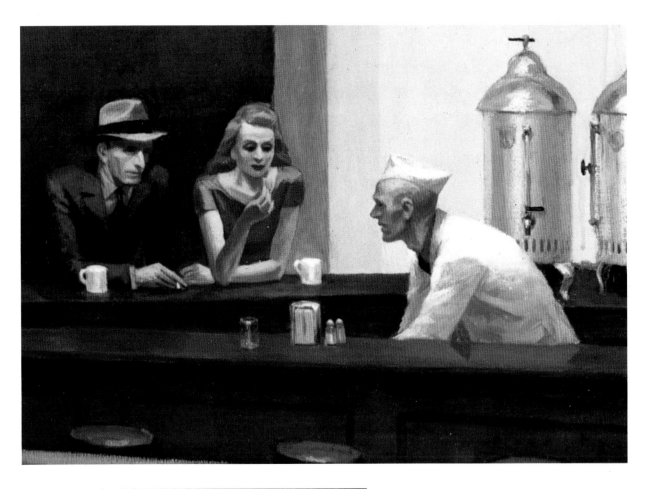

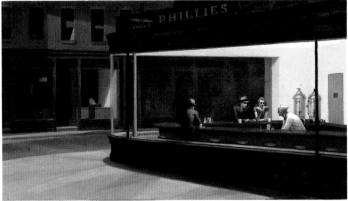

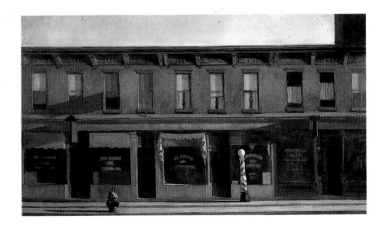

Pages 34–35: Truro, 1963; *Sun in An Empty Room* (in progress): oil on canvas, 29″ x 40″.
Left: *Early Sunday Morning*: oil on canvas, 35″ x 60″, 1930 (Whitney Museum of American Art).
Left, above: *Nighthawks*: oil on canvas, 33″ x 60″, 1942 (Art Institute of Chicago).
Opposite: Detail, *Early Sunday Morning*.
Top: Detail, *Nighthawks*.

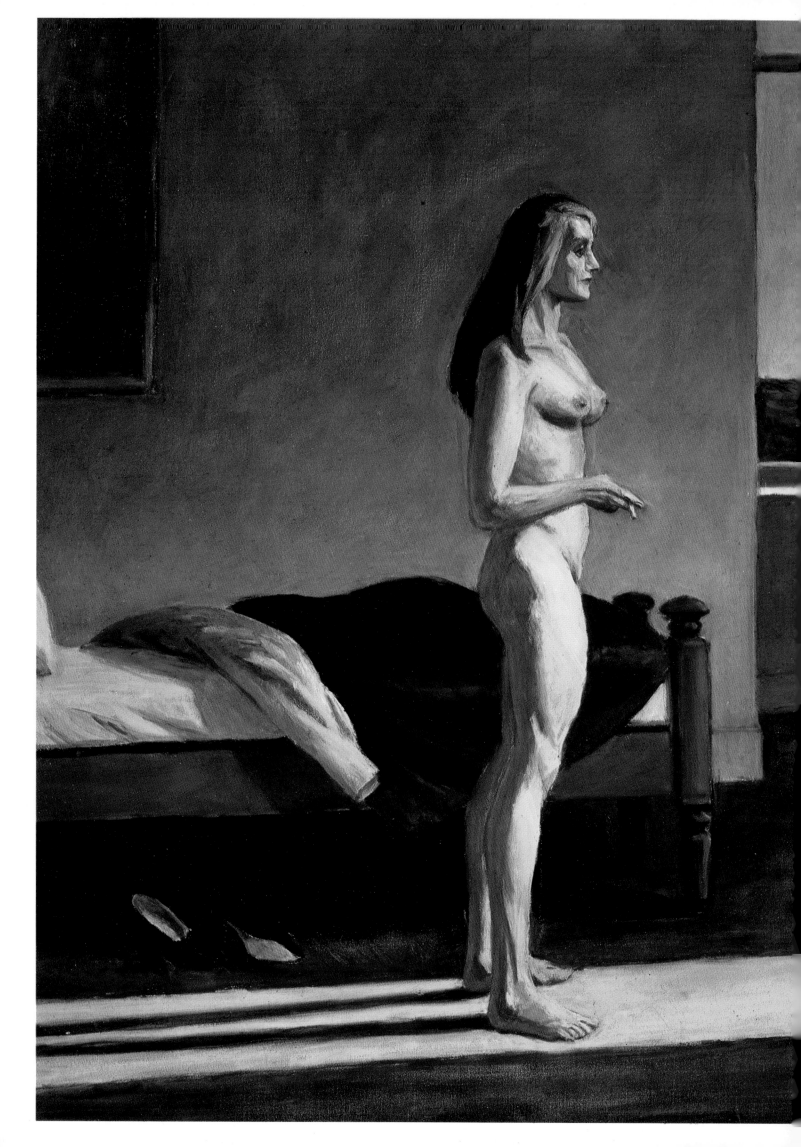

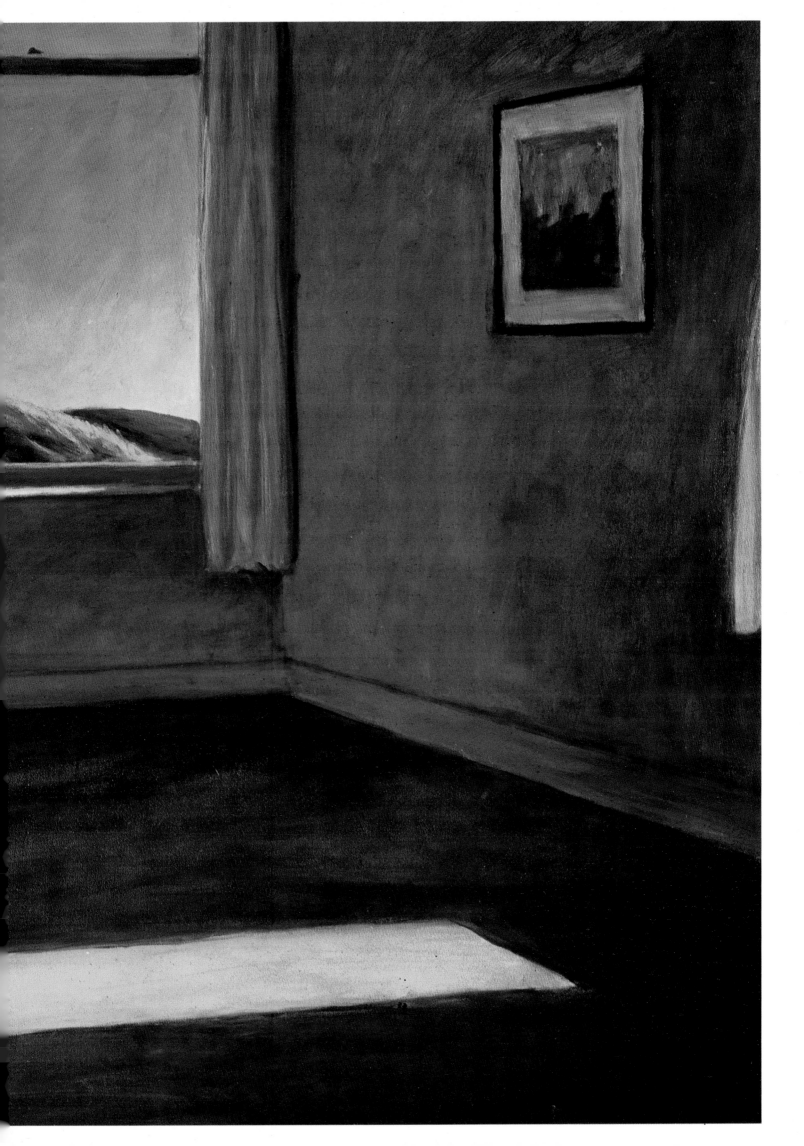

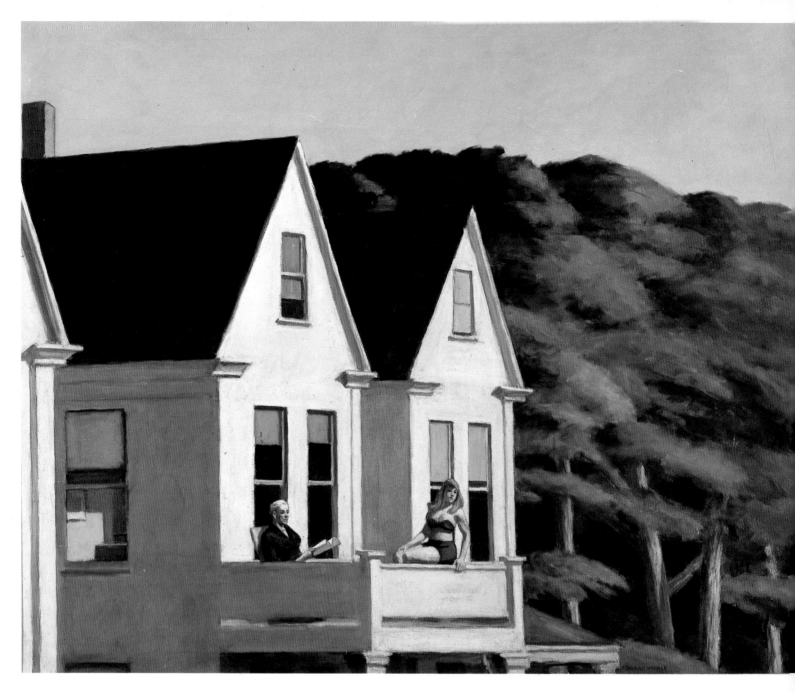

Preceding pages: *A Woman in the Sun*:
oil on canvas, 40″ x 60″,
1961 (M/M Albert Hackett).
Above: *Second-story Sunlight*: oil
on canvas, 40″ x 50″, 1960
(Whitney Museum of American Art).
Right: *Dawn in Pennsylvania*:
oil on canvas, 24″ x 44″,
1942 (Dr/M James Hustead Semans).

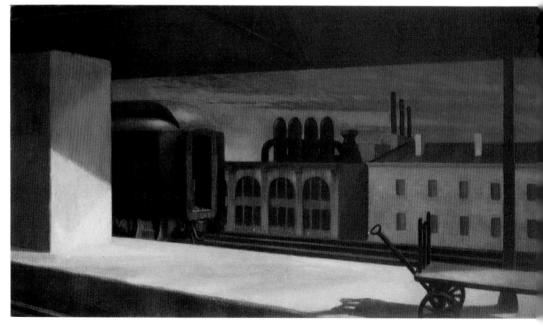

Homer those waves after waves come toward you with tremendous weight." When pressed he said: "Do you find anything [in modern art] that brings you to the ground with ponderous weight? Like Courbet?" Pressed further, he said with slight asperity: "We call a ton of iron weight, don't we? It's a kind of foolish argument."

"I'm conscious of working for light," he said later, "but not for weight." He believed weight was in the character and personality of a person.

As he talked, Mrs. Hopper, her ponytail quivering, held up milkweed pods by the window, pointing out how they open to give birth to the seed swathed in white hairs. She used to gather them, take them indoors, let them dry and die ("They die beautifully"). Upstairs on the landing outside the attic, near the top of the chimney, at one gable of the studio, was a graveyard of dried plants in jars and cans.

"I don't like throwing anything out," she said.

"I don't care very much for flowers." Hopper surprised us by talking unprovoked. "In all the work I've done there's only one painting with flowers, *Room in Brooklyn*, a little vase on the table with flowers." He didn't paint flowers because "the so-called beauty is all there. You can't add anything to them of your own—yourself."

"That's egotistic, isn't it?" said Mrs. Hopper.

"I don't know. Manet added something. Of paint quality and pigment. If you like that. It's like sunsets. The people around here telling me about beautiful sunsets. It's what you *add* that makes it beautiful. No, the unsophisticated think there's something inherent in it [the subject]. A pond with lilies or something. There isn't, of course."

"Why do you choose your subjects as you do?"

He paused until he found out. "I think it's just the things I like to paint."

"When do you paint?"

"When I can force myself to."

"Eddie always waits for it," said Mrs. Hopper, "and it isn't until it knocks him over that he gets up and stretches a canvas. Sometimes it starts him when I start."

He found painting hard labor. "So many people say painting is fun. I don't find it fun at all. It's hard work for me."

Mrs. Hopper was sitting erect by the seaward window, the gulls drifting behind her. Hopper's brushes and knives and paints were in a wooden box, painted gray, on the floor near her. She looked over at him. He remained opaquely silent. It seemed to irritate and charm her. "You know once in a row I said, 'Why, why did you marry me? Give me three reasons.' He said, 'You have curly hair. You know some French. And you're an orphan.' " She quivered against the window, the evening light through her hair giving her a sort of halo. Through the studio window the wind was combing the long grass.

"I knew a girl who threw a knife at her husband," Mrs. Hopper was told in an attempt to lessen her apparent irritation.

"What did he do to her?" she asked, outraged.

"She shouldn't have been so responsive," said Hopper.

He was told Andrew Wyeth had got $65,000 for a painting that day.

"Think I'd get sixty-five thousand for it?" he asked, indicating the painting on the easel.

"You should get a hundred thousand for it."

"What would I do with it?"

"I wouldn't know what to do with it," said Mrs. Hopper.

Mrs. Hopper leaned forward. "I once bit him to the bone," she said confidentially.

"It's a lot of money, a hundred thousand dollars."

"I felt the bone under my teeth. Next day *he* was bragging about it."

Mrs. Hopper was told she had great energy.

"Who, me?" she said femininely. "I'm dying all over the place most of the time until the phone rings and then I come to life. I collapse until someone mentions a party. Once I felt tired and I went to the doctor. He told me I was suffering from nothing but fatigue and outrage." She watched Hans photograph Hopper. "I'll never forgive you if you don't stand up straight."

"That man," she said, shaking her head, "was six feet, four and five-eighths inches when I married him. Now he runs along on all fours. I feel cheated."

"Napoleon was very small," said Mr. Hopper.

"I loathe Napoleon."

"He changed the face of the world."

"Anything you'd want to do?" she said.

"No."

The studio was gradually filling with golden light. The beach below was deserted. The wind had blown itself out. We talked of descriptive passages in poetry of morning and evening.

"There's a beautiful thing of Verlaine's on evening," he said.

> *"Un vaste et tendre*
> *Apaisement*
> *Semble descendre*
> *Du firmament*
> *Que l'astre irise . . .*
>
> *C'est l'heure exquise"*

"Once," said Mrs. Hopper, "he started quoting Verlaine on Bass Rock in Gloucester. I took it up when he stopped. He was surprised."

On the easel the painted room seemed a deserted mirror of the room we sat in, strangely emptied by the suspenseful light. Through the window in the painting the woods were livid and mysterious. "Some say your woods and Robert Frost's are menacing: 'The woods are lovely, dark and deep' . . ."

"I admire Frost. That one and another called 'Come In.' I'm an admirer of rhyme in verse. There's a beautiful verse in Goethe's 'Wanderer's Night Song.' "

He said flatly in German:

> *"Über allen Gipfeln*
> *Ist Ruh,*
> *In allen Wipfeln*
> *Spürest du*
> *Kaum einen Hauch;*

> *Die Vögelein schweigen im Walde*
> *Warte nur, balde*
> *Ruhest du auch."*

He translated:

> *"Over all the hills is quiet,*
> *Over all the dells you can hardly hear a sound.*
> *All the birds are quiet in the woods.*
> *Soon you will rest, too."*

"It's an extraordinary visual picture," he said.

VIII

Hopper brought to the question of the artist's myth the unimpressed and steady inquiry he brought to anything he cared about. He was sensitive to the dialogue between his conception of himself, his art, and the audience. He seemed to find the legend an acceptable enough context, though he criticized it for its deficiencies and crudities. For one who found his identity elusive, the legend was a kind of quasi-information, and he was curious as to what this public echo aroused by his work told him about himself.

"I don't know what my identity is," he said once. "The critics give you an identity. And sometimes, even, you give it a push." This unexpected co-operation was, in my view, a response to the major problem of Hopper's generation: How to be a major artist in America. Though Hopper's myth obviously convinced people that he could be a very popular artist, I don't think he ever will be. The myth, as is to be expected, fulfilled certain public needs, not the least of which is to protect the public from the radical nature of art, even an art as apparently conservative as Hopper's. But the dialogue between the artist and his myth is an unexplored subject in that he uses the myth (consciously or not) to assist him in producing the kind of art he wants to make.

Hopper was physically and mentally eligible to tap a powerful American myth, that of an obstinate individualism, of a self-reliant and no-nonsense masculinity. The history of this machismo in American art has (as in

American literature) distinct episodes—from the American Scene red-neck to the bullish Abstract-Expressionist. But Hopper suffered the ill-fortune of having American Scene isolationism projected on him; his myth was appropriated by the national iconography and connected with aspects of art he despised. He quickly reached the stage where the artist ceases to be the beneficiary of his myth and becomes its victim. In the latter part of his life, the myth of his isolation discouraged visitors he would have enjoyed meeting, and that version of the pathetic fallacy which reads the work according to the artist, and vice versa, was firmly entrenched.

But part of the task now is to deal with Hopper's art in the wider contexts into which it has been projected since his death in 1967. It is clear that his theme, like so much that has been considered "American," was simply a *subject* in advance of the rest of the world—the commercial landscape has no American patent. And the sophistication of Hopper's thinking, and its relations to French literature, are only beginning to be brought into the oddly postponed critical discourse about his work. It is now time to advance the claim that, like Morandi, he is one of the great realists of the twentieth century, of which there are hardly a handful. We are thus watching Hopper transcend his American status, and so fulfill it in a far more effective way than those of his colleagues who achieved a more limited goal more completely.

Hopper, like Davis—their careers are surprisingly comparable—had larger ambitions. The two of them used certain American myths to create the contexts in which, unsupported by a strong contemporary tradition, their voices could be heard. The myths they engineered were of a different order and magnitude from those their colleagues appropriated—and so they amount to a kind of inspiration. There is no question that the artists of Hopper's and Davis' generation were aware that there were powerful myths to be tapped, myths that would establish a sense of place and a confidence from which to undertake the modernist enterprise in America. Hopper and Davis both coped successfully with the problem of being major artists in America at a time when this was not thought possible. Hopper's voice was nourished by silence, stealth, and a camouflaged sophistication, Davis' by aggressively acclimating Cubism to the American vernacular. But that their myths would eventually come into conflict with their work was inevitable.

DAVIS

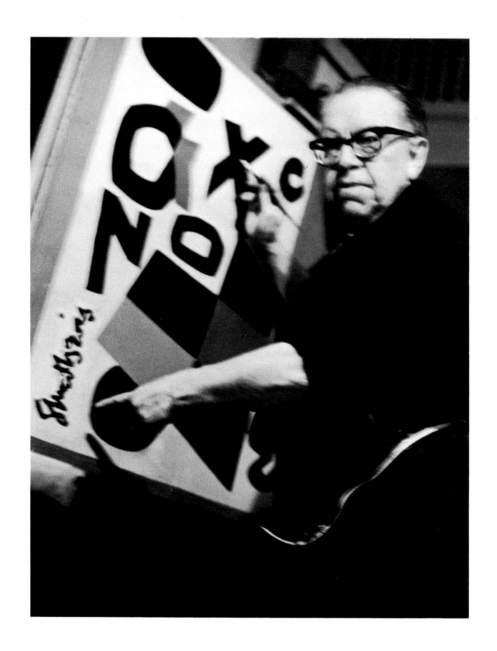

Stuart Davis: Colonial Cubism

Cubism is the bridge from percept to concept.

To paint, is in itself a Social act.

——Stuart Davis

I

In 1909, when Edward Hopper, a former student of Robert Henri, was twenty-seven, Stuart Davis, not yet fifteen, got permission from his father to leave high school and enter Henri's school at 69th and Broadway in New York. The Henri school, wrote Davis in 1945, "took art off the academic pedestal and, by affirming its origin in the life of the day, developed a critical sense toward social values in the student...."

That Hopper and Davis shared a common origin in Henri's studio, suggests that Henri's influence on American painting may be underestimated. As well as legitimizing casual subject matter—the city around them —Henri's training helped both develop the personae that enabled them to paint the pictures they wanted to, while giving rise to myths that ultimately affected the way these pictures were seen.

The similarities between Hopper and Davis—the involved watcher and the disengaged participant—are deeper than a superficial reading indicates. Both were classic in temperament and conservative in nature, though Davis' surface ebullience masked this. Through isolation and withdrawal, Hopper colonized the American experience; Davis used the American experience to colonize Cubism. Exemplars and prototypes, both exhibited in the Armory Show. Indeed, the dialogue between their personae, their attitudes to America, to the city, to their work, is clearly there, but has not been overheard.

In creating a situation which would make his ambitions possible, Davis particularly felt the need of a workable self-image that would open the way to more than limited provincial gains. Unerringly, he recognized what was most genuine and vital in American culture and based his persona on it. He was the first artist to find in jazz a model for extended visual improvisation and to appropriate the style and lingo of the jazz milieu.

The American artist's use of vernacular to promote his aspirations is a recurring habit and an unwritten history: Sheeler's appreciation of Shaker furniture, and David Smith's use of native ironwork and craft are obvious examples. At the end, Davis was still thinking of jazz. "I think jazz is very important," he said during his last stay in the hospital. "Over in Europe they had art for years. Over here they hadn't. Jazz isn't folk art. It's an art of the city and therefore sophisticated. The original fellows, untutored though they may have been —they had a real sense of the instrument as a thing. They take a pop song and make an object out of it, a sound object."

A photograph from the mid-twenties shows the young Davis slouching at the wheel of a Ford, brilliantined hair as shiny as a movie sheik's. In another the young man in vest and shirt sleeves, cigarette dangling and hair brushed straight back without a part, half turns from the piano. Both photos are redolent of boogie-woogie, Baby Peggy, Capone, Tom Mix, and speakeasies. Davis was happy to foster this cool-cat image, spiritually set in the twenties, for the rest of his life. But the image was skin deep. The young man in the driver's seat couldn't drive very well and the piano player couldn't play. "I tried it," he wrote, "and I couldn't and I decided from then on to listen instead of getting mixed up in it—a very good decision." On another occasion he said, "I have a better regard for the real thing than to attempt to intrude."

"Henri's is different than any other school in the world," he wrote his cousin Helen Foulke on December 8, 1909, "and if he should stop I would never go to any other teacher because the rest of them don't know what *real* drawing is, an' that's straight." "We were encouraged," he wrote later, "to make sketches of everyday life in the streets, the theater, the restaurant, and everywhere else." Davis and two fellow students, Glenn O. Coleman and Henry Glintenkamp, shared a studio and went everywhere together. A typical Davis catalogue lists "Chinatown; the Bowery; the burlesque

Pages 44–45: New York City, 1964. Above: At work, New York.

shows, the Brooklyn Bridge; McSorley's Saloon on East 7th Street; the Music Halls of Hoboken; the Negro Saloons; riding on the canal boats under the Public Market...."

His early drawings and watercolors of music halls, floozies, gin mills got the young Davis a reputation as an *enfant terrible*. They show a mordant wit; for example, a man undressing as fast as he can to service a doxy draped over a gunwale. The boat is too small, with a seat across the middle—a music-hall joke? Toulouse-Lautrec is obviously present. A comparison of Hopper's and Davis' early caricatures reveals similar acerbities and—for the only time in their careers—stylistic coincidences. Davis' wit eventually went into his painting, and his satire into an occasional savage pessimism his painting does not show. Hopper for years exercised his wit in casual, private drawings, and it entered his mature art only in the way he engineered anticipation and constructed surprise.

"The borderline between descriptive and illustrative painting, and art as an autonomous sensate object, was never clarified," Davis wrote of his time at Henri's. "Because of this, reliance on the vitality of the subject matter to carry the interest prevented an objective appraisal of the dynamics of the actual color-space relations on the canvas. I became vaguely aware of this on seeing the work at the Armory Show." Five of his low-life watercolors were in the show; one sold. They serve as a marker for the earliest Davis persona—the provincial prodigy inheriting Beardsley and Lautrec. "When I was a kid and read translations from the Yellow Book—Verlaine, Rimbaud—the translations were meaningful to me. Huneker wrote about these European marvels over here. Rimbaud. It hit me—a shape and a color. The spirit of the fellow just sticks." On the same occasion he said, "I always thought Beardsley was an inspiring artist in spite of all the lace-work."

In an oft-quoted passage from his autobiography he wrote, "I was enormously excited by the [Armory] show, and responded particularly to Gauguin, Van Gogh, and Matisse, because broad generalization of form and the non-imitative use of color were already prac-

tices within my own experience. I also sensed an objective order in these works which I felt was lacking in my own. It gave me the same kind of excitement I got from the numerical precisions of the Negro piano-players in the Negro saloons, and I resolved that I would quite definitely have to become a 'modern' artist." Curiously, he found "objective order" in Van Gogh and Gauguin, and doesn't refer to the Cubist paintings in the show. He had a long way to go to become a "modern" artist. "I guess I'm a nineteenth-century product from the northeastern seaboard," he said once, with an irony that always arose when talking about himself.

His apprehension of structure, wherever he found it, was a source of pride to him. He admired the "tremendous structure and balance" in Varèse's music. Structure gives an illusion of method, and Davis always had a rather ambiguous attitude toward method. He seems to have worked toward something that would refute and surprise his method, and so recondition it for further use. He went to great pains to evolve a method. Feeling the need to compose a vocabulary to talk about art, he defined his terms and thought through a kind of Yankee Cubist aesthetic that was hard-headed and practical, like carpentry. Yet he was aware that if a system couldn't paint a picture, it could open the way to one. "The use of Method," he wrote in one of his last notes in 1964, "can create Subjects." Eventually, like Rothko, he spent most of his time in his chair looking at the picture on the easel, handling it with his mind, spending brief periods painting. When this was remarked, he responded, "I don't do anything else except wonder how to make it." No American artist has been so literate about the problems of making art, a literacy unfashionable in Davis' maturity, when Romantic painting was in the ascendancy. The dialogue between method and spontaneity led to a highly developed artistic conscience, a painful perfectionism, and a slow rate of production.

Through the analogical glimpses of structure that he saw in modernist art and jazz he identified the means by which he would become a "modern" artist. His extensive early writings[1] clarify the ideas through

[1] See *Stuart Davis*, 1971, edited by Diane Kelder, New York, 1971.

which he would liberate his art from provincialism and join it to the European tradition, hoping that native energies would impart an independent complexion. These notes experience on the level of aesthetics a conflict between European and American traditions more overtly investigated in American literature. Though Davis' carefully planned campaign to become a modern artist in America was successful, he has to some extent been its victim. He saw his task as one of accommodation—between high art and the vernacular, between avant-gardism and provincialism, between Europe and America—but always in a context of preserving tradition. Once when questioned about adding to tradition by rejecting it he answered, "You don't preserve tradition by imitating it. But you don't preserve it by destroying it either." Thus, his works lack the glamour of modernist breakthrough, though his Eggbeater series *has* assumed mildly mythic dimensions. As an avant-garde artist he was one of a small company of outsiders through the mid-forties. But he was further isolated by the radical transformations of American art in the late forties. He was never quite in fashion, nor ever quite out of it. (Pollock's sudden achievement, vis-à-vis Davis' work, prompts one to recall Conrad Aiken's and William Carlos Williams' outrage at Eliot's *Waste Land*, which abruptly cut across long-term campaigns they had been conducting successfully enough until then.)

This has delayed an appreciation of Davis' achievement, which tests classical Cubism by methods derived from his American situation. Davis did not influence American painting in the forties and fifties, except by the moral example of his career and character. But as a classic and conservative figure Davis occupies the same position to Cubism as Hopper does to Realism. He is its authenticator, summarizing it in terms that affect its meaning and add to its definition. Such acts of consolidation are not valued highly in modernist art, where the advance to new formal ground redefines tradition in another way. But Davis' summary of Cubism was made with an informality that gives it the air of a subject, as he suggested his method did. One is reminded of

Pollock and de Kooning, both of whom define their achievement against Cubism, Pollock by transcending it, de Kooning by attacking it. Davis mobilized Cubism through vernacular energies and his formidable wit, indicated by the ironic title he gave one of his paintings —*Colonial Cubism*.

It can be argued that this summary could best be made from the perspective America afforded on Europe. When Davis went to Europe he painted some of his weakest Cubist pictures; they can be read as an American's view of French culture, parodying the strengths of the French sensibility.

The young Davis, then, had a nineties' romanticism and a journalist's involvement with the present, an argumentative sense of mission, an appetite for avant-garde ideas and for method, an appreciation of structure wherever he found it, and a determination to become a modern artist. And he was developing a tough persona to mask his sensitivity and intelligence, minimizing the liabilities of the artist's position in the teens in New York.

II

Like the Eight and Hopper, Davis began with the topical, disposable art of illustration. He worked for *The Masses* from 1913 to 1916, when John Sloan was art editor, and did cartoons for *Harper's Weekly* from 1913 on. In the years immediately after the Armory Show his own work shows him coping with the ideas that had so affected him. In a number of richly painted bird's-eye landscapes, patterns become more important than the subject (for example, *Rockport Beach*, 1916), in a way not too different from what Hartley was doing around the same time. He pinned rather than painted his subjects onto a flat space where they hold somewhat uneasily, as if about to slide down, as the horizon is tipped to join the top of the picture. The vanishing horizon is of course a theme of landscape painting aspiring toward flatness and abstraction, since the bird's-eye view encourages topography to coincide with formal solutions.

And in Davis' case it coincided with those aerial

prospects—hitherto unavailable to artists—that he associated with modernity. Transport and communications media were appropriated by Davis the way jazz was, as paradigms of method on the one hand, and to shill for modernism on the other. This, Davis felt, would open the way to a wider audience by firmly putting the modernist enterprise at the center of modern life. (Once when Davis was broke, he tried to carry out his theory by taking one of his cigarette pictures of the twenties to the cigarette manufacturer to sell it or to get sponsorship; he reported they didn't know what he was talking about.)

Automobiles (and a Matisse influence) lumber through *Gloucester Street* (1916). Houses stand on each others' shoulders the same year in *Rocky Neck, Gloucester*, a painting that shares a Cubist bias with the frank rectangles of *House, Tree Shapes* (1915) and the facets of *The President* (1916). This structural preoccupation is the theme of a Cézanne-like self-portrait of about 1918. Soon after, again in search of self-images, he tried out Van Gogh in a self-portrait (1919) ladled with impastos and tied down by an un-Van Gogh-like strut at the upper left. (Van Gogh painted a few landscapes for him, too: *Landscape*, 1916, and *Yellow Hills*, 1919.) The Search for the Individual Style became, in modernism, an obligatory overture to a serious career. Davis was the only early American modernist of major stature who hadn't been to Paris before putting his art through this process. Until artists were assured an audience for their search (one of the marks of aging modernism), the search was a vulnerable matter. Davis' is marked by more than the usual ricochets between contradictory aesthetics without perceiving their incompatibility. And as African art contributed to the Cubist idea, Davis' search for his summary of Cubism was facilitated by Afro-American jazz.

In all these early works the struggle between illustrative and abstract space is obvious, as is the disjunction between the subject and its manner of presentation. This struggle, experienced in terms of formal etiquette, is particularly touching in Davis' case, for it is nothing less than a somewhat literal attempt to accommodate the real world to the imperatives of a powerful idea. As Davis indicated, he wished to traverse the bridge from percept to concept, and Cubism was that bridge. But he also wished to remain a realist, one who, by his own definition, related the autonomous system of the work of art to the reality outside it; and to do this not by representation, but by analogy, by a "coding." This has been neglected in writings about Davis, as indeed has his claim to being a realist, usually considered an eccentricity. This necessarily involves a discussion of the idea of "place" in synthetic Cubism.

Synthetic Cubism—Picasso's *Three Musicians*, for instance—is consistent in terms of place. The three musicians are obviously sitting side by side, and the space they occupy can be grasped as a single concept. Though if we fix on a detail, we quickly lose our bearings. The parts, as in a de Kooning, declare their autonomy; destroying the subject, they become a subject of their own. And with this emancipation to a purely relational level of existence, the idea of place is a casualty. As the parts become self-referential, the referent location of each component is lost. This sense of location is what Davis, classicist that he was, wished to retain If Davis has an anxiety, it refers to where everything *is*, not only in the picture, but as a system interpreting the order of things outside it. It is necessary to understand this classic ambition if we are to understand Davis' theories about the function of art, which he attempted to make socially relevant in a way that preserved it from social misuse. One is again reminded that artists of his generation, and of the first generation of Abstract Expressionists, were deeply involved in the thirties in questions of art's social function and that their later art, apparently excluding such ideas, actually does respond to them.

So, as a classic artist Davis was committed to reflecting, through method and analogy, a social order which clarified experience while also providing a lucid model for it. His method of working on one section of the canvas at a time, covering the rest, and finally bringing them all into relationship, refers not only to jazz, but is itself an analogy of the social structure—all the

more so in that it allows for spontaneity to break out and be rectified by visual law. His conceptual clarification of parts recalls Edward Hopper's later method. Hopper eventually fitted together remembered and somewhat abstract parts. Though Hopper's later pictures are generalized and indeterminate in their components, they give a remarkable illusion of a specific place. Davis, the more classic artist, was concerned with objective correlates between the picture and experience; Hopper, a much more personal artist, conveys an impression of disorder momentarily held in abeyance. Oversimplified, the dialogue between them is between optimism and pessimism, on the theme of urban experience. Both recognized and accepted the banal when it was still unmentionable; Hopper's litany of banalities (page 20) and Davis' (pages 74-75) aren't too far apart. In both, the taste for banality had to come to terms with ideas of high art and a deep respect for tradition. There was not much respect for each other's art. Davis on Hopper: "I don't know why anyone would want to make dull pictures out of dull subjects." Hopper on Davis: "Am I interested in Davis' work? No."

Davis' key early picture is *Multiple Views* of 1918. So many subjects (though all on the same theme) are invited in that they start to fight with each other, and Davis has no clear idea how to establish peace. The picture is a compendium of vistas: a close-up of a garden, a small-town street, two girls in a bar, a man walking a country road, a middle-distance shot of a tower, and a helicopter shot of a curving beach—the only view that isn't at ground level. These snapshots are articulated by means of fairly definite borders, like a soft-edged jigsaw (jigsaws and crossword puzzles interested Davis as vernacular formal systems). Since each of the views is seen with illustrative perspective, the attempt to make a convincing design is full of holes. The effect is one of simple addition rather than multiplication of parts and the introduction of simultaneity and sequences recalls the narrative habits of Trecento and comic-strip art. Davis keeps the parts separate and distinct, as if avoiding any effort to synthesize them into a unity. This persistent habit sometimes made his

work look naïve. The side-by-side accumulations of objects, memories, and mementos persist through the New York-Paris series (1931) to the famous (and not very successful) *Package Deal* (1956), when he was commissioned to shop for his subject in a supermarket and paint it. In this case words stand for objects, indeed, *are* objects, in a proximity that recalls concrete poetry. A verbal scenario accompanies Davis' work throughout his career. Words, usually indeterminate, reinforce their shapes with a sound. At the same time they signify place, or bridge an interval as they do in speech. The word-as-object idea, which assigns a place to a word, has an interesting relationship to Johns' labels. Johns' words comment on the picture in a way that opens up matters of definition and aesthetics, within which the picture finds its place. Davis' words contribute sharply to a specific structure and do not distance or "quote" the picture. Johns' words are silent—we do not *hear* them—but Davis' are part of the picture's voice; when we look at the picture we hear his words. He successfully adds a sound track to his classic structures, part of that desire to encompass more of the environment that sometimes led him, especially in the early forties, into incoherence.

Accumulating things on a thematic basis, as in *Multiple Views*, gives a conceptual but not a visual unity. Not too far from the rebus idea, it is an ancestor to Rauschenberg's image clusters. At one time (1952) Davis, like Rauschenberg, thought that "all subject matter is equal," and that all parts of the canvas were equal, too. Davis saw this continuity as the classicist's undifferentiated space, to be allocated at will. To Rauschenberg this continuity was an unbroken continuum in which any activity would have an inescapable unity. Thus Rauschenberg's genial approximations of objects have a temporary look, like words brought together to utter a sentence before moving on to other dialogues. What keeps them together are two antagonistic forces: first, Rauschenberg's belief that anything can be plonked beside anything without the slightest surprise (surprise would be a Surrealist echo) and, secondly, his taste. The taste frequently betrays the

picture into an aesthetic it wishes to avoid. This is clearer from a distance when the picture or combine looks unified—before one sees the words and specific images. These, when we get closer, have a centrifugal force which disrupts the aesthetic occasion, and relates Rauschenberg's work through de Kooning to synthetic Cubism. The centrifugal words and images want to get *out* of the situation in which they find themselves, that is, the space between them is exacerbated and placeless.

Such a conception of the medium is completely contrary to Davis' classic instincts. He considered place, position, and interval as carefully as Poussin, but at the same time opened himself to what he took to epitomize contemporary life—speed, media, jazz—and struggled to rationalize the spontaneous and make the rational spontaneous. The image that came up most often when he described his art was that of an object that worked, like an engine or machine. So that each part, no matter how odd its morphology, had a specific function within the total. And no matter how long it took to build, it should, like an engine, respond at once to the eye's ignition. "What is required is that all areas be simultaneously perceived by the spectator," Davis said in 1953. "You see things as a unity at the same time. What there is, *all* at the same time." This idea found its aesthetic in the sixties, when instantaneous apprehension of the total field became an article of one perceptual faith.

Davis painted his first important pictures in the early twenties, but they remain somewhat outside the "work-in-progress" aspect of his development. *Lucky Strike, Cigarette Papers,* and *Bull Durham* (all 1921) and *Sweet Caporal* (1922) are in many ways his most original works. Derived from Cubist collage, all the collage elements are painted *trompe l'oeil*—even the gold in *Lucky Strike* is reproduced in gold paint. H. H. Arnason points out that they can be seen in a tradition from Harnett and Peto to Pop. They stand midway aesthetically, too. For Davis, the most traditional of avant-gardists, couldn't bring himself to violate the canvas. He describes amusingly in his autobiography how, after Duchamp's example, he was brave enough to sew a button on the canvas, but followed up this breakthrough

unsuccessfully. At the end, when he had difficulty working, he rejected the suggestion of doing collage cutouts à la Matisse ("Got to be painting and space"). And objects destroyed the objectness of the art work. So he painted objects (for example, *Odol*, 1924, a nose spray) with exaggerated formality, transposed into conceptual environments, often activating the objects with arrows, letters, and skewed perspectives.

Odol, and the *Salt Shaker* of 1931, which is not as successful, lead one to ask why Davis picked such subject matter, and to wonder about Davis' knowledge of Gerald Murphy, who painted a handful of Pop precursors (for example, a huge razor) in the twenties. Davis himself, in rejecting Pop as his stepchild, responded strongly to a question about similar attitudes to banal objects. He wasn't being funny, he said. He just wanted "to paint the little stinker with a twist to it. It was an affirmation, not a snide kinda thing."

Davis' choice of crass objects lacking the pedigree of Cubism's guitars and bottles is analogous to his introduction of faster rhythms, louder colors, and abrupt transitions into Cubist diction, formal "vulgarities" that match his choice of subject. These twenties pictures have a completeness that makes one wonder why there aren't more of them. Perhaps the absence of precedents took away his conviction and, indeed, they remain somewhat idiosyncratic. Although he made contact with them after he returned from Paris, in the *Salt Shaker*, Davis didn't make them central to his work. His main direction was to resolve the problems he had stated first in *Multiple Views*.

"I brought drawings of different places and things into a single focus," he wrote in his autobiography. "The necessity to select and define the spatial limits of these separate drawings, in relation to the unity of the whole picture, developed an objective attitude toward size and shape relations. Having already achieved this objectivity to a degree in relation to color, the two ideas now had to be integrated and thought about simultaneously. The 'abstract' kick was on. The culmination of these efforts occurred in 1927-1928, when I nailed an electric fan, a rubber glove and an eggbeater

to a table and used it as my exclusive subject matter for a year." None of the subjects is recognizable in the results, his most sophisticated work to that date. They refer to a variety of synthetic Cubism practiced widely in America in those decades (twenties and thirties) which has received insufficient attention. From Ralston Crawford to Ad Reinhardt, from George L. K. Morris to Arshile Gorky, it has a family resemblance and results in a picture standing for the problems of a generation. (There are at least three such "period" pictures in modern American art: the Cubist one just mentioned; a type of freely brushed landscape out of Henri's studio that stands for a bluff indigenous idea, and a typical Abstract Expressionist picture of the early fifties that summarizes certain discoveries and attempts to escape or extend them.) Davis was the central figure in the assimilation of this Cubism, and in the thirties was to some extent the leader of an informal school.

The Eggbeater series was the farthest Davis had gone in "coding" his subject, and as a realist it led him into some contradictions. "I invented these geometric elements," he said, but denied that his aim was to "establish a self-sufficient system to take the place of the immediate and accidental. . . ." He wanted to "strip a subject down to the real physical source of its stimulus." The connections between the painting and the real world were becoming a little shaky, but they were real enough in Davis' mind. "In 1928," he said, "I repudiated the label 'abstract.' " In explaining why he considered himself a realist, he had recourse to electronic similes and ideas of multiplicity and simultaneity. Davis' stubbornness arose from a view of the twentieth century we now share, but which his colleagues either did not, or hesitated to bring into their art. One can see Davis' emphasis on contemporaneity, on a space and time altered by communications, as having a somewhat Futurist cast.

When the Eggbeater year was over, Davis was a master of Cubist syntax and had developed his ideas about it beyond anyone then working in America. The Eggbeaters were Davis' certificate that he could become what he had set out to be fifteen years before—a

"modern" artist. He was a good, but not a major one. After selling two pictures, he suddenly went to Paris, where he advanced his skills but not his achievement.

III

On July 9, 1928, the Paris edition of the *Herald Tribune* carried a small item that Mr. Stuart Davis had arrived for a visit of several months. "Mr. Davis has been one of the principal exponents of abstract painting in America and has seen no reason, in spite of the about-face of most of his colleagues, to revert to old-fashioned theories of art."

The loaded journey of the American to Paris is disclosed by Davis' "Self-Interview" in *Creative Arts* a few years later.

Q—Now tell me, Mr. Davis, is there any one outstanding event in your artistic life that has special significance for you?

A—Yes. My trip to Europe in 1928.

Q—What was its particular value?

A—It enabled me to spike the disheartening rumor that there were hundreds of talented young modern artists in Paris who completely outclassed their American equivalents. It demonstrated to me that work being done here was comparable in every way with the best of the work over there by contemporary artists. It proved to me that one might go on working in New York without laboring under an impossible artistic handicap. It allowed me to observe the enormous vitality of the American atmosphere as compared to Europe and made me regard the necessity of working in New York a positive advantage.

Q—Can you name some of the important positive factors that contribute to the vitality of the American atmosphere you spoke about?

A—The movies and the radio.

Q—Why?

A—Because they allow us to experience hundreds of diverse scenes, sounds and ideas in a juxtaposition that has never before been possible. Regardless of their significance they force a new sense of reality and this, of course, must be reflected in art.

Q—But don't they have radios and movies in Europe?

A—Of course, but they don't have the same volume or quantity. It is precisely this volume which forces the issue.

Q—Could you name some of the younger artists who reflect this American spirit of which you speak?

A—Yes. Cab Calloway, Louis Armstrong, the Three Doctors. . . .

If one follows up the idea of Davis as a processor of environmental data which are reconstituted in his paintings, one might expect great changes in Paris. There were. The environment didn't assault him—"The pressure of American anti-art was removed"—it seduced him. The city "was so interesting I found a desire to paint it just as it was." This led to a series of Parisian scenes with a bright, hollow nostalgia in which he gently warped space with a mannerly consideration far from the drillmaster toughness of the Eggbeater series. Though full of piquancies (for example, the left end of *Rue de l'Echaude*), they have a confected quality that suggests he was trying on the self-image (which Baudelaire once suggested) of the artist as superb French cook. Apart from the excellent *Café, Place des Vosges*, with its tilted rectangular shopfront, they seem to me idealized stage sets for a nostalgic musical of an American artist in Paris. He painted Paris as if he'd first seen it twenty years before. There is almost no tension, beyond the suspense of the empty stage idea. "I like tension," Davis said. "If there isn't any around I feel vacant." There was no tension in Paris.

But the stage idea is a major one in Davis' painting (as it is in Hopper's) from *The Music Hall* of 1912 on. The classic artist is concerned with limits, and Davis liked to know exactly the limits of what he was dealing with. "New York," he wrote in one of his more surprising statements, "has the sense of limited space, something you can deal with." *The Town Square* of 1925-26, before he got to Paris, is already a stage set and, as Rudi Blesh pointed out, is a test run for *Report from Rockport* in 1940. The framing of his subject is a theme that tends to go unnoticed in Davis' art, but it is

one of his most important considerations. (One is reminded of Hopper again, who said that he considered the frame "very forcibly.") The stage underwent certain transformations as his ideas changed. It eventually turned into the framing idea—borders frequently run around his later paintings, within which the abstract shapes appear to hold their places on a vanished stage. The stage and the border both convey the thought that everything occupies its correct place, no matter how the shapes themselves blurt or flash. Before the stage turned into the border, however, two other framing devices derived from the movie and, later, the TV screen entered his pictures. The split screen of *House and Street* (1931) obviously owes something to movie frames, and his tilting of the right-hand frame seems to recall movie screens seen from the side. *Letter and his Ecol* (1963), like a few smaller pictures from the exhibition of that year (his last), is perceived in the same simultaneous way one sees a TV screen, especially when one can't read what's on it.

The voyage of the American to Europe for the first time is mythic. No one talks much about the voyage back. But there is evidence that the impact of their own country, after Europe, is a devastating experience for civilized Americans. Hopper's and Davis' encounter with their own milieu when they got back was a decisive shock to their art. Significantly, each made his mature style by confronting high art with the vernacular, with what Davis called "a New York visual dialect." "I was appalled and depressed by its giantism," wrote Davis of his return to New York in 1929. "It was difficult to think of either art or oneself as having any significance whatever in the face of this frenetic commercial engine."

Yet, typically, he was glad to be back: "As an American I had need for the impersonal dynamics of New York City." Davis wasn't pulled between contradictions in "crisis" fashion. Everything was relative, thus adjustable; he was capable of holding two contradictory ideas in check, retaining a high measure of maneuverability. The masked classicism of his pictures is based on this tolerance for contradictions, and the

urge to resolve them was more intellectual than emotional. Gorky, though obviously paraphrasing Braque, was perceptive when he wrote of Davis in 1931, "He chooses new rules to discipline his emotions."

Still, a puzzling characteristic of Davis' art, particularly in the thirties, is the way in which contradictory elements are not resolved, but kept at bay: graphic outline versus color shape, literal versus abstract space, high style and vernacular, geometry and irregular form, simplicity and multiplicity, words and their morphology, spontaneity and calculation. What surprises is the appearance of resolution given by a style that keeps everything at the same distance. Perhaps this arose from Davis' conception of media and art. Media homogenize content and relax its contradictory elements. Davis seems to have learned from the way media (under the disguise of intimacy) distance experience, rendering it suitable for other contexts, that is, high art. This is clearly seen in pictures juxtaposing objects and symbols to produce a simultaneous impression—the New York-Paris pictures already mentioned, the *Windshield Mirror* (1932), where it works better, and in his Radio City mural, *Men without Women* (1932), in which men's attributes (it was done for the men's lounge) are shuffled with an arbitrary confidence Davis didn't find again until the late thirties.

The decade of the thirties was the most active and disturbed in Davis' life. There were physical trials ("the economic terror lasts to this very day," he said in 1962), WPA work, succeeded by the Artists' Union, and later the Artists' Congress. He became the major spokesman for advanced ideas, and battles were fought against philistinism and the American Scene. At one point he seems hardly to have painted at all. His maturity may have been delayed by the wintry conditions of the thirties, by the isolationist threat in politics, economics, and art. Around this time abstract art became identified in some quarters with subversive ideologies. As late as 1945, Davis felt constrained to state for J. J. Sweeney's catalogue for the Museum of Modern Art retrospective, "I am an American, born in Philadelphia of American stock. I studied art in America. I paint what I see in America, in other words, I paint the American scene."

It is hard now to conceive the atmosphere in which Davis and other pioneering abstractionists worked in the thirties and early forties. An article on Davis in *Life* magazine in February, 1947 (two-and-a-half years before the famous article on Pollock), reproduced four of his more realist works in color and explained them: "Fundamentally, there is nothing very mysterious or difficult to understand about the work of an abstract painter like Stuart Davis. He goes about painting a picture in very much the spirit grandma had when she was making a patchwork quilt, placing squares and oblongs of color where they will contribute tastefully to the overall pattern. Being a professional, he is somewhat more skillful and imaginative than grandma. He knows how to produce striking contrasts and how to lead the eye through interesting little adventures in observation."

Davis partly previewed his journeys of the thirties in a 1931 picture. It shows an artist in front of a canvas in a Miró-like landscape. The canvas is stocked with undeniable Davis shapes, as if he knew where he wanted to go and what influences he had to transform. The picture is called *Artist in Search of a Model*. During the thirties Davis had an extended dialogue with Miró. As important to him was the artist he called, rather Steinishly, "the most American painter painting today" —Léger (see Léger's *Umbrella and Bowler* of 1926). The *Eggbeater No. 5* he painted in 1930, a few years after he came back from Paris, is a genteel Léger-Braque, the still-life equivalent of the street scenes painted in Paris. Significantly, the electric fan has been replaced by a guitar, which was soon to disappear. As Elaine de Kooning wrote, "You really can't have Whitman's Open Road run through the parlor without changing the look of things."

Compared to the tough, abstract *Eggbeaters* of 1927-28, *No. 5* is a mild postscript, but it points up a movement Davis repeated frequently enough to give his career a certain motif. Until he reached his maturity toward the end of the forties, each advance into abstrac-

tion was paralleled by a return to a schematic realism. The quasi-realist *Report from Rockport* (1940) appeared the same year as the abstract *Summer Landscape No. 2*. After his maturity he often retained or inserted a realist cue into abstract engines. In the fifties, such works as the great *Midi* (1954), *Tournos* (1954), *Lesson 1* (1956), and particularly *Tropes de Teens* (1956) scramble abstract shapes and stylized reality. In other paintings (*Blips and Ifs*, 1963-64; *Seme*, 1953; *Owh! In San Paó*, 1951; *Pochade*, 1958; and particularly in *Combination Concrete*, 1958), words seem to offer the same reassuring check on his abstraction that bits of realism provide. Relatively "pure" pictures, like the splendid *Colonial Cubism* (1954), *Nu* (1953), and *Ready to Wear* (1955), are somewhat rare, and those large official compositions without words, such as the *Composition Concrete* mural (1957-60), the United Nations mural (1956), and the *Allée* (1955) mural for Drake University lack the plangency of his best work. They seem overcomposed and unspontaneous. From this perspective one understands Davis' insistence on being called a "realist."

If this can be seen as a horizontal movement in Davis' career—between real components and abstraction—a vertical movement is also remarkable. He had a habit of retrieving earlier work. *New York Under Gaslight* (1941) brings *The Barber Shop* (1930) up to date. *Medium Still Life* (1953) rehearses numbers 1 and 3 of the Eggbeater series. *Tournos* (1954) picks up *Shapes of Landscape Space* (1939). "Davis," wrote E. C. Goosen in 1959, "has been his own verifier throughout his career." This also signifies a way of seeing his career all at once, simultaneously, as if near and far were not understood in terms of time, but in terms of space, of surface, with everything remaining contemporary and accessible. Toward the mid-forties he painted some pictures that stand for this: *Ursine Park, Arboretum by Flashbulb, Ultramarine*—each choked with forms and ideas. They climax in *The Mellow Pad*, which occupied him off and on between 1945 and '51, exactly the years during which he matured. He seems to have clarified his style *against* this picture, in which he summarized his future career in a glut of possibilities which never occurred in such profusion again.

This double movement imparts a complicated appearance—and an unevenness—to Davis' career. But the changes of thought, the rehearsal of previous imagery, the checking and rechecking, the switches between high style and vernacular inscribe a motif that stands for the course of the most advanced American art from the twenties to the early forties. That motif can be read as a little desperate at times in its tenacity, though always rejecting the heroic posture.

Davis attempted to emancipate his art from provincialism by a logical and firmly grounded attack. Allowing more irreconcilables into his art than any other American artist of his time, he tried to maintain them by classic means—with intelligence, order, clarification, endless theorizing, trial and error. How profoundly disconcerting it must have been for him to witness these opposites brought together in the late forties through a romantic absolutism foreign to his nature. This gives Davis' career a somewhat doubtful cast, and it has not helped his reputation. He coped with this in his usual somewhat self-deprecating fashion, sometimes with wit. Indeed, Davis' wit was part of that vernacular which focused his art and his emotions.

IV

"One is struck again with the singularly impersonal, almost disembodied nature of his art. One does not feel a contact with its inception (as with Abstract Expressionist work) or recognize in it the sensuality of an individual effort. It seems to be all there at once—the product of an aggregate impulse and perception, like slang."

Elaine de Kooning, Davis' best critic, wrote this in 1957, brilliantly pinpointing the effect of his "color-shape" units. Their muteness and blankness is matched by their own loudness and attack. They seem masked by their abrupt frankness. The artist's personality is extruded from the paint, which is laid on in thick, workmanlike impastos that light up a shape exactly and keep it on the surface with heavy textures. Edges are always decisive even when delimiting uncategoriz-

able shapes. In their unexpected appropriateness, such shapes are indeed like slang.

In the dialogue they conduct among themselves, mediated by an impeccable Cubism, wit lurks behind deadpan surfaces. Davis, like Miró, is one of the few artists who made Cubism witty. Wit, as Ernst Kris put it, can relax a high-art style and mobilize it into wider contexts. It is thus a useful instrument for provincial ambitions, and in Davis' case, compresses Cubism's diction, but not its syntax, into slangy shorthand.

From the beginning Davis had a great interest in humor and wit. He could be an amusing talker and writer; his reminiscence of Arshile Gorky is hilarious. In December, 1914, he had a show of caricatures, and in May, 1915, participated in something called The American Salon of Humor at the Folsom Galleries. His friend Emanuel Jules wrote in the *New York Call* of May 2, 1915, that he was "the most exasperating humorist I know. . . . Davis is not a polite artist; he will never be popular in drawing rooms. Davis is determined to ridicule people, to show his contempt for them." One of Davis' pictures, reproduced in the St. Louis *Post-Dispatch* (May 9, 1915) shows a carousing group with yellow Toulouse-Lautrec faces. It was called, in one of his earliest word-plays, *Hobohemia*.

Around this time his black-and-white caricatures for newspapers became more abstract, as if Beardsley's curlicues were being unraveled by the Cubists. In the *Paint Rag* of August 5, 1915, the intention comes through less in the facial expression than in line and shape in the service of some notion of character. The comment is transferred from the subject to the means, from illustration to a sort of abstraction *manqué*. One might look on this as the beginning of Davis' coding of information, and of the transference of wit from subject to style. The wit ("What makes Stuart Davis is his wit," wrote Henry McBride in 1929) remains overt in his serious work as late as 1941. In *New York Under Gaslight* of that year, the "ROOM" sign in the window is cut off at the M—there is no room for ROOM. And beneath it, the large "DENT" (part of "DENTIST" in a previous version) has a dent in the D.

The subject of wit in Davis' style is a large one and it remains somewhat elusive. But much of it is "about" synthetic Cubism. Synthetic Cubism keeps in touch with the surface of the picture by over- and underlapping it; there is a gliding syntax of before and after. Davis' wit, at its best when most deadpan, makes this formal gaming a matter of humor but never of parody. Endlessly engaging Cubist syntax in unexpected dialogues, he gave it a slangy voice that gets its formal cheek by talking back to itself through color and shape. Cubist space becomes a kind of straight man for the slangy comic articulating shapes, words, colors. Cubism gets an appearance of informality from this process, and Davis added to tradition as he wished, by preserving it, not by imitating or destroying it.

The wit is of course connected to Davis' idea of spontaneity and, as we have seen, his methodology was applied to its manufacture. So the shapes and colors have an aggressive appearance of spontaneity and their pithiness is cheeky rather than genuinely surprising. This gives his wit an impersonal front that is the very medium of monologue, the form Davis' pictures most approximate. The comic's dead pan withdraws the comment that facial expression could make on what's being said, and gives the listener the feeling that he may not have heard something right. The listener's response is often discharged after a delay, while he "gets it." Davis' brushstrokes, which might comment on the shapes and colors they present, are similarly deadpan. His organization of spontaneity, the rehearsal of his visual patter, has removed the personal. This dead pan puts the onus of response on the audience. Davis' monologues, if we can call them that, remain discursive, but without a punch line, except insofar as the whole picture itself, which telegraphs its message immediately, is a punch line—one, however, that precedes the story.

Through wit, Davis introduced vernacular elements into high-style syntax, and the syntax itself was distanced (in 1951, he remarked on "the objectivity of humor"). Through wit, vernacular and high style qualify each other, constituting, if anything does, the essence of Davis' art. The deadpan convention, impersonal

(continued on page 73)

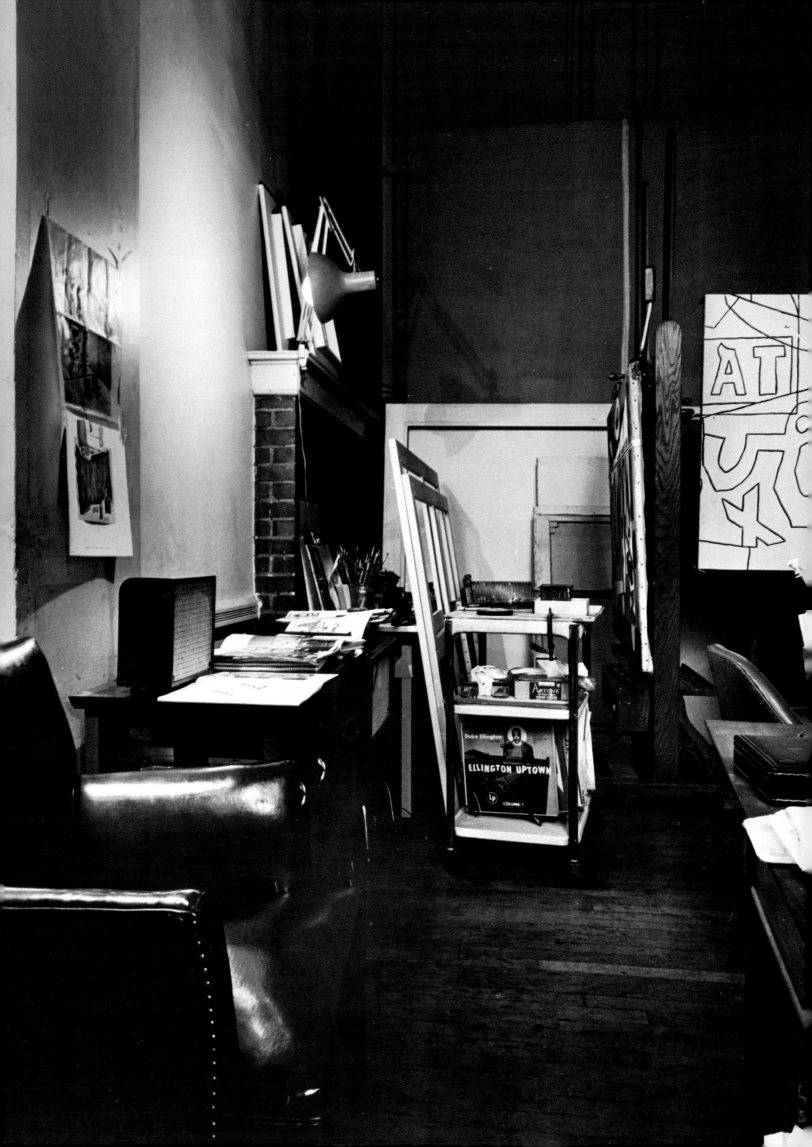

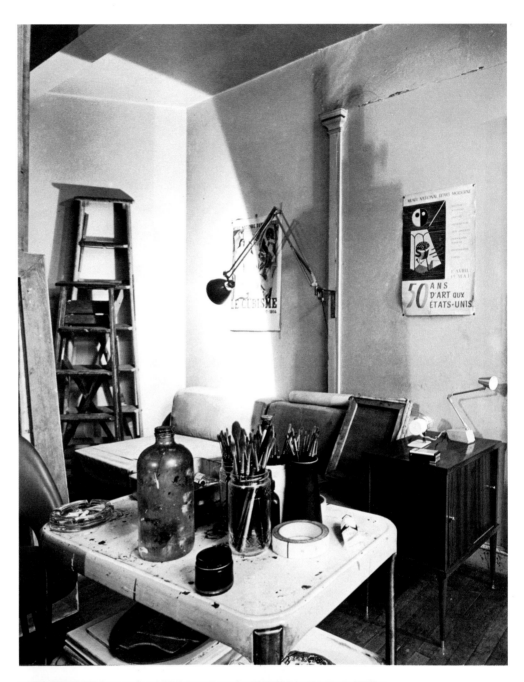

Studio, New York, August, 1964.

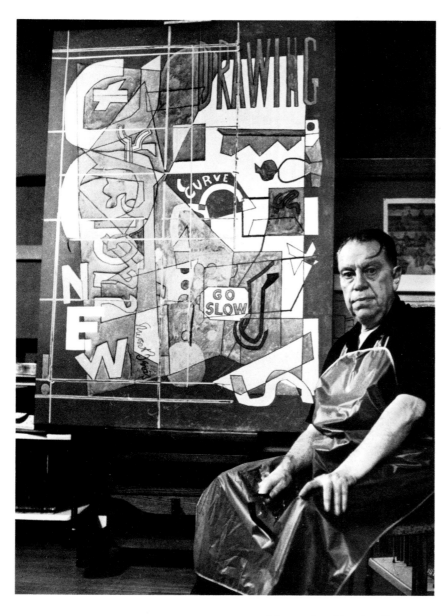

Above: *Combination Concrete*:
oil on canvas, 71″ x 53″, 1958
(M/M Earl Wade Hubbard).
Right: Studio, New York, August, 1964.

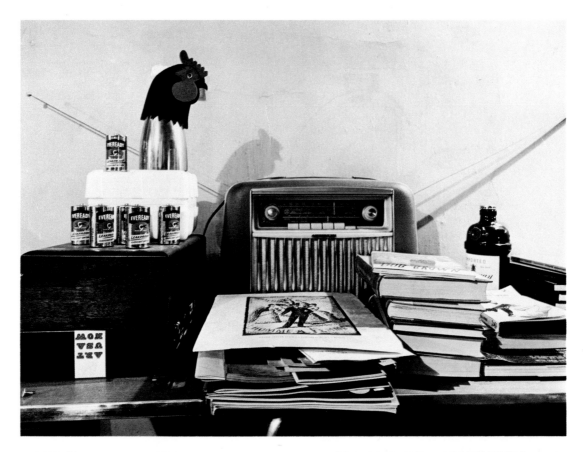

Details, studio, New York, August, 1964.

Detail, studio, New York,
August, 1964. Opposite: Untitled
(unfinished), New York, 1964.

Opposite: *Odol*:
oil on canvas, 24″ x 18″,
1924. Above:
Still Life: oil on
canvas, 1924. (Both
Collection of
Mrs. Stuart Davis.)

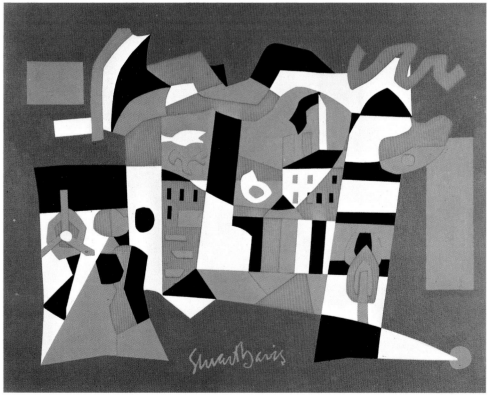

Opposite: *Multiple Views*: oil on canvas,
47″ x 35″, 1918 (Mrs. Stuart Davis). Top: *New York
Under Gaslight*: oil on canvas, 32″ x 45″,
1941 (Bezalel National Museum).. Above: *Midi*: oil on canvas,
28″ x 36″, 1954 (Wadsworth Atheneum, Schnakenberg Fund).

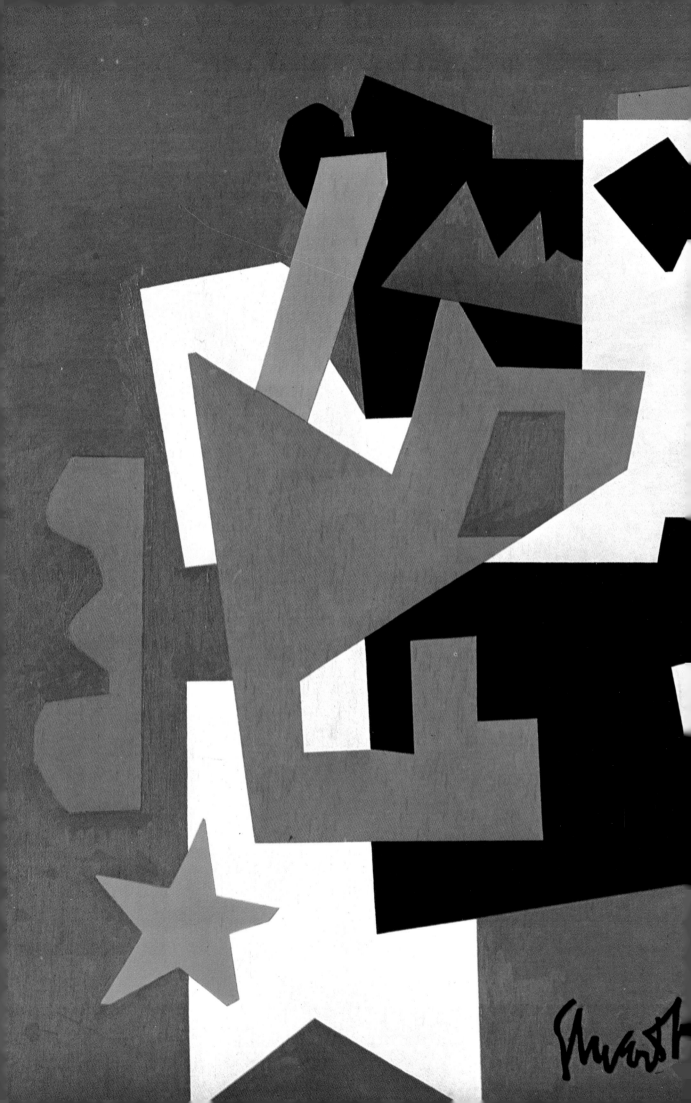

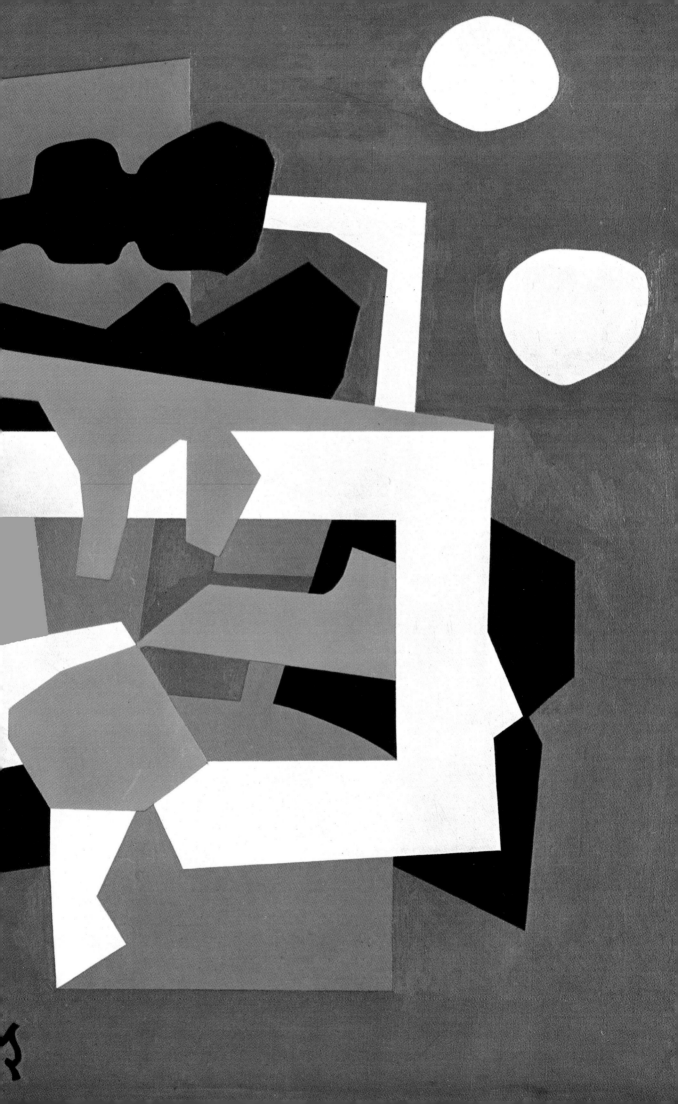

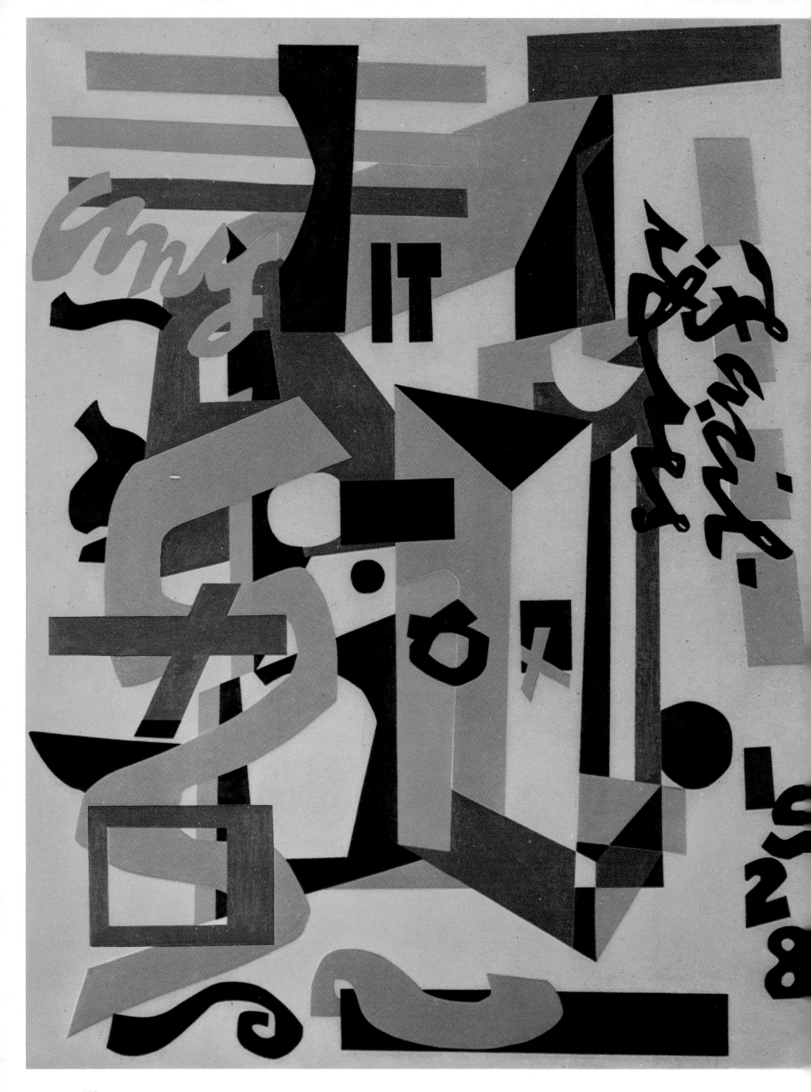

72

spontaneity, and Cubist syntax exactly focus the distance at which Davis' pictures remain, while giving an impression of intimate experience. It is of course a cliché that behind the dead pan, the monologuist is painfully sensitive. In private, Davis could surprise one with his gentleness and sudden failures of confidence, shared very honestly while maintaining that deadpan, tough-guy façade that made one wonder if one was hearing right.

For Internal Use Only (1945) is not his best picture but it is certainly one of his wittiest. Nearly every irregular shape (the black one with two dots, the flash of white against blue surrounded by a black envelope, the two irregular shapes immediately above the red bar) has nerve and cheek. The space "framed" internally is also particularly alert and quirky. Each outward movement is slapped down or checked; that is, the black shape with the two white dots checks the blue squiggles at one point, and is itself held down by the polka dots, which it, in turn, holds back. As relational painting it is brilliant, though in a discursive, somewhat monotonous way, and seems precisely to wed Mondrian and Miró. Miró's wit, gentler and more subtle, provided Davis with many clues.

I've said that Davis' monologues are not discharged by a punch line. But Davis discovered that the punch line—the title—could be outside the picture, although this is not quite accurate, since his titles bounce around in the paintings releasing further witticisms to the alert. They do, however, confirm one's view of the stylistic importance of wit in his work. "The title of my painting is reasonable in the same way as the image itself," he wrote of *Owh! In San Paó.*

"Just at the time that the jive talk of the musicians began circulating outside the jazz world," wrote Rudi Blesh, "Davis began creating 'jive' titles and has kept on ever since." Blesh cites "alliterations like *Report from Rockport* and *Rapt at Rappaport's*, enigmas like *Combination Concrete* and *Eye Level*, puzzle words like *Triatic* and *Tournos*, 'hip' names like *The Mellow Pad*, ironic ones like *Ready to Wear* and *For Internal Use Only*, straight puns like *Nu* that combines the French word for nude with a well-known Yiddish expletive (plus referring to this being a *new* version of the 1927 *Matches*), hilarious near-nonsense titles like *Something on the Eight Ball* and *Owh! In San Paó....*"

"*For Internal Use Only*," Blesh wrote in 1951, "is a gag, a switch on the old saying, maybe to mean that art, giving new value to reality, is something 'for internal use only.'" Art isn't easy to swallow, and many are content to apply it, like an ointment, to the surface.

"The making of a good title is mostly a process of elimination," Davis wrote. "One does not seek a set of words that immediately compose themselves with a drawing already presumed complete. The validity of an attractive title, its appropriateness, depends on the faculty of total non-recall." That is, his title should be as abruptly disconnected as the words *in* the picture, and tagged onto it like a detachable extra shape. "Total non-recall" is a reticence which Davis' shapes, for all their immediacy, cultivate; it assists that side-by-side coexistence of contradictions rather than attempt their resolution. Davis' titles, then, extend his formal strategies verbally, illuminate the operation of his wit, and provide clues to his attitudes to words in the picture.

Within the picture, as suggested earlier, words carry a reassuring sense of place and check the other forms with their vernacular probity. And they assist, in their careful indeterminacy, the movement of the picture's syntax through a kind of subliminal commentary. "It" and "the" point at something; "any" suggests free choice; "else," that the eye go elsewhere to encourage "the amazing continuity" that he wrote out complete in *Visa*, perhaps referring to the endless improvisation offered by his version of synthetic Cubism. And "now" obviously refers to that immediacy of effect that encourages "total non-recall." Occasionally words comment on the process of perception. In *Combination Concrete*, "Curve" and "Go Slow" suggest a highway journey, but the journey is around and about the painting, as the large blue headline "DRAWING" suggests, resulting hopefully in new perspectives as the word "New" (with an exclamation mark displaced to the left under it) perhaps indicates. Far from being hard to read, each of

Pages 70–71: *Colonial Cubism*: oil on canvas, 45″ x 60″, 1954 (Walker Art Center).
Opposite: *Something on the Eight Ball*: oil on canvas, 56″ x 45″, 1953–54 (Philadelphia Museum of Art, Adele Haas Turner and Beatrice Pastorius Turner Memorial Fund).

Davis' words has a specific duty within a picture and a specific effect. Words enabled him to open up Cubist syntax on a number of levels.

Rarely, puns occur. "Facilities" in *Something on the Eight Ball* (1954) is written "Facil-it ies," that is, "facile, it is," making three readings possible, depending on emphasis. Less successful, to my mind, are the uses of words like "Tabac" in the late fifties and sixties, recalling his Paris experience. Frequent in the late twenties and thirties, they invited, at the end of his career, an estimation of his exact distance from and transformation of his French models. But the words that issue this invitation at the same time prejudice one's judgment. While his last six years—when his work was changing again—did produce a few of his best paintings, his greatest works are undoubtedly those larger and simpler compositions of the fifties (*Owh! In San Paó, Memo, Medium Still Life, Deuce, Midi, Visa, Lesson 1, Something on the Eight Ball, Colonial Cubism*, and a handful of others).

Davis' signature, like his titles, illuminates his ideas. Originally printed in small, block letters, it is next scribbled in an open, informal script. Around the mid-fifties, it thickens into toothpaste-tube wriggles, until in *Eye Level* (1954) it is halted, slightly backhand, on a small rectangle of its own that is put to work in the composition. After this it frequently becomes a protagonist. He turns it on its side, upside down, makes it dense and solid (printing it again), runs it together like melting candy.

"Manufacturers," he told Aline Saarinen, "put their name on your refrigerator and [on] the automobiles. They're proud of it. So I thought if it's going to be there, it ought to be a decent-looking thing. In the context of a total composition you plan a place for it and regard it as an object."

Davis' signature provides a further opportunity to check out his attitudes. A signature is supposed to betray personality. By making it impersonal Davis comments on the nature of the author and his role in the work. "Materials are quite neutral in the creation of art," he wrote in 1922. Davis makes the author a material, too, included in the picture on exactly the same terms as everything else. The pictures, however, articulate the author's name differently. In *Combination Concrete* the signature focuses the picture's theme in an epigrammatic summation of a drive along a twisting road. In *Pochade* the printed signature defines one of the painting's borders, signifying that recurring theme of limits, as, in another way, it does in *Lesson 1*. In *Letter and his Ecol* and *Blips and Ifs* the signature is blurred with visual static; the author is present but hardly recognizable. Davis' signature emphasizes the great distance he puts between us and himself while appearing to be on easy and intimate terms. It emphasizes his classic nature and his deep distrust of Expressionism of any kind. "Expressionism," he wrote in his last notes, "fails in its Purpose of Spontaneity because it omits the reality of Logic as a prime tool of the act of Perception. A tool which is integral and simultaneous to Perception."

More than any single element, his signature again confirms the stylizing of spontaneity, the distancing of wit, and the singularly impersonal nature of his art. Both de Kooning and Davis share the necessity to make everything abstract before they can use it. De Kooning then tries to retrieve it, but Davis leaves it alone. It is simply another object from which to build and construct the picture. "The quality of direct and spontaneous perception," he wrote again in those last notes, "occurs in the logic of composition." What Davis was composing, or rather constructing, leads one to some comments on that elusive voice in his work—personal but impersonal, spontaneous but classic, slangy but articulating impeccably. To hear it, however, one must tinker with those engines, those objects which Davis so carefully assembled.

V

"All my pictures," wrote Davis, "have their originating impulse in the impact of the contemporary American scene." He then went on to his famous catalogue. "Some of the things which have made me want to paint, outside of other paintings, are: American wood- and

ironwork of the past; Civil War and skyscraper architecture; the brilliant colors on gasoline stations, chain-store fronts, and taxicabs; the music of Bach; synthetic chemistry; the poetry of Rimbaud; fast travel by train, auto and aeroplane which brought new and multiple perspectives; electric signs; the landscape and boats of Gloucester, Mass.; 5 & 10-cent-store kitchen utensils; movies and radio; Earl Hines' hot piano and Negro jazz music in general, etc. In one way or another the quality of these things plays a role in determining the character of my paintings. Not in the sense of describing them in graphic images, but by predetermining an analogous dynamics in the design, which becomes a new part of the American environment. Paris School, Abstraction, Escapism? Nope.... Just Color-Space compositions celebrating the resolution in art of stresses set up by some aspects of the American scene."

This listing, like Hopper's catalogue of banalities, by and large identifies the vernacular that can correct and vivify high style. Both listings suggest that in bringing a "native heritage" into alignment with artistic tradition (a cliché problem for the provincial artist), a large part of the difficulty lies in identifying the "native heritage." If Davis and Hopper hadn't identified previously ignored subjects in their surroundings, their achievement wouldn't have been possible. So the newness of both artists' work—if that must be considered—is more in the way they invent a context for their art than in patenting new forms. That is, they extend their heritage by acknowledging through their art an ignored environment. The character, energy, and invention this demands doesn't get points in the modernist ratings. But it enabled Hopper's and Davis' art to transcend not their surroundings (that is, the cliché view of provincialism), *but their adapted styles.*

Though each of Hopper's observations is separated and contemplated with leisurely deliberation, all are contained in one scan, in one clear view. Davis' are jumbled and as frequently describe generalities as particulars, processes as much as specifics. The city is the main theme of both lists, but their views of it are opposed in terms of subject, mood, and approach.

Hopper's listing is stimulated by a wish not to neglect the unimportant. Davis, who lists the important, had a vision of modern life as subject matter and process at once. Hopper assembled elements of personal concern, and his voids echo with his impersonal pursuit of an elusive identity. Davis eliminated his psyche and all Expressionist taint to summarize modern life by analogy.

For all their differences, both Hopper and Davis sought to energize and correct their art with the vernacular. Hopper's recognition of ignored subjects as an arena for his personal quest legitimized an old-fashioned style so that its rehabilitation becomes mysterious. Davis' interest in jazz, and later in media, so profoundly informed his ideas about synthetic Cubism as to rehabilitate a style also somewhat old-fashioned by the 1940's and '50's—so much so that formalist criticism, no matter how scrupulous, can find nothing "new" in Davis. Naturally, since newness was not his criterion. "I'm not looking for something newer and greater," he told Rudi Blesh. "Everything new and great already exists—has always existed. We need to make our connection with it."

Instead, as with Hopper, a style is subjected to pressures that alter its "look" in ways not quite available to formalist analysis. Davis' voice is brought into being by this pressure, this underpinning of a style with ideas and impulses brought from jazz and media (rather than vice versa).

That voice has something to do with the manufacture of spontaneity within the clearly defined limits that jazz and media allow. Modern art already had one major example of how a style derived from synthetic Cubism looks when juiced up by jazz: Mondrian's *Broadway Boogie-Woogie* (1942-43).

According to Davis, he and Mondrian "spent a friendly evening" talking about jazz, to which Mondrian extended his jesuitical distinctions of pure and non-pure. (Later, attending a Davis opening at which some "grade-A jazz musicians" played, Mondrian took the opportunity to point out to the American artist the paintings in which he was approaching "Pure Plastic

Art.") In *Broadway Boogie-Woogie*, Mondrian's units within lines open up a recessive infinity. The picture could be framed by a picture which is framed by another picture. And by encouraging readings along a line, both down and across, he re-emphasized the grid idea without, however, using it. Down and across remain somewhat different ideas, and their distraction, emphasized further by the interrupted hop of the lines, is flagged down by the solid-color concentric rectangles. The latter keep all that traffic from getting too far from the surface, and literally out of line.

In contrast to Davis, who identified the spontaneity and method of jazz with his own work in a way that is traceable, Mondrian seems to have responded to a general feeling about jazz, which he quickly converted, in typical fashion, into a powerful idea—as the influence of *Boogie-Woogie* shows. And one gets the impression that if he had shown *Boogie-Woogie* to a jazz man, Mondrian would expect it to improve his music. Davis always kept jazz in its place. When one jazz man looked at Davis' art and started painting like Davis, Davis wasn't too enthusiastic. That, apparently, took the vernacular out of its place. Mondrian was a spiritual leader. Davis was an unimpressed school of one, and he liked to keep it that way. (Davis' influence was limited. Sugarman's sculptures and Al Held's late-sixties paintings are perhaps his most distinguished progeny.)

The issue of impulse and spontaneity is repeatedly referred to by Davis throughout his career. He became aware of a distinction between spontaneity and enthusiasm: "Up to now I've been working on painting my enthusiastic responses. But you come to realize that experiences which are *not* enthusiastic are easiest to come by and should not be wasted. For several years I've been thinking of *not* making enthusiasm a condition for uninterrupted continuity of interest."

"The act of perception," he went on, "is itself a good reason for enthusiasm. Ability to perceive is common to *both* elating and depressing experiences. Sometimes I get my most satisfying results on a day I have no real stimulus to paint at all." In his last notes he repeated these ideas more succinctly: "Impulse is an Act of Will," and "Part of the Impulse is the Physical Action of Technique Realization"—this latter not unrelated to Hopper's idea of technique and decay.

These must have been troubling ideas to hold onto in the late forties and fifties as the new American painting and its mystique became all-powerful. Although Davis' comments on a style he found intolerable were always lacking in rancor, Abstract Expressionism did change the way he thought of himself in relation to his work. When jazz was his predominant concern he emphasized that the painting was an object. As late as 1958, he wrote that *Pochade* "carries out the idea that a first-class painting is an Object. All feelings incident[al] to its subject matter and execution, along with theories of procedure, disappear with the emergence of the Object. Discovery is its own reward, especially when what is found doesn't look too much like the artist." But as media (which became of increasing interest to him) and Abstract Expressionism redefined the nature of process, he began to speak of his pictures as events, and of the choices that determined their appearance: "I consider my drawing, my painting, as a progressive and continuous event or activity, and the direction and character of it are determined by my obligation to make choices in what is presented to me as subject matter."

This led to long speculations about the nature of method and its relationship to content, subject, object, etc., categories that were, like his shapes and colors, subjected to continual nudging and (to adapt Elaine de Kooning's word) argument. "When Method is taken as Subject, the Object is a Bore" apparently referred to subjectless, nonobjective painting, which he called "Idealism" and detested. Yet one of his very last notes was "Method is Basic Content."

On one of my last visits, Davis said he had limited himself to a few colors and could do all he wanted with them. Repeating the sentence a few times until he had ironed it out he said, "I'm satisfied that certain limitations are sufficient to include everything I want to do. A simpler formula for the content of my

spontaneity." This improvement of a spontaneous phrase by repetition was in line with the way his art continually quoted and rephrased itself.

(That day eventually provided another example of this. He had just seen himself interviewed by Aline Saarinen on a television program on "modern masters," and he found their luxurious life-styles a bit much. "Hell, I saw all those guys with their houses on the Riviera and Porsches and what have you, and then there's me here in this studio. I don't perform on the bars or anything. Some do. I don't put them down. But I'm not the type." After he had seen the affluent masters doing everything from water-skiing to hobnobbing with film stars he defended his isolation. "An artist without his mystery is a bum," he said, looking sideways to see how it would be taken. It was a gem, but hoping for more, I said nothing. Later I discovered he'd already used the phrase on that television show, liked it, and, like so many of his motifs, was reusing it. He'd watched himself say it the day before.)

"Why wander around?" Davis once wrote. "I take what I can get—even in one of my own paintings. I can take a painting I made forty years ago and use it as a basis for developing an idea today." Among the sets of oppositions that informed his art, a study of his ideas about spontaneity and method is overdue. As I mentioned before, Davis didn't attempt to resolve oppositions, he fiddled with the terms, held them in brief alliance, let them fall apart, and puzzled about them again. His early writing was sometimes a bit loquacious and toward the end tended to be epigrammatic. The tone was coolly reasonable, in line with the kind of syntactical tinkering he conducted on the canvas between shapes and color. He viewed spontaneity as he did method, as multiple—and he was always on a kind of conceptual prowl looking for ways to steal up on it. Usually spontaneity arose out of one of three areas: the materials of expression, the past, and jazz and media.

"The subject matter of painting," he wrote, "always includes the materials of expression." Very little has been written about Davis' paint; its rather sour quality matched his predominant contrast of navy blue and vermilion. The stroke is often heavy and impersonal, painted rather than painterly, to use Carter Ratcliffe's distinction. This encouraged a somewhat insensitive surface that keeps things at a distance while assertively bearing the color area into the eye. Davis was unashamedly downright in forcing this impersonal intimacy. Whenever accidents arose, he studied them, rehearsed them, and incorporated them into the picture as prearranged quotas of surprise. Though he used symbols, he didn't make them symbolic, appropriating their shape rather than their signal.

He also saw spontaneity as the reorganization of past work. He viewed his career without temporal perspectives, but as all-present and simultaneous while always being revised by memory. It offered him subjects continuously. He saw his previous career as a kind of nature to move around in, and since no problem had a final solution, it could be revisited and restated on different terms. He kept dropping in on his past in this way This habit gives his oeuvre a provisional aspect, and seen all at once it is rich in dialogues with itself somewhat similar to the voice in his writing. It argues, revises, cracks jokes, remains within conventions of clarity and accessibility, organizes its slangy elements, slips from one thing to another in abrupt transitions that appear more surprising than they are. Despite all this variety, it remains in touch with disciplines that legitimize endless inventions, which never tear away from their premises but return to them for confirmation and focus. In other words, very like jazz.

A lot remains to be written about what Davis found in jazz, but there is basically no great mystery. Jazz's syncopation and polyrhythm are both, John Kouwenhoven points out, "devices for upsetting expected patterns." Syncopation "is the upsetting of a rhythmic expectation by accenting a normally unstressed beat and depriving a normally stressed beat of its emphasis." Polyrhythm "consists of imposing a one-two-three rhythmical element upon the fundamental one-two-three-four rhythm which underlies all jazz." Davis' use of color, and his surprising contrasts of shape (which totally avoid any organic-geometric dialogue) can be

reconciled with these ideas without much difficulty. But more important perhaps is Davis' recognition that, as Kouwenhoven puts it, "The polyrhythmic and syncopated flights of hot solos and breaks, with their abrupt impulsive adjustment to ever-changing rhythmic situations, give jazz an extraordinary flexibility; but they could exist only in a simple, firmly established musical framework." Davis understood this process, sometimes too well, in those works that forget their structure and expire in endless improvisation (for example, *The Mellow Pad*). Like jazz, jazz "talk" identifies complex attitudes with a phrase or a name, makes verbal elisions and abrupt transitions, switches subjects rapidly, leaving the uninitiated foundering. These properties are organized in Davis' pictures.

The dialogue between method and spontaneity in his work undoubtedly found its model in jazz practice; and jazz, as well as providing that model, became a symbol of modern life insofar as its vernacular probities were a social paradigm. At the same time as he exploited jazz's subtle process, Davis referred to the jazz musician's construction of a "sound Object." His habit of calling his paintings objects derived from this as well as from the modernist idea of the picture's autonomy. Thinking of his work as an object served to eliminate any personal connection to the artist. Though the object idea was modified later by media, particularly television, it is an important clue in assembling the voice in Davis' work.

"An artist who has used telegraph, telephone, and radio doesn't feel the same way about light and color as one who has not," wrote Davis in 1940, and a visit to his studio usually found him sitting in his Saarinen chair, four radios scattered around him, the television set on, usually with the sound off. Television had a tremendous reality for him. He had a perfect apprehension of how that medium, under its overt subject matter, kept up a kind of meta-commentary that makes television the most neutral and suggestive of media. "I may be watching a prizefight while I have a painting in progress," he wrote in 1957, "and some sort of action in the fight, or some sort of decision in it, may create an emotional attitude which gives me an idea for a painting. I don't mean in any sense of imitating the motion of the fighters, etc., but one which gives me an impulse to do something else in the painting. Without the outside stimulation of the fight there might not be any impulse to do something more on the picture."

The translation of life onto the TV screen and his impulse to deposit an analogous code on the canvas were very clear. "We have information about events all over the world practically instantaneously with their happening," he wrote. "We have it by the written word, by ear, even visually, at almost the time of the event itself." On November 24, 1963, I telephoned him. He had a sense of tragedy and exaltation that seemed to come from a kind of ecumenical vision in terms of the TV medium. "I've been watching twenty-four hours a day.... I'm amazed it doesn't happen more.... I think it's going to be better ... the response to it as a world thing ... Negroes, Asiatics, Frenchmen.... It's a little world.... This thing [the Kennedy assassination] has brought it all into focus on TV and we can look at it...."

Davis' voice, then, involves an object and a process. It can be best understood by an image he turned to frequently: "A radio is the product of an extremely complex set of abstract generalizations but no one calls it 'an abstraction' or 'an escape from reality' because the loud speaker is not equipped with a set of teeth." This image gives easy access to some of Davis' primary concerns: replication, static, tuning in two stations at once, the idea of words in the work, the syntax of Cubism applied to a "spoken," slangy voice, or, more truly, vice versa. No matter how intimate the voice, it is distanced by the fact that it emerges from an object or transmitter—there is *simultaneous* objectivity and subjectivity. Radio and television themselves, highly mediated experiences with complicated dialogues between method, content, spontaneity, etc., were models which clarified his thinking.

If the influence of jazz is the major question in Davis' work up to the early fifties, the influence of television is the major question in the later work. The juxtaposition of content in newscasts, the interruption

by commercials, the ubiquity of the word, and the processing and coding of information all reinforced his ideas and gave, I suspect, clarity and authority to his work in the fifties. As had the movie screen earlier, the television screen influenced his compositions and their containment. (The influence of the movie screen on twentieth-century painting is an important and unrecognized issue.) Exactly how is a question which lies outside the formal realm, but is not less important for that. Such considerations are inseparable from the issues Davis' work raises. And the dialogue between Cubism and the vernacular that gives his work its particular cast remains a neglected area of study. As does his relationship to American synthetic Cubism which, between 1930 and 1950, reached remarkable degrees of sophistication.

In the end the distance Davis puts between us and him is immense, a sign perhaps of a rigorous abstractness of attitude, however apparently relieved by immediacy of effect. Ultimately, a Davis picture allows the viewer no deep imaginative purchase. Despite the wit there is no release from the gymnastics of form. There is, and this is an odd word to use, a sobriety that is almost academic, a hard exclusion of enigma, of mystery, in favor of an impersonality that bestows on Davis' work, over long acquaintance, a troubling quality. Its contradictions do not ultimately come into the single focus that a degree of absolutist striving, with its sense of impossibility, would give. Davis' art seems like a long holding action, offering many complexions without ever reducing them to a single one, and it lacks the elevation and release we ordinarily expect from great art. It remains what Dave Hickey calls "secular," obstinately secular. If there's anything transcendent in a Davis, it's a kind of common sense. "I feel that common sense," he said during one of his last days in the hospital, "is a part of the psychophysical entity. You don't buy it. It's given to you with your body—part of your balance."

Davis' classicism, then, is established from picture to picture, but it is not augmented by this succession. This empiricism, which gave him the long career so unusual in American art, can be seen as a kind of discretion. It can also be looked on as a failure to dominate formally the wide range of pictorial, cultural, and psychological factors he entertained in his short-term syntheses. Maybe an unconscious awareness of this has denied him equal status with the major Abstract Expressionists. Yet his is the most successful assimilation of Cubist style to a native temperament and vernacular in American painting, giving to synthetic Cubism a not insignificant climax in another culture, which then quickly moved to undercut the Cubist tradition. When relational painting becomes possible again, and the virtues of classic order are recognized as virtues, Davis' work will be accorded the major status it is now not quite denied but also not fully granted. Davis' myth still has not released his work. The image of an art that, though significant, is somehow local and American remains attached to it. One is reminded that Hopper's American Scene identification has similarly kept his work from serious examination. To many, in practice if not in theory, Davis' art seems to be an extension of that vernacular on which he based it, an idea that receives unfortunate support from Davis' persistent, tough-guy myth. In a cruel paradox, his art tends to be reclaimed by that vernacular through which he brilliantly transformed Cubist style. Both Hopper and Davis' myths then have an "American" identification that has retarded their true appreciation. Not the least of Pollock's achievements is a myth that transcended this "American" status.

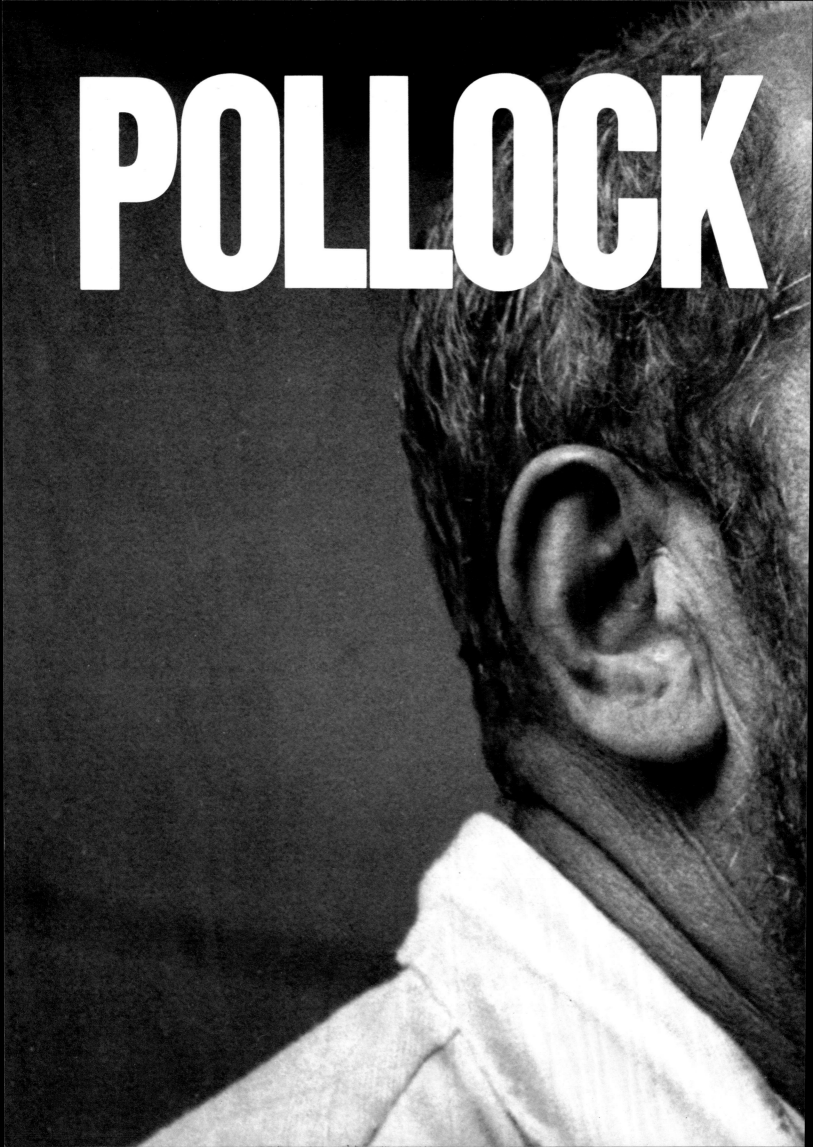

POLLOCK

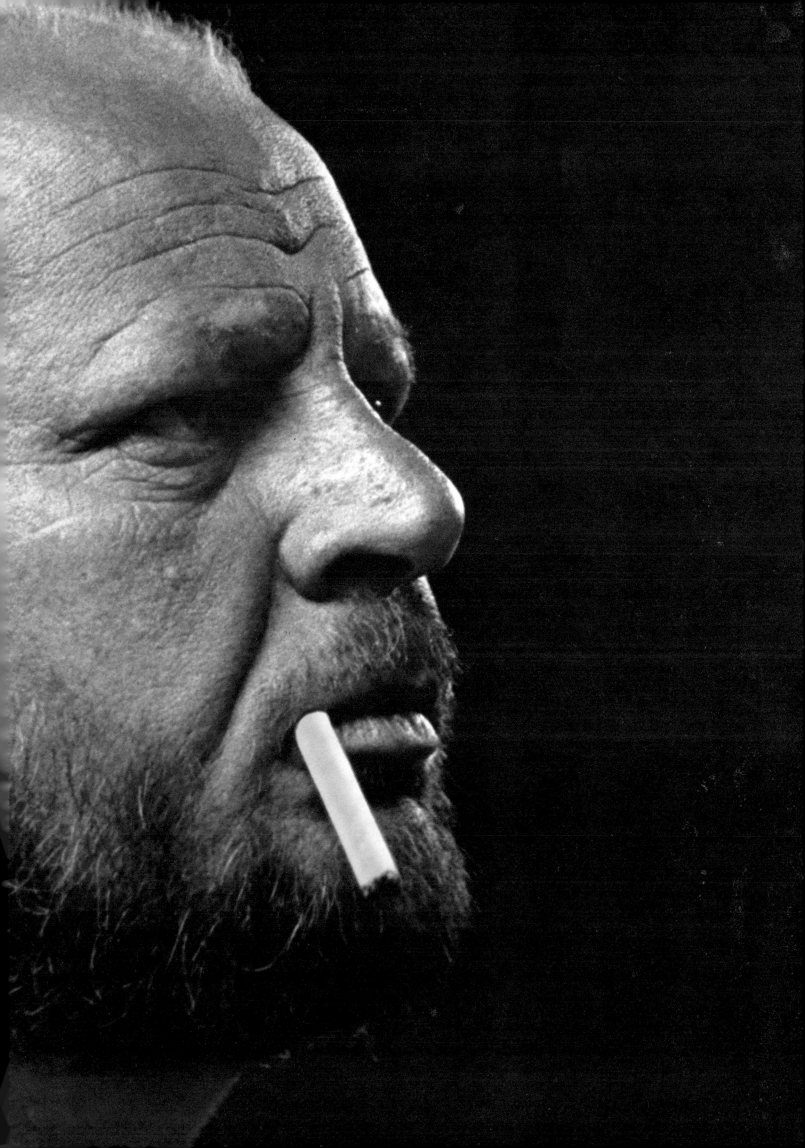

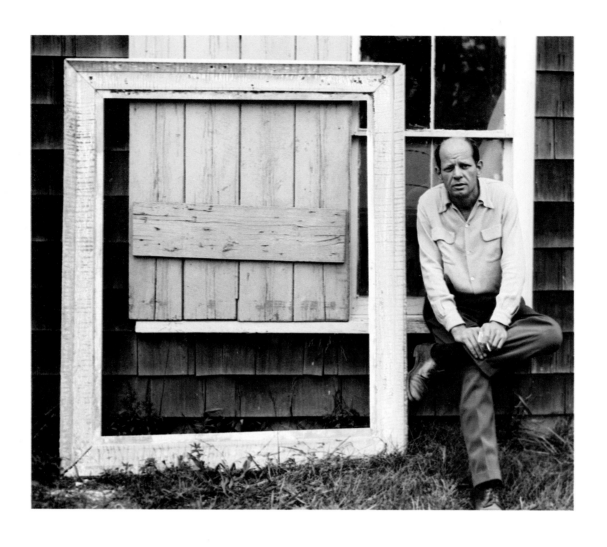

Jackson Pollock's Myth

Jackson Pollock's myth has been so frequently used as a club by both friends and enemies that in opening it up for further discussion one has, even now, the sense of entering an arena. But enough time has passed for us to see Pollock's myth as clearly as his art; both have effected major changes in our thinking. The myth was—is—as much a creation in its own right as the art. Pollock participated in it to some degree and remained deeply ambiguous toward it. Because it involves large themes that Americans have chosen to identify as fundamental to their culture, Pollock's myth transcends the precincts of visual art. Its history, its literature, and its effects are now part of our cultural history, a history that remains, to put it mildly, misunderstood. It also exemplifies a modern obsession, what Nietzsche called "the superstition of our century," that the "superstitious belief in 'genius' helps."

The fusion of certain American (noble savage and frontiersman) and modern (artist-outcast) legends makes Pollock's myth a classic text within which can be read the tragicomedies of ambition, both personal and cultural, the habits of modernism and the hazards of art, and the dialogue between public expectation and inspired surprise. Like most powerful myths, it received its energies from the fact that it was necessary to help accomplish certain aims and having done so, presides over its own history in a way that conceals profound contradictions. Like all modernist myths, it is a powerful lie that tells the truth, if one can read it. For myths present a certain oracular question to history, to which they are antagonistic, inviting us to suspend judgment in return for a somewhat spurious sense of poetic truth. Of all the artists in this book, Pollock's voice and myth are most fully engaged in an endless squabble, are polarized in a way that reveals their deep antagonism. Pollock's personality and art are intermittently darkened by this myth's shadow.

The myth is thus as legitimate a subject of study as Pollock's art. It draws on large ideas that keep our engines of culture turning, matters so inextricably fused with our American dilemmas as to have an urgency for each generation that transcends their period air. Pollock brought into American art mythic energies previously confined to American literature, to Poe, Melville, Wolfe, Hemingway. Coming from the West, he could more easily embody the two antagonistic legends of the savage and the frontiersman, the banality of which can never completely devalue them. They return in a variety of disguises to elicit a response in an emotional area we had thought fully bankrupt.

Traversing the country in search of new experience keeps the frontier one step ahead, while rolling up experience on a spool. This hobo-adventurer cycle (the unrecognized hero traveling his country in disguise) is, of course, more familiar in literature, where trainees for the task of writing the Great American Novel put themselves through the obligatory apprenticeship. Knowing the land was essential, and wandering over it—a figure in a continental landscape—was a way, not of possessing it, but of echoing its emptiness. Pollock was the first artist to invite his audience to think in these continental terms. This stands out when you compare his myth to those of his predecessors: Weber, Hartley, Marin, Sheeler, O'Keeffe and others, who, in a climate inimical to art, adapted other ways of "being an artist."

Most of the early modernists took what one might call the route of double exile: first the journey to Paris, modernism's Vatican, where one was an exile from home; then the return, where one was an exile from art—though still a member of the modernist community. Aesthetic legislation, reinterpretations of formal dogma, even new heresies came from Paris. Revisions couldn't come from the provinces. All that was allowed were slight adjustments of the international canon to acknowledge the *place* where the aesthetic exile worked. The early American modernists tried to align aesthetic ideas with bits and pieces of their own cultural and historical environment.

The artists' search for what could lock these two components together led them to narrow their focus. Hartley's final ambition to be *the* Maine painter is full of discreet ironies; he was biting off as much of the country as he could mythically chew. Many of the best American modernists found themselves conducting

regional campaigns. Charles Sheeler, for instance, fixed on two gilt-edged vernacular subjects—the machine and the industrial landscape—and was content to realize a limited opportunity with the utmost clarity. Georgia O'Keeffe demonstrated that the landscape of the Southwest is highly tractable to modernist vision, to the point where her work makes modernism picturesque. John Marin imposed his modernism on Maine and the skyscraper, both authentic "American" subjects, a tradition that includes such "national" emblems as Niagara Falls, the Rockies, and the Brooklyn Bridge. His national ambition forced a small, brilliant talent to go through its paces in an arena too large for it. In life style, dress, and pronouncement, Marin tried to fit the mythic bill, giving America some visual legitimacy in Europe, and thus, by one of the laws of American culture, in American eyes, as well.

As we have seen, the major artists of the pre-Pollock era, Hopper and Davis, were more subtly ambitious than their colleagues. Identifying the city and its culture as a twentieth-century text, they allowed it, in their different ways, to instruct their styles. Their success is measured by the way their work gets less "American" every day. Two other major figures, Milton Avery and Arthur Dove (whose contributions are among the overlooked glories of American art) completely avoided the temptation to fill the mythic vacuum, seeing through, or refusing to see, the issues that engaged more obviously ambitious talents. For this they have paid with their reputations, which lag far behind their achievements.

Such discretions, however, were foreign to Pollock. There is something naïve and smart about his ambition to be the greatest American artist, which leads us back into those heartlands where innocence and shrewdness tap American "verities" through isolationism. American Scene painting's most fascinating aspect was its mythology, and it was, of course, with American Scene painting that Pollock began. Its "honest" exploitation of the national physiognomy (both of landscape and character) "exposed" Europe as overcivilized and spiritually exhausted. The idea of the new beginning, the devalua-

tion of foreign culture and the aggressive posture of Abstract Expressionism's myth in the fifties, came, in my view, as much from American Scene painting as from the Futurism that subliminally runs through twentieth-century American art.

"I love America so well," wrote Thomas Hart Benton, Pollock's teacher, who like Leo Stein, de Chirico, Derain, and John Graham, converted from modernism, "that all its crudities and gross stupidities are no more to me than the little imperfections which give character and individuality to personal beauty. A windmill, a junk heap, and a Rotarian in their American setting have more meaning to me than Notre Dame, the Parthenon, or the heroes of the ages. I understand them. I get them emotionally. . . . The stuff of this America which I know directly and immoderately is to me more important actually and substantially than all the art of the past." This is the voice of the exile repatriated, with its rejection of the past (an American habit), of Europe, of culture. Its bluff philistinism appeals to a national audience, aspires to the renewal of the land, the rebirth of innocence, and the rejection of complexity in favor of the simple solution—an attitude which this book more fully examines in the chapter on Andrew Wyeth.

Pollock's identification with nature ("I am Nature") is not unrelated to this chauvinism, which drops certain large ideas neatly into place—the continental wanderer, the savage state of grace which can renew civilization, and the rituals through which this renewal can be accomplished. Nature, of course, is the locus of the romantic fascination with instinct, fecundity, the unconscious, and the primitive, and Pollock was far from the first to identify with these powers. Such powers, part of the larger myth of Romanticism, are, of course, available to anyone who wants to invoke them, but the demands they impose are enough to make the prudent step aside and even the most ambitious hesitate. Tellingly, Pollock, whose instincts for what was usable were faultless, frequently invoked the Indian who embodied these powers—the original noble savage with whose art he was more than casually conversant. "The notion of an 'art of raw sensation,'" wrote Clement Greenberg,

"meets certain cherished preconceptions about what Americans are capable of in the way of original art." The savage lives in mythical rather than historical time, and one of modernism's most extended liaisons, which began with Gauguin, was with the myths that could slow the historical clock and the avant-garde cycle.

The frontiersman, as the savage's mythic twin, provided other equally persuasive characteristics, and stands perhaps for that vernacular tradition which has, in the absence of a dominating high culture, vigorously interrupted the genteel musings that often passed for it in America. Always vigilant and alert, the frontiersman can read subliminal signs, has an empirical way of solving problems, a shorthand manner of speaking, a mode of casual dress appropriate to his calling which becomes an honorable uniform. Here we run into a lot of myth-making hocus-pocus, the Americana of being American. But however obscured the frontiersman may be with kitsch mythology, the energies his figure taps are powerful enough. Both Indian and frontiersman have a history in American culture; in one disguise or another they have been applied to literature (Philip Rahv's Redskin), to art (Harold Rosenberg's Coonskinism), and to history (Turner's frontier hypothesis). All define the "American" achievement as taking place in a continual emergency, in unorthodox situations, against a larger background of the unknown. As tamer of the savage, the frontiersman mediates between nature and culture, but in extinguishing the savage and the frontier, he also extinguishes himself, surviving as an idea, a strategy, and an imaginative reverberation.

The savage and the frontiersman underpin Pollock's persona. One provides a temperament, the other a strategy. While both carry the authority of the "genuine," they tend to be self-limiting, as Philip Rahv described perfectly in his 1944 Partisan Review essay, "Paleface and Redskin": "Unable to relate himself in any significant manner to the cultural heritage, the redskin writer is always on his own; and since his personality resists growth and change, he must continually repeat himself. His work is ridden by compulsions that depress the literary tradition, because they are compulsions of a kind that put a strain on literature, that literature more often than not can neither assimilate nor sublimate. He is the passive instead of the active agent of the Zeitgeist, he lives off it rather than through it." One senses in Pollock, however, an intelligence aware of the exact limits his mythic posture forced on him, and of an instinctive desire to transcend them by a single stroke or discovery toward which his impatience directed him. There is about Pollock's art up to 1947 a sense of expectation underlined by its obvious striving. The punishing confrontation between instinct and intelligence is a major theme in Pollock's art—a confrontation in which, as Rahv suggested, art is sometimes a casualty. Until he discovered the "drip," Pollock lacked the patience with the means, and the prudence that would restrain him long enough to allow his art to define itself within the necessary conventional boundaries.

One does not have to go far to find evidence for Pollock's appropriation of the Western myth. An early photograph shows him in Stetson, boots, and with gun. He assisted his father in surveying some Western territories and moved around a lot in that avatar of continental dreams—the automobile. Later, he carried "regionalism with him," wrote Harold Rosenberg, "in the form of his frontier behavior": the alertness (which could become paranoid); the taciturnity; the sudden problem-solving, even if it meant ripping the door off the men's room at the Cedar Bar; the hard drinking, even if it meant becoming an alcoholic; above all, the mode of dress. Pollock's famous boots announced the frontiersman's contempt for the city slickers, a message received by his colleagues with a resentment Pollock perversely thrived on. Pollock's boots tramp through the informal memoirs of the time: "Crazy fella, with those boots," said Stuart Davis of a night of drinking with Pollock. Davis' reasonable temper must have found Pollock's manner trying. The urban jazz fancier mustn't have taken too much to the frontiersman, who epitomized a kind of future Davis didn't want.

When Pollock had his first show at Peggy Guggenheim's Art of This Century Gallery in 1943, critics

responded as much to the frontier myth as to the art. Robert Coates, in *The New Yorker*, identified Pollock as "a young Western artist." James Johnson Sweeney's catalogue introduction went: "Pollock's talent . . . has fire. It is unpredictable. It is undisciplined. [Pollock objected immoderately to the "undisciplined."] It spills itself out in a mineral prodigality, not yet crystalized. It is lavish, explosive, untidy." Sweeney's language carried a heavy mythological cargo, affirming the artist as a force of nature, instinctive and undisciplined. This, of course, puts the art outside criticism, since nature, unlike culture, cannot be criticized. Pollock's difficulty in finding his voice could be interpreted as an incoherent attempt to speak a new language—again an attribute of the acculturated savage, whose sense of difficulty in speaking was easily referred to one of Pollock's primary materials, the sense of difficulty itself.

Even Clement Greenberg, Pollock's most effective champion, was not immune, on this first occasion, to the rhetorical persuasiveness of Pollock's art and presence: "He is the first painter I know of to have got something positive from the muddiness of color that so profoundly characterizes a great deal of American painting. It is the equivalent, even if in a negative, helpless way, of that American chiaroscuro which dominated Melville, Hawthorne, Poe, and has been best translated into painting by Blakelock and Ryder. The mud abounds in Pollock's larger works, and these, though the least consummated, are his most original and ambitious. Being young and full of energy, he takes orders he can't fill. In the large, audacious *Guardians of the Secret* he struggles between two slabs of inscribed mud (Pollock almost always *inscribes* his purer colors); and space tautens, but does not burst into a picture; nor is the mud quite transmuted. . . ."

Despite Greenberg's scrupulous formalism, the choice of words concurs with the emerging myth of Pollock as a natural force: "the negative, helpless way," "full of energy," "space tautens, but does not burst into a picture." Greenberg's early criticism emphasized Pollock's clumsiness, ambition, and his frequently expressed respect for Ryder and Melville—all as important

as the heavy Picasso influence, which indicated another of the tasks of the artist-hero: to combat the figure that confines his activity by means learned from him, and in Oedipal fashion to extend the paternity of forms in modernism by denying it.

The third myth that contributed to Pollock's persona, that of the artist-outcast, is more truly a cluster of romantic myths, European rather than American: the artist as hero (Rodin), as revolutionary (Courbet), as scapegoat and suffering redeemer (Van Gogh), as outsider rejecting society (Modigliani) and civilization (Gauguin)—the artist who is hero, conscience, victim, and rebel all in one, and who stands out most clearly against the social fabric he calls into question. This group of romantic postures—dear to the bourgeois soul —are all-or-nothing occasions; they switch between transcendence and oblivion, between social transformation—a new order—and social disarray. In a way, art inevitably betrays these ambitions, for their social impetus is absorbed by a society eager for new sensations but not revolutions. Tolerated as emblems of subversive longings, the critical content of these myths is extinguished by the very romanticism they invoke. An eccentricity that begins to threaten is quickly labeled madness, opening the way for the revolutionary artist to be revered as a saint *manqué*, or the opposite, as a creature engaged in diabolisms which, it seems, are also not immune to society's chic. Such artists, re-assuring the public of the value of art (something vaguely spiritual that should be kept around), are above all exemplary. The artist-hero's emotions are larger than ours, his torments deeper. All his actions have potential mythic significance; his silences have a powerful rhetoric, like Rodin's rather farcical *Thinker*. This leaves very little in the way of departure, either for artist or public, from the scenario devised by the public to re-enact its illusions of redemption.

The society that needs this kind of heroism acknowledges art's necessity, though imperfectly. Its absence indicates a society either totally indifferent to art, or totally accepting of it. Here the histories of American art and literature are unlike. Poe, Whitman, Mel-

ville, and many others are examples of the writer-victim in American literature. This myth is missing from American art in any substantial way before Pollock. One can only draw the two conclusions above: that art didn't matter very much, or that art was so accepted a part of the social fabric that the symptoms of alienation didn't exist. The latter is certainly true up to the Civil War and for a while after. New frontiers simply meant new subjects, and the artist-explorer was turned outward, not inward. Toward the end of the century alienation entered, and artists like Rimmer, Eakins, and later Carles and Maurer fulfilled all the iconography of the outcast-victim, but their example found no resonance in their society. Though they were mythic material, their myths were stillborn. Pollock's myth of the transforming hero, however, was borrowed from literature, and from the gradually imported myth of modern art itself, which, through the mass media, was the American public's first education in visual art.

Out of all this emerge the usual paradoxical facts: The artist-hero needs the bourgeoisie and their values as much as they need him. There is a mutual resentment and attraction, a surfeit of contradictions which, however complex, have a clear motif. In the conduct of this dialogue, pressures on the artist-hero make life hard to bear, not the least of them being the public license for his megalomaniacal instincts. The artist is encouraged to cooperate in his own self-destruction, while having an inkling that he is not free to do otherwise, leading to an imperfectly understood resentment that erodes his belief in his own freedom. This in turn he finds intolerable, leading again to further excesses. Only by destroying what the public feels is its vested interest—that is, himself—can the artist exercise the last freedom available to him. But this also is not unexpected. For the artist who destroys himself—and American success has devised a number of ways short of killing himself—becomes the relic of his genius, that is, very like his pictures. In the case of the visual artist, the scenario includes the auction house as the stage for society's final act of restitution, where the emblems of the artist's myth are certified by the bourgeois values of fame and money. After all, it is the bourgeoisie who make the modern artist possible.

Such scenarios happen for clear purposes. James Dean, for instance, focused the drama of postwar Pop existentialism, and gave as well some mythic status to the quasi-existential mode of Method acting. Dylan Thomas obliged with an impeccable rehearsal of the classic artist-hero text, even joining the audience in his distress at his own decline—a charming form of alienation. He confirmed the public's expectation of what constituted "poetry," thus damaging the very idea of poetry while extending it—and culture in general—into the public domain, another postwar theme. Yves Klein, through a suicidal flamboyance, restored a sense of vitality to European avant-gardism around the time the avant-garde idea had been revivified in America, mainly through Pollock's efforts. All these involve some sense of democratizing the difficulties of art, all have an attractive panache, and all provide texts by which we could think of acting, poetry, and art on the one hand, and meditate comfortably on large issues (the state of civilization and its discontents) on the other. But Pollock's myth, which he seems to have accepted far more ambiguously than those others accepted theirs, effected a major *artistic* task, that of transferring the avant-garde idea, with all its modernist appurtenances and iconography, to America, and in the process giving it an infusion of "New World" energies. The paradox of this is that his art, as Greenberg was to demonstrate, fitted naturally into the mainstream of post-Cubist abstraction, and so seemed to confirm the mythic task he had undertaken—a "new art in the New World"—while in fact it contradicted it.

The artist-outcast myth contains elements of the savage and the frontiersman. Modernism has, of course, kept up a dialogue with the unconscious and the primitive, with the radical energies civilization represses in favor of the artificial. Language betrays this in phrases like "breaking the veneer of civilization." Repression and violence provide a kind of dialectic of suspense and catharsis. The primitive in the artist-outcast is directed toward some interior frontier within the

artist which, once breached, makes accessible a self which then becomes exemplary. The artist's external frontier, art itself, persuasively brings into play the tactics of the frontiersman. Modernism, in its orthodox revolutionary progress, made a fetish of the limits of art. The discovery of the new meant that "the frontiers of art" had been pushed out, and the next generation could begin from this settled ground.

The rhetoric of this process buzzes with such formulations as "the unknown," "the marvelous," "the unexpected," "tests and trials," "new pathways," "visions," "defeat and death," "handing on to the next," etc. All these, after centuries when the awareness of exploration was a central *donnée* of everyday life, are still embedded in the popular psyche. One of modernism's extraordinary—and almost involuntary—mythic achievements was to take such a body of conceits from life and transpose them to art. Such a transposition prolonged the idea of exploration. The explorer, who often lost his way, opened the way for others. Similarly, the artist's transgressions could be seen as explorations that would eventually benefit his fellows. This transposition of exploration from life to art involved a metaphorical transposal. In fact, modernism itself can be seen as a huge metaphor serving, no matter how indirectly, a social need. Its demise signals that that need is no longer a force in our society.

II

In the famous *Life* magazine photograph of the "Irascible" artists who protested the Museum of Modern Art's policies in 1951,[1] the whole issue of the artist's myth finds a text. There's a great deal of mugging going on. Stamos, whose art is gentle, looks fierce, Newman properly insouciant, Rothko embarrassed and resentful, an image of that immobility he wished his art to break. One suspects that Motherwell has just parked a rumble-seat flivver of the Fitzgerald era outside. Still looks as intense, humorless, and transcendent as an El Greco— the very picture of the artist as genius. De Kooning is as good-looking and angelic as a movie hero who has learned to cooperate with his own face. James Brooks,

1*Life*, January 15, 1951. See page 168.

who didn't develop a myth, is quietly present, as if this were a family photo. Ad Reinhardt, whose art opposed everyone else's, is a dark, immobile, and negative presence in the midst of the drama of so many psyches. Reinhardt, Brooks, and Pollock are the only ones whose eyes are not filmed over with the kind of self-regard the others, all in their different ways, share. Pollock's immediate presence, at the center of the photograph, springs out. He is casual but intense, posed but convincing. As Betty Parsons says, "Everyone remarked on his vitality." Pollock's directness of response—"if he thought of something he'd just go ahead and do it" (Lee Krasner Pollock)—made him appear dangerous and uncompromising. Pollock's career is, of course, littered with such instances of sudden response: ripping headlights off parked cars, punching his fist through a pane of glass, crushing a drinking glass in his hand. Most of these stories come from the Cedar Bar milieu of the early fifties; but Irving Sandler points out that the Cedar Bar stories, though they guide the myth into the area of primitive and frontier machismo, embellish a myth well-formed by then. In the thirties and forties the cast, the context, and the stories differ considerably, and the Pollock who emerges from that earlier Surrealist ethos is a more lonely, troubled figure, whose struggles with himself and with European art are most acutely isolated. Mondrian provided the text for this while jurying an exhibition at Peggy Guggenheim's new Art of This Century Gallery in the early forties; he thought Pollock's works were "exciting and unusual. . . . I don't understand them, but something very important is happening here."

Speaking of heroes, Emerson mentioned "a reserved force which acts directly by presence, and without means." Pollock's physical presence and impulsive character had a great deal to do with why his colleagues were willing to accept his ambitions, and his art, allowing him to assume a role they felt was necessary and could benefit themselves. For without his colleagues' implicit assent, no wider myth would have been possible. Their agreement to support him is remarkable, since Pollock was younger than most of them.

Such support is withheld in the art community from those who are highly sophisticated and self-conscious, since sophistication is often maintained by irony, a fatal antidote to mythic ambitions. No more than Braque do sophisticated artists like Motherwell, Tomlin, and Guston give rise to myths. Pollock's brooding, taciturn image reassured other artists and, eventually, the public. His friends sometimes refer to Pollock's humor, but they don't quote it, and I suspect it was not a major trait. Humor, of course, is not allowed the hero since it may eliminate distance and encourage intimacy. His colleagues, then, allowed Pollock pre-eminence, though this is given on a complicated basis. De Kooning's famous phrase, "Jackson broke the ice," acknowledges this priority, remarkable from one whose competitiveness is legendary. And Franz Kline's comment, reported by Elise Asher, "Jackson *divined* himself," completes that picture of breaking through inner and outer frontiers.

Putting together the often contrary views his friends had of him, one finds a shy, restrained personality, deeply involved in understanding himself and his situation, often through anthropology and myth, particularly that of the American Indian; a contemplative mind interested in ideas about transcendence, to some degree the Oriental variety; a man curious about things in a way that tended to present itself as naïve (which may have covered some embarrassment), puritanical about sex, easily angered but often unexpectedly calm, at ease when working and somewhat at a loss when not. To people he knew well and trusted, he behaved with consideration. With those he didn't, a certain amount of role-playing crept into the picture. After he moved with Lee Krasner to Springs, Long Island, he developed a great affection for his small holding and wanted to extend it in ways clearly symbolic. He showed signs of wanting to belong to his community and was well up on its current events.

He tended to be impatient with anything connected to his deeper interests, that is, his work. From himself and others he wanted proof, not promises, performance, not theory. His criterion, like the inventor's, was whether "it worked" or not. This trait may have come from tinkering with cars, which he enjoyed. Apart from anthropology and myth, his main interests were jazz—which he sometimes played on records incessantly—and Melville and Joyce, particularly *Finnegan's Wake*, something of a breviary for himself and his colleagues. He admired little current art, but knew exactly what was going on.

His sudden and abrupt temperament seems to have come from a low tolerance for frustration. His mode of dealing with a problem was direct at all costs, and there usually were costs. This impatience seems to have been there from the start. As a boy he smashed a violin when he couldn't get the right sound out of it. Almost any kind of problem seems to have provoked a predictable cycle: puzzlement, engagement, frustration, anger which could proceed to violence, then purgation or depression —a cycle easily established when he was drinking. During this cycle he seems to have almost consciously refused to relieve the pressure on himself. Solutions that didn't pass through frustration had little validity, a puritanical self-punishment to which he was addicted. This pressure, which produced an enormous sense of difficulty, forced on art elements irrelevant to it, insofar as art was pressed to reveal truths and solutions it cannot be expected to provide.

Caught between emotional imperatives and a clear-headed awareness of the tasks to be accomplished, Pollock's progress had an erratic cast, attended by doubts and irritations arising from his own awareness that his romantic energies and his intellectual insights were somewhat out of kilter. There seems to have been a frequent "submerging" of his intelligence, a willful attempt to stuff it into his emotions without compromise. Consciousness itself seems to have been something he could not tolerate for long, and his career zigzags from moments of extraordinary clarity and insight (which could falsely encourage those around him) to a kind of opaque resentment. Just as his mind seems to have switched between these two states, his art bears something of the same relation to history. There is a desire to belong to history (the highest form of communal self-consciousness), and yet to transcend it, to destroy his-

tory and aspire to the condition of myth. These two attitudes toward time—the linear and the mythic—form a motif not only in Pollock's career but in modernism itself. So there were two distinct acts of liberation that Pollock could perform in an exemplary way for his colleagues, one mythic, the other formal.

The formal imperative preoccupying the painters of the forties was to find a way of inheriting the two traditions (as Gene Swenson rightly called them) that modernist politics has succeeded in isolating from each other: the Cubist—including the purist—tradition, assiduously cultivated by American artists in the twenties; and the Surrealist tradition emphasizing the contribution of the unconscious, which began to interest American artists more in the forties. These two traditions were falsely polarized as rationalism and instinct. The latter tradition received considerable impetus with the arrival from Europe of that group of artists and ideologues (Masson, Breton, Miró, et al.) who reversed the American artist's symbolic journey to Europe by bringing Europe to the American artist.

Injecting Surrealism's symbolic apparatus into the classical tradition scrambled the two in a way that now appears predictably reciprocal. Cubism was "romanticized" with open brushstrokes, its space mobilized as an active rather than static agent; de Kooning made this the main theme of his career. Surrealism was purged of its more irrelevant pictorial excesses in two ways: It gained a structural armature, and its emptied-out poetic space became formally cogent in a way that could "remember" mythic content—the main theme of Rothko's art. From this distance the figure that increasingly hovers over such transactions is as much Mondrian as the overt agent, Picasso, or the less overt one, Miró. Quite apart from the difficulties of crossbreeding two traditions, the separation of which was a strict convention, the generation of the forties had to come to terms with its own situation in a country torn between parochialism and internationalism, and confused by inconsistent ideologies. The larger context of these artists' dilemmas is too easily forgotten in the streamlined successions of formalist art history. To the

Abstract Expressionist artists of the forties, their art had a distinct social and ethical function. Though the *terms* in which they saw their dilemmas were predominantly formal, this should not be forgotten.

While the history of the forties is still gapped, one can recognize a sense of superimposed impasse and opportunity that called for resolution. Pollock was looked to as the one who could point the way to new options that Europe, or European émigrés, could no longer offer. His ambition, the rudeness and intensity of his attack, his sense of difficulty, his puzzling and individual results gave his art an impact that that of his colleagues did not have. Through the forties Greenberg focused Pollock's formal task clearly, and contributed, to a degree impossible to measure, to the artist's achievement—as did, indeed, Lee Krasner's exact appreciation of Pollock's status. Pollock's impatience—with himself, with art, with the historical situation—gave his search for a solution a somewhat exaggerated rhetoric. And Pollock's search or quest, in the Surrealist New York milieu of the forties, was a preface to a solution that would have to be instantly recognizable. In a word taken from World War II tactics, that solution became a "breakthrough," opening up new areas for formal colonization, and symbolizing the successful accomplishment of a task that needed all the potent myths previously described to effect it. Pollock's breakthrough would divert the mainstream of modernist art history from Europe to America, making the artist an indispensable link, like Cézanne, or Picasso, or Mondrian. Pollock's breakthrough (in 1947) clarified the lines of formalist succession, removing in one stroke the American artist's provincial position, which Davis and Hopper had coped with through limited holding actions. Yet insofar as his myth dominated, Pollock was destroying history (which American discoveries tend to do).

So Pollock's breakthrough cast large cultural shadows. His career itself makes a kind of picture not unlike his own: "A boggy, soggy, squitchy picture truly, enough to drive a nervous man distracted. Yet was there a sort of indefinite, half-attained, unimaginable sublimity about it that fairly froze you to it, till you invol-

(continued on page 105)

Lee Krasner (Mrs. Jackson Pollock), East Hampton, 1962.

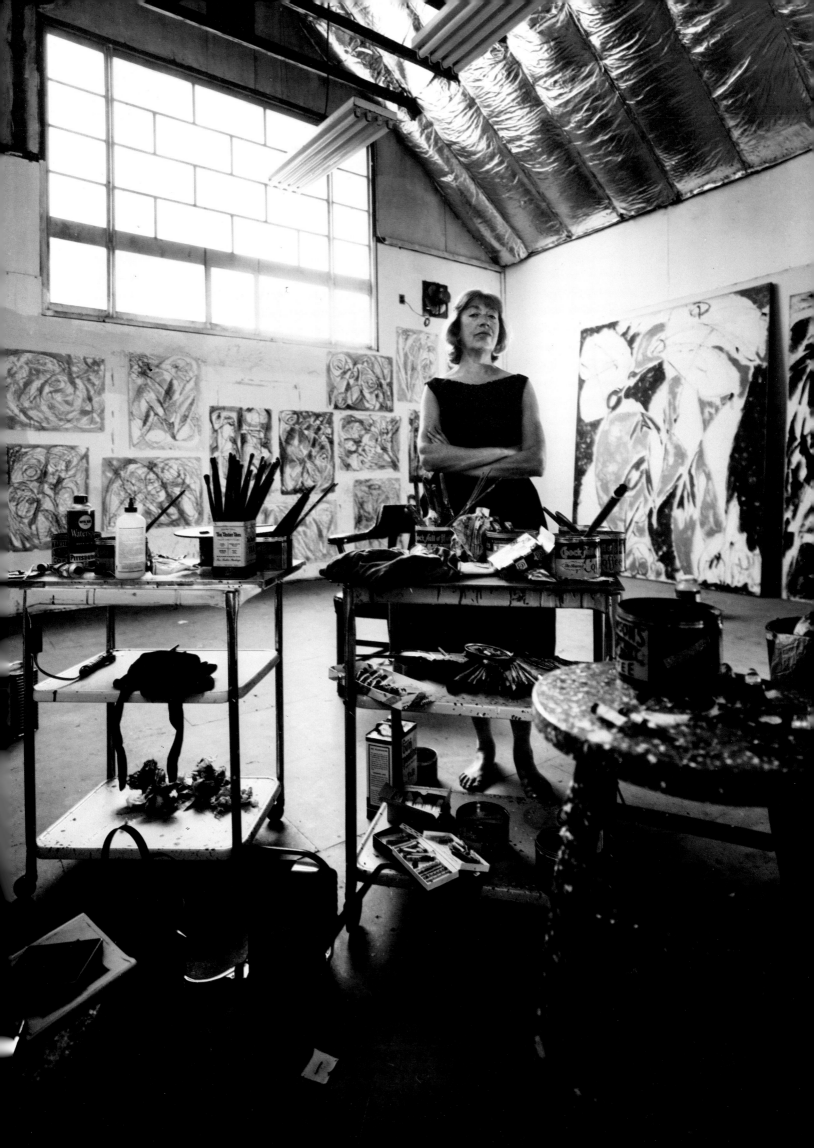

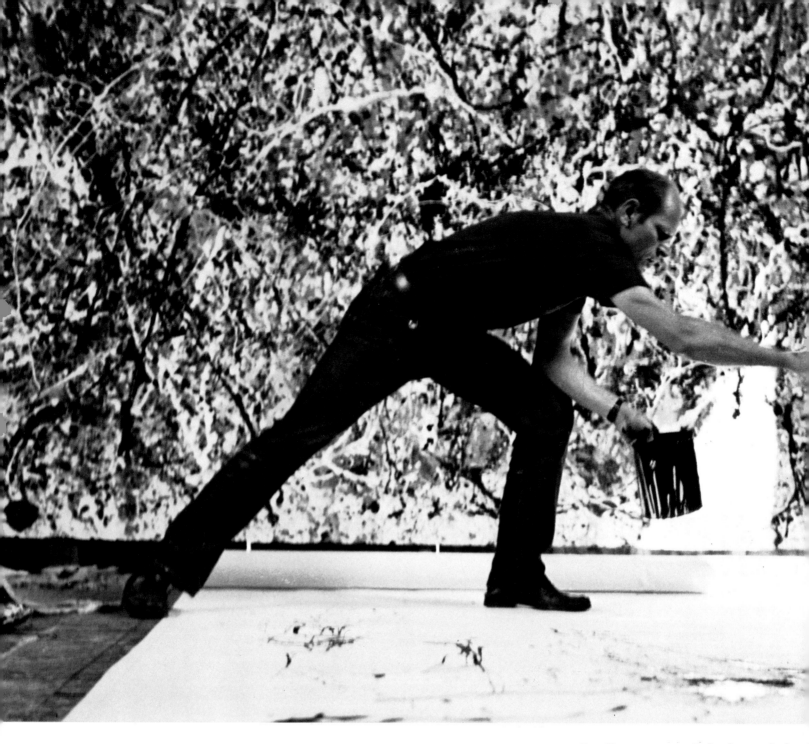

East Hampton, 1950. In background, abov
part of *One Number 31, 1950*: oil and enamel on canva
106″ x 210″, (Museum of Modern Ar

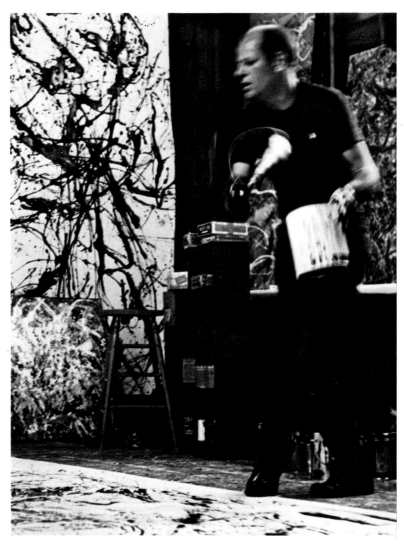

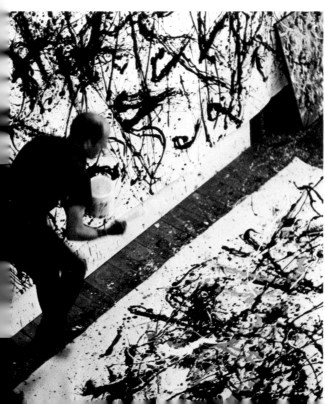

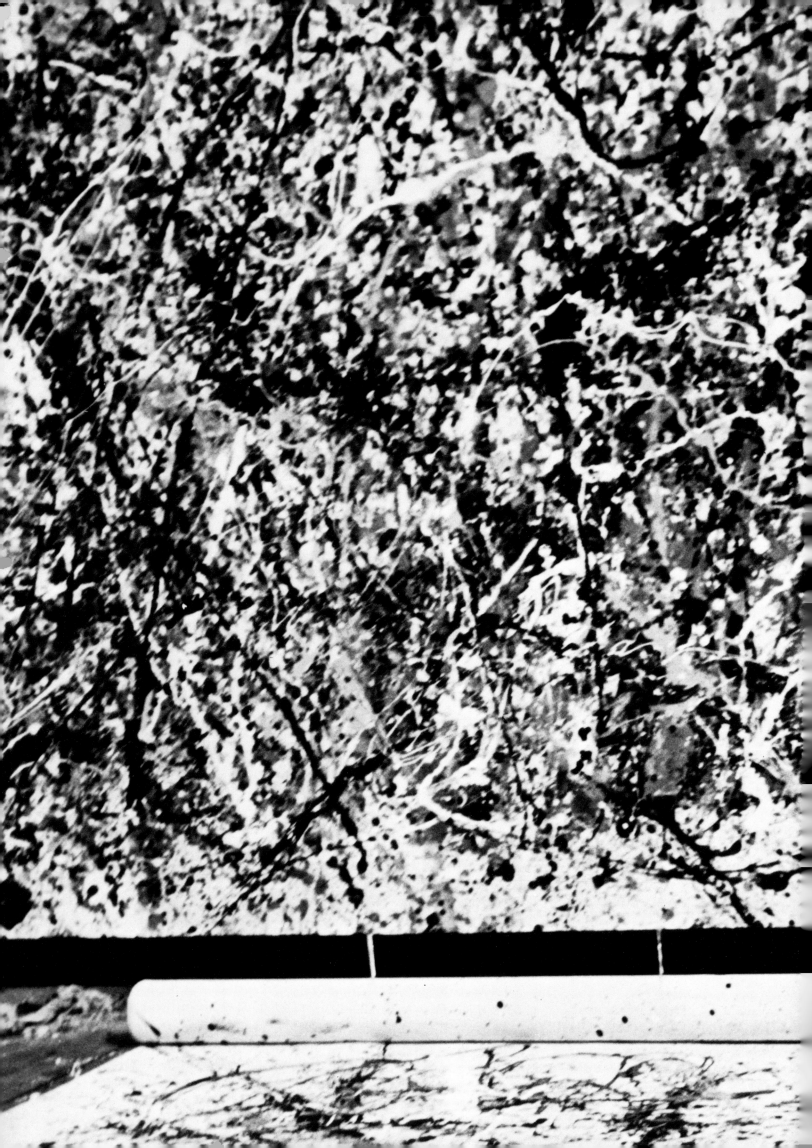

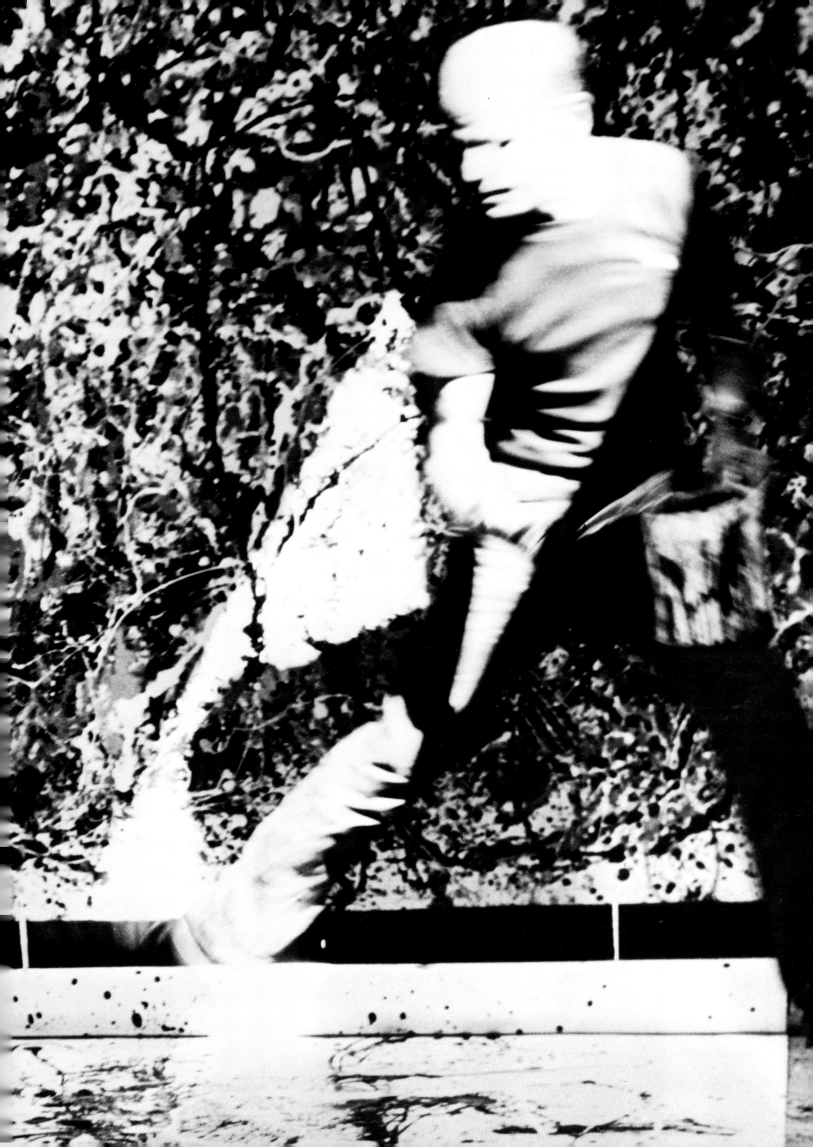

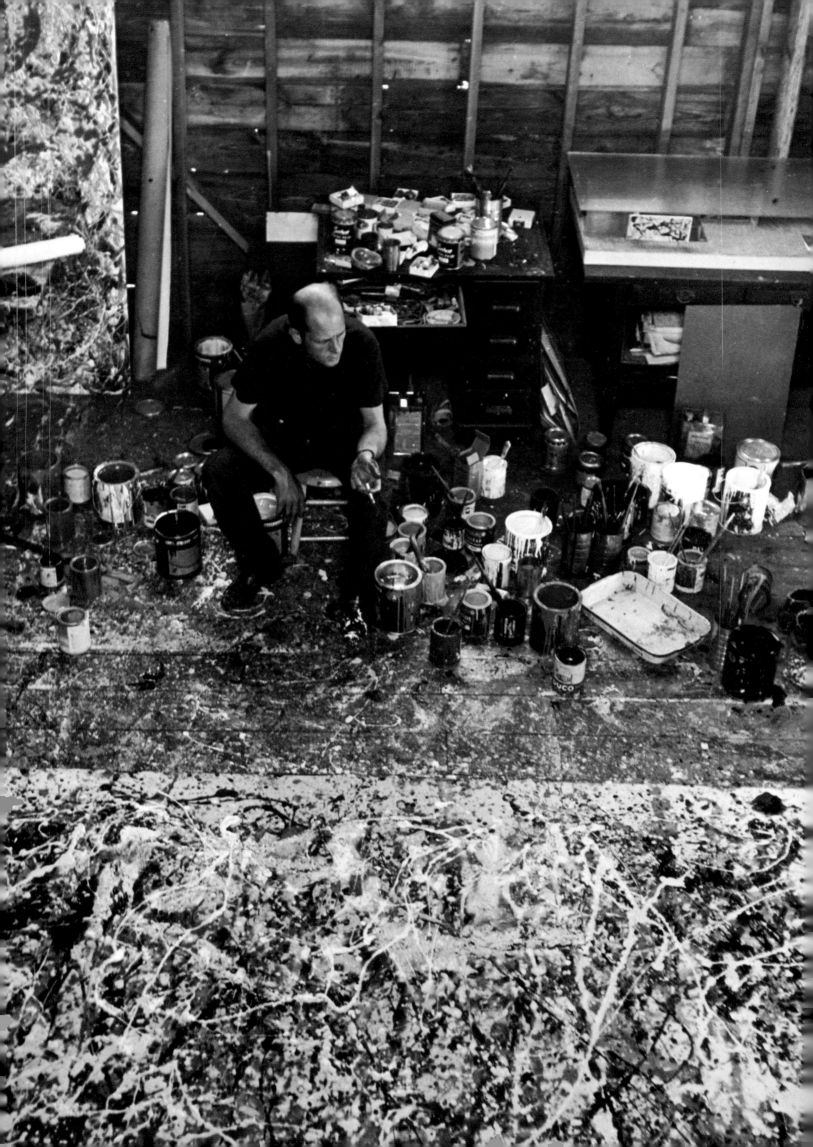

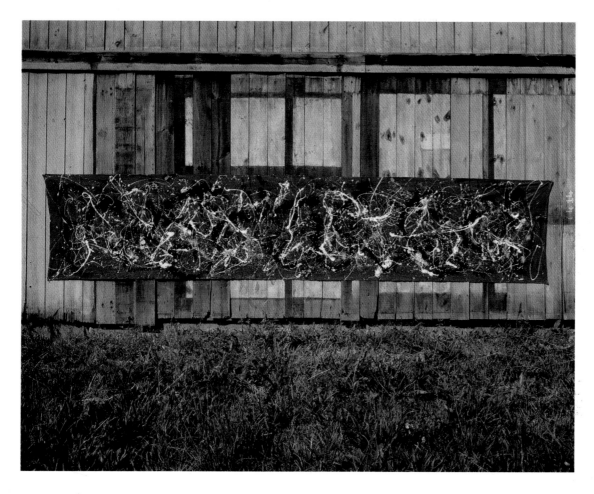

Pages 94–95: East Hampton,
1950. On floor, in progress,
probably *Autumn Rhythm.*
Left: East Hampton, 1950.
Above: *Number Two, 1949:*
Duco and aluminum
paint on canvas, 39″ x 190″,
(Munson-Williams-
Proctor Institute).

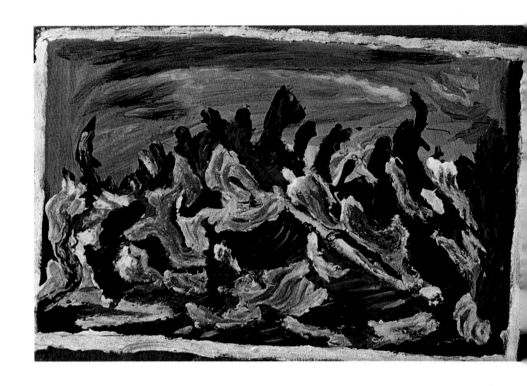

Above: Untitled: oil on canvas,
10¾″ x 16¾″, c. 1936
(Lee Krasner Pollock). Below: *Pasiphaë*:
oil on canvas, 56″ x 96″, 1943
(Lee Krasner Pollock).
Right: *Ritual*: oil on canvas, 91″ x 42″,
1953 (Robert Meyerhoff).

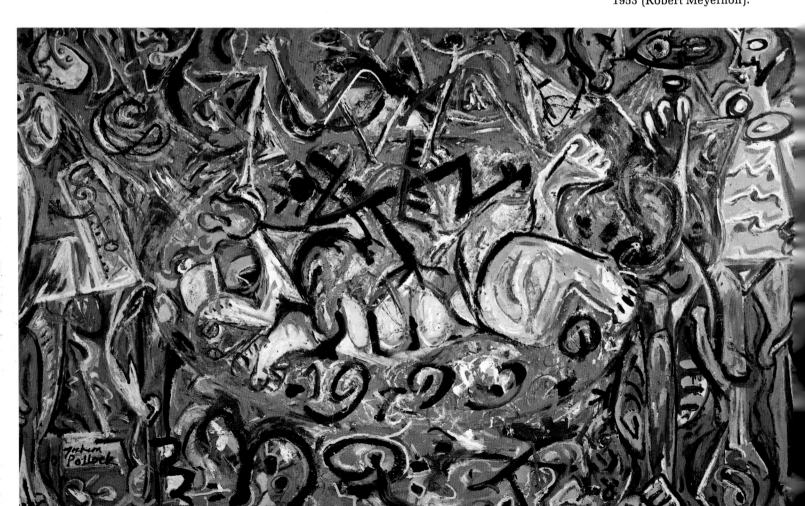

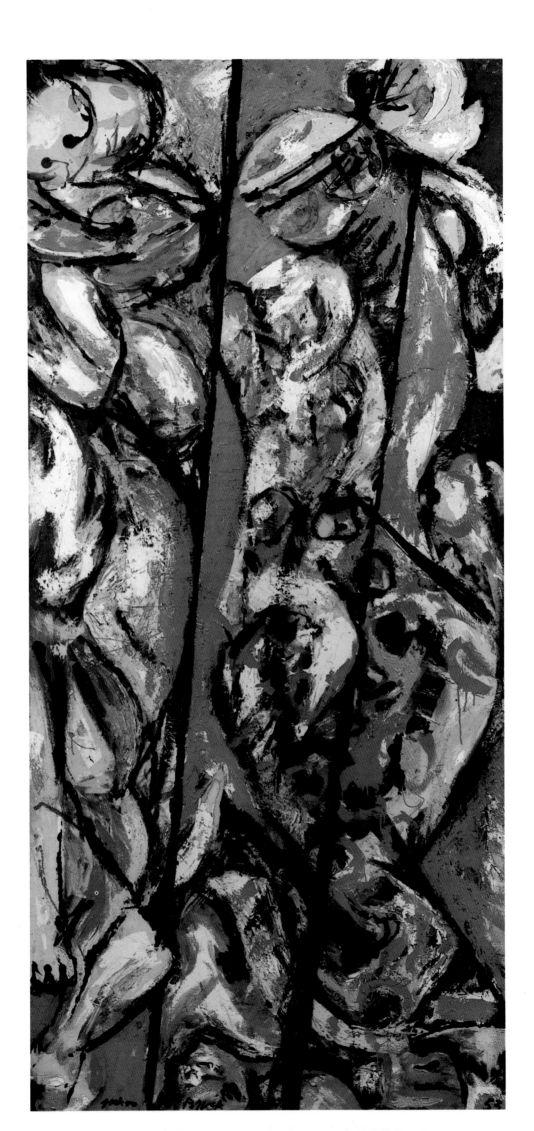

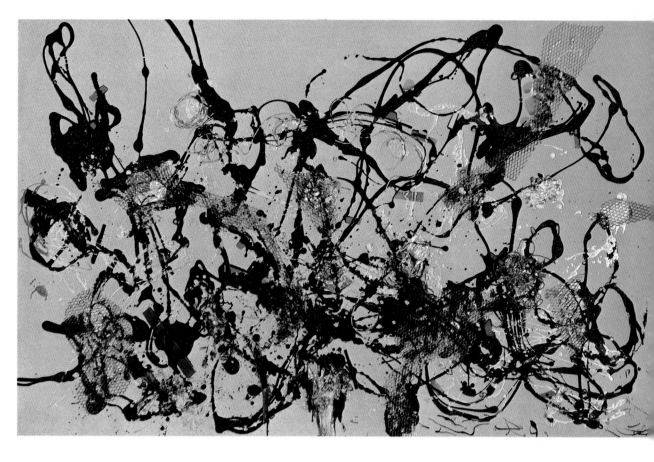

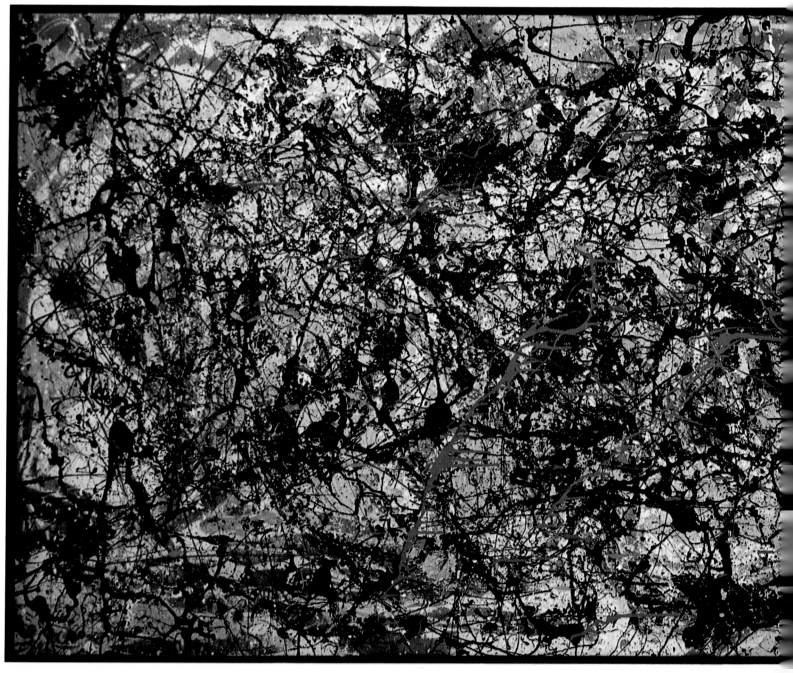

eft: *Number 29*: oil and other
aterials on glass, 48″ x 72″,
950 (National Gallery of Canada).
elow: *Lucifer*: oil, enamel,
nd aluminum paint
n canvas, 41″ x 106″, 1947
oseph H. Hazen).

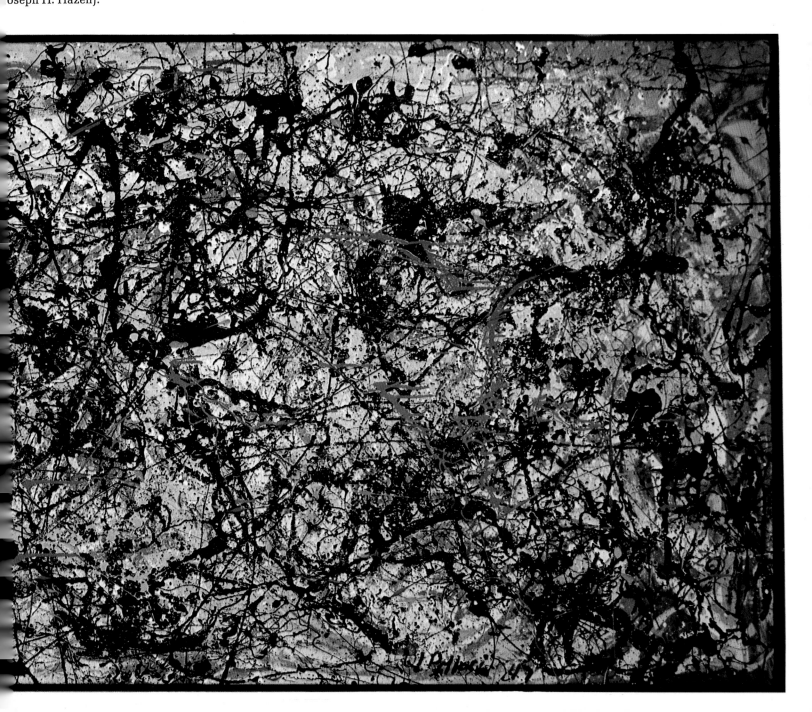

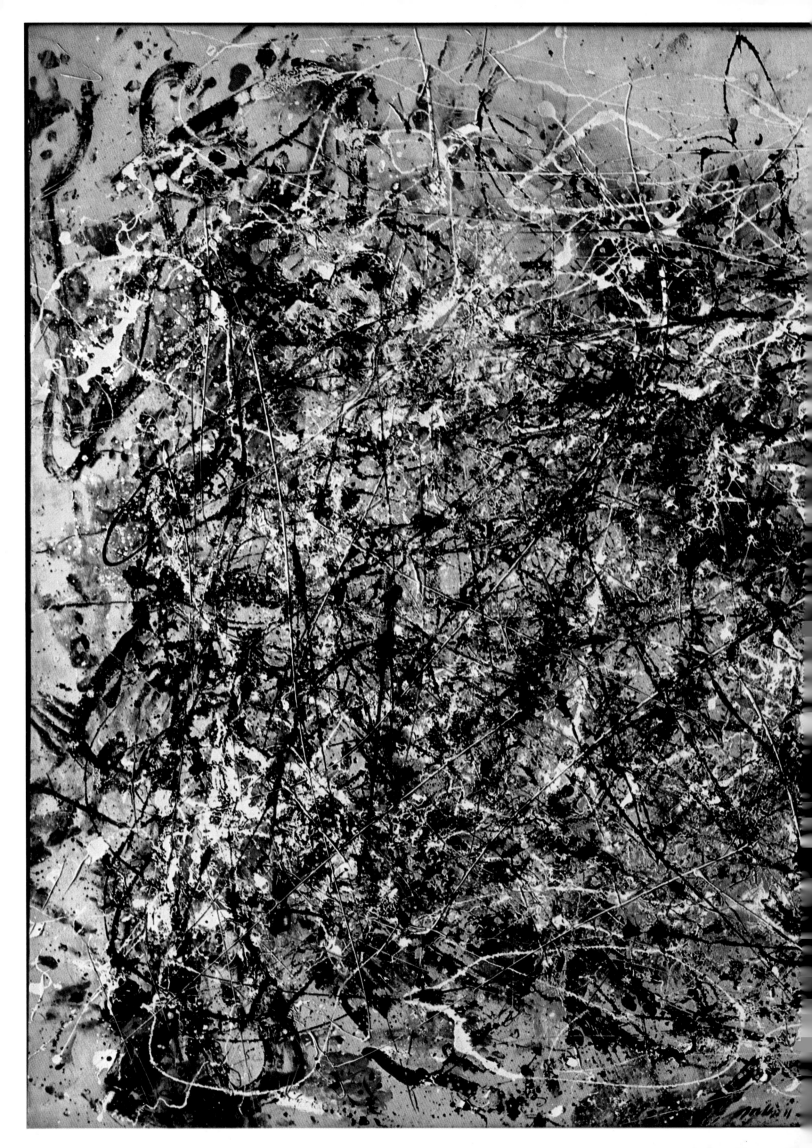

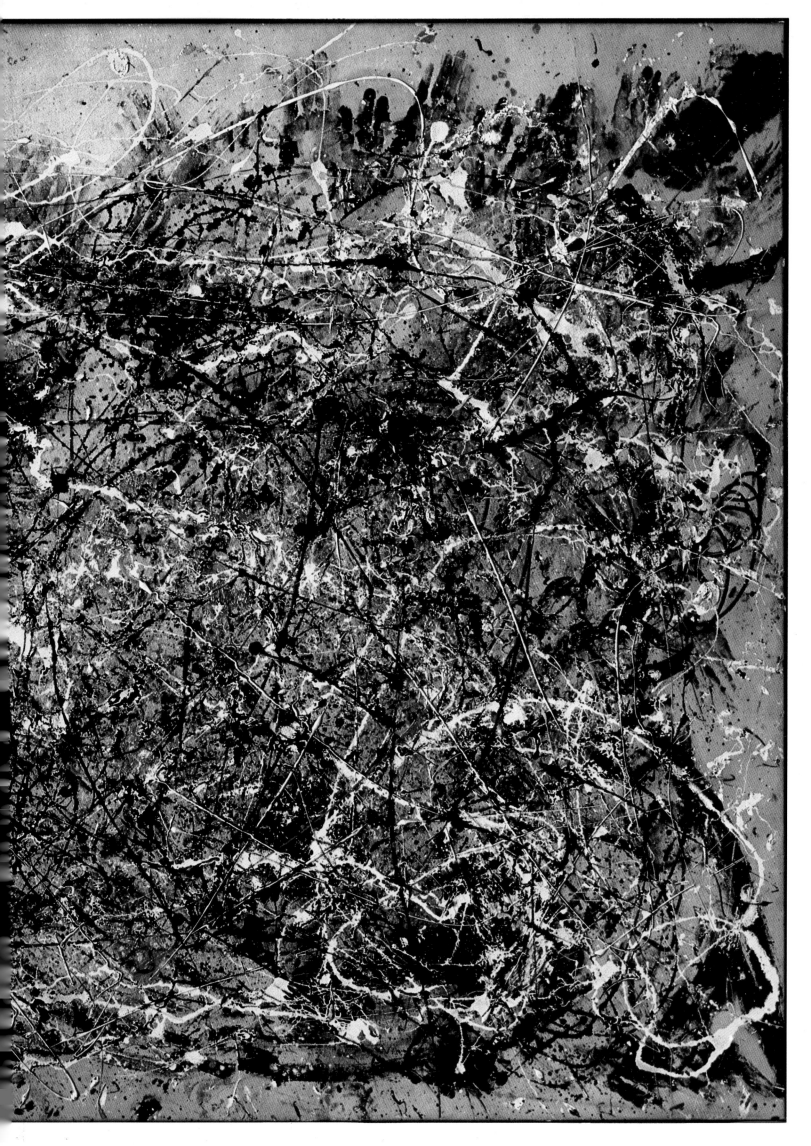

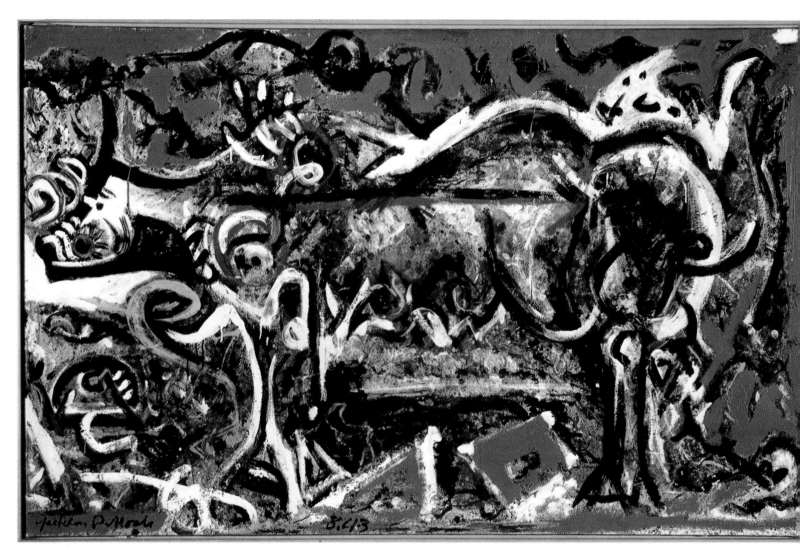

Preceding pages: *Number 1*: oil on canv
68″ x 104″, 1948 (Museum of Modern A
Top: *The She-Wolf*: oil on canv
42″ x 67″, 1943 (Museum of Modern A
Above: *Portrait and A Dream*: enamel on canv
58″ x 134″, 1953 (Dallas Museum of Fine A
M/M Algur H. Meado
and the Meadows Foundatic

untarily took an oath with yourself to find out what the marvellous painting meant." This is a description of the picture that hung in the Spouter Inn, the picture that stood for Ahab's quest. *Moby Dick*, Lee Krasner reports, was one of Pollock's favorite books—he even called his dog "Ahab." *Pasiphaë* was originally called *Moby Dick* before it was renamed during a visit from James Johnson Sweeney.

Melville goes on to describe that picture further, forecasting the kind of fallacies Pollock's work would provoke: "Ever and anon a bright, but, alas, deceptive idea would dart you through.—It's the Black Sea in a midnight gale.—It's the unnatural combat of the four primal elements.—It's a blasted heath.—It's a Hyperborean winter scene.—It's the breaking up of the ice-bound stream of Time. But at last all these fancies yielded to that one portentous something in the picture's midst. *That* once found out, and all the rest were plain. But stop; does it not bear a faint resemblance to a gigantic fish? even the great leviathan himself?"

This kind of churning over of hypotheses rehearses Pollock's quest. Allegories momentarily hold imaginative conviction and are discarded. Every "explanation" proves limited, as the picture suggests a further mystery that can be named but not explained. Ahab's quest for the whale, the multiform symbol whose lineaments remain indistinct, which is sensed rather than perceived, which forces contradictions on us with absolute firmness, can be seen as a model of Pollock's and modernism's quest for that absolute visual symbol which would summarize knowledge and make the spirit whole. Which would in fact utter the word that would reconcile man to his own nature, or enable him to transcend and transform nature. If this sounds extravagant, one can quote Barnett Newman's comment on his work: "If this work were understood, capitalism and oppression would disappear."

Nature is indeed a key word in Pollock's art, and while it has always been mentioned it has not been sufficiently emphasized. For nature is the context and substance of Pollock's art, as myth was the context of much of his thinking. He was never an urban artist. His travels, his moods as changeable as the weather, his paint, conveying in its spasms, nodes, and loops a sense of endless motion and repetition, all mirror an organic plethora. And just as some of Pollock's titles are a kind of scenario to his thinking with regard to mythic postures, others (*Autumn Rhythm, Lavender Mist, Ocean Greyness*) announce a spirit in love with nature.

Pollock's quest is identified with nature, yet apart from it, seeking to become nature, yet exiled from it. In other words, Pollock's quest, with its elements of challenge, submission, refusal and anger, was not unlike Ahab's, though he didn't respond to nature's indifference with Ahab's moral insistence on its—and his—evil. Pollock's quest had far less of a moral cast than, for instance, Rothko's, whose thinking eventually became narrow, almost prescriptive in a way he couldn't allow his art to be. Rothko's quest was formally exemplary in an almost evangelical way, but Pollock's was intimate and personal. Pollock, one must remember, did not question a climate of feeling in which myth, the unconscious, and the quest for personal identity, were the bric-a-brac of the age. The individual psyche mirrored the larger nature in which it resided; this organic world view was Pollock's strength and weakness. Correspondence between individual and universal "minds" is the romantic vocabulary, but it leaves no room, outside a rather doubtful "natural law," for moral or behavioral order, which Pollock's models provided only in the most wearing and destructive way. Negotiating between his art and the myths from which he derived inspiration demanded every scrap of energy he could summon. Between 1943 and 1947 his work shows the stresses of this; its clumsiness results from an exacerbated impatience, and its themes are often forced. Its trawl through the unconscious comes up with pretty familiar trophies; it approaches cliché through an excess of feeling, while at the same time cultivating a rather obvious geometric armature against which his brushstrokes appear to flail, but which, in fact, they support. The attack—in every way a frontal attack—lacks subtlety and tactical sophistication, as if an excess of energy would force the issue. What is convincing is the force one

senses.

Pollock's quest was to escape the toils of process in a double way. Modernism's Utopian and transforming desires could be realized through that absolute formal signature glimpsed in the art of the late forties and early fifties. But insofar as this is accomplished it makes art unnecessary. Culture becomes nature and nature becomes culture, and at the crossroads the ultimate work of art, now a sign of magical potential, is triumphantly raised. Seen in the context of culture, this work of art becomes the avatar of history, and Pollock's all-over paintings between 1947 and 1950 were, of course, those that formalist criticism canonized. Seen in the context of nature, the work of art becomes its analogue, eventually an icon. The few paintings Pollock did on glass are especially revealing when set up outdoors against the landscape, to which the eye can penetrate between the paint. The work is referred to its natural context, and human nature is joined to both, composing the organic trinity to which Pollock presumably laid claim in his unusually extravagant reply to Hofmann: "I am Nature."

Pollock's all-over drip paintings between 1947 and 1950 accomplished this Melvillian quest on a level of transcendent optimism rather than tragedy. Such paintings performed the heroic task of providing that mythical sign mentioned above *and* of diverting the course of modernist history to America, thus resolving the problem every American artist had before Pollock: the consciousness of being American as part of his creative premise. This accomplishment has its share of obvious paradoxes, though it seems to me their implications have been misread. Much has been made of Pollock's abrupt move to a lyrical, alert, and vivid mode of discourse. Clumsiness was replaced suddenly by grace, angst by the rococo, the masculine principle by the feminine principle, and process, through a surfeit of repetition and replication, was succeeded by a sudden, immediate effect. Many have found something troubling about this dialectical swing of the pendulum. It must be seen, however, in a long perspective of works scrambling their way to a tenaciously sought trans-

cendence. And transcending Cubism through a rather styleless gestalt that is very beautiful. The sheer beauty of Pollock's work at this time has been used as evidence that the "breakthrough" was a switch to the other pole of the dialectic, and to that degree a parody of transcendence. I imagine that Pollock himself came to share this suspicion, though Nietzsche might not have found it surprising. "Beauty," he wrote, "is for the artist something outside all orders of rank, because in beauty opposites are tamed; the highest sign of power, namely power over opposites; moreover, without tension:—that violence is no longer needed; that everything follows, obeys, so easily and so pleasantly—that is what delights the artist's will to power."

The all-over drip pictures mark a touching moment in Pollock's work—and in American art. The switch from difficulty to transcendence posits an artist who, at the very moment of his triumph, is gone—and remains, as it were, out to lunch. Pollock, instead of finding his identity, had lost it. Indeed, these pictures, after what has gone before, seem to articulate a question from the missing artist: "Where am I?" That question is, I think, very much part of Pollock's subsequent private and professional history. It coincides with the temporary cure of his alcoholism, the abandonment, indeed purgation, of his previous imagery, which had something of the charnel house about it, and the formulation of a technique that united instinct and execution.

Hans Namuth and Paul Falkenberg's film of Pollock at work shows how the drip technique allowed him to be "in my painting," engaged in an easy give-and-take. Looking at Pollock painting, his concentration is as clear as our sense that he knows exactly what he is doing. The artist at work can easily slip into the idea of the artist as medium in two ways: one in terms of execution, his whole body as instrument or brush; the other in terms of eliminating impediments to become the medium of an inspiration which carries through a very ancient idea of the unity of artist and natural forces. Pollock painting—one of the most radical visions in the history of art—is, to my mind, a very calm sight. It lacks that frenzy so dear to the public's melodrama of the

creative process. Pollock's intelligence is what comes through most clearly, including his scattering of a constructivist collage as a base for painting on the glass through which Namuth photographed him, a gesture that to me betrays one of Pollock's deepest aesthetic problems: the need for an armature that his art eventually returned to in a variety of disguises.

Pollock's occupancy of his art has a history of semievictions; being half in and half out of his art balances it between process and transcendence, between consciousness and unconsciousness, between art and myth, between culture and nature. In this he rehearses the dialectic of "the only American artist who interests me," Ryder, whose art oscillated between anthropomorphic baroque and a sinuous transcendental calm. Pollock's transcendental paintings between 1947 and 1950 perfectly superimpose the formal and the mythic but do not fuse them, so that they could easily slip apart again. The formal achievement that fulfilled the heroic myth at the same time invalidated it by making it unnecessary. Yet there is no doubt the myth made the formal achievement possible. So Pollock's influence is oddly forked. The art leads in one direction, eventually to the rich territories of postpainterly abstraction; the myth—a myth that now includes the rhetoric of breakthrough, process, and action—in another. All this of course has a literature, a vigorous literature, which has used rather than clarified these issues.

But to return to Pollock at his moment of transcendence. The "Where am I?" remains unanswered. Inevitably, to a spirit habitually engaged in a Faustian drama, this escape from the self begins to present itself as a form of alienation, and makes the very technique by which it was accomplished, which kept hand away from canvas, suspect. The history of Pollock's art in the fifties bears this out; the technique becomes far less assured, and proceeds to erratic spasms and arabesques that register exactly the interference with that spontaneous ease. The only way in which Pollock could make sure he'd "done it" was to reverse the quest, to make contact with what he had transcended. It is eerie to watch Pollock's career begin to mirror itself: the intimations of figuration, now sought instead of avoided; the recourse to the brush; the re-emergence of the mythic charnel house; the rehearsal of previous themes and formal frustrations—all now experienced from the other side in a kind of re-entry. The presence of the self is confirmed, but at a cost.

This is the darker side of Pollock's career and it needs greater illumination than it has received. Though it has its famous markers and signposts (*Echo*, 1951; *Blue Poles* and *Easter and the Totem*, both 1952; *Portrait and a Dream* and *The Deep*, both 1953; *Scent* and *Search*, both 1955), they point ambiguously to aborted directions. Yet they have a general theme: Pollock, except for the transcendental pictures (1947-1950), usually tried to *anchor* his insecurities. The text for this might be *Cut Out* of 1949, in which an animalcule is cut out of a fairly typical all-over tracery. One can see in this gesture formal, symbolic, and allegorical intimations. Is it an emblem of that search for a single formal image that Pollock and others of his generation pursued —a quest prompted by a primitivist and mythic urge? *The Deep* (1953)—an irregular dark shape that can become figure or ground—restates the desire for focus that led him to insert overt structure into his earlier as well as later work, a structure that always has an awkward relation to the problem it is called in to solve (e.g., *Ritual*, 1953); from this judgment I don't exempt *Blue Poles* (1952), to my mind an overrated picture. This desire for the single image and an irrefutably apt structure is, of course, the brilliantly paradoxical achievement of the transcendental drip paintings. There is an easy dispersal of composition into nodes and clusters, threaded in and out by skeins of paint that appear to be the very signatures of process and are abruptly halted by the total image, apprehended all at once. This circulation of energy between a convention of intense nervous motion and a sudden all-over image is Pollock's major dialectical triumph.

No wonder the work of the fifties, encountering such acute difficulties, urges commentators to accept the idea that his emotional state, his alcoholism and diminished output, resulted in an abrupt failure of

quality. Periods, unfortunately, are usually read in the light of the preceding period, and encountering Pollock's art of the fifties immediately after the transcendental paintings is a shock, a brutal shock. But Pollock was folding back his career to its pretranscendental beginnings; a good way to study a duplication he must have been aware of would be an exhibition of his early and late work, with appropriate "twinning" of examples from each period. This is not the place for that examination, but one is fairly justified in concluding that the late pictures, like those of many major artists, must apparently serve their time in limbo, whence "relevant issues" will, in the future, rescue them.

In terms of the myth, of course, these pictures can be read as stations in Pollock's final passion, so that retrospectively his death can be seen as destined. This unnecessary death, like Camus's in a car crash, launched the Pollock myth into an autonomous existence where it could be used to reassure the public of the passage of "genius," and to provide the art community with a patron saint, as well as with ammunition in the art-politics of the era.

III

"One of the nobler stereotypes in criticism," wrote Thomas Hess in Art News in 1964 ("Pollock: The Art of a Myth"), "is the so-called duty to disentangle a genius from his myth, and by reconsidering his art as coldly as a searchlight, free it from the irrelevancies of sentimentality, superstition and half-truth." After offering such epitaphs as "Rodeo Rimbaud" and "Marshal Dillon Thomas," Hess went on to touch on the questions that inevitably have to be asked about the relationship between the voice of a work of art and its mythic reverberation. He concludes that Pollock's myth was necessary "to reassure the artist about the risks he was taking," but took care to point out that though the myth was, in his opinion, to a degree self-induced, it covered very rational and clear decisions, a conclusion Rosenberg had come to earlier[2] in a severe review of Bryan Robertson's Pollock book: "Playing cowboy helped make it possible for Pollock to paint under hardships

[2]Art News, February, 1961.

that regularly filled him with despair." Later in the same essay, Rosenberg referred to "this talented playactor."

This motif—the irrational and inspired versus shrewd self-consciousness—runs ambiguously, as already stated, through Pollock's myth, art, and through modernism itself. It became exacerbated in the literature of the myth. The issue is: "To what degree did Pollock contribute to his myth? And if he did, how germane is this to his art? Does it affect our judgment of its quality? And finally, what valuable functions, if any, did the myth perform?"

That "Pollock himself was not entirely guiltless in this matter" of encouraging his myth, even Greenberg admitted in 1961. The New York Times Magazine article, "The Jackson Pollock Market Soars" (totally misnamed), is clearly about Pollock's myth. "In the final analysis," wrote Greenberg in the same article, "myths about artists like Pollock and Dylan Thomas feed less on their art than on their personalities." Pollock, through his dress and behavior, clearly generated and encouraged his legend. Where Rosenberg/Hess and Greenberg differ is in their assumptions about Pollock's premeditation. Rosenberg and Hess emphasize the shrewdness and thus the aspect of charlatanry. Greenberg makes a more charitable reading of a very divided personality who, when sober, was shy, "had no artist's airs and cut no figure." But his drunken behavior showed a "noisy self-assertiveness . . . that has singularly little direct relation to either his art or his serious self." Both Rosenberg and Greenberg, then, carry through their larger views about art in their thinking about Pollock. One picks up a sense of discomfort about Pollock, however, in some of Rosenberg's writing.

Despite Rosenberg's denial of it, his remarkable essay, "The American Action Painters," focused and gave impetus to the myth of "action painting." The emphasis in that essay is on the irrelevance of the past ("The Great Works of the Past and the Good Life of the Future became equally nil"), on the quest ("The American vanguard painter took to the white expanse of the canvas as Melville's Ishmael took to the sea"), on risk ("The artist . . . risking, to follow Kierkegaard, the

anguish of the aesthetic . . ."), on dissolving convention with reality ("The new painting has broken down every distinction between art and life"). In Rosenberg's book, *The Tradition of the New*, the action-painting essay is preceded by the opening "Parable of American Painting," in which he makes his distinction between Redcoat (roughly, European culture and its rules) and Coonskinism (empirical "anti-formal or transformal" American art). Coonskin triumphs "have been achieved against the prevailing style or apart from it, rather than within it, or through it." "Coonskinism is the search for the principle that applies, even if it applies only once." And, "Today, Coonskinism itself in the form of 'free' abstract expressionism is in danger of becoming a 'style'. . . ."

While Rosenberg has subsequently clarified the "voice" in his essay as distinct from its mythic invocations, these invocations are undeniable. Generally anti-European, to some degree antiart, they tap, exactly as Pollock's myth did, the energies available in the frontiersman idea. The occasion is clearly a polemical one, and the essay is now part of our cultural history. Rosenberg invokes the redeeming potential of the frontiersman in his existential view of the artist; at the same time he favors the emancipation of the individual from culture, even at the moment he is to transform society through culture. One would have expected Pollock's reaction to Rosenberg's article to be favorable. But his concern appeared to be with his art rather than with availing himself of yet another powerful myth so readily provided. Lee Krasner recalls that she, Bradley Walker Tomlin, and Pollock read the article with outrage in the Pollocks' East Hampton home. De Kooning dropped by while this response was at its height and, after he announced his liking for the article, the discussion reached new heights. Soon after de Kooning left, Clyfford Still came by and the negative verdict received further impetus. The influence of this essay is reflected in the *Art News* criticism of the fifties and early sixties, a densely poetic mode of art writing—which doesn't mean it was necessarily unintelligent or obtuse. This writing had a very "American" complexion, and it performed its task of supporting the avant-garde and winning it acceptance. Its declared prejudices were anti-historical, and for its proponents to make claims for its historical cogency is to do their efforts an injustice. Like all passionate polemics, it now has a period air and is subject to revivals. Rather than being part of the historical dialogue, such writing is material, somewhat raw material, for history.

Pollock is almost typecast for the role of hero in Rosenberg's action-painting scenario: His "common-man" origins, as Bernard Poli remarked, are *de rigueur* for American heroism. His primitive sense of difficulties and his switches between the retiring and the exalted complete the iconographic necessities. Rosenberg and Hess focused this myth-making apparatus on de Kooning, who came from Europe, whose art conducts an ambiguous affair with tradition under the guise of academicism and with America under the guise of certain European views of its myths. Rosenberg's essay was presumed to be about Pollock, yet contains a contemptuous reference to "apocalyptic wall-paper," which could be easily interpreted as a hostile description of Pollock's work. Was Rosenberg's apparently ambiguous attitude to Pollock due to the latter aligning himself with Clement Greenberg, the voice of historical continuity and tradition? In Rosenberg's discussion of Pollock, he seems to suffer irritation that the actor he has cast to play the leading role is not available, despite his denial, not unusual in such cases, that he wanted Pollock for the part. In his criticism of Robertson's book, Rosenberg's irritation occasionally spills over on Pollock. At the same time he is further provoked by the fact that Pollock's myth, to which he gave considerable, if involuntary impetus, is now entrenched in Europe, and has become an instrument for exalting Pollock (the positive side of the myth) and an opportunity to attack Pollock, and American painting, as primitive and philistine. So Rosenberg is obliged to deflate myths and to emphasize the art's visual contribution, a role in which he is not comfortable. He concludes with an attack on "the tired mythmakers of our day" who have hidden still deeper "the tie between the soft, lyrical sensibility

evident in his best paintings and the shy, gentle spirit that animated the blustering mimic of force. . . ."

If none of this directly answers our first question—"To what degree did Pollock contribute to his myth?"—it also indicates that enough information is available. Pollock did contribute to his legend, not as a charlatan, but as one who, first of all, was made aware of what was available to him through the *données* of his personality and situation, and who used what they provided to advance his aims. How self-conscious he was of this—Rosenberg and Hess's question—is relevant in its degree. If he did so consciously contribute, does it lessen his achievement? It certainly lessens the idea of a "natural" genius. But the pattern of Pollock's life suggests that his relation to his own myth was deeply troubling and ambiguous, and that instinct and self-consciousness present their alternating complexions here as clearly as in his art, adding further to the erratic motif that characterized both.

The next question—"How germane is this to the art?"—is very appropriate. The myth has certainly confused the art's outlines. The art up to 1947, with its rhetorical hesitations, impatience, and difficulties, is clearly in sync with the myth. It must have been a happy surprise to Greenberg when Pollock, in 1947, began to paint pictures which absolve that quintessential formalist critic of the embarrassments of "content." Yet the radical method used to paint them—the drip—was, as Max Kozloff points out, unmentioned by Greenberg in his first review of this development—a suspicion on Greenberg's part, perhaps, of the rhetoric of "new" means and breakthrough. The drip, of course, in the canon of Pollock's myth, represents cutting the Gordian knot of his difficulties. The myth, then, as mentioned previously, is somehow irrelevant to Pollock's most elevated achievement, since the tragic dramas of the Jungian psyche are succeeded by a transcendentalism that eliminates them. Yet these transcendental paintings benefitted from the legend in that the latter conducted a kind of exalted public relations for them. Indeed, the disparity between these pictures and the myth was not evident to Pollock's most intoxi-

cated admirers; reading these works by the myths of process, energy, and space (the traditional European view of American heroism, derived from Whitman) severely distorted them, to the point, as Hilton Kramer rightly remarked (*Arts Yearbook 3*, 1959) that the pictures became "a kind of currency used in the commerce of his reputation, and for the faithful they bear the same relation to aesthetic value that paper money bears to gold." The myth was again used not to defeat or transcend history, but to subdue its critical voice.

Kramer's position on Pollock represented a new departure in the dialogue described to date. Rosenberg, Hess, and Greenberg had little disagreement about Pollock's stature, even though *Art News*, under Hess's editorship, was rather slow to acknowledge it. Kramer, who edited *Arts* magazine during many of the years under discussion (1950's)—when that magazine cultivated a temperate voice drowned by *Art News* rhetoric—introduced the idea of Pollock as a false Messiah: ". . . when fate denies us an authentic genius to preserve our faith in the future viability of art, we are not altogether unwilling to take a counterfeit in its place." Unfortunately, to Kramer's perceptions, false Messiahs abounded; his career is marked by its total failure to perceive the importance of the new American painting as it was happening around him. His conservative temper was ill-served by a conservative sensibility, a sensibility which, however convincingly it articulates its judgments, remains, alas, obstinately academic. "We learn to despise first competence, then talent, then genius itself," wrote Kramer in the same essay, with unintentional irony, "even as we devise expedients in their name. The paradox of our period is that we have learned to despise genius in the name of the historical necessity which makes of genius a talisman of artistic survival." The work of an artist so bedeviled by mythic urgencies, imaginative blunders, and popular gestalts is in severe difficulties in presenting itself for critical judgment. As William Rubin wrote in 1967 in his meticulous examination and explosion of every Pollock myth: "Myths are easier to grasp than new and original abstract art." Yet, he added in the same essay, "As in

most myths, there are seeds of truths . . . which we want to preserve."

As Hess remarked, "Jackson Pollock's myth is a piece of his art; it reflects an aspect of the content of his painting." For Greenberg it was an embarrassing distortion making readings of Pollock's real originality difficult. Here two views of art are in profound conflict. Greenberg's cultivation of tradition, his view of art history as a continuous and definable process, provides a purely aesthetic context for the artistic enterprise and refuses to go beyond it. His obvious pride in the "New American Painting" was clearly due to his belief that it was the next railroad stop for the train of historical inevitability. Thus Greenberg's vision was—is—basically conservative, but in a complicated way. The new is simply an extension of the old, but his recognition of the new, and the terms of his recognition, amount to inspiration. Rosenberg's attempt to give painting an ethical as well as aesthetic dimension was, I imagine, his fundamental intention—so pressing art into service as a critic of and model for society. One detail of the creative process—"the next decision"—gained a rhetoric that would, through its moral exacerbation, invalidate purely aesthetic criticism. This demands nothing less than the translation of art into social action (the disappearance of art) and the transformation of society. Though disguised as frontier existentialism, the aim is Utopian, a Utopia that despite its apparent placelessness, has a distinct American locale. If Greenberg's absorption of disruptive energies into tradition suggests a radical conservatism, Rosenberg's artist-hero redeeming society seems to suggest a kind of democratic existentialism. Rosenberg, then, attempted to extend to Pollock's art a sense of place, and of the dilemmas from which it emerged—without which context it would become merely a diminished artifact of its own genesis. Greenberg wiped away this "provincial" idea in favor of modernist placelessness. We have then two positions so extreme that they are easily stereotyped, which introduces an element of parody into their dialogue.

But this historical quarrel is now far enough away to see that each side complemented the other in helping Pollock's art accomplish its task, that of displacing the art-historical succession from Europe to New York. Rosenberg provided the myth with an impetus that made it a powerful piece of propaganda but, as we have seen, at a certain cost to the art. Greenberg's steady view of the art's formal contribution neatly reversed the roles on European critics by responding with the voice of culture to their mythic appropriation of Pollock, which would eventually have confined him, like noble savages from the New World before him, to the cage of European culture, remaining there to certify its ultimate superiority after completing his revivifying task. Greenberg effectively forced Pollock's work into the formal dialogue, and followed up the mythic gains by rationalizing them historically. Both Rosenberg and Greenberg, then, while attacking each other's positions, were each accomplishing the other's aims, if not on terms they could admire.

Pollock's myth, we see now, was essential to the task he had undertaken; without it, his work would hardly have inherited the modernist tradition, or have had its immense influence. Indeed, both art and myth separately influenced subsequent art. Not that this is a bad thing. Modernism has its share of good art made out of legendary misunderstandings—"the psychological equivalents of pure form," "the integrity of the picture plane," "the autonomy of the work of art," etc. But more than that of any other modern artist, Pollock's myth was an active agent in establishing a shift in the direction of art history—very unusual, this. As a protagonist in the codification of art history, Pollock's myth is a subject the importance of which goes far beyond the usual sociology of the culture hero.

The mythic thinking of de Kooning, and his view of himself as a mythic beast, would hardly have been possible without Pollock's authentication of the role. De Kooning's myth is more subtle than Pollock's and cannot be considered apart from his art. Both de Kooning and Rothko conduct a dialogue between history and myth, between the quest and the modernist void, which gives to their careers, as it does to Pollock's, an exalted, paradoxical cast.

KOONING

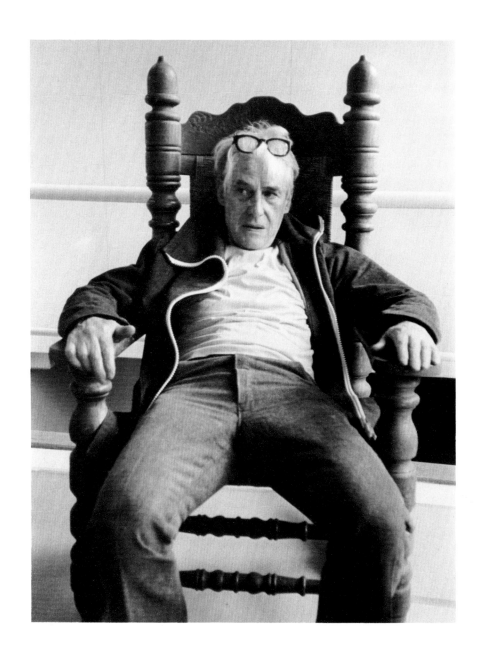

Willem de Kooning: Notes toward A Figure

Although Willem de Kooning has donated himself to us along with his art, he has done so in his usual elliptical way. The voice of the artist is constantly in our ear. It coaches our responses to particular hesitations, invites us to a connoisseurship of difficulties, and finally suggests congratulations that the picture should be there at all.

One of the phenomena of modernism is the development and survival of this voice. It exists as certainly in a Malevich or a Mondrian, though there our problem is to seek it out. Its corruption is a myth, the artist's myth. The myth presumes that the person the voice implies is the artist. So, on the artist's person is projected the iconography of "genius," domesticating that anarchic creature. This public reverberation of the artist's voice is heroically banal and safely dangerous. The conjunction of benign domesticity and the "unknown" is primarily a nineteenth-century idea, its potency expressed in thousands of photographic icons. Our sepia grandfathers in family albums mimic the dominant set of prescriptions. Magnificent façades standing for certainty, their eye, no matter how gleaming, is level. Their mien is judicious and their beards, soft masks with fixed expressions, are signatures of a magnificent aplomb. Are the lips thick or thin, is the mouth wide or tight? Such mobility or passion is concealed in the prescribed façade. Behind the brow (the phrenologist's delight) are *thoughts*, metaphysical pebbles. Even the most haunted and mad of nineteenth-century great men frequently submitted to this transcendent bourgeois posture. Tennyson is interchangeable with Parnell, Marx with Claude Bernard, Darwin with Tolstoy. We never think of them as moving. They all are frozen in their chairs. To be clean-shaven was to admit doubt. The clean-shaven men were very strange or not quite grown up, men who created a sort of delirium among systems, like Michael Faraday or Lewis Carroll. To the deeper tranquility of the bearded they counterpose the erratic perversity and innocence of the clean-shaven. Their naked faces are full of restlessness. Lacking a beard excludes them from the Victorian Byzantium, where genius is timeless and not fretful.

This ramshackle iconography of the bearded and the beardless seems an appropriate way of describing de Kooning's myth. He is a clean-shaven man who has had the majesty of the beard conferred on him. Photographs of him in his studio show him preserving an equivocation against those poses that would confirm the photographer's (and thus the public's) idea of his genius. In other words, he keeps trying to "take off" the photograph, the beard which domesticates his eminence. (Yet he submits to the photograph, for somewhere in his work he included the idea of a hero. Again it is a nineteenth-century idea of the great artist—one with periods, followers, and the ability to change history.) It's as if he couldn't tell where his voice ended and the myth began. Having invented himself, de Kooning has every right to suspect that other people are now inventing him.

The genius struggling against art, like Jacob wrestling with the angel, is one of modernism's prime bits of propaganda, and it suits the demands of public mythology. For a myth is simply a way of making talk possible, of "experiencing" something while leaving it unchanged. It is thus a form of understanding that substitutes for comprehension. Struggling against art (the public's myth) is the exaggerated shadow of the artist struggling with his means, or locating his struggle within the means, which again is simply an excuse for art, like any subject. But this is an impossible subject, and the anxiety arising from it is one of modernism's main themes from Cézanne to Picasso to de Kooning. Modernism begins with nothing possible and it retreats through impossibilities until now, in postmodernism, everything is possible. It begins in a dead end and ends in another kind of dead end.

Modernism's invention was to take the means and give them this voice, this possibility of self-reflection. It has been disguised, denied, or cultivated during modernism's progress. In the mid-fifties especially, a de Kooning painting turns this voice into a diction that seems equally vulnerable and omniscient. A de Kooning painting, particularly of this period, is a mess of cancellations, houses of cards continually being blown

down. It's the blowing down that brings this voice into the picture, certifying it as a fiction, as a dream of passion, in the actor's sense. Which is why we often call de Kooning's Expressionism "expressionism without expressionism." The voice suffers such replication and echoes that it is almost extinguished.

The lack of Expressionism is something quickly seen in de Kooning's work when so much bravura simply doesn't carry that expected afflatus. This neutralization of "expression" imparts an odd lack of resonance, of easy emotional tone, and a strange hysterical lightness. It covers the work with an idea of distance, like a pane of glass. It is a kind of pseudo-synthesis that keeps his pictures from going to pieces, though nearly all his pictures are in pieces. (These pieces would be very painful if they were, like Soutine's, full of conviction about emotion.) De Kooning has talked about how everything must be made abstract before he can use it. Parts are neutralized in a way that enables them to bear multiple functions. Engaged in such busy ambiguities, everything seems a prologue to paralysis. Meaning is extinguished through a surfeit of it, which gives the brushstrokes an unexpected impersonality. Yet the stroke is unmistakable, so one is led into glib little contradictions and critical double entendres. I wish Gertrude Stein had written about de Kooning as she wrote about Picasso, and we might have paradox meeting paradox, such as "he excludes nothing so that everything can be subtracted from everything."

De Kooning's anxiety, this rhetoric of difficulty that his "voice" explicates, is of course a hoax, since it implies that de Kooning owns it, and that Malevich and Hopper, for instance, don't know about it. Modernism divides itself on this issue. The Russian avant-garde, de Stijl, Mondrian have been socially useful, so the anxiety has been ignored. You can't have an anxious urban design in South America inspired by Mondrian. The other tradition (Cézanne to de Kooning) is useless. It stays in the studios and museums. Two traditions: one useless, one mixed up with Utopianism, which changes the world. But the fate of either shouldn't condemn it. For it is a part of the tradition of anxiety that each side thinks it owns it, just as Caravaggio has been awarded a certain kind of light and Poussin has been ceded rationalism. Classicism at its origin is anxious, but its anxiety is deceptive, like the calm of hysteria. Ingres used to throw down his brushes and stamp around in agony, but history suppresses that fact. De Kooning's voice is a magnification of and commentary on previous voices of every kind, including those that declare a categorical silence. In making these voices his theme he nearly extinguishes the possibility of speaking at all, and at the same time gives all of them an echo they didn't have before. De Kooning attempts to add to history in such a way that his success would threaten it with destruction.

II

Cézanne's anxiety, that is what interests us.

—Picasso

Hang yourself, you will regret it; do not hang yourself and you will also regret that; hang yourself or do not hang yourself, you will regret both; whether you hang yourself or do not hang yourself, you will regret both. This, gentlemen, is the sum and substance of all philosophy.

—Kierkegaard

Modernist art could be looked on as a series of changes in scale, and in this it resembles modernist science, which keeps splitting indivisible fractions to reveal further cosmologies. We tend to think that change in scale (a blowup of a fraction) is a diminution; indeed, it would be odd if we didn't. But it is just a change in the scale of dilemmas. Every change in scale invents as much as it wipes out. Now anxiety has a scale in modernism. Picasso invented Cézanne's anxiety—that is, he made us conscious of it and thus of his own. And de Kooning, turning Picasso's restlessness (Picasso's habit of escaping his problem) back on itself, makes it into a subject. De Kooning is constantly trying to reveal to himself the content of this subject: "Content is a glimpse. It's very

tiny, content." So this anxiety may momentarily put something in the mirror that isn't in front of it. That's impossible enough.

If we follow up this scale of anxiety in modernism, we find its climax (or postscript) in Jasper Johns, who relieves himself of it by incorporating his method into the picture—brushes, rulers, handprints, footprints (the latter signs of the artist become as objectified as his means). These marks and instruments make the canvas a physical rather than a metaphysical object. Johns' practice has precedents in those paintings of the artist's tools that we see in the seventeenth century. There the pathos of the instruments (it's a musical idea) creates the missing artist. Johns' attributes, however, make him permanently invisible. The dilemma of the means is an elusive presence that haunts the work. In literalizing his anxiety Johns destroyed a particular convention of "expression" and selfhood. Instead of the artist creating a picture, we have a picture creating an artist who isn't there. The voice in the picture has manipulated itself into an epicurean silence.

The anxiety in de Kooning's paintings of the mid-fifties turns into huge irritation at order, an order associated, particularly in the *Women*, with Cubism. It's easier to see the Cubism than the irritation. In constructing chaos from order, de Kooning is the converse of Picasso. Picasso couldn't stop because he never seemed to know when order was achieved. He never recognized the click. His restlessness became a perseveration, a parody of its heroic past (now and then a picture managed to escape). De Kooning never knows when to stop because his definition of chaos is self-cancelling. If he finds what he's looking for, he has to lose it again. Is he eliminating the specter of academicism? (Academicism is also included in de Kooning's work.) Yet this dilemma is a very romantic one. Washington Allston spent much of his later life painting and repainting one picture, and de Kooning has this habit. This is as much a temporal dilemma as a spatial one. It turns time into a place on the canvas, and it gives that place a memory by accumulating deposit on deposit. It is thus a somewhat literal experience of the passage of time, one of the great romantic agonies. In artistic terms this literalism with regard to time confounds the nature of art, and by refusing to allow it its definition keeps the threat of destruction over the painting.

This literal insertion of time into the picture is de Kooning's most interesting convention. Corrections, versions, eliminations are all part of traditional practice. Painterliness itself, though it can be sometimes read in terms of time, has been traditionally unself-conscious of time and process as disruptive; the time in a Hals or a Delacroix is neatly superimposed on the canvas.

More than any of his contemporaries, including Pollock, de Kooning identified the crisis of the means in time and thus fabricated a drama of impossibility. He exaggerated into a major theme the problem of putting one mark beside another, because he apparently wished to do so without letting either stroke modify the other. He was thus in search of a distance or gap between these strokes, readily associated with the idea of time. An idea of time became a convention through which to search for relationships or the lack of them. It takes only a fractional distortion to corrupt this idea into the myth of Abstract Expressionism with its theatrics and drama. The myth again stifles the voice. For the myth, as usual, celebrates a matter as dear to the public as the crazy artist—the creative act.

The public possession of the "creative act" dates mostly from the late forties and fifties—the age of "psychology"—confirmed by the many photographs of artists at work in their studios. Partly it was a holdover of a romantic fascination with means and partly—in America at least—a revelation of how-to-do-it. But above all, the sight of the artist at work is a fetish of modernism, turned by public necessities (that is, by myth) into an icon of magical potential—both a revelation of a secret, intimate act and a purging of its subversive qualities.

"The creative process" seemed to promise the public a privileged location, *inside* the artist, and was thus a perversion of a major tradition in aesthetics. Anyway, it is much easier to cope with the creative act than with art. The reactions of the two leading critics of

the fifties to the act and the artwork were diametrically opposite. As has been noted earlier, Harold Rosenberg emphasized the context of the work, the dialectics involved in the action. Clement Greenberg, the voice of history (one kind of history), received the work simply as art, the same as any other work of art, and he proceeded, with considerable prescience, to define its similarity to and difference from its antecedents. Greenberg eliminates the voice in the work to substitute his own under the disguise of objectivity. Rosenberg magnifies the voice into myth and eliminates the work. All de Kooning wanted, I feel, was a work of art with that voice, which *is* the work. Perhaps one *can* reconstruct it, or hear it, by reading his space in terms of the convention of time he included in his work. There are confusions in this idea of time as there are confusions in his idea of space. A voice, similarly flawed, does exist in them, attempting a description of an ideal artist who does not exist. This of course is an invitation to mythology, and de Kooning himself, in person, has been called upon to fulfill this role, for which nature has equipped him admirably.

Something interesting begins to happen. The voice in the work becomes mythic propaganda, which attempts to ensure the work's survival in history on *its* terms, by providing a further context for it. We can identify this propaganda as a fictive curator. This curator attaches to the name of the artist a typical image which may amount to no more than a fragment. We remember Cézanne's gable ends and not those soft vacancies, tentatively annotated, at the borders of his pictures. Atypical works are disallowed. A myth is a stabilizing phenomenon that paralyzes entire oeuvres and hands them on to the future under a particular emblem. Art and history are particularly vulnerable to this process, which provides "values" against which change can reassure itself. Against this fixity, the voice of the works attempts to manifest itself, a voice now itself altered and redefined as it recedes into the past.

In de Kooning's case the voice and its curatorial echo are somewhat confused, for we do not know how much he has contributed to that echo. One of the agonies of modernism is that it can do so little, and even that little is so vulnerable. There is a temptation to augment the voice by directing those myths eager to surround it. But makers of revolutions and myths find them difficult to control, so myths in the age of modernism are appropriated and "authenticated" by certain public values. Even in this matter we find de Kooning and his art making a knot that includes previous and subsequent history.

After de Kooning, the voice and the myth clarify themselves in separate extremes. Johns eliminates the voice completely (by making a portrait of the creative process), so the myth, stifled at its possible source, can summon up only a shadowy presence. And Warhol, completely identifying the voice with the myth, uses the mythology of public reception to create *him*. Warhol thus makes the public contribute to his art, which is the mythology of an artist. Looking at Warhol as myth, he (that is, his art) is such a magnificent creation that we can truly say, "We didn't know the public had it in them."

III

We constantly tend to think that the discontinuities in nature are only apparent, and that a fuller investigation would reveal the underlying continuity. This shrinking from a gap or jump in nature has developed to a degree which paralyzes any objective perception, and prejudices our seeing things as they really are. For an objective view of reality we must make use both of the categories of continuity and discontinuity. Our principal concern then at the present moment should be the reestablishment of the temper or disposition of mind which can look at a gap or chasm without shuddering.
——T. E. Hulme, *Speculations,* 1924

Art never seems to make me peaceful or pure. I always seem to be wrapped in the melodrama of vulgarity.
——Willem de Kooning, 1951

In the brain there are so-called silent areas, continents

without a voice. In the hullabaloo of the brain's transactions they make no apparent contribution. So, to relieve the insult of such anonymity at the very seat of consciousness, they are labeled with a possible function and forgotten. They have, it is thought, something to do with association. So on this large gap we have inscribed the function of eliminating gaps between one thing and another. From this small cerebral parable we might extract a moral.

Some of modernism's major energies have been directed toward recognizing silent areas that contain the possibility of subjects. And these subjects often have elucidated the gaps between things. We have learned to identify such areas by ignoring the incident in favor of its remote echo. We look not at Vermeer's *Lady Reading A Letter*, but at the light on the wall above her, and we cannot decide whether the color is light or wall, spirit or substance. Our attention is displaced from the face of a Velazquez to the small painterly delirium in a piece of lace. The subject dies of inattention as we discover (that is, invent) a voice where there was none. We encourage our own form of blindness or our own blindness of form. This may be a way of saying that modernism doesn't turn tradition upside down, but rather inside out. A part becomes a whole. The Velazquez is a whole filled with parts. But we have invented the converse: a part filled with wholes. This seems to me a description of de Kooning's paintings of the mid-fifties, the period in which his art most clearly declared its ambitions. *Police Gazette* and *Saturday Night* are parts containing a distracted congress of wholes. Since these pictures are *parts* we try to find a location for them, so we invent aesthetics and relieve our anxiety with a system. Formalism, for instance, can become an idea of *place* carried around by an ideal audience, so we initiate the idea of privileged understanding and the avant-garde audience.

But the artist doesn't protect his art with aesthetics. He does it with the voice—and with the myth if he can't bear to leave it to the voice alone. Mondrian strenuously promoted an absolute ideal of which his works partook. But the works often deny this absolute and expel his idea, making the artist merely another, if somewhat privileged, witness. Which did Mondrian's followers believe, him or his work? I think they believed what he said, and so codified the absolute idea. Perhaps we are still missing the artist who will reveal Mondrian to us, as Picasso did Cézanne (or one idea of Cézanne). De Kooning seems to want his fabricated "voice" in the picture to include history, so that it can proclaim his succession, and, as I've said a number of times, the impossibility of this causes disruptions. For de Kooning's voice to reach its apogee, it would need a missing civilization around it, a civilization that would do some of its work. This creates a nostalgia which is a way of including the past. For it encourages the idea that perhaps he was born too late, that "if he had lived then" he would have known what to do. This is just a way of saying that with the idea of the past he has now, he could have changed it then. It is simply another form of self-harassment, another machine to chop up the picture.

In this nostalgia there is, I think, a willful confusion of the future and the past. For de Kooning to some degree invents a missing civilization around his work, his own version of the dream of America—of which more later. But if his work shows a great sense of the contemporaneousness of history (so that history can offer competition and insult), so the contemporary (in this case, the dream of America) becomes potentially historical experience. Over all these transactions there hovers, as Clement Greenberg acutely remarked, "the dream of an obviously grand and an obviously heroic style."

We began this section talking about parts. Now we are talking about style, and each is very much involved in the other. Style, a key word in modernism, is a synthetic abstraction that became, through some necessary misunderstanding, a certificate of "identity." Style, the emblem of the successful creation of a personality, was considered self-defining. When successful, of course, it is totally self-eliminating. De Kooning, who has thought of everything, has given us a marvelous image of the disappearing artist—though what he is disappearing into is a kind of omnipotence. Instead of the vanishing point

being in the picture, the artist becomes the vanishing point outside the picture. The artist becomes "the idea, the center, and the vanishing point himself—and all at the same time." He is an organizing principle who disappears, leaving system upon system of cross-reference attempting to define itself. As I have suggested earlier, this results in cancellation after cancellation. Severe discontinuities occur, reviving the idea of a number of more or less independent wholes making up a part. What we witness is a negative idea of style trying to define a style. A de Kooning of the mid-fifties is as much about the possibility of a style as it is about doing something with it.

Pictures like *Gotham News* simply look impossible. De Kooning achieves that look of impossibility in his way, just as Rothko achieved it in his. Rothko convinced you that the picture was an apparition without a history. Although de Kooning's pictures present a surfeit of historical drama—if his work belongs to any academic genre, it is history painting—the more you look at the complications the more they begin to cancel themselves out, like those knots that, when you pull, disappear. De Kooning wants everything and ends up very close to nothing. Rothko appeared to want nothing and ended up with everything.

Where does this look of impossibility come from? Hidden in the work—and in much that was produced in the fifties—is a quasi-structural principle that greatly contributed, in my opinion, to this fabrication of the impossible. How did the fifties receive the idea of collage? Motherwell's early collages, rehearsing a French tradition, helped define the conflict in the sensibilities of an American Francophile. Hesitating between a lyrical connoisseurship and a more pessimistic self-consciousness, they slip out of focus into a "wrong" gestalt. Exquisite pictures are treated roughly, as a sensibility is constructed, rather than "expressed." This tentativeness is both an admission and a denial of provincial status, which is thus confronted. There is, in fact, the beginning of a new idea—not the relationship of parts, but their autonomy. Occasional Dada practices, in which Motherwell was superbly versed, touched this

idea. Arp had torn sheets of paper and, recovering the parts from a hat, set them side by side without overlap—the sort of cagey blunder history picks up. In *Asheville* de Kooning transplanted a piece of painted canvas from another picture and painted it in. Carried on serially, this kind of transposition makes a picture continually surprise itself. One also remembers here the homunculus Pollock cut out of a typical Pollock, a very complicated act. Another idea some of the major figures of the fifties appropriated was the old academic idea of squaring off.

A piece of film footage from the fifties shows de Kooning in his old Broadway studio. Behind him is a large painting which had been squared off, cut into squares, and reshuffled—a conjugation designed to destroy and redefine the "whole." Here a painting is made not on a grid, but by means of movable parts cut along the grid. (William Burroughs has done the same thing with prose. Reading, you miss the seams, or sometimes find them, relieving your anxiety a little. Since this idea makes meaning—the literary equivalent of depth—inaccessible, it results in an impenetrable *surface*.) I think this structural idea is behind de Kooning's disruptions, a way of making use, as Hulme says, "both of the categories of continuity and discontinuity" and of looking "at a gap or chasm without shuddering." In various ways this idea occurs in the forties and fifties, from Gottlieb's pictographs to Kline's blowups. Wholes confound parts and parts confound wholes and the look of a picture is conjured out of this. This immediately implies problems of scale.

The increased scale the fifties invented had to do with parts, wholes, and the missing figure of the artist, which was replaced by the spectator in front of the picture. More than any other, I think Kline epitomized this conjuring with scale. Sometimes he overlapped two parts, introducing a structural wrinkle; then squared that off, producing a new constellation of parts and wholes from this new subject. Pictures begin to occur within pictures. I feel he often blew up not the parts that could make a picture, but the unlikely ones that couldn't be pictures, and to some degree this explains

the "look" of a Kline. It also makes his pictures impossible to cope with by formalism or "psychology." For his apparent painting of the picture at high speed gives it a phony biography, diverting attention from its real source of construction. (The idea of instantaneity is aided by carefully painting white between the black, flattening the picture further and doing away with the silhouette idea that Soulages favors. Color, however, slowed Kline up.) Other popular confusions about Kline arise here: the idea that the picture contains an event or climax. Actually, the climax, if there was one, may be in a contiguous part that was not blown up. Related to this is the idea that the picture is a frame from some larger continuum, that the lines have been traveling for a long time. But, like Mondrian, strokes are often stopped short of the edge, underlining the edge's containing function. So containment and endlessness are both stated. We become aware not of "biography" in brushstrokes, but of a methodology of wit.

Almost anyone could paint a good small Abstract Expressionist picture, since small size made edges highly structural and encouraged the kind of patterned sketchiness for which there are precedents. Very few could paint a large one. Kline's struggle was in the blowing up, which involved a change in category. He succeeded by reducing his interest to a particular part, essentially very simple (Kline is, along with Rothko and Newman, a reductive artist), and preserving its impossibility when he blew it up; indeed, making that his theme. All that held it in place was conviction, will, whatever fills that interval until the "look" becomes a Kline. But that recognition lacks for me a discernible logic, as indeed does a Rothko or a de Kooning, and building a logic is done against the picture rather than with its co-operation. There is thus an attitude to criticism in the picture —Abstract Expressionism was the first art to more or less consciously anticipate and thus in a way forestall what had become the clichés of critical discourse. (This is a part of the picture's "voice"; far from being a pure "expression" of the artist, avant-garde art exchanges signals with a particular and immediate audience, whose expectations are a form of subject matter.) Anyway,

particularly in Kline's case, one recognizes the image. It adds to the master image of the artist, and at the same time (because of its specificity) detracts from it; you have to struggle to see this particular picture, and Kline seems to encourage this blindness under the disguise of instantaneity. In Kline, and to a degree in Rothko and Newman, one is confronted with this problem, which in fact is a dialectic between universal and particular in the medieval sense. The public distortion of this (the myth) is to assume that Kline was painting Klines. He was of course painting pictures. It's a small difference, but it contains an abyss.

But where—to get back to the structural idea—does this grid come from? It may be related to de Kooning's admiration for another Dutch artist, Mondrian. De Kooning's paradoxical thinking abhors an extreme. His wish to circumscribe all extremes might make it an attractive idea to build his chaos. If it is conventional to make order out of chaos, why not chaos out of order— Mondrian's order? (Morton Feldman proposed Mondrian as someone the Abstract Expressionists "passed through," in the process revealing the anxiety in Mondrian and the order in Expressionist abstraction.) Now this idea of a movable grid has large implications for de Kooning's work of the mid-fifties (as, indeed, it has for Feldman's music). What does the movable grid actually do to a picture?

First of all, it restates the question of scale, of parts and wholes. The space of the canvas is not absolute, but is given a crude permutational exit that can be taken when necessary. This permutation (exchanging parts and moving them around) is a destruction of subject, even if that subject is abstract. All the space on the canvas is thus made equal. All the space becomes charged, or all of it is discharged, and so can be continually filled up and emptied out. If the canvas is a place, that place is given the opportunity of continually redefining itself. This is visible in Picasso's painting and repainting of one picture in *Les Mystères de Picasso*, although in this case it occurs against a subject, which resists the process.

With de Kooning the process becomes the subject,

and it is continually disappearing and reappearing. When a subject (for example, a woman) appears in a de Kooning, it appears like an abstraction embedded in the real subject—the process. In this way de Kooning attempts to minimize and falsify his apparent oscillation between subject and abstraction, form and content, between real space and abstract space, thus removing a common dialectical cliché while appearing to fulfill it. In this some of the Women are successful and some are not. I am not, of course, saying that all de Kooning's mid-fifties pictures actually use this grid, actually make cuts and transpositions. Some do. As Dore Ashton points out, de Kooning "also experimented with abrupt breaks in the surface (the slice of the knife cutting a plane clean off from its contour). . . ." This becomes a way of wiping out a part, conjugating it differently, without actual relocation. All that is needed is the idea of the grid, and skill. Finally, the grid can imply time and spatialize history in a highly conventional way. But of this more later. For the present let us examine the huge messes of the artist's mid-fifties period and the preposterous Women preceding and interspersed with them.

IV

Confronting the poetic act in terms of the sublime and the ridiculous, we are disposed to think of the issue in terms of a situation and a strategy for confronting or encompassing that situation, a scene and an act, with each professing its own genius, but the two fields interwoven.

—Kenneth Burke,
The Philosophy of Literary Form

The Women are made up of anatomical parts that resist, by a sort of metaphorical overkill, the service of representation they are performing. As Thomas Hess pointed out in his pioneering book on de Kooning published in 1959, all the parts look as if they want to be elsewhere. An elbow wants to be a foot, an eye wants to be a breast, a flank wants to be a thigh. Other critics have seen telescopic reversals of scale: ". . . limbs given in terms of landscape—they can be vast" (Dore Ashton). The Women are compromising pictures, since they are as much an attempt to destroy an icon as preserve one. They are very varied. It is hard to speak of them together, and it might be more correct to disperse the stylistic equivocations with which they are summoned up throughout the rest of de Kooning's oeuvre. And if, as indicated previously, the subject—the Woman— is an abstraction and the real subject is something else, what is that something else?

One way of coping with a dominant previous style is to try to turn it into subject matter, as the dots in Pointillism survive into Cubism, where they simply define a plane or, going through it, create a memory of Pointillist atmosphere. It is a matter both of adding a pedigree and synthesizing history, the "subject" of much late modernist painting. If a style is dominant, this at best mitigates its effect by putting it at a distance; at worst it results in modish quotations.

Cubism is as much the "subject" of the Women as the biological mythologies her presence has invited. The irritation at Cubism in *Woman, I*, for instance, is extreme and the disposal of it incomplete. (De Kooning is the most distinguished example of a figurative dilemma of the late forties and early fifties: how to use and not be used by Cubism. In the late forties, artists such as Robert Colquhoun and Louis le Brocquy— influenced by Jankel Adler—did pictures that are cousins to de Kooning's.) Planes still slide behind planes, though brushstrokes consciously contradict and repair this. Facets of form, though worried ragged, are left open for space to invade and flatten, so they can survive attack. It is a very odd sight. If one can see *Woman, I* as an abstraction, and style (Cubism) as subject, this series is an attack on the maternity of styles in modernism. The Women are an attack on history, thus reluctantly admitting its existence. As abstractions they are mythic, but the myth is the darker side of the American dream, just as de Kooning's whole performance is made possible by the illusion of freedom the dream also provides.

So the Women may be Cubism turned into a subject, but not completely. Perhaps we can read this "subject," literary-fashion, into the Women's terrible goofiness. Their heads make cockeyed comments on the monstrous bodies. Are they illustrations of the rape of Cubism being perpetrated on them, a mock-heroic farce in which de Kooning doesn't seem to know whether he is the body (Michelangelo) or the head (Harpo Marx)? Also, throughout this series, he has trouble in making the head just another part. (In *Woman, VI* he succeeds.) But its gestalt keeps coming through, composing a comment on the picture. The best de Kooning could do for the series was to make the head as absurd as possible, as if no one should believe anything it says. Whether it varies from a Marilyn Monroe to a Daughter of the American Revolution (*Woman, I*), the Women parody the idea of being there at all. Heroism and the banal coexist. The voice in the picture is that of the hero and antihero. The sublime and the ridiculous have a vested interest in preserving each other—which seems to imply a dialectic, when in fact they merely exist side by side. So de Kooning is able to give superb imitations of pictures he might paint if he were able, another way of saying his pictures are about the possibility of pictures.

One of the constant insecurities of these Women is their situation. Where are they? Is there a confusion between the democracy of space in the picture and the single focus, the icon to which the Women seem to aspire? Some Women compress a frame of strokes against the real frame as if they had been painted from the center outward. Some, like Marilyn, are flat, imprinted on a slightly wrinkled space. These are more abstract than those conjuring with space in the middle. Another conflict here is between a psychology of space and its disinterested abstractness. There is thus a conscious attempt to interfere with the burden of recollection, the figurative ideas we bring to a picture. There is an attempt to define what we are to remember and what we are to forget—a crucial matter in de Kooning's best work. If we remember too much, there is paralysis through that Old Faithful of the fifties, ambiguity of

content. If we forget, there is another kind of gap. Which brings us again to this idea of a crisis among the parts (or wholes) which makes up that larger part, the picture.

This crisis reached its height in the large, more or less all-over pictures that accompanied or followed the Women—*Police Gazette, Saturday Night, Interchange,* and, above all, *Gotham News.* They are wonderful messes. All have a chaotic air; colors seem to lack any discernible replications that could be construed as "composition"; strokes deny planes as much as form them; there is a great deal of repainting of paint—that is, bad painting. Parts keep trying to declare themselves as wholes. But they can no more declare themselves than can the entire picture, which continues to look impossible.

What has happened to these parts? In *Gotham News,* they are destroyed systematically. Every corner that could be snapshot out of the picture is cancelled. Everywhere one goes, one finds oneself anticipated. Far from being unconscious or instinctive, this picture is the height of self-consciousness. Every part of the picture is instructed not to emancipate itself. But this is done without relating the parts to each other. They all are kept from autonomy, as in a way the entire picture is. For the parts are not kept together by establishing relationships, but by simply painting them together in an assumption (deception) of unity. The discontinuities in this huge maquillage are scribbled across and disguised, but they are still there and they are not denied.

One can go further. If what defines a part are its boundaries, and if the whole picture behaves like one of its parts, we must look to the edges. They have little to do with structure and their Cubist rhetoric is thus more or less silenced. Sometimes edges do pop up, cutting off something we were following—an echo of Pollock's destruction and mobilization of edges. Boundaries can thus be used or ignored, like a color. Yet there is something "off" about them, as if the picture, finished on one canvas, were inexactly transferred to another. The "fit" is slightly wrong. This gives the works a degree of artificiality, as if they had been painted between

quotation marks—which makes their excess tolerable.

This excess, however, brings in the idea of paralysis. One discerns a large irritation filling in everything, then filling in on top of that, until the artist is literally discharged from the rug of paint. Instead of being "in" the picture, de Kooning is expelled from it. All that is left behind is that voice, a commentary on his expulsion. In these pseudoclimactic works, the voice is at times interrupted or extinguished by incoherence or silence. Distracted by large ambitions and historical dilemmas— and uncertain of the possibility of art—it often concentrates on preserving epigrams, puns, and quotations. For all its self-inflicted flaws, it is a voice unwilling to relinquish the myth of omniscience, of an almost classic idea of Renaissance man. (Here de Kooning's early Ingresian drawings, with fixed eyes and hysterical calm, come to mind. If, as Freud thought, hysteria is a caricature of a work of art, these drawings caricature the idea of Renaissance order. But it is the later "messes" that make the Renaissance idea viable, however indirectly.)

But that idea is fragmented and dispersed in time, which raises again the specters of parts and wholes, the dialectic of all proportion. But the parts do not know each other. Spatially distracted, they seem to aspire to a synthesis in terms of time, or more truly, a convention of time.

<div align="center">V</div>

. . . time has turned into space and there will be no more time.

<div align="right">—Samuel Beckett,
Text for Nothing #9</div>

The attention demanded by Morton Feldman's music— which almost cannot be heard—is so uniform that it suggests the idea of a surface. This has large implications. One knows where the sounds are coming from, even though one can't quite focus it; "where" is presented to us as an idea. Sounds don't progress but merely heap up and accumulate in the same place (like Jasper Johns' numbers). This obliterates the past and, obliterating it, removes the possibility of a future. Deprived of relational ideas (rhythm, etc.), the present seems to be all there is. There are durations of silence and sprays and clusters of sound. There is thus a sort of vertical movement (accumulation) and a horizontal movement (succession but not relationships—a missing causology). The space in Feldman's music is described by the way each of these co-ordinates equivocates. They cancel each other because they are contradictory, and preserve each other because they need not be. The music, then, is haunted by the idea of a grid that does not exist. What is offered is not just music in time, but a new conception of time.

"Real" time, then, its literal passage, is used to describe a convention of time, a fabrication. The resulting stasis is what opens the way to the spatial idea. Time is used to destroy time. And in turn the spatial idea more or less suggests simultaneity, the possibility of seeing all the piece at once. Here we have telescopic reciprocities occurring between wholes and parts. And again there is a control of remembering and forgetting, or rather a prompting to forget. I also get the idea occasionally that time is being reversed and cut up, bits of the future interspersing bits of the past (entirely acceptable if you spatialize time). Therefore, though one knows more or less where the sounds are coming from, one does not know where one is. The present may be the future or the past. This may to some extent explain the feeling one has in Feldman's work of an exact and maddening superimposition of logic and enigma.

By coincidence, Feldman's "de Kooning" emphasizes these aspects of his music. Now, just as Feldman's music constructs a very sophisticated idea of space, de Kooning's paintings of the early and mid-fifties construct a sophisticated idea of time. Ordinarily one sees space and listens to time. Can one see time and listen to space? This is not a synaesthesic idea, for it demands not the crossover or union of senses, but their formal separation.

Obviously, de Kooning put a lot of time into *Gotham*

News. It has been worked over and over. Sometimes parts survive from pictures that have gone under (top middle, bottom right). The picture is thus full of discontinuities between remembering (keeping something from the past) and forgetting (painting over it). But this process "on top of" is more than matched by "side by side" evolutions—around those spokes that divide the picture but hardly give it composition. In its different contiguous systems, its different scales of shape, size, and contour, *Gotham News* is like a mosaic of Chinese boxes. Or, with its different densities, heights, and arbitrary contours, it is like a map of some oddly coincidental geologies. (Jasper Johns again, with unusual astuteness, painted real maps, adding systems of verbal contradiction on top of them. He thus preserved in a deeper sense the arbitrariness of contiguous areas, but confirmed them by reference to the map of the United States, a kind of grid we all carry around in our heads, anyway.)

So instead of an anxiety about making formal sense—that is, relationships—between the parts of *Gotham News*, we now have an interest in deepening its discontinuities so that we can see them better. Let us remove those brushstrokes that indicate the hope rather than the fact of synthesis. Let us ignore the way contained parts attempt to flow around spokes trying to establish connections between parts that have very different scales, and which again point to the hope of synthesis. Let us instead emphasize the paralysis of paint, the seizing of the picture, and its demand to be remobilized in some sort of time. Let us imagine that we are looking at lumps of time—misplaced lumps, since each survives a lost context—and let the bits of newspaper mixed up in *Gotham News* stand for this. Then, in the space in front of us there may be five months between top and bottom, a year between left and right, instants between somewhere else and somewhere else. There is a conjunction of different times (rather than disjunctions of space) trying to describe the picture. In one sense, of course, this brings in the idea of history again, and of the missing civilization that will validate the picture. But what have we discovered in the picture,

using this convention of time which gave us the illusion we would find something new? We have discovered the anguish of nineteenth-century academic painting.

Academic art made a finished sketch, squared it off and transferred it to a large canvas, taking time to assemble the parts. The result was then seamless and timeless. First, the composition—how one thing should be in relation to another—was solved. On this was superimposed the grid, which sliced up the composition. The academic agony lay in the transfer to the large canvas, in keeping one part going in relation to another. One sees this for instance in Thomas Moran's landscapes. He is trying to give landscape a rhetoric à la Turner, which is essentially sketchy, and sustain it by academic means on a large scale. In *The Grand Canyon of the Yellowstone* parts keep breaking off from the all-over vision. Underneath, I suspect, is a grid, that imprint of temporal crisis. The picture should appear instantaneous, but the parts are in a kind of insurrection. The rhetoric of the picture is not in the dramatic landscape, but in the conflict between ambition and frustration. Into this disruption, de Kooning has introduced the final disruption, remembering and forgetting, which gives autonomy to the parts of the grid as they permute themselves in time, around the idea of a lost whole.

Where does this grid come from? This brings us back to the Renaissance and perspective, both matters of concern to the artist who has written about "The Renaissance and Order." And with these, like an image developing on a film, comes the shadow of anthropomorphism.

If the Renaissance has a collective voice, it tells us where everything is or might be. Through perspective the voice implies an idea of proportion, an ideal man. So perspective, which tells us where he stands, itself comes to stand for this figure. The deep space of a Quattrocento painting continues out to include another witness, the bystander before it, just as surely as it defines the positions of the bystanders within. When perspective disappears, it is not just a device that is vanishing but an idea of man. And in de Kooning's pictures, the voice, which is always calling history to

witness, begins to question history.

Perhaps the Renaissance didn't know where everything was. Perhaps when you do away with perspective, there are lurches, gaps between things. De Kooning's early figurative works are about that suspicion, a suspicion learned from Gorky, who was obsessed with the Renaissance. For in de Kooning's great insight, when the artist is situated at the vanishing point, the Renaissance is reversed. He represents a figure and a possibility of order, but he can only project a kind of chaos. And when that figure itself vanishes and becomes a memory, the chaotic parts attempt a definition of the missing artist.

What this definition consists of is answered variously by the major figures of the forties and fifties. It is a definition that obviously makes nothing of the artist who stands in front of the canvas. The idea of a drama residing in the athletic give-and-take between the artist and the canvas does not liberate the picture but ties it to a myth that destroys it. That interpretation of action is a literal one, but the artists knew they were not engaged in self-definition of that sort, or in that sort of time. Rather they were putting a voice into the picture that would define, or afford the possibility of defining, the "artist." This figure is exactly equal to the strategies that produce it, and is thus an ideal surrogate for the artist. It also is superimposed on the spectator. De Kooning's "figure" is a dream of proportions, a distracted emblem of the Renaissance, subjected to insult by the very panorama in which it attempts to manifest itself. For since the hope of synthesis resides in time, it extends an anthropomorphic image to history. If this definition could be successful, a new civilization would be implied. This is the impossible task de Kooning set himself in the mid-fifties.

There is something very close to science-fiction in this ambition—that is, to a vulgar idea of history. The figures such historical engines as *Gotham News* grind out are caricatures of Renaissance man, Frankensteinian constructions invoking dimensions of laughter. For the voice in the picture aspires to a solution that, if found, would be rejected. It is quite lucidly in favor of its own puzzlement. It is even in favor of its own extinction—of art eliminating itself because history is false and the artist has vanished. The Superman reveals himself as the antihero, disguised in laughter. These transactions take place between a caricatured future and a caricatured past—for there is not hope, but a regret at its absence; not regret, but a hope for its presence. The multiplicity of roles offered within these paradoxes, returns us to the paralysis of *Gotham News*.

VI

For who would not be astonished at the fact that our body, which a little while ago was imperceptible in the universe, itself imperceptible in the bosom of the whole, is now a colossus, a world, or rather a whole, in respect to the nothingness which we cannot reach? He who regards himself in this light will be afraid of himself and observing himself sustained in the body given him by nature between these two absysses of the Infinite and Nothing, will tremble at the sight of these marvels.
—Pascal, *Pensées*

If I stretch my arms . . . and wonder where my fingers are—that is all the space I need as a painter.
—de Kooning, 1951

Let us place a bystander in front of *Gotham News*. And let us project on him the full anthropomorphic implications of that picture. However one chooses to see it (a glut of information, a plethora of biography, an almanac of the city), the multiplicity is fundamental. Because of all its dislocations, the picture demands that image which will give order to the insurrection in the parts, and we have already pointed to the painted equivocations that signify this hope. But the parts, once we remove these equivocations, are at different scales. The gaps between them are stated in terms of a time convention. Thus, if we (and the bystander) are in quest of a definition of identity, that definition always consists in remembering what we are, so that we can anticipate what we may be. Thus these gaps contain an unpleasant

possibility—our extinction. They exaggerate a simple fact of life—that is, of time. We say that we wouldn't do something we did a year ago, because we're not the same person now. One of Pirandello's characters says, "You must not count overmuch on your reality as you feel it today, since like that of yesterday, it may prove an illusion for you tomorrow."

Gotham News exaggerates this to the extreme. How are we to be sure we are maintaining ourselves from moment to moment? How is a picture to be painted (or seen) when the "artist" cannot maintain his identity in front of it, when every moment is, in fact, a vanishing point? That form of synthesis we call self-definition or identity stands in for the idea of synthesis itself. It is confronted at such an extreme, however, that it begins to parody itself. The idea the picture may give of the real artist caught in the toils of process is not quite true. For de Kooning, as Dore Ashton pointed out, sometimes preserves a stroke or passage from the past for inclusion in some future work. It is thus a quotation from a lost "self." This further confirms the structural idea of a grid in time, disguised as space.

Gotham News looks as if it had been painted by an army, but it is an army in search of an "artist." But that artist is translated into time and lost there. The head is in next week; an arm may be detained in some yesterday or other; the trunk mislaid in some month past. We have a vision of parts, but they may not belong to the same person, and may not even be of the same size, for there is no scale by which they may be defined.

The figure of the artist is a kind of defective, cinematographic picture, trembling, appearing, and disappearing, only parts visible at any one time. This is de Kooning's version of what we might call Abstract-Expressionist Man, spread out in time, as Leonardo's version of Vitruvian Man is spread out on a page. The mid-fifties pictures invite this anthropomorphism, an anthropomorphism that extends to history, for the "space" of this man lies between the Renaissance and these mid-fifties. This space, however, is confused with another space, the future we call the American Dream.

The sophisticated idea of time, then, in de Koon-

ing's work is never literal, though it may appear to be. It is a convention that the pictures, having used, throw out. However we may use it, as we have used it, it doesn't "explain" the pictures. However vigorously they test the conventions of easel painting, the pictures finally invoke them. But subsequent art underlined the virtuosity of ideas in *Gotham News*. Rauschenberg and Johns read de Kooning uncannily. Rauschenberg "illustrated" the disjunction of parts by substituting photographs, which always carry a negative content, the context of which they have been deprived. Time thus becomes a much more manifest idea than in a de Kooning, and through the photographs there is a great deal of apparent cutting and splicing of time, which is spatialized without anxiety. So ideas of collage and montage come in, invitations to real time which Rauschenberg eventually accepted. With the loss of anxiety, the voice in de Kooning's work is multiplied into a genial and motley chorus, all playing their roles without contradiction. It is but a short step to those multimedia occasions, which are perhaps the most literal interpretations of de Kooning. Multimedia eliminate the bystander by incorporating him, making him a part of the work. They are thus all myth, and pertain more to social ideas than to art. Such occasions are pure theatricality in the sense that they are role-playing without a role.

However, once we enter real time there are as many conventions of time as there are of space, and real time does not in itself mean theatricality, for theater may be concerned with eliminating time in its own way, as Feldman's music eliminates it. Feldman's music, in fact, points the way to a new kind of theater, of which Gertrude Stein's is the closest example.

If de Kooning's work is anxious about defining proportions, while aware that the possibility of a definition is hopelessly lost, that loss is accepted by Johns. His work incorporates numerous scales and measurements. They do not measure anything and are often reversed and wrong. They are, like the occasional hand and foot prints, a memory of the missing artist, of a missing body and its possible size. The incorpora-

(continued on page 145)

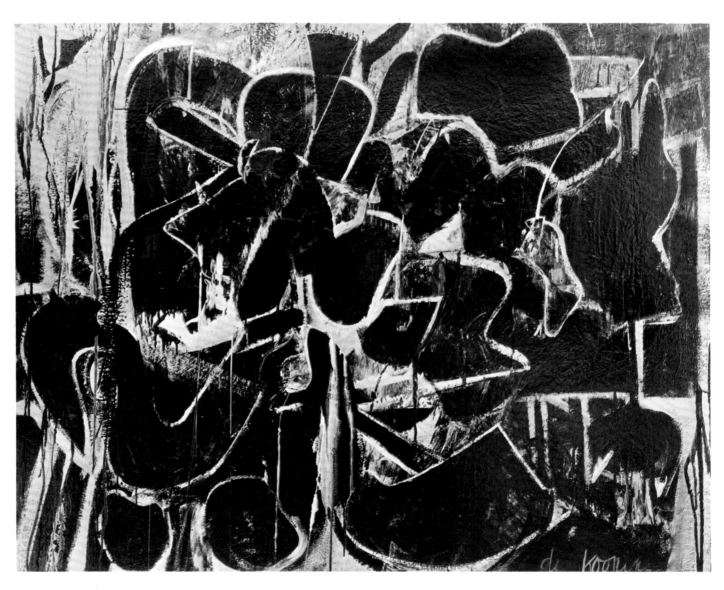

Painting: enamel and oil on canvas,
42⅝″ x 56⅛″, 1948
(Museum of Modern Art). Right:
East Hampton, 1953.

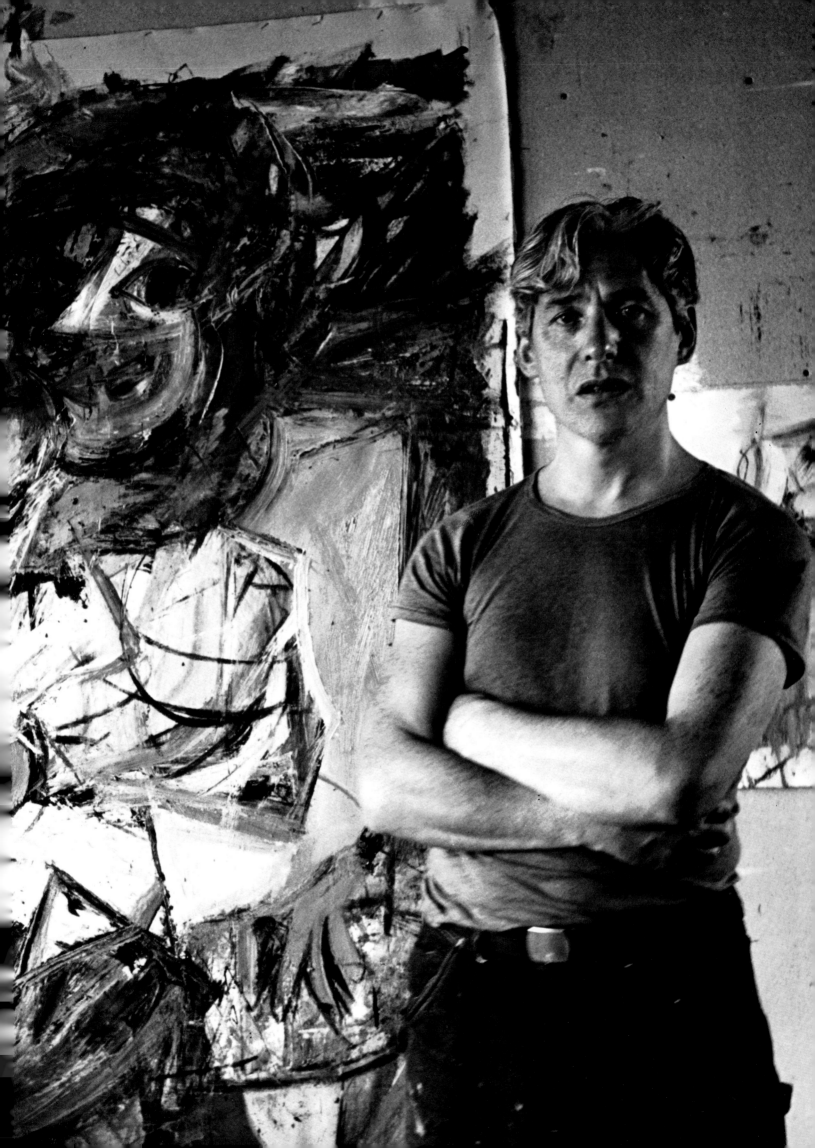

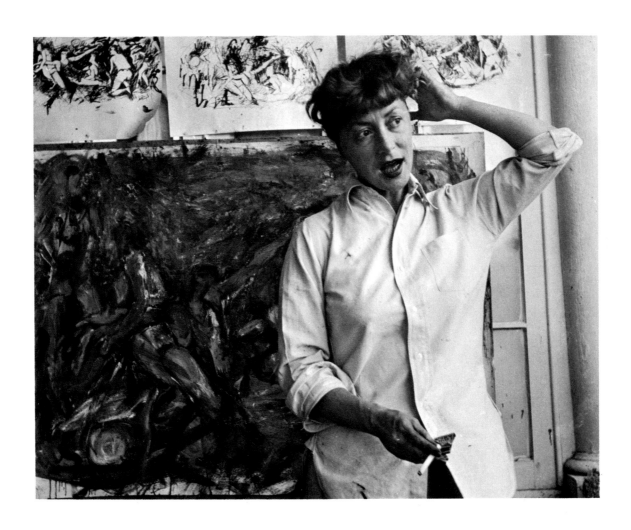

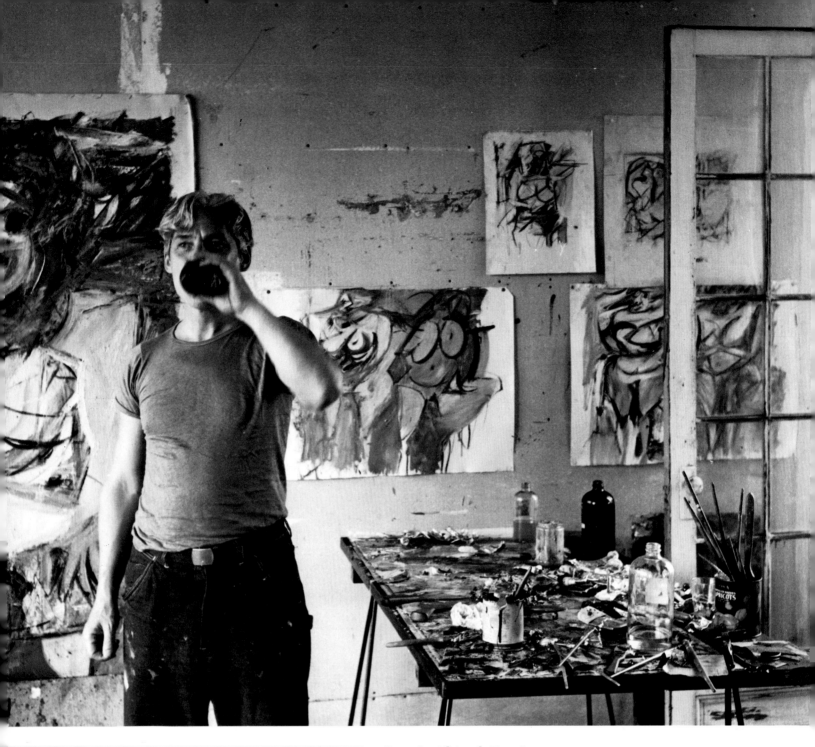

Opposite: Elaine de Kooning,
East Hampton, 1953.
This page: East Hampton, 1953
(top), and 1964 (bottom).

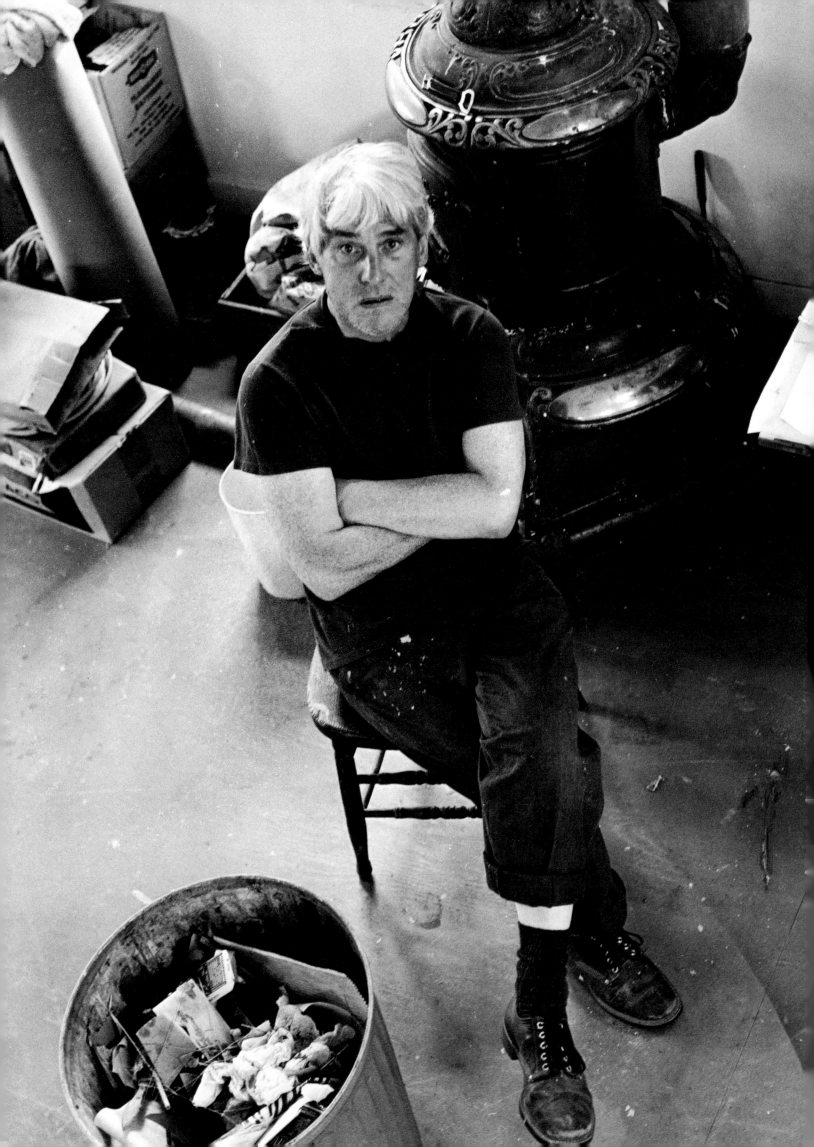

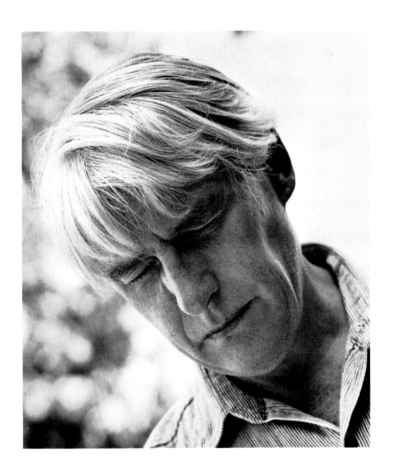

East Hampton, 1963.

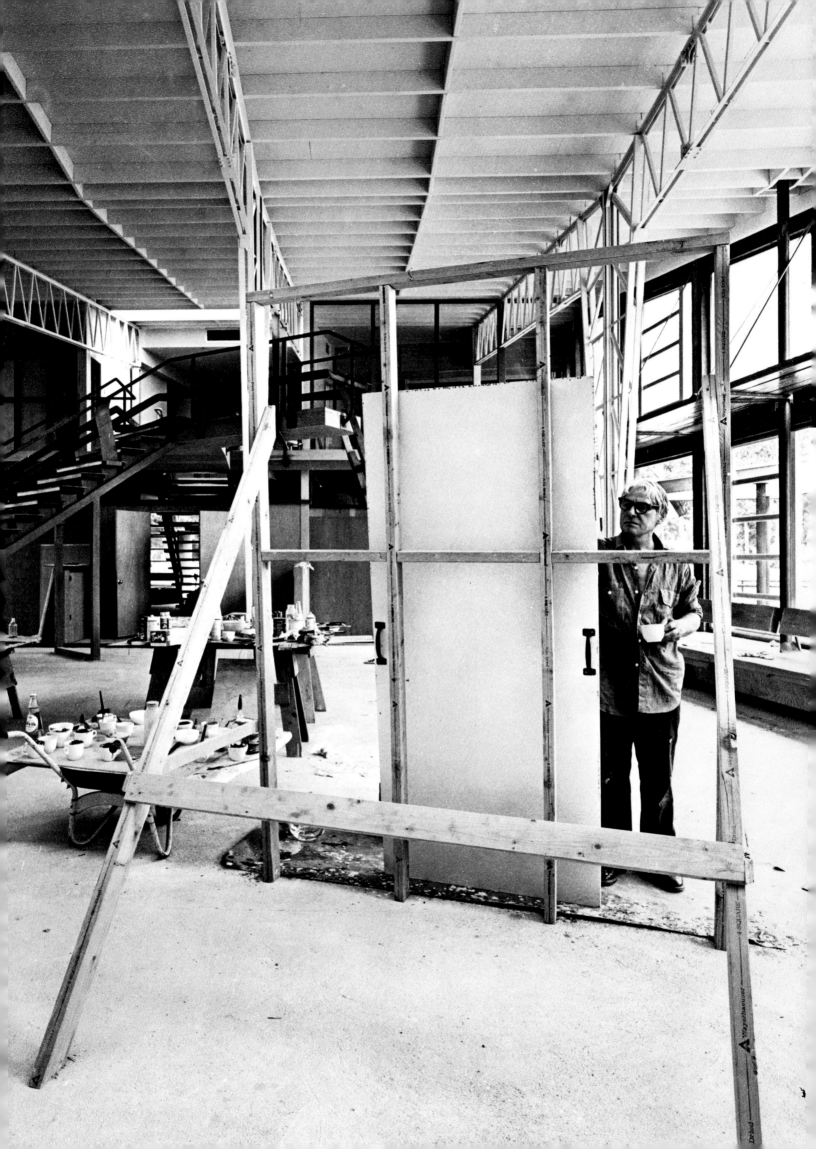

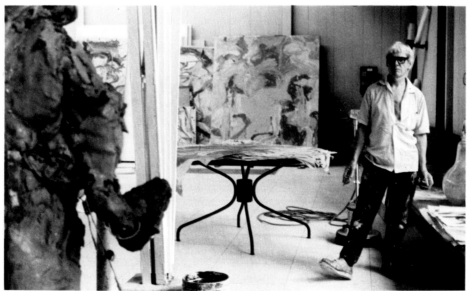

Studio, East Hampton, 1964 (left), and 1972 (this page).

Studio, East Hampton, 1964.

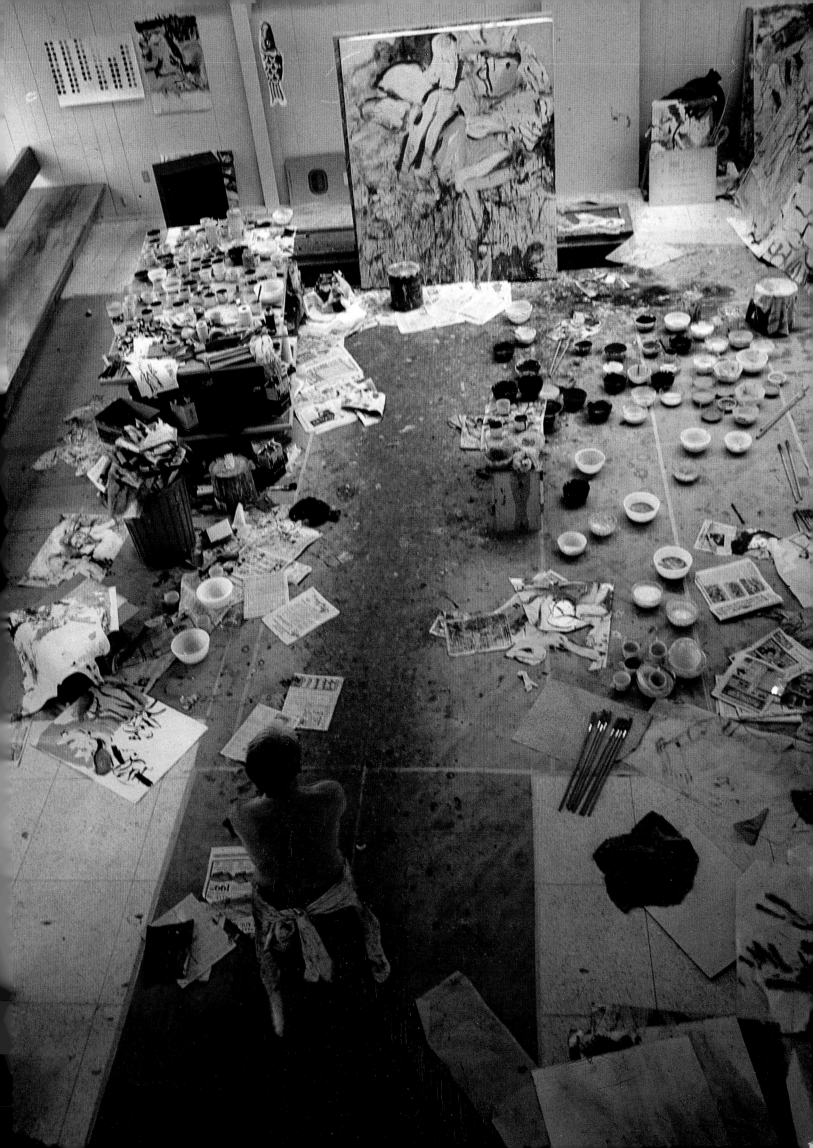

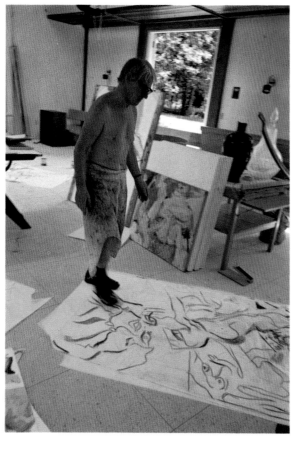

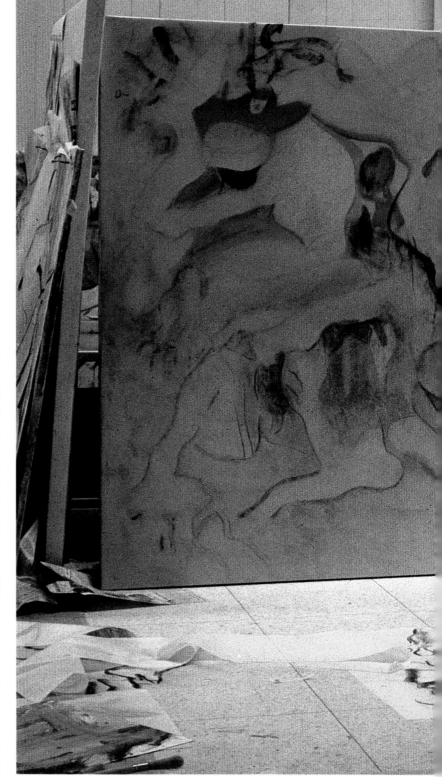

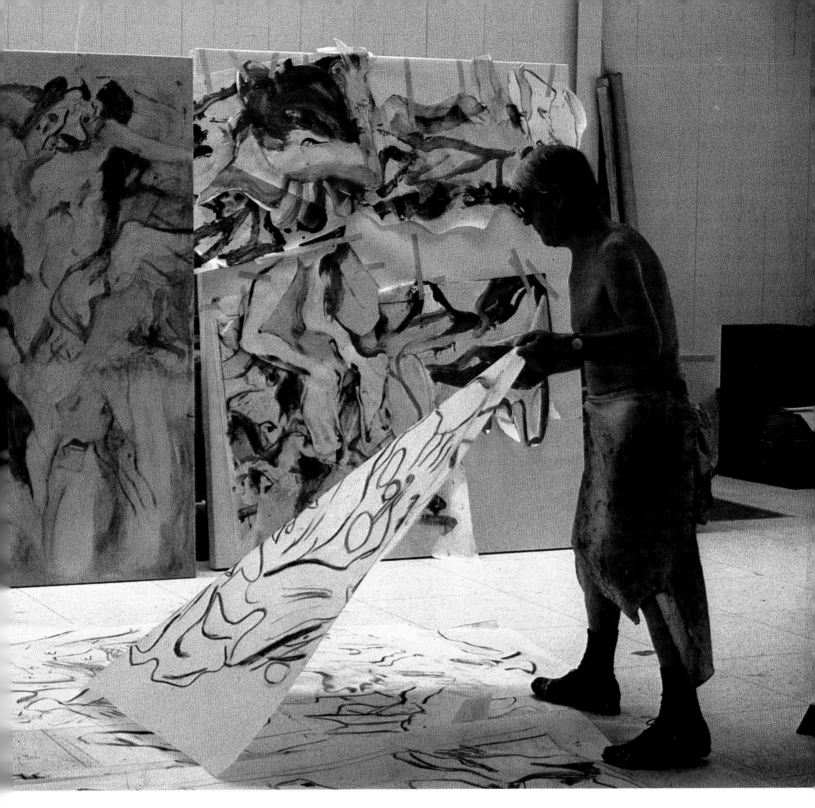

Studio, East Hampton, 1964.

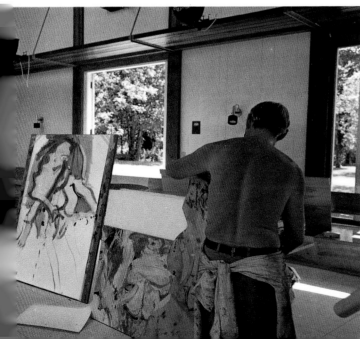

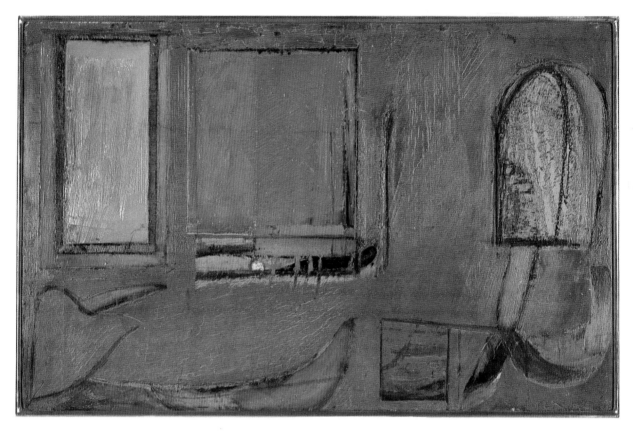

Top: Untitled: oil and charcoal
on paper, mounted on composition board,
13½″ x 21¼″, c. 1944 (M/M Lee
V. Eastman). Left: *Seated Man*:
oil on canvas, 38″ x 34″,
c. 1939 (Collection of the artist).
Above: Portrait of a
woman, unnamed, c. 1940. Right:
Woman I: oil on canvas, 76″ x 58″,
1950–52 (Museum of Modern Art).

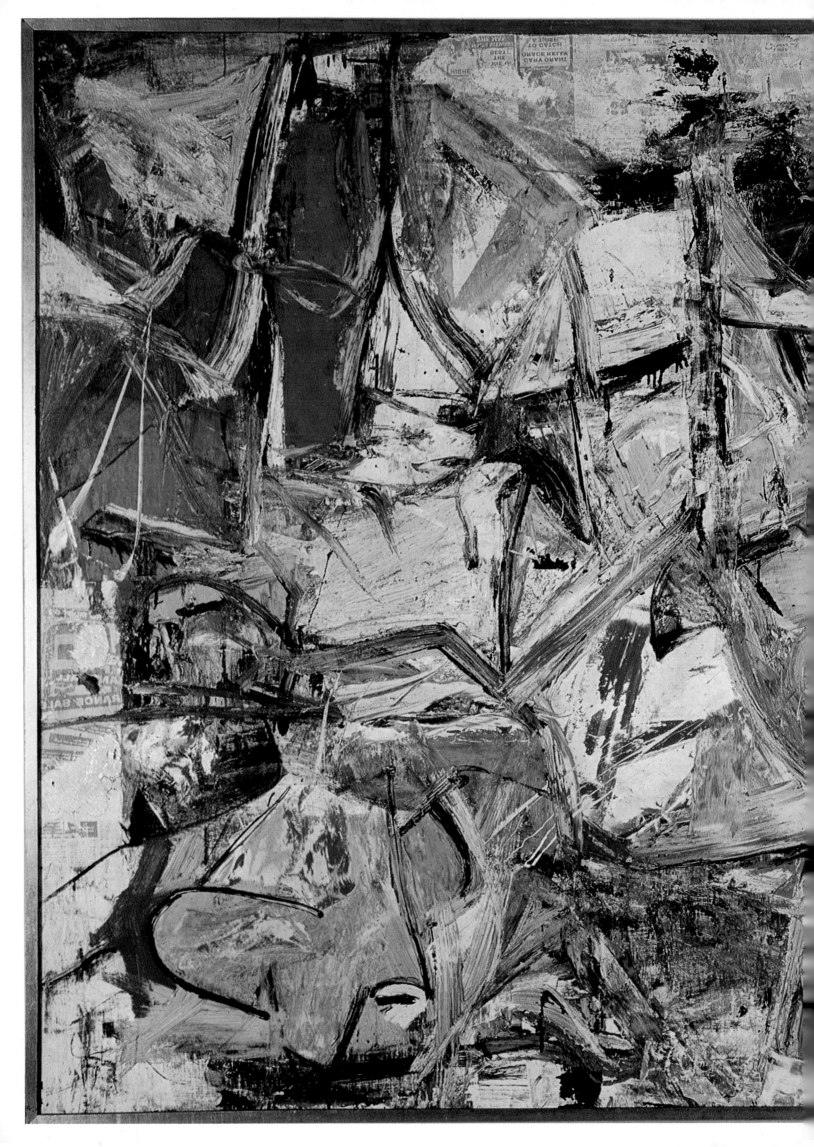

Gotham News: oil on canvas,
69″ x 79″, c. 1955
(Albert-Knox Art Gallery. Gift of
Seymour H. Knox). Above: Detail.

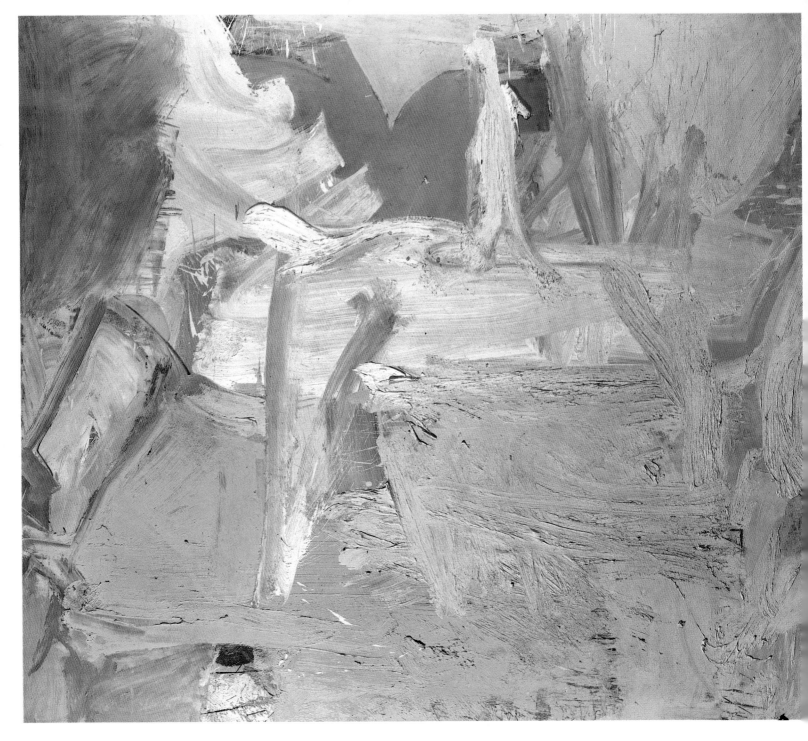

Pastorale: oil on canvas, 70″ x 80″, 1963 (Thomas B. Hess).

tion of phony scales and measurements is a mark of sixties art. It seems to show a rage for measurement, but is in fact the residue of a vanishing anthropomorphism. The reintroduction of perspective in the mid-sixties also had to do with a missing figure. Conventions of measurement and perspective actually stood in for the figure. At the same time, they were turned into a subject as neutral as Cubism's guitars. Perspective, then, which does not locate anything, and measurement, which does not measure anything (except occasionally its own inability to measure), had an ambiguous content in the sixties. They contained a memory of a figure, but at the same time redefined the nature of that figure, which was both artist and spectator. One of the themes of the sixties, however, was the gradual replacement of this idea of measurement with the grid. The grid in turn reintroduces ideas of spatialized time. But the figure it implies was no longer a memory imprint from the Renaissance.

De Kooning's puzzlement about proportion introduces another theme. We have suggested how the parts have lost each other, and would not recognize their contiguous parts if these were restored to them. The body is thus like a watch that cannot be put together, and this introduces us to the naming of parts that was a concern of late fifties and early sixties art, especially of Johns and Rivers. The naming of parts, though it may mimic childlike simplicities, is of course a far from simple occupation. For it involves language and an object. Johns' attempts at this have an astute irony and a precise, if elusive, logic, reminiscent (inevitably, it seems) of Wittgenstein in the *Blue Book*. Rivers' namings have a euphoric humor composed of a not unattractive exhibitionism—a kind of hysteria that subsumes the role of "being an artist." After Rivers, Johns, Rauschenberg, and Dine, parts replace wholes. Abstract-Expressionist Man, an attempt at an impossible definition, disappears.

But just as the Mannerists included—one way or another—High-Renaissance Man in their art, Abstract-Expressionist Man survived in various fragments and disguises in the art of the late fifties and sixties. De Kooning was a Mannerist artist trying to get back into the High Renaissance. The artists after him were more purely mannered. De Kooning used contradiction as a tool with which he hoped to get rid of contradiction. Succeeding art rejected the synthetic assumption hidden in this.

One of the worst things Orwell could think of for Newspeak was that it should ask an audience to believe contrary matters as equally true. De Kooning always maintained, if not the hope of a synthesis, at least a regret at its impossibility. In this he is very much an artist formed in the thirties working in the forties and fifties. Once that hope is abandoned, so is dialectics. Johns' dry and precise contradictory notations were anticipated by Magritte. Magritte's contradictions are a kind of connoisseurship of absurdity. Johns' are not absurd, for they signify the extinction of contradiction as a dialectical tool. Johns' contradictions are perfectly tolerated, so the possibility of dialectics disappears. Gaps and intervals become simply gaps and intervals. Contradiction becomes a form of play, and art subverting itself (along with the very word "subversion") became a sixties cliché. It was a permutational decade. For once the hope or regret of synthesis is abandoned, the parts, separated by neutral intervals, become parts in another sense. They become roles that can be played or switched. Feelings lose their rhetoric but roles discover theirs. We are consoled with an interesting, if fashion-mongering superficiality.

Clement Greenberg wrote that if de Kooning's ambitions were realized he would forestall the past as well as destroy the future. Actually, this has occurred in caricatured fashion. For the fractured anthropomorphic image de Kooning projected on history was also projected onto the future—only it was broken up into parts that have forgotten the projectionist. De Kooning's ambitions were realized not in the school he fathered in the fifties, but in the art of the sixties. De Kooning, however, is the victim of the history he so repeatedly invoked. For his own children do not believe he existed. This brings us to our final theme: de Kooning's nostalgia for the future, the Utopianism which is his version of

the American Dream; and his regret for the past, which is his dream of history. But for a man who spatializes time, these get confused with each other, so we shall deal with them as one.

VII

Now you have to pay for the folly of wanting it, just as I had to pay for the folly of making it.
—Mark Rothko to a collector

Anyone who has seen de Kooning painting will have noticed he often puts a lot of time into one part. The artist at work is a fetish of modernism. Instead of an artist painting a picture, we have a picture painting a mythic artist. This confuses the simple act of looking at someone working on a picture. If we remove the expectations the myth creates, all we see is a man stuck on something, a man who has lost his freedom. Instead of the myth "de Kooning," we see a puzzled biped. Instead of a mythology of "action," we notice certain things happening.

The sight of this creature painting one corner over and over makes us curious to know what is going on there. If we examine the matter closely, it seems that one stroke is being repeated—the same stroke, or one very close to it. Maybe the biped does not know it's the same stroke. Or maybe he can know it is only by repeating it. Here the possibility of an infinite regression opens up. Such regressions are a form of imprisonment (as well as a form of vanishing point), but what is imprisoned, among other things, is a terror of change. This is produced by, and produces, a wish to control it. That very wish masks a desire for change, a desire to escape. For each stroke, as much as being a reconfirmation of the old, wants to be completely new—that is, unrelated to the previous stroke. Yet this can only be confirmed by the previous stroke. Exact repetition perfectly renews each moment even though it is a fake newness. So such fragments of a de Kooning contain a nascent Warhol. For Warhol's soup cans solve the problem of the new by completely forgetting a past which was

exactly similar. Warhol repeats himself and is thus new. De Kooning tries to escape from the past and is thus tied to it.

If we further examine this de Kooning fragment (still from the mid-fifties), we find epigrams and puns in terms of painting itself, and quotations from the past. We find confusions about space and time experienced very lucidly. So the sight of de Kooning stuck in one corner is like watching a blind man. He can't—as far as we can see—tell one stroke from another, itself an exaggeration of not being able to tell one part from another, or one picture, or one period. For he sees history in terms of space, all of it simultaneous and contemporary. He paints on a canvas identified with the space of history. So now we have some idea of what de Kooning is doing in that corner. He is engaged in the absurd task of painting European art over again. He is putting periods, movements, centuries into a fragment. This is an appallingly near-sighted view of history—the view of a person for whom all history has turned into space and for whom space keeps turning into time, and who doesn't know, or chooses not to know, the difference. Paradoxically, this is a characteristic of the most ambitious and gifted, and it leads to repetition. Who could be more narrow than Michelangelo?

Why should anyone want to paint European art over again? Perhaps to make sure it exists. Perhaps to compete with it. Perhaps to correct it. This absurd ambition cannot be mocked, for the artist has mocked it already; laughter is an intrinsic part of de Kooning's work. From this absurdity we go on to de Kooning's periods, little histories within the larger idea of History, and to the only thing that would fit a person for the tasks he has undertaken—that confidence or ignorance that refuses to learn from the past, in a word, innocence. But innocence and laughter are mutually exclusive. They cannot engage in a dialectic, except by accident, when each fails to recognize the other. They appear and disappear in the work like different physiognomies.

Periods exist, however, even in a fragment of a de Kooning. (Indeed, all his work is a fragment of something else, so his sketches, which admit that, are more

complete than "finished" work.) So we can say that his periods, though strung out in time, may appear simultaneous. In this way his periods begin to present a fake idea of periods, just as his pictures finally are imitations of pictures. Is this very periodicity, then, something he thought about in relation to the idea of mastery, and specifically in relation to Picasso? The idea of periods has been corrupted into the idea of progress, of avant-gardism in little. Each new period is "ahead" of the last. In this sense periods are a kind of striptease, each approaching some finality, the artist's "naked self." Perhaps, when the last thing comes off, there's nothing there. In this area Picasso's voice and myth were deeply confused. His periods were predominantly a way of wiping out, so that he could start again. But his periods, assimilated by myth, became a kind of reassuring clock on which to tell the cultural time. Picasso's final period, his final striptease act, was of course his death. De Kooning's periods are a more limited adaption of Picasso's example. If masters have periods, the idea of mastery is approached through parody, a parody careful not to destroy but to license that approach. De Kooning's "periods" are more truly oscillations.

There is an oscillation between abstraction and the figure; between all-over and focused space; between varieties of relative confusion and varieties of relative calm; between, finally, opacity and invisibility. There are also remarkably consistent themes—a persistence of certain habits and flourishes on the one hand and certain strategies on the other. We may also point to two persistent motifs: a woman, and an elbow-like brushstroke. And to certain moods: irritation and humor. And finally to a color: pink. And the ambition, however dissembled or cancelled, that tries to include all these, so that they can all be treated equally, like the spaces in which they are set. These, by and large, are what his "periods" take place against.

In talking about periods, however, one is assuming they can be distinguished. If one tells a new period, presumably from looking at the old, this is a form of retroactive imprisonment for the artist. An amusing essay can be written on this matter of periods. De Kooning, however, has partly written it, since his periods are first-class delusions. He has had his identity and eaten it, too. Let us enunciate the litany of de Kooning's accepted periods:

—Early Picassoid, with many Miró-Ingres variations. This often resulted in an exquisite hysteria—the pictures are falsely held together.

—The famous black-and-white paintings shown in 1948. Cubism is flattened into a kind of drawing with lines. An impetus is given to the lines so that the idea of movement enters, and with it the implication that space is being mobilized for some alternative purpose. Space begins to escape the lines, and thus has the possibility of describing them as much as the other way round. Space and line are made clearly ambiguous, that is, figure and ground. Black and white, of course, aid this.

—The flattened, jigsaw spaces (late forties, early fifties) are a kind of all-over Cubism expressed in a brusque shorthand. The paintings (*Asheville, Excavation*) are landscapes with figures in that all show a distinct compression of motif toward the top—that is, they have a right side up. *Excavation*, with its grasshopper strokes, is a kind of mercurial puzzle of slipping fragments.

—The Women reappear again. Systems are developed by means of a formal and metaphorical multivalence of parts—puns between ideas of form and content. A surfeit of such references introduces the possibility of paralysis.

—At the same time, and increasingly, the *Gotham News* period of the mid-fifties. Pictures are painted on top of one another, ambition and dreams of history are incorporated, and the idea of time as a form most clearly emerges.

—For a brief time brushstrokes enlarge and compositions have a cousinship with Kline's. There are traces of irritation, pockets of painting done over and over, but this is disappearing.

—The neo-Revlon period of the later fifties. Large brushstrokes simply coexist side by side. Ideas of movement are codified in terms of speed, direction, sprays,

and sudden halts, etc. This suggests obvious ideas of process which were misunderstood both by artists and critics. What really suggests it is a new interest in the compression of time—whether it is possible to eliminate all the gaps by a disguise of instantaneity, so that the strokes simply stay side by side. The "process" idea could have been corrected by just looking at the falsity of these pictures. Their colors are highly artificial, variations of pink become a major theme. Pink is reminiscent of maquillage. These works appear fleshy, but they are really cosmetic, consciously false. This implies that the rhetoric of brushstrokes is not to be believed. Pastel colors are flirtatious and psychologically are associated with ambiguity. Highly vulnerable to misuse, these pictures were, inevitably, raped.

—The rococo of the sixties, with the predominant theme of Women again, but this time ludicrous goo-goo-eyed creatures, often coming in pairs. The tones are higher, the values closer, figures and landscape interpenetrate. The brush slips and twists instead of developing magisterial tundras and sprays.

Many of these divisions are not divisions at all, since they shade into one another, or proceed concurrently, or are new ways of handling old themes. But cutting through all these divisions, false or not, is an approach to and a withdrawal from a climax—that *Gotham News* period of the mid-fifties. It is as if that climax called up a further tower of ambition, and the art, transfixed by it, could not proceed except by the pretense of unimportance. The informality of the work since then, as Harold Rosenberg pointed out, has been read as a decline. This myth contains a truth and distorts it. Though there has been a withdrawal from omnipotence, this withdrawal has a theme, a theme very much of its time, the sixties.

The sixties pictures are fragmentary, with few exceptions. The strokes are laid down side by side and areas of color do not disappear behind each other. Colors are high in saturation and closely valued. The pictures' flatness is accentuated by the frequently close values. A thin tissue of paint seems to have been rapidly wiped across the canvas. *Pastorale* (1963) is not a typical picture but it shows the idea. It also approaches invisibility. The instantaneity is another convention of time, as artificial as that of the mid-fifties. But instead of the picture being strung out in time, and hopefully obtaining its unity from this, it is now compressed into one instant. The gaps between strokes are not exaggerated, they are compressed.

If we compare *Gotham News* and, say, *Pastorale*, there is a reversal of method. In the earlier picture we discovered a chaos which the parts struggled to eliminate by a convention of extended time that constituted an appeal to history. In the later picture we see a single mood, a promise of unity. But when we look into it the parts still don't go together. Yet if matters are instantaneous the parts *must* stay together. There is an escape from history here. De Kooning, one might say, has discovered the present.

This aspiration clearly is contained in the earlier struggles with history, with reversible futures and pasts. It is signified even by subject and style, which in de Kooning's work we can consider as components of structure. The figure in these sixties paintings is a kind of Barbie-doll caricature of a fertility figure. Timelessness (instantaneity) is indicated by this icon, and it is introduced into the least demanding of histories, the rococo. It is a rococo that also signifies an escape from the artist's own past, for it parodies his own baroque period. So the escape is not complete.

Instantaneity is the structural idea against which these later fragments define themselves—just as the early work defined itself against Cubism, or rather a Cubist jigsaw cut and spliced into history. Instead of accumulating picture on top of picture, in the manner of *Gotham News*, the later pictures are dealt off one by one. Since they inflect the same theme again and again, their family resemblance is strong. The idea enters that he may not be trying to paint different pictures, but to paint the same picture, again a way of eliminating history. The bystander now has the problem of superimposing the images. This is clearer in the drawings, very puzzling fragments when seen individually. Each one of them avoids a figure, giving just a few inadequate

notations. A flip-book of these drawings might provide a glimpse of the figure they are avoiding. In this sense the drawings comment on the practices of the past and are footnotes to de Kooning's own history.

The more successful this convention of instantaneity, the more history disappears. Ambition becomes more prudent and imitates humility. And as ambition is suppressed, humor increases. There is a history of laughter in de Kooning's work, and in these works the laughter is very peculiar. "Laughter," said Baudelaire, "comes from the idea of one's own superiority." But if one has given up that idea laughter becomes unnecessary. If it continues, it is as one sees it in these sixties paintings—a gallery of giggles. Perhaps they indicate a relief from past ambitions and a recovery of innocence. This brings us back full cycle. For innocence is connected with wiping out the past and turning an optimistic face to the future. It is connected with that dream that allowed de Kooning to fulfill his career under the disguise of failure.

Emerson wrote that the New World was made up of the party of Hope and the party of Memory. One is Utopian, the other Dystopian. The party of Hope is continually reborn in every immigrant. Whatever happens to him is unremarkable because it *should*. In avant-garde circles in Europe this idea was associated with Whitman. The expansive illusion of freedom does away with the past, for one is starting again. Yet the past the immigrant brings with him is projected into the future, for he can only define his expectations in terms of this past. It undergoes odd transformations, since the immigrant forgets he's brought it.

One can tentatively identify Whitman's anthropomorphic self-image spread across the future with de Kooning's art spread across history, across the past. The two can be superimposed without too much difficulty, although one is whole and the other, a century later, has suffered large losses. Every immigrant for a time thinks he is discovering America. Eventually he finds out he has discovered Europe idealized in terms of his own expectation. If the future is shaped by this memory, the past is resuscitated by this optimism. De Kooning discovered an idea of Europe that could only be experienced or discovered in America. He has always confused Hope and Memory, optimism and regret, history and a dream. He has confused them because he has so often used each to cancel the other—a way of making them interchangeable. No wonder an art caught in such a cat's cradle of illusions is itself a supreme fiction. In this fiction voice and myth are liable to confusion also. No wonder when we look at de Kooning's work we are impressed, above all, with its folly.

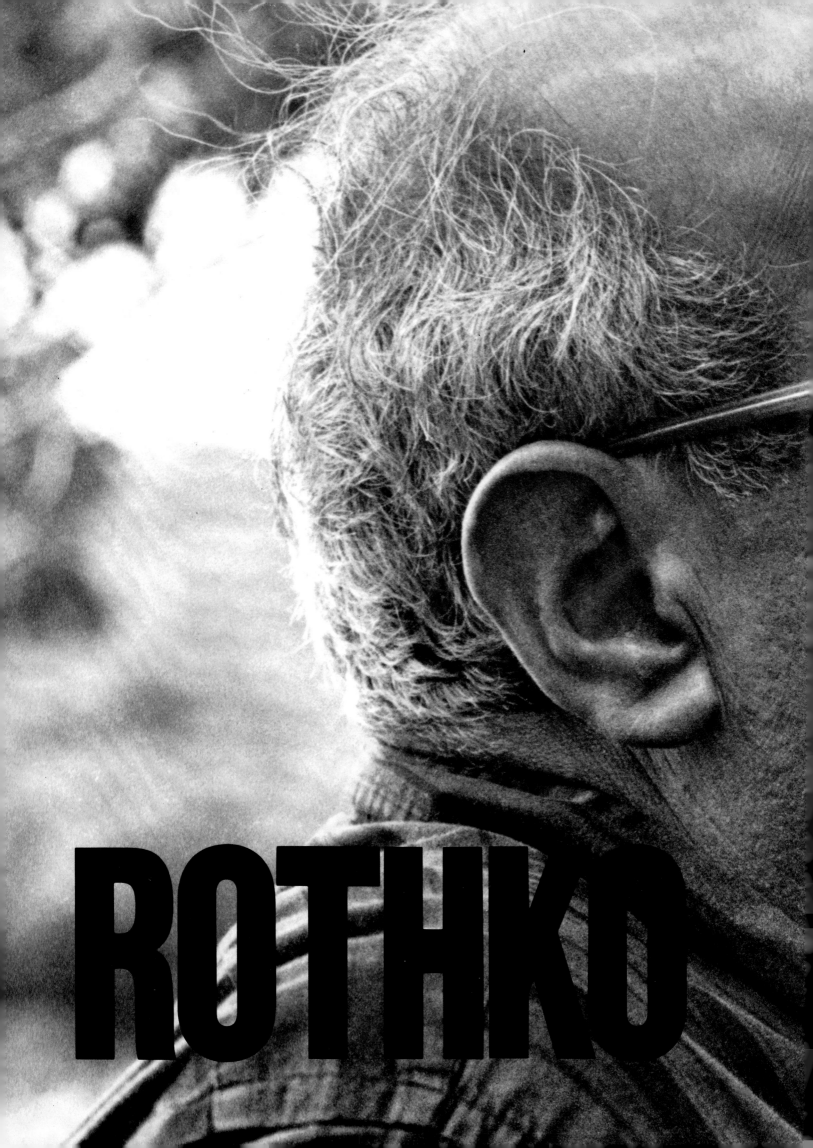

ROTHKO

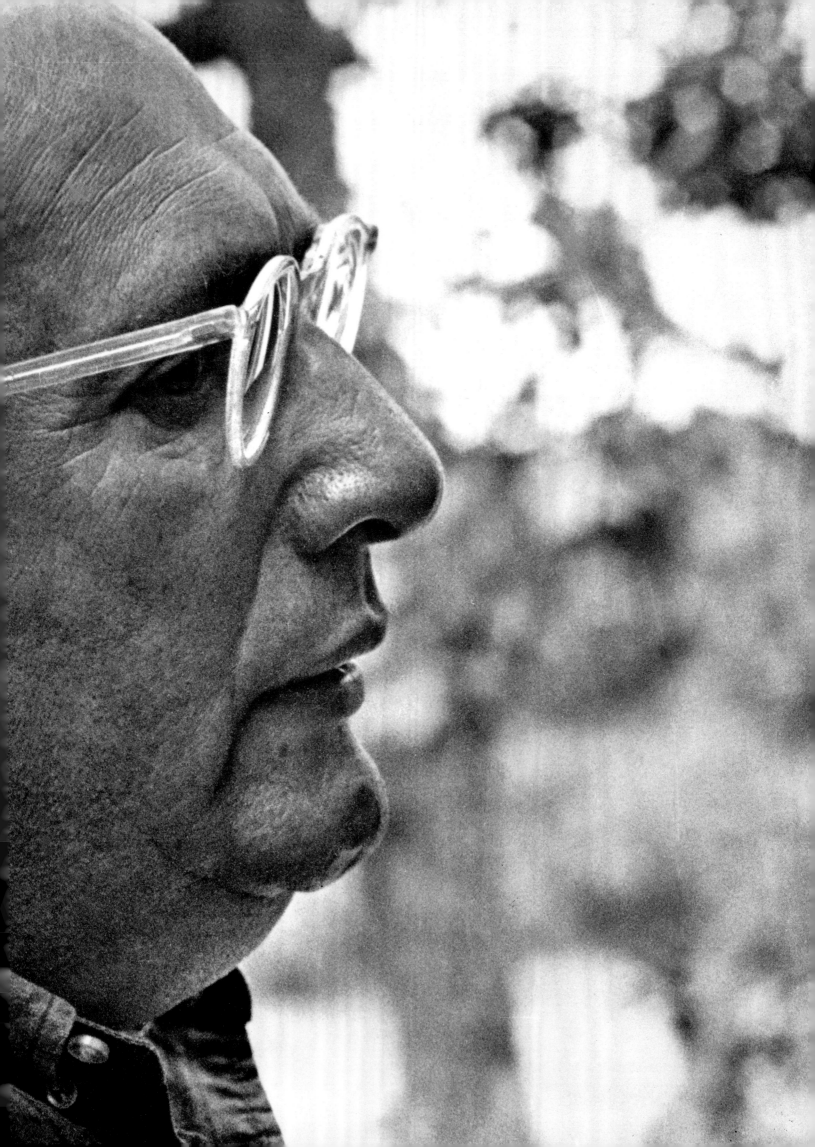

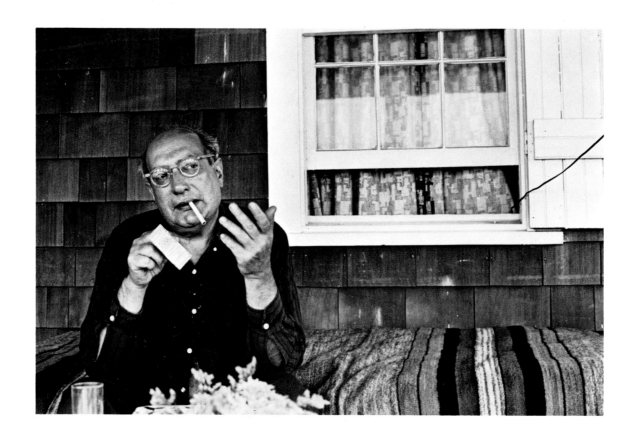

Mark Rothko: The Tragic and the Transcendental

I became a painter because I wanted to raise painting to the level of poignancy of music and poetry.
 ——Mark Rothko

I

Jean Richepin wrote a short story about a writer whose first work, a poem, was so overwhelming that his friends thought it should be at least a novel or a play. For years he revised and expanded it, returning to his circle for advice and reassurance, until his life was consumed and the unfinished work had become mythical. Finally, he pared off thousands of words, refining and refining, until on his deathbed he had reduced his life's work to a single word. But he died before he could utter it to the friends bending over him. If one could have heard it, one might perfectly understand Rothko's art—at the point where art becomes alchemy and criticism gives way to perfect apprehension.

Can we imagine a civilization in which language has vanished except for one word, where no one has a face until this word inscribes it? Rothko's art utters a single word, insistently. But everyone hears a different word. The civilization works perfectly until someone tries to describe the word, to separate it from its functions. This is where a community ends and modernism begins. "Recollection by painting of its own particular means" was the way George Rivière put it about the Impressionists in 1877. Art now describes itself, the word explains the word, idealism is transferred into a tautological universe. And modernism must continue until it exposes its own tautologies and phantom futures.

Rothko's art comes out of modernism, but it is not at home there, nor is it in postmodernism. Scrupulous and erudite as his means are, his work rests uncomfortably within the category of art as currently defined. There is, one senses from these numinous surfaces, an urgent nostalgia for another time or place—so much so, indeed, that one often wishes to escape from his pictures, so that one can remember them instead. Using

art to deny art is, of course, an orthodox modernist habit. But however equivocal his means, Rothko was without irony. His work denies art, not for the purposes of making more of it, but to be something else. What is the evidence for this?

The most cursory glance at the Rothko literature reveals two responses. Most of the writers see the work through the literature of their own feelings. Mystical and dramatic images occur frequently. They have projected an extravisual universe and are in the interesting state of being exalted and blind. I think this response bears witness to the persuasiveness of Rothko's muted rhetoric, that voice confined to a single word, mood, color. These writers are perhaps Rothko's proper audience, for they have forgotten art.

For this they are despised by the second group, which takes the clear view that Rothko was an artist and that what he did is obviously art. They explicate his formal emancipations, his debts to others and to history. They are not blind, but rather deaf to the voice in the work. The two groups are roughly equivalent to nature and culture. Since it is both art and "something else," Rothko's work encourages this split, a split experienced deeply in the sixties. One leads to an anthropology of art, the other to an aesthetic. These two incompatible audiences join in admiration for Rothko's work, which extends to them the dialectic on which his absolutism—that single and infinitely mutable word previously mentioned—is based.

This absolutism returns us to the most convincing locus of Rothko's art—the beginnings of Romanticism. Writing about a picture by Caspar David Friedrich, Erich Heller called him Romantic, not for his theme, "but because of the opposites that come together in it; the vital and the abstract, an appetite of the soul and a geometrical design, the intimation of a dream and the submission to rational order, an ecstacy and a definition." This applies more to Rothko. Romanticism—and avant-gardism—persisted longest in the visual arts. And at its end an artist occurs who can paint the pictures Schelling and Hegel could intimate but not visualize. Hegel foresaw the obsolescence of the imagination and

of art, unless, as Heller puts it, "it miraculously rises above historical necessity and creates 'out of its own pure self' something which he [Hegel] called 'absolute art.' " Is Rothko the artist Hegel was describing?

He continues the paradoxes which Romanticism, in its beginnings, experienced with clarity. Rothko's two audiences embody these paradoxes. One, which has forgotten itself, writes obscure poetry. The other, which remembers itself, writes lucid prose. These audiences represent the breakdown of what Rothko put together: the poetic and the analytic, the imaginative and the rational, the transcendent and the historical, alternatives of which early Romanticism was very conscious. Which of the audiences would Rothko have chosen? Obviously neither. To understand his art we have to recognize its true audience—and it may be very small. By various strategies, Rothko smuggled this idea of an audience into his work, derived perhaps from his urgent social concerns of the thirties and having to do with that "something else," outside of formal modernist concerns, that gives his work spiritual as well as physical scale. The "something else" is too positive to be a void, too negative to be a substance. We can call it mystery or enigma.

We can trace the breakdown of enigma from Gothick distancing ("the mystery of mystery"), into Romantic exhaustion, effete diabolisms, and then its redefinition in the arc from symbolism to Surrealism, where it again breaks down and becomes an appropriate cosmetic, "a touch of mystery." This is the mystery Rothko inherited from Surrealism and restored to its Romantic beginnings through brilliant formal solutions. But what is the status of "mystery" at present? Since the essence of mystery is that it is indescribable, a category that refutes itself, what is indescribable now? To that, one must answer—nothing. When the imagination becomes a rational faculty (when fantasies become, no matter how indirectly, practically attainable), enigmas become banal—that is, a category, a subject for language. Genuine enigma tends to destroy language, leaving us again perhaps with that single mutable word. When contradictions become tolerable this word, this

absolutism, unable to find any purchase on itself, reveals its conventional nature by relapsing back into its chaotic parts, into a tower of Babel. The opposites that sustained it may not be opposites at all. Hierarchies of value are replaced by permutational ingenuities, commitment is replaced by distance and irony, the fifties by the sixties. Dialectical energies can only be sustained when incompatibilities are urgently experienced as a problem. Thus Rothko's art, which once seemed a perfect interfusion of mind and nature, could be revealed as artificial, idealistic, unnecessary. That is, Rothko, like others of his generation, so successfully used dialectics that he eliminated them, opening up the landscapes into which he was unable to advance.

There is a large paradox here. Rothko desired to fuse absolute consciousness with the imagination, and so eliminate both (and the need for art). In doing so, a particular Romantic—and nineteenth-century—theme is fulfilled: the quest, the search for knowledge that is the opposite of another nineteenth-century concern—the void. But in Rothko the quest—that idealistic clarification of hope—was undertaken with the modernist implements that have engineered that void. Thus his enigma is checked by the very means that produce it, the probity of his art is undercut by a metaphysical yearning. Poised between magic and the rational, between myth and history, his work cannot do without either and is unable to relieve itself with either. Its urgent sensualities may be connected to this dilemma. And the relentless subtlety of his equivocations produces a certain dynamism that erodes his absolutism as well as maintains it. Whatever is stated is immediately revoked, everything encloses its opposite and so refutes it. Emotionally, this produces a certain calm *and* bafflement, a transcendence partly experienced through rage. Whoever said we are calm in front of a Rothko? Don't we frequently suffer an irritation not lessened by the fact that we are forced to experience what we think we are free to reject—to be guilty when we deny the possibility of guilt?

All this is connected to certain technical devices in Rothko's art. We have an aesthetic armory mimicking

an ethical journey. So what have we described? We have re-experienced the quest, a quest presented, as I have said, in terms of the void. Traditionally, the fulfillment of the quest results in death or transformation, and what is asked here is the death of the spectator. This, of course, completes what we have been describing—the tragic experience, but without a drama. And that tragedy, insisted on so gently and so firmly, is enacted by a single person in front of the picture, the figure which, as he said years ago, his art couldn't represent without mutilation and loss. This figure experiences much more than the transcendental calm usually assigned to Rothko's audience. For the figure, if one reads the voice in Rothko's work correctly, is a particular kind of man—ethical, sensual, guilty, aching for transcendence and aware of its illusory nature, a man forced to imagine his reason and to rationally invent his imagination, a figure in fact that stands for the myth of the tragic, whose shadow falls across a certain music. Its precedents are not in art, which may be why Rothko rejected painting as a self-supporting category.

Yet the figure that stands in front of Rothko's work is, if not obsolete, severely threatened. Its history is in the past. Many of Rothko's works are about the possibility of escaping from this figure, since he was the kind of artist who wanted to be relieved of his own vision. The tragedy of the tragic, however, is now its obsolescence. Yet Rothko's work seeks this figure, interrogating each member of the audience. It is frankly conspiratorial. There is a nostalgia in Rothko's art for a man who, he said, may not be allowed to exist in the future—private, intimate, moral, transcendental. Rothko's real audience has always seemed to be such a man, a number of such men, who do not know each other, but who form a society, communicating, though they hardly know it, through that mutable word with which we began.

We have described the epitome of Romanticism, which, like tragedy, witnesses its own demise. Rothko's art, then, may become a sign in the face of a dumbness it is unable to relieve. In this Rothko was the last Romantic. But the last of something is usually the first of something else.

II

If he was the last Romantic, his hoax was to convince us he was the first artist. If one can successfully deny the history of art, then one's art is unique; in fact, it may be impossible to call it art at all. Can we imagine a single work of art—Matisse's *Red Studio*, Picasso's *Three Musicians*—without a history of modernism? What an archaeology of perception it would create. And what would a painting by Rothko, deprived of history, create? Everything but the means would be visible. Indeed, Rothko's camouflage of the means has to do with his antagonism to modernist history. Once the means were connected with modernism they entered into academic pastures, into the delusions of the explicable.

The means are concealed in a Rothko by the predominance of effect over evidence: By an exact disproportion, a calculated impossibility which becomes identified with the enigma in the work of Rothko. (As he said himself, "It [the effect] often happens in the last few minutes"—in proper alchemical fashion.) Rothko's means are like the purloined letter. They lie there, the source of the entire search, and we cannot see them. The instantaneity of their effect also helps mislay them. No art that I know of presses this so far. To have to depend on what you wish to eliminate, to be forced to love what you despise: What else is this but the absolutist's rage against the dialectic that enables him to transcend dialectics? (It is also the sensualist's rage against being forced to transcend sensuality.) In this his pictures literally *represent* Rothko's quest. In 1951, he wrote, like Delacroix, of his desire directly to transfer his idea to another, with the elimination of all impediments. No wonder such an art often produces an effect of exalted irritation. There is regret that art should be there at all; one might succeed better if one could do without it, so he who cannot communicate dreams of the perfect communication. Again we are returned to that single word through which a hypothetical community might conduct its

transactions.

This conflict also illustrates another aspect of Rothko's irritation—an irritation at the result of his own quest. It often mimics the void. For Rothko's enigma, like Schelling's "absolute point of indifference," was really very blank. Maybe the disparity between evidence and effect can result in less rather than more. Maybe the mystery of a Rothko doesn't exist until we fill it up. It is only a convincing fiction. Thus one can fall into the fallacies of naming it, of reinscribing on one's own face, which has been wiped blank, the signature of one's incomprehension.

"The result of my life is simply nothing, a mood, a single color. My result is like the painting of the artist who has to paint a picture of the Israelites crossing the Red Sea. To this end he painted the whole wall red, explaining that the Israelites had already crossed over, and that the Egyptians were drowned." So Kierkegaard, describing the confusion of the quest with the void, the enigma with the disappearance of content, the sensuous with the symbolic. His artist asked for an act of faith, and so does Rothko. But what has passed through Rothko's art? That whole history that we cannot see, or can see only with difficulty: the history of the means, a mythology, and an atmosphere. This atmosphere has, as Robert Goldwater pointed out, a definite history. In Rothko's art, it consumes what is suspended in it and becomes itself a subject, a theme, a form.

His early "Magic Vessels" (1945-47) are part of the Surrealist theme in American art about the mid-forties. Baziotes, Stamos, Gottlieb, Pousette-Dart, among others, articulate and suspend their forms in this atmosphere. The forms themselves—a plethora of the organic—inscribe certain mythological concerns. They have to do with germination (the virtuosity of the biological), suggestiveness and mystery (metaphorical virtuosity), and above all language (the virtuosity of signs). These concerns imprisoned a generation in an associational paralysis (as if everything had to be remembered), and so directed them toward their emancipation (by performing radical surgery on this undergrowth, and

searching for the sign or style that would summarize "all"). A theme of the late forties and early fifties was how each artist absorbed this apparatus into his later style.

Among the themes that enacted themselves in this atmosphere, or more truly medium, was the dissociation of shape and line, of color and shape—something Gorky already was clarifying. Another was the way pictographic and anthropomorphic references were arranged. Somewhat arbitrarily scattered through this sustaining medium, they were approximated rather than composed (in distinction to the boxed-in compositions of Gottlieb and Pousette-Dart functioning as primitive grids). The example of Miró must have been instructive. For this surrounding medium is a translation of Surrealism's protozoic "garden," usually described as subaqueous. The medium is more buoyant than air. It is an ether in which the forms manifest the undulations of currents and arbitrarily realize their specific gravities.

But this in turn is but a further translation of a painterly dream that goes back to Giorgione. It intensifies a romantic atmosphere that, in the nineteenth century, appears and disappears like an apparition—never apparently an overt concern, but actually a major theme of the century. It occurs to different minds with nothing else in common, ignoring styles, geography, decades. One can see it in Caspar David Friedrich, in Turneresque effusions ("He stole from me," said Rothko, at the Turner exhibition at the Museum of Modern Art), and in Whistlerian fogs. By the end of the century it is a common academic theme. Why the ubiquity of this specific physiognomy, no matter how disguised? Surely it is a desire for a new freedom from pictorial law, a transcendence poetically rather than formally desired.

For this atmosphere demands its own autonomy. Objects in it are seen by proxy. Rollin Crampton and Pousette-Dart reduced the objects in this ether almost to invisibility—the clearer to see what obscured them. Such was the energy the forties introduced into the Surrealist garden, displacing the comforts of "poetry." The logical result would be a blank canvas—a perfect medium—that would be full, an absence that would be

rich. A quest could possibly be realized through a void, and modernism could solve one of the nineteenth century's dreams. Attesting to this, before the sixties, is the sporadic history of the monochrome canvas. The monochromes of the sixties came from another impulse.

What would we see if this perfect medium had realized itself? Not just a poetic effusion, but a formal idea. The mythologies that have disappeared inside this space (like the Israelites of Kierkegaard's artist) bespeak concealment, but concealment and revelation are actually superimposed, introducing us to the rhetoric of the void. (At the end of the nineteenth century, the common image for this was "the veil.") From this space the idea of "mysticism" is summarily extruded as an intolerable form of content. The recurrent titles of the forties—*Presence, Icon*—would be exchanged for a presence, a present.

Deprived of such "mythologies," our space might signify the possibility of a myth without a myth—a consciousness brought forth in a particular kind of time, which, as Schelling put it, "is indivisible by nature and absolutely identical, which therefore, whatever duration can be imputed to it, can only be regarded as a moment, that is, as time in which the end is like the beginning and the beginning is like the end, a kind of eternity because it is itself not a sequence of time, but only One Time, which is not in itself an objective time." Much forties' art attempted to describe this space, this time, which, if successful, would have displaced avant-gardism and its tyrannical idea of progress and, indeed, art, too, thus consummating modernism's flirtation with mythology and religion.

But again, how are we to describe—and recognize—such a space? This space is, as we said, derived from mythologies that have disappeared after undergoing a series of metaphorical transposals. The end of metaphor, the ultimate metaphor, is one that finally has transposed itself into nothing, but a nothing on which everything is superimposed. On such a surface, which "remembers" everything, any inflection will have immense effect, "composition" will tend to decompose itself, and color will declare itself as D'Annunzio

described it, "light in potency, light buried in translucent substance." What Schelling called the "lights and colors, incorporeal and, in a certain degree, spiritual means" of painting become profoundly ambiguous, since that metaphorical transposition now resides in the means. These means will tend to mimic each other's roles, thus switching from establishing relationships to presentation. For the absolute to maintain itself, the means, paradoxically, must lose all idealism. The predominance of effect over evidence is a sign of their mutability.

Rothko's Surrealist paintings of the forties study such equivocations. The half-translucent forms, brushed and stained lightly into the surface, partake of the atmosphere around them. The lines describe the forms with a certain reluctance, as if they wished to float away and scribble on the general atmosphere, which indeed they frequently do. The lines recall certain histories: the whiplash and spidery wheels—Surrealism; some of those that curve and turn on themselves—Gorky. Generally the lines and puffs of color are arranged in linear fashion across the canvas. A consistent motif is a horizontal zone against which the forms are established. Sometimes it is simply a darkness above and a lightness below, or vice versa. More often there are three zones and two horizons. Gradually, in 1948-49, these come forward, uniting with the puffs of color to make areas that at first echo the morphology of the Surrealist forms. At a certain point these shapes become maplike in their contiguities, staying together because that's the way they were put. (Maps are full of the impertinence of the arbitrary.) These pictures tend to be buffered from the edges of the canvas by crowdings of form and subtle framing devices. There is a lot of rubbing and brushing together of forms, jostlings across edges, all frankly organic and sensuous (a mode Carl Holty investigated later). A particular mood is being sought in which color describes form—though form is hardly allowed to describe color. Thus their synthetic Cubist nature is disguised.

For the implications of synthetic Cubism are met in a color-and-light situation that militates against this

possibility. We seem to know, looking at these "color islands," what is in front and what is behind. But if we look closely, we are not sure. Each of the shapes can come forward or go back—there is great virtuosity in tone and across edges, even though the painting of the edges is not particularly mysterious. They adhere to a plane and yet are free to leave it in either direction. What happens depends on the perceptual prejudice of the moment. "Composition" becomes something of an illusion derived from proximity. Yet undoubtedly the theme of these pictures is a search for a "composition" that produces an *effect* that will distract from the composition. Nor can we say that any of these shapes is without weight. In an instant, depending on a perceptual fix, one of them may appear to weigh a ton. The *density* of the picture is extremely labile. It can appear like a sheath, and then break up into pockets and bumps of light. The space, in fact, is very close to that etheric potential already described, in which perceptions mutate with changes of mood. All that can hold the picture together is an intention, an act of will. Anyway, these pictures have an urgency that submerges delectation—perhaps because they are located in the etheric space which fuses the formal and the psychological in one motif; or perhaps because they are pictures in search of that composition, eventually formed by the adhesion of smaller into larger pieces, until rectangles finally displace all particulations.

The well-known *No. 22, 1950*, illustrates much of this. The large rectangle above is discreetly framed from the edges of the canvas. It is interrupted by a window-sill shape at the top, so it is not a pure rectangle. The bottom rectangle is framed more definitely by lighted edges. The long rectangle between the two major ones is not merely background; its edges are contained enough to give it an autonomy of shape. Within it is a peculiar motif: three stretched-out lines, touching very gently at their centers. This is a Surrealist recollection, a device denoting the space as atmospheric, bringing it forward on a level with those above and below. These lines signify the dilemma of the horizon—the zone between. After this the lines disappear completely.

Color alone transacts the business of coercing dialectical instabilities into the penumbra of an absolute idea.

It would be easy enough to take every one of Rothko's means and show its paradoxical status: the surface, the forms within, the edges of the shapes, the edges of the canvas, scale. This paradoxicality allows us to glimpse the intention that defines these means according to an absolute idea. According to Schelling, it is inseparable from the attainment of the absolute—the point of indifference where "anything can become anything." Historically, such paradoxicality attends the fulfillment of idealism, but also points toward its end. The Romantic self, and the Romantic will, disappear into the flat landscape of paradox, into provisional responses to a continual emergency for which there is no answer, and ultimately no question, so that it becomes banal. The emblems of the quest are released to describe the cartography of the void.

Take one of these means: the edges of Rothko's pictures. Since he painted around the edges of the stretcher, the entire canvas was emphasized and became its own frame—that is, an object. The surface is continuous around the edges. When Seurat painted over his frames there was a kind of wit in operation, making the frame an intermediate zone between canvas and wall, floating and flattening the canvas further. Rothko's device, while reminding us that the canvas has edges, lessens the tension on them. The tension is further relieved by the way the edges are blurred by the internal rectangles.

Why all this blurring of edges? Because it serves an environmental ambition, an ambition of sentiment. Once in Rothko's studio I saw a green monochrome canvas, even, velvety, immediately declarative. (Such monochromes underlie all Rothko's tonal paintings, further evidence of that atmosphere mentioned previously.) The edges of this monochrome were so unequivocally present it made a patch of green advancing firmly toward the eye. After some time, the relational paradox of monochrome painting began to assert itself. It became less of a painting and more of a concept with an exact dimension, relating to whatever was around.

Eventually this patch of green became a limited space in an environment from which one would have to banish everything to recover its impact.

Proust is supposed to have said he didn't understand Turner's pictures until he saw Ruskin looking at them. In his studio early one evening, Rothko was staring at one of his Chapel pictures. The work kept changing and the mild edges, though visible in the difficult light, hardly seemed to contain the painting. An effect of diffusion occurred, much as Turner's fogs appear to spill over the edges. I remembered that in exhibitions Rothko's work is usually "badly lit." Then I realized this was intentional. Rothko wanted his atmosphere to diffuse itself over the surroundings, *to become Nature*, like Magritte's landscapes on an easel continuing into a "real" landscape.

If his canvas became nature, what did Rothko, or any other watcher, become? One is reminded of another figure, back toward us, absorbed in the effects of nature. The history of attitudes to nature in the nineteenth century is the history of that figure, who licenses our entry into the picture, whose back makes us conscious of our own. It is as if the figures disposed through the eighteenth-century landscape had come together as one, to commune with a nature of which it had just become conscious. That figure is no longer a part of nature. It stands as immobile in a Courbet as in a Friedrich, a point of focus for one great idea. Surely this figure represents mind—mind separated from nature so that, in the epitome of the Romantic idea, it may be reabsorbed and interfused with it.

That figure is not to be confused with another nineteenth-century figure: the artist representing himself painting at his easel before the view. By painting himself painting the view, the view becomes both nature and art fused through the offices of this surrogate. That figure stands for a process of apprehension, most clearly, perhaps, for the medium. Toward the end of the century that figure—the artist—disappears into the medium, is replaced by touch and color and process. The figure representing mind also disappears. Its remnants of idealism join with the medium to fill the void caused by its departure, and thus initiate the proper history of modernism, rehearsing Romanticism in terms suitably transposed. How does this apply to Rothko? Under certain conditions of light his art mimics Nature. (Indeed, it is easy to see in Rothko what the nineteenth century painted: mists and colors, iodine horizons, banks of purple cloud, egg-shell yellows, and greens.) Before this nature the spectator is reminiscent of a figure for which Rothko had the highest regard and regrets, a "picture of the single human figure—alone in a moment of utter immobility," which he could not, however, directly include in his own art. Before Rothko's "nature," this figure, representing mind, is taken up and loses himself.

Beyond this transcendentalism lies the territory first noted by Robert Rosenblum with respect to Rothko, Newman, and Still—the sublime. To achieve the sublime and the transcendental, Rothko accepted whatever generosities the atmosphere offered. Newman, in contrast, insisted on the probity of his means, their clear rationality, while at the same time claiming a sublimity he would appear to have made inaccessible. Still lays more direct claim to sublimity by the rhetoric of his forms, which clearly derive from nature. Their corniness is imprinted with often ugly force, as if the will could not bear to suffer the prudence to advance itself successfully. This is clear from the way their pictures hang on the wall. Rothko's are half-submerged by the light they gather and offer. Newman's hang evenly and exactly in place. Still's, mobilized by flanges of color that approach the edges and "go around" them, seem to resent the wall, and in another rhetorical gesture are forced forward. How differently the sublime is approached! Rothko approaches it through a dream, Newman through lucidity, Still through hysteria. When the Houston Chapel pictures were in Rothko's studio, the sublime aspect of his art was obviously illustrated on one occasion. The sun suddenly streamed through the cupola on the roof (his studio was an old fire station), past the screen (operated by pulleys and ropes) which shaded out direct light, and solidified the atmosphere in front of the pictures. Its abrupt changes

masked and unmasked the paintings in a literal display of sublimity. One thought of nature and mind, of the pictures, and of Rothko standing away from them.

But although these huge dark pictures are among the most transcendental he painted, they resist the sublimity then thrust onto them. For the key to the Chapel pictures lies in a rhetorical coup which Rothko accomplished by raising the middle of the three touching panels in the two triptychs. This is a Christian and tragic gesture, giving the triptychs a subject they would not otherwise have. This subject is echoed in monochrome canvases nearby. They absorb attention, mark a pause, and relate one's contemplation to the rest of the pictures around. By such phases and pauses the ensemble effect is carefully handled. The edges of these canvases are more assertive than usual and, in a reversal of Rothko's usual procedure, emphasize the edges of the huge rectangles within. These edges, though sharply linear, are so subdued that they serve, like the habitual softer edges, to separate zones rather than advance themselves. The surfaces vary in their opacity. They contain stretches of what can only be called the indefinite—a dimension that must be there for effect, but which of itself seems unmotivated. Within this atmospheric opacity a certain amount of turbulence or process can be divined. The amount allotted to each individual canvas varies, but generally it is more subdued than usual. The raised central panels of the triptychs introduce the idea of tragedy. The process, with its obvious strokes, hesitations, and repaintings, introduces the idea of fallibility.

A human dimension, coaxed into the area of the tragic by means of a rhetorical gesture, seems to be part of the Chapel's theme. But this is at odds with the transcendental impulse. For the two figures we postulated in front of a Rothko, the tragic spectator and the transcendental watcher, are opposed. One seeks to remember himself and his history. The other is forced to forget. Yet both, by dialectical necessity, must coincide. We have a situation that can be neither fully transcended nor fully realized as tragic. The medium then, to paraphrase Randall Jarrell, is half transcendence and half tragedy, and cannot fulfill either. (To apply Oriental ideas to Rothko is to ignore this Faustian insistence.) So Rothko's pictures locate themselves between mind and medium, between mind and nature, between nature and art. There's a vagueness about such categories that gives an illusion of release to that immobile figure that sought to end the paralysis of "silence and solitude" by "breathing and stretching one's arms again" (Rothko).

There is no doubt that the tragic, the sensual, and the transcendental were the three categories of Rothko's difficulty. When one or the other predominated it did so at its peril. The work negotiates an equivocation among all three. This raises the idea of a tragedy that isn't tragic, a sensuality that isn't sensual, and a transcendence that doesn't transcend. In this equivocation there is the possibility of an immense vagueness willed into order by what can be described as a frontality, or a "stare."

III

Delacroix made "vagueness" a category in a dictionary he once planned. In his mind vagueness was connected with declining light, atmosphere, and the sublime. "Painting is vaguer than poetry," he wrote, "in spite of the definite appearance it presents to the eyes." When Delacroix made that remark in 1857, vagueness was a romantic cliché. Delacroix wasn't concerned with this. He connected the vague with an effect sometimes produced by the sketchy and incomplete, more often by certain lights. We have touched on this before, since that previously described atmosphere is a kind of vagueness. The vagueness I am referring to is not a category, but escapes categories—that is, it escapes attention.

There are oceans of vagueness in Rothko's later large works, particularly in the Chapel pictures. It takes an effort to see them. Effect predominates. As one approaches a surface, particularly a dark one, areas simply covered with paint, rather than painted, appear. They are neither pure atmosphere nor painterly process —neither transcendence nor fallibility. They may shine with unabsorbed oil, or be flecked with knots of can-

vas and contain "mistakes"—meaningless strokes that should disturb the effect and don't. These areas are sometimes casually painted with a brush so large that the stroke goes unnoticed, introducing the idea of a random and organic vagueness only distantly acquainted with intention. Perhaps there is a kind of ratio between these areas and the effect of Rothko's pictures. We have trouble seeing this vagueness because of the predominance of effect. We also have difficulty seeing it because it's so obvious. The vague is merely a phenomenon of attention—or, more precisely, the lack of it. Once attention is drawn to it we realize that Rothko's expanses of colored canvas are somehow the lack of necessity made necessary. Which brings us to the idea of scale.

Rothko's canvases, as he said himself, must be large to achieve intimacy. Small pictures, unless they contain illusory distances, are simply little slices of flatness. Large sizes, when flat, expand until they pass beyond human scale and reduce the figure to a spectator. Abstract Expressionism was the first modernist occasion when size consistently became as much a material as paint. The idea of "stretching one's arms" in front of a canvas turns up in artists' talk. Thus the size of the canvas became a surrogate for the figure—the figure banished by the imperatives of abstraction, with some degree of residual guilt. This guilt is one of the forces acting on the spectator, who is summoned to stand in for the missing figure. De Kooning's figure is a fiction made up of different durations and scales. Kline's is Gulliver-like, subject to sudden enlargement and shrinkage. Still's is small and awestruck, the Grand Canyon observer.

In the sixties, size ranged easily from gigantism to minuteness. If size was necessary to make a point, it was made. Scale was used polemically. One of the earliest polemical exercises in scale was Barnett Newman's extraordinary *The Wild*, which pressed categories beyond the point of paradox. A canvas a few inches wide and seven feet long is no longer a canvas, it becomes sculptural. The edges, ostensibly there to define a surface, are now defined by it. The painting on the surface becomes an absurdly extended activity. Deprived of relationships, it becomes an idea, indeed an inspiration.

After many years, Newman's narrow strip paintings, part polemic, part gesture, part absurdity, calmly assert the idea of preposterous scale as radical material. The strip paintings are formally cheeky, almost insulting. Yet they are infused with a stubborn and ridiculous passion. The logical Q.E.D. of the preposterous, the consolidation of what appears to be caprice, is one of Newman's major themes. The vertical line off-center in *Jericho* is a typical witticism, a typical bit of cheek, and wit, after all, is the paradoxical proof of the arbitrary. Then the wit is subjected to scrupulous imperatives. This combination of wit and declarative bluntness, of humor and a cool surface, can be seen as a definition of elegance. Elegance of this kind, like some sorts of dandification, gives conviction to the preposterous. The confused reactions, enthusiasms, and resentments of the avant-garde audience to Newman's work come from this. What then are we to think of the "figure" in front of Newman's work? Is there a figure there at all? Hardly, in the sense of his generation's anthropomorphism. What is there is a combination of the primitive and the dandy, a figure that knows it is preposterous, but is just as sure the rest of the world is in error. Thus, the way Newman redefined art became an intense polemical force.

Rothko's figure, however, set at an exact human scale, and suffering the distraction between the tragic and the transcendental, has a paradigm in the picture. Or more truly, a physiognomy, a face. In the nineteenth century there was an intense desire to "read" the face, to decipher, as Schopenhauer put it, its hieroglyphic, "an alphabet that we carry around in us already perfected." This nineteenth-century passion fulfilled itself in the one art the twentieth century invented: the movies. The expansion of a face into a continent revealed to us a new geography. As faces fill the screen, recognition becomes a matter of memory. A remembered gestalt is projected on features now being released into the area of the vague. In this magnified vagueness

the fractional movement of an eye, a change in the tone of the mouth, or the inclination of a brow has an immediate impact on the whole flattened screen in which the face becomes identified with the surface.

Surely this was part of the enigma of Garbo's face. Her vertical forehead, the architecture of eye-orbits and nose, made up an unmistakable gestalt, recognized as one no matter how rotated or foreshortened. Yet that face, seen close up, especially through the shimmer of filters, had a curious nondescriptness. Neutral spaces opened up between mouth and eye, between the eye and the eyebrow above it. As the head turned it revealed pockets of nothingness, which, however, tended to disappear as that remembered gestalt—"Garbo"—was projected on it. Thus the audience "saw" her face most clearly when they could not really have seen it at all. What they saw was a vagueness that, fixed by the gestalt of her structure, made up an enigma. Perhaps this vagueness *was* Garbo, for it made the frozen icon of her face equally remote and intimate.

The magnetism of the close-up may be related to the intimacies of love, when the lover's face is similarly enlarged, its edges lost. A few inches apart, eyes look into eyes, but aren't aware they perceive. Both are intensely aware of each moment, yet have forgotten time. Afterward, no real image remains. There is an intimation of a glance or stare, and a feeling. Features are not remembered, only the sense of a perfect regard, an intimacy (within the convention of romantic love) deeper than physical exertions. This brings us easily to the language of the mystics and to the durable conceit of the "face of God," presumably the ultimate stare. After their transports, the mystics have difficulty describing what they have seen. The intensity of the experience forestalls memory. They are left with a vague image and an intense conviction.

Rothko's work, with its frontality, scale, and anthropomorphic regard, may not be unconnected to this mode of perception. When looking at a Rothko we are partially blind. Effect obscures evidence. Subsequently, however, the experience is different. One can recall the work better than one can see it when it is present. Between actual confrontation and recall there is a continual flow of energy, which leads us further into the mutual qualifications of vagueness and the "stare," and into a poetics of recall that might bear investigation.

Is there an iconography of the "stare"? Can a rectangle have a stare? Surely anything blank and frontal can have a stare—the Boscoreale frescos at the Metropolitan (which Rothko used to visit), a blank movie screen, a wall—provided they are seen frontally. In Abstract Expressionism there was a strong urge toward black-and-white contrasts on the one hand, and on the other, toward a surface unrelieved by incident. Just before Pollock's all-over surface declared itself in 1948 one remembers those eyes that appeared and disappeared in his paint. Were these a literal illustration of the "stare"?

But if we are to elaborate some iconography of the stare, we must first look to the Byzantine, the transcendental stare, its declarative impact mitigated by the mosaic surface which inflects the light. Not too far from this is the rigid stare of primitive art, another form of frontality. Both the Byzantine and the primitive tend to fix the spectator in a single place, undefined by perspective, that already has a spiritual status.

European art, too, is full of looks and glances, and their formal impact has been neglected. Just as the contrapposto stance buckled frontality and allowed easy circulating relationships, so glances are a kind of contrapposto in attention, indicating other planes. Glances within groups dispose these planes. They are a form of perspective on top of perspective. Glances that meet the spectator's eye tend to re-establish the surface. One extraordinary Renaissance stare combines the humanistic and the Byzantine: Piero della Francesca's *Christ Rising from the Tomb*. But more relevant is a glance that has some of this iconic power while seeming to dispose of it; a fallible glance that interacts with the surrounding vagueness from which it receives much of its eloquence. This is the glance in Rembrandt's late self-portraits. Extended comparisons could be made between the atmospheric vagueness of some of these portraits

and Rothko's atmosphere, between golden lights and indeterminately brushed surfaces. Need we go further to find precedents for the frontality in Rothko's art? The Byzantine stare and the Rembrandtian glance, the superimposition of the transcendental and the humane, mediated by a vagueness that is elusive and difficult to perceive. One is hard, the other atmospheric. Both, when united, bespeak a particular kind of frontality and effect.

Frontality is established absolutely when the surface holds absolutely. It conjures up the image of the static viewer, with no opportunity to go sideways. There is a kind of kinesthetic determinism here, established through perception rather than any association. (This can be produced by almost anything frontal and extended, and is a raw material with which the artist begins.) This immobility introduces the idea that perfect frontality is more one-dimensional than anything else. The dimensions of space collapse into a moment. This in turn depends on the amount of available surface, and the distance of the viewer from it. Edges are more important in denoting the limit of an area than as a self-assertive structural idea, and in this Rothko's work differs from color-field painting.

Much American painting of the sixties was devoted to a heraldic surface that made for sudden apprehension and easy recall. This declarative surface signified the end of modernist illusionism. (It also ended humanistic scale—that is, released the viewer from his singular position. Much color-field painting, for instance, lacks scale. Insensitively hung it can look like a postage stamp from a distance, or closer, like a blown-up reproduction.) Once declared, however, this surface emphasized the idea of objectness. For many this displaced the idea of painting completely, acknowledged by the sudden movement of painters to similarly declarative sculpture, to so-called minimalism.

Yet the idea of frontality is—and was—deeply persistent. Judd and Lewitt, for instance, are the purest exemplars, since they disdain irony as a mode of smuggling in certain literary intimations. Their work has a conceptual plane easily apprehended through the simple declarative structure. Braque spoke of searching for the rule that corrects the emotion. Lewitt may be looking for the perception that donates a concept, which in turn corrects the perception. This is the "plane" in conceptualism: a mental frontality, a particular kind of apprehension that, freed from actual space, is also free from illusion. This mental plane can accommodate what perspective cannot—the full apprehension of a three-dimensional idea in terms of two dimensions, without illusion.

This plane, a sizable discovery, persists through the protean scenarios of postminimal conceptualism. While fully exploited, it has also been abused by the usual proliferation of "good" ideas. Its somewhat equivocal location has made it vulnerable to change. For instance, it is easy to identify this plane with a page, with the conceptual documentation. Thus the passion for the photographic sequences (or non-sequences) spatially disposed, for the single page. This conceptual plane became literature on the one hand, and aspired toward a new conception of film on the other. From 1966 to mid-1969, the plane, like the Happenings of the early sixties, was poised between categories which it subsequently entered.

The frontality of Rothko's art stops and embraces us in a single action. The aspect of frontality, here called the "stare," can be identified with authority, will, and control. How is it modified? How is it that the work is not simply declarative and instantaneous, but hypnotic and sustained in its effect on the viewer? This brings us to the most mysterious question about Rothko's work: its atmosphere, light, and color.

How do these modify frontality and mobilize it as a material? Here again we confront those risky equivocations Rothko gave to his means. Rothko's atmosphere, or light, has the expected relationship to the surface. When the surface becomes atmospheric and enterable, the effect of frontality is relieved and sustained at a more elusive level. This atmosphere is produced by a variety of modes of painting. With Pollock, Rothko was probably the first to use a surface onto which paint had been stained or soaked as a formal device. As we have heard so often, this identification of paint and surface

reinforces the reality of the surface, but unless that weave is coarse enough, it becomes illusory and floating. The weave in Rothko's canvases is constant for all his pictures and codifies an idea of distance. The choice of weave was very deliberate, since Rothko's effects depend on fractional measurements and ratios. As he painted, the effect he was after often appeared only in the last few minutes before completion. The crepuscular atmosphere depends partly on the monochrome stain over white canvas, which underlined all his mature work until 1969. That velvety stain is already a form of atmosphere to be fixed or freed by subsequent working and overpainting. By working in and on an atmosphere, Rothko could neutralize it with vagueness, or fix it with varying degrees of perceptible process.

Rothko asserted the surface, then, by placing on it an abstracted reverie, complete with mistakes, pentimenti, vague intervals, and degrees of process. One of his commonest devices, clearly seen in the black paintings of 1969, is the opposition of "squares" of atmospheric indeterminacy and varying degrees of process, of blankness and brushstrokes. Rothko's "touch" used to be very studied, redolent of the painterly masters, particularly Rembrandt, whose brushstrokes Rothko said he had studied as a young painter. Eventually, in larger works, Rothko became confident enough to be careless about it. Some murals (those meant for The Four Seasons Restaurant) do not emphasize the atmospheric embrace. Flatter, more clearly edged, with little incident within, they remain paintings rather than experiences. That is, the effect doesn't dominate, which doesn't occur again in any consistent way until the dark paintings. Generally, the more effective earlier paintings were those approximating color in terms of value. Their slight optical fibrillation was carefully controlled. The contrast between the colors didn't break the plane, though leaving the possibility that one color or the other might come forward or retreat. (The optical potential of equal-value contrast between colors became an imperial force in New York painting in 1963. In exhibition after exhibition artists adjusted their colors and values to gain the immediate perceptual bonus.)

Thus the modality of color is subjected to the structural exigencies of, for instance, Matisse, whose *Red Studio* and *The Blue Window* must have instructed Rothko. As a bridge between Matisse and his own interests—how color could be quantified without being sharply edged or defined—Milton Avery, whom Rothko greatly admired, must have been useful, although Avery's most typical pictures were painted after Rothko's maturity.

The subtle inflections of Rothko's atmosphere have been well described by Max Kozloff in terms of organic intimacy: heats, exhalations, minimal frictions, and stirrings. The amount of atmosphere released is determined by the main compositional elements, the rectangles. The way they are "paragraphed" inflects mood and attention. Indefinite edges, which could be areas of focus, are not. It is often an effort to fix on them. They simply limit color and atmosphere without emphasizing shape. Yet that shape is sometimes gratuitously indicated by a stroke of another color at the edge of a rectangle—a "mistake" an imitator would never be guilty of. (Indeed, the painterly latitude Rothko's method allowed him gives further credence to the idea of the vague.) These pseudo-edges echo the frame and are reinforced by it. Reciprocally they duplicate and blur the edges of the canvas. The rectangles, then, are a form of frontality so discreetly stated that they relieve frontality, and their division of attention (their number) sustains attention. The vignette or ground around the margins is also vital in how the frontality is mobilized and modified. An apparently fixed and uniform structure provides opportunities for infinite inflection. Rothko's means are not so much reductive and singular as multiple and orchestral. With an almost tyrannical insistence, the pictures bear witness to an immense vagueness, an immense possibility. Under the disguise of a single motif, the paintings lay claim to a plurality of moods, moods without situations, except those they find in the viewer. (In this sense Rothko's paintings are unabashedly literary—nineteenth-century novels inviting the viewer to be the hero, his life the content; the viewer, in fact, to be his own mythologist. He once said, sounding a bit like Malevich, that his squares were

not squares but "all my feelings about life, about humanity.")

The paragraphing of rectangles also creates internal horizons and junctions. These might be expected to work as areas of high focus, but they deal equivocally with this expectation. They can be seen as a kind of internal junction between two pictures on the same canvas. Rothko midwifed this contiguity by degrees of separation (letting the ground do most of the work), by hazy overlap, by horizons that are a numinous memory of Surrealist filaments. Some of the best solutions occur when the junction is treated not so much with skill as declaratively. In the 1969 dark paintings it is almost contemptuously drawn. The emphasis is on the total image. Though colors "rub" together, the overall image is a single apprehension. From all this description one can harvest only a weak fact: All Rothko's means exist in an indeterminate area between categories. All qualities of a visual stimulus are mobilized out of their determinism and made accessible to almost any kind of projection. How does one really know what's going on in there? Yet this mobilization of means is requisite to any successful absolutism. Only then can an idea be impressed on a body of work, an idea intimated by scale, repetition, insistence, effect, and that extraordinary color and light. But Rothko was not a colorist in the sense that he was detained by its immediate properties. The color is after something else. Though it has been to school in modernism and is formally cogent, it is also light conceived as spiritual desire. Where do we go to find a light such as this, or a language to talk about it?

IV

Among the objects of perception, light is the one that arouses the greatest desire.

—Liber de intelligentiis

Enigma is inseparable from the history of light. Color and light, of course, as Mme. Cavé suggested, and Delacroix wrote in his notebook, should be thought of as one and the same. But why, of all phenomena, should light generate systems which it constantly destroys? Its perfect indifference arouses the acutest appetites. It thus caters to a complicated human need: to suffer exaltation and frustration simultaneously. Even Hegel in his aesthetics allowed light to escape his arbitrary categories. Though art would be supplanted by philosophy, he recognized the possibility of a light and color that would survive the destruction of painting, opening the way to a universe of subtle reflections in which the individual mind reveals and recognizes itself. These elusive fibrillations of light then constantly promise the eternal. Here is a trace of the obdurate rhetoric infused into light. An absolute, spoken of in terms of eternity, and a sensation, often spoken of in terms of time—this too is the rhetoric of Rothko's light and color.

It is also the theme of the medievalists who wrote on light. Their arbitrary inquiries can be seen as a form of primitive aesthetics concerned with perception, with formality and formlessness, intention and vagueness, with essence and effect. These are the questions that Rothko's light raises, but in a context that is not "aesthetic" but experiential. For Rothko's light, in its own way, declares the end of painting, and deprived of the context of art aspires to a community more poignantly than the work of any other artist of his generation.

Fundamental to the medieval idea is the notion of that which exists and is invisible, and that which is seen. Yet in medieval thinking (for which one depends on Wolfgang Schoene's explication of Clemens Baeumker's "The Metaphysics of Light in Antiquity and the Middle Ages") the spiritual and the physical are constantly obliterating each other into a primitive idea of process, into the capacity of light to outpour, reproduce, and regenerate itself. These metaphysical twins, essence and effect, inhabit a single word, light. Light arouses desire, a yearning. Through desire it creates its own end, some hopeful point of arrival. Both medieval and romantic light share this possibility of repose. Both are imprinted with an idealism revealed and frustrated through sensation. Such a light is highly literary and

abstract. It thus subjects the observer to the mutable delusions of his own mind, as does Rothko's light.

This situation tends to remove the idea of painting, of art, substituting instead "experience." Observer and viewer are enclosed in a single occasion and, as Meister Eckhart put it, "images are seen directly without the mediation of other images." Mythical, romantic, and medieval modes of perception intersect at that point where the spectator is assimilated and apprehends directly "without the mediation of other images." Rothko's light likewise bespeaks enigma, an enigma that spurs the individual mind (to quote Eckhart again) "to get into the secret, to which no man is privy, where it is satisfied by a Light whose unity is greater than its own. This core is a simple stillness, which is unmoved itself, but by whose immobility all things are moved. . . ." It is appropriate that Eckhart should have been rediscovered by the German Romantics who stimulated Rothko.

Rothko's light, like medieval light, has no location, no perspective. It lacks modeling and shadows. Its frequent darkness is a spiritual phenomenon. ("One really finds light best in the darkness"—Eckhart.) Its "desire" brings with it the imprint of an idea, signified in the frontality, fixity, and numinous quality of the light, which is held between form and formlessness. That light has a great range. It moves from more uniform, dark, and brushless surfaces, which have a conceptual toughness, to loose, fluffy surfaces of frank sensuality and "poetry." Rothko's light thus can tease, can lead on "desire" in a way that hovers between surface and pure light, between repose and yearning. In this process we can discern the furious equivocations of a will forced to dissemble to preserve itself. This is another point of contact between medieval and modernist thinking. Rothko's light, paragraphed in rectangles that augment rather than break the single image, contains both a hope and an impotence (further reflections of the tragic and transcendental figure spoken of before). Authority is necessarily disguised, so that it can be read only by the subtlest intimations. There is a desire to control an audience and the realization that to indulge it is to destroy the audience. Despite the intense, hypnotic quality of Rothko's light there is a kind of free will in the picture. The artist's role is like that of the god Rothko occasionally described—one who made the universe, then forgot about it and went on to make others; the abandoned inhabitants then invent a morality for their survival. Morality, rage, impotence, sensuality, free will, authority, transcendence—these are the qualities inherent in Rothko's light, all of them related to that yearning which creates its own fatal idealism.

There is no doubt the fascination of Rothko's light has to do with process. The inflections of stroke and surface constantly dimple the image. Light is processed, as it were, and attention held. But how does a unitary image emerge from the sets of rectangles? This was clarified when I saw Rothko listening to a piece of music he particularly enjoyed: Morton Feldman's "The Swallows of Salangan." Here a single note is held, is augmented by other voices, then others. The chord waxes and expands, like a huge breath drawn in and in—not dissimilar in effect to the radiance of Rothko's light. The additive voices do not introduce any idea of succession. They stabilize attention, keep it on a high wire as it were. We are not sure whether the piece goes on a long or a short time. There is, as with Rothko, a singular, powerful idea, and a delusion of process (the additional voices entering in). Afterward—and Rothko's pictures and Feldman's music have a persistent afterlife in the memory—there is nothing to remember except that expansion, that radiance. Thus Feldman achieves the illusion of a single note. By the addition of "lengths" of voices expanding and deluding the original note, the sound is continually infused with new attention. (Indeed, it is possible to see "Swallows" as a series of different "lengths" parallel to each other, and thus a bit Rothko-like in form.)

So "Swallows" fixes attention as hypnotically as Rothko's paintings. The paragraphed rectangles in Rothko's work have the same effect as the additional voices in "Swallows." The paragraphs—and the painterly inflections of process—sustain attention, where a monochrome canvas tends to lose it. They also force one to remember, but what one remembers is the same,

continually renewed—as in the Feldman. In this sense, both Rothko's and Feldman's processes give glimpses of instantaneity reached by very elusive modes of handling attention. The instantaneous idea is simply a convention by which attention is translated into yearning or desire, a yearning implicit in Rothko's light and Feldman's expanding sound.

The individual work then, continually renews attention through the friction of cultural and perceptual energies. Attention, however, may be transferred from work to work through an entire oeuvre, leading, as Max Kozloff suggests, to the idea of one picture or mood being replicated again and again.

The repetition haunts modernism and is its delusion and achievement. A narcissism inevitably develops through the imprint of a repeated style. Thus style in modernism is both a prison and a salvation, an emblem purchased through paradoxes of freedom. If modernism has any single complexion it is this: style as repetition, with all its attendant agonies of equivocation and doubt, its confusion of stasis and progress, of the predictable and the new. Repetition promises an escape from history but tends to confirm it. Repetition promises a release from self-consciousness but tends to reinvent it. No wonder modernism ends and postmodernism begins with repetition extended to boredom, and boredom brought to a state where history and self-consciousness disappear, a state with a non-content, a vacuum, a void. This is not modernism's void, which is sounded by a quest for spirit or a profound pessimism. It is a void and a repetition perfectly tolerated. Thus the idea of style is parodied and tends to disappear. Once recognized as the armature of modernism, it had no alternative.

In Rothko's work repetition affirms style, as modernism clarified it, but also escapes it. Can we speak of repetition in relation to his work? Is there one mood or many? Does that one mood contain the possibility of an escape from mood? That is, does repetition in Rothko's art find a way to destroy repetition? And by doing so allow the past to enter under the guise of recollection? And what is the consequence of this?

The medium of both repetition and recollection is time. Both are paradoxical in relation to time and the illusion of both is timelessness. Recollection continually translates the past into the future, where it can be safely re-experienced. Repetition is harder, more urgent. While both recollection and repetition depend on memory, memory functions very differently in each. Recollection is based on processes of recall. Repetition is based on the instant of recognition.

Recollection, as Kierkegaard says, "begins with the loss, hence it is secure, for it has nothing to lose." But what is lost in part is recollection itself. The pain of recollection, which is not too different from its pleasure, in part arises from a sense of what is being lost in the very process of recollection, the very process of clarification (this introduces us again to the idea of vagueness). Recollection trying to recollect itself is the process that makes pain inseparable from the substance of remembered images. Repetition, on the other hand, either confirms itself or loses itself, depending on recognition. If recognition fails, everything will be new. If it does not, everything will be confirmed, including the past and the future. This newness (Kierkegaard hasn't much time for it) is of great interest to the artist, since it promises freedom, the possibility of a break with the past. The artist is surprised that this exercise of freedom ends up with what he is forced to recognize as a repetition (when he looks at his previous work). What he recognizes is his own mode of imprisonment, whether it be called a motif, an appearance, or a style. Is painting the picture an attempt not to recognize these? Or at least defer recognition? Thus, within repetition as applied to modernism two forces intersect. The one easily remembers the future and so continues the past. The other forgets the past and so locates an impossible picture in the future. This brings into focus the strategies necessary to continue and the specters of two kinds of academicism—of the old and of the new. Modernism potentially offers us two extreme artists: one who repeats the same picture exactly day after day; and another, each of whose pictures is totally unrelated to any other.

(continued on page 185)

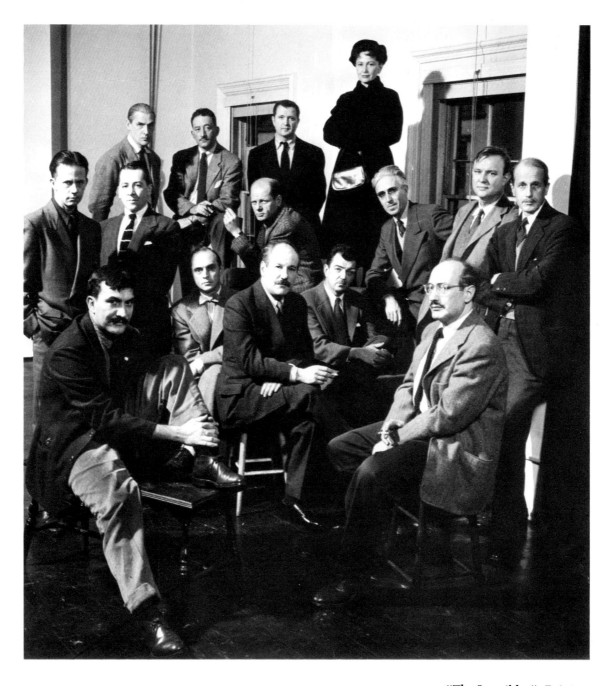

"The Irascibles": Painters
of the New York School, 1951. Back row,
left to right: Willem de Kooning,
Jimmy Ernst, Ad Reinhardt, Hedda Sterne.
Middle row: Richard Pousette-Dart,
William Baziotes, Jackson Pollock,
Clyfford Still, Robert Motherwell,
Bradley Walker Tomlin. Seated: Theodore
Stamos, Adolph Gottlieb, Barnett Newman,
James Brooks, Mark Rothko. (Photograph
by Nina Leen.) Right: New York City, 1964.

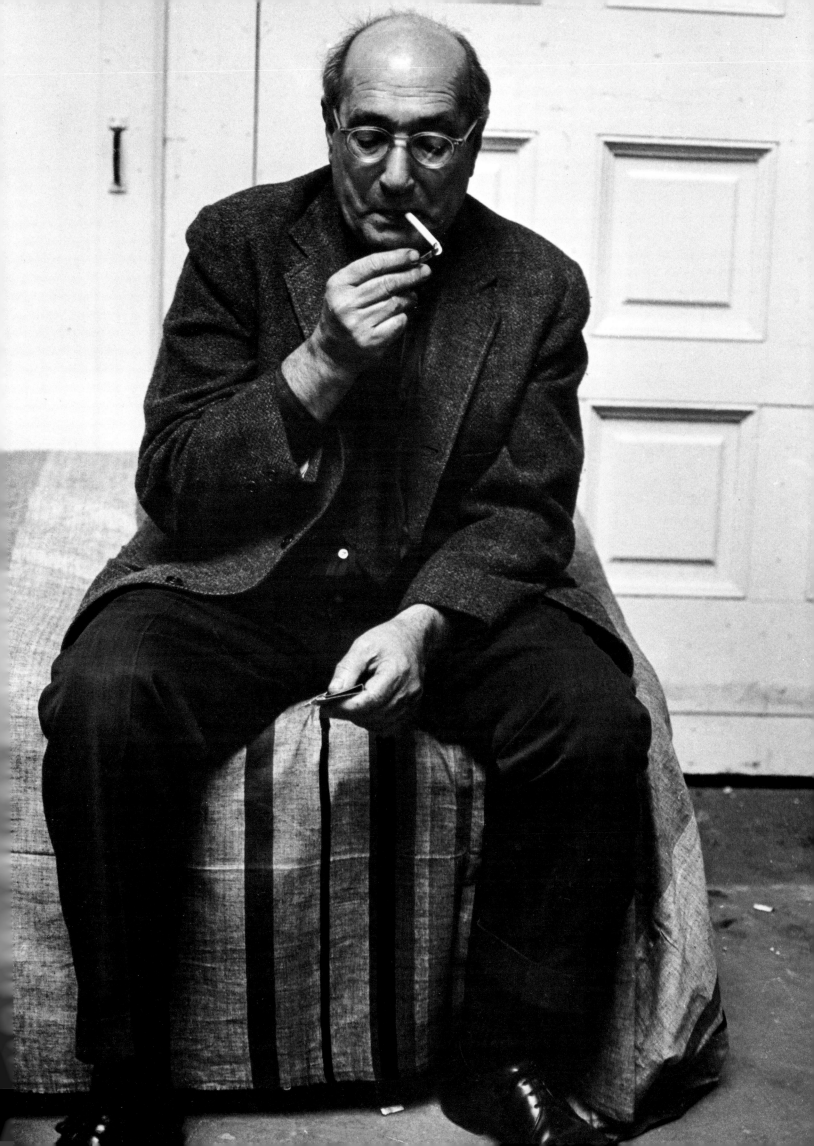

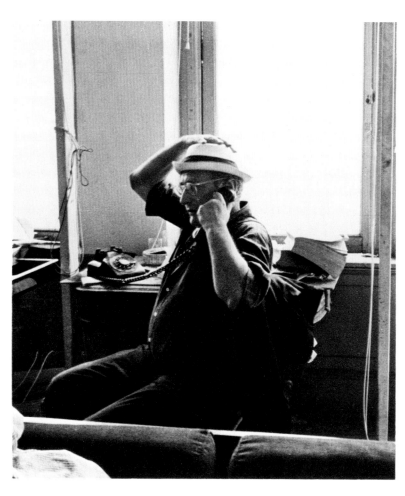

These pages and following four: New York City, 1964.

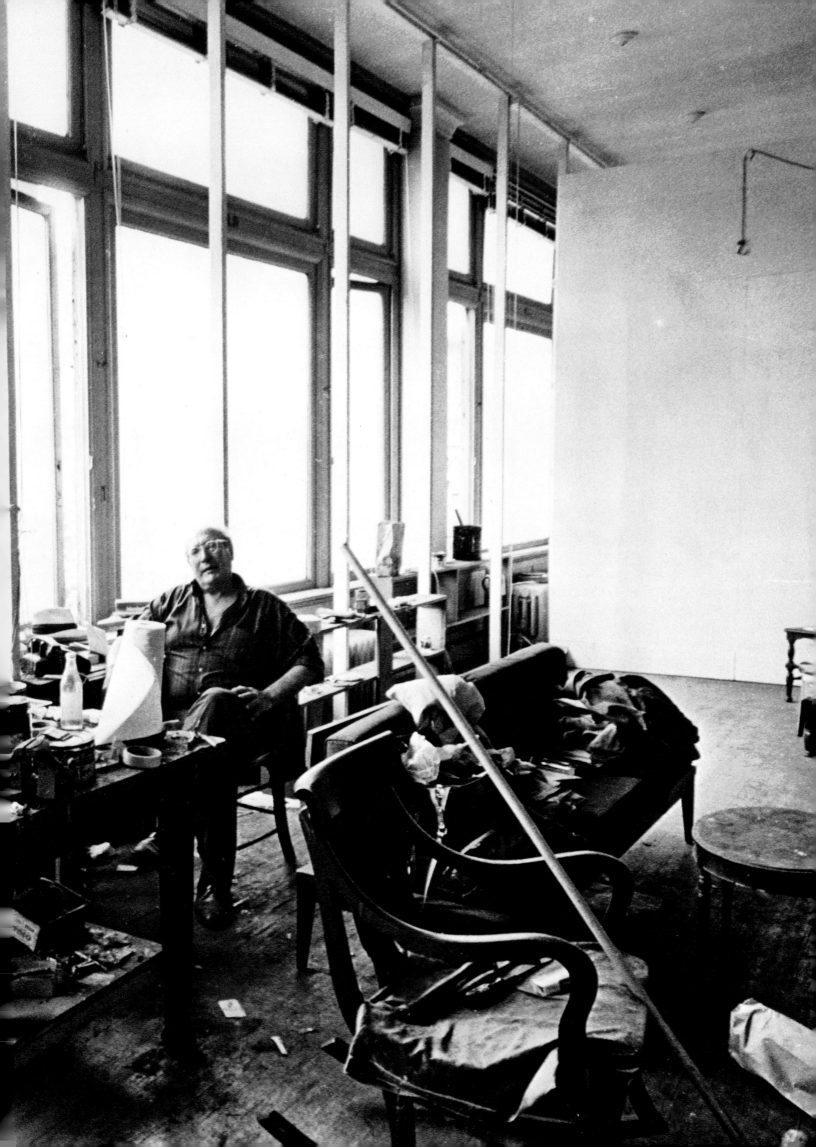

26

26

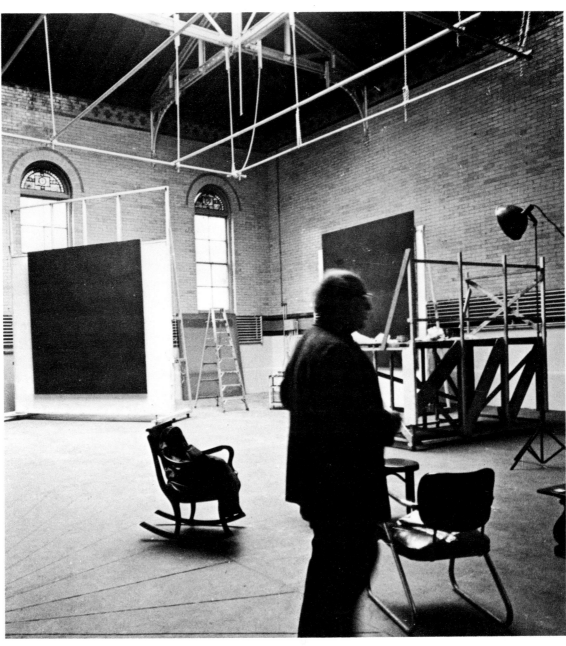

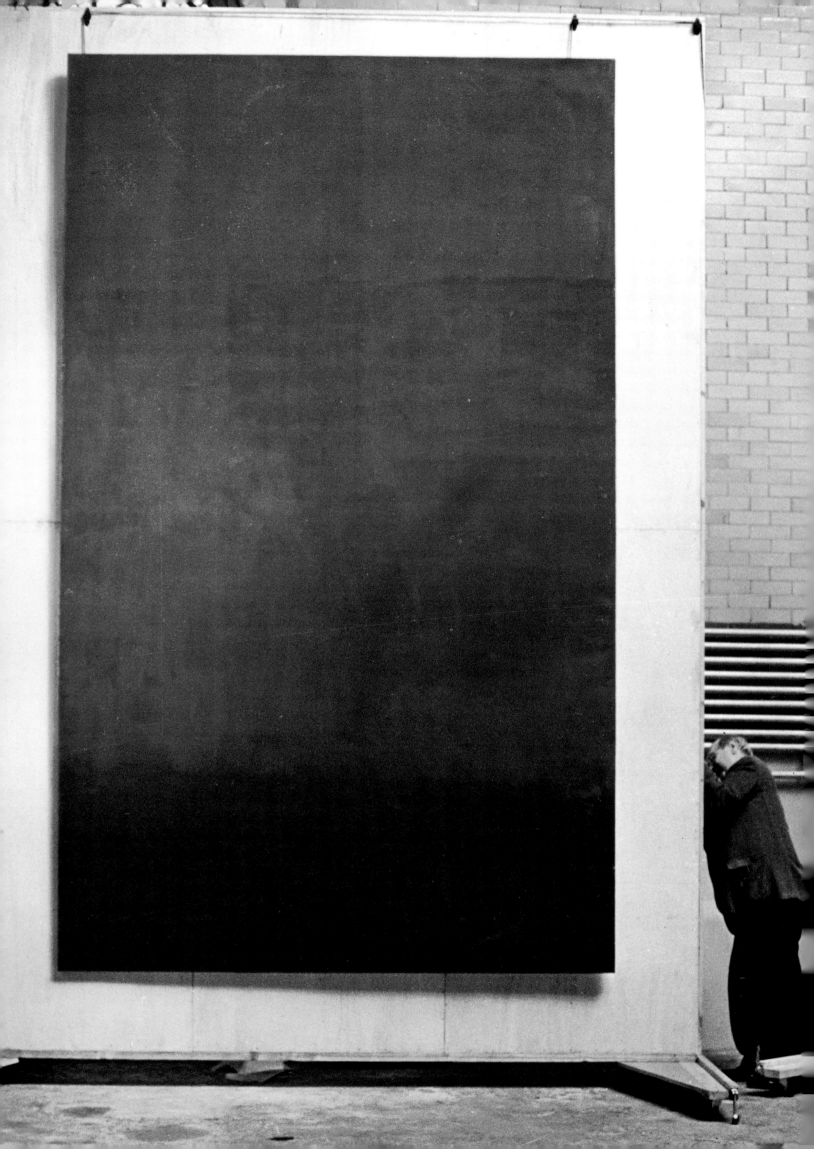

Left: With one of the
Houston Chapel panels, New York,
1964. Above: Untitled:
oil on canvas, 31½'' x 18¾'', 1930
(Marlborough Gallery, New York).

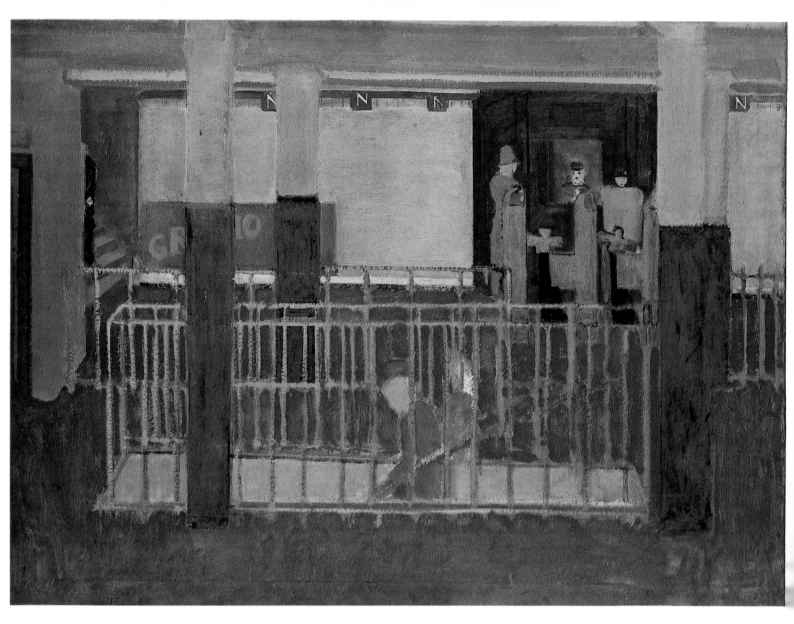

Opposite, top: *Subway Scene:*
oil on canvas, 33¾" x 46", 1938.
Opposite, bottom: *Poised Elements,*
oil on canvas, 35¾" x 48", 1944.
Right: *Multiform:* oil on canvas,
89" x 65", 1947. Above: Detail.
(All Marlborough Gallery, New York.)

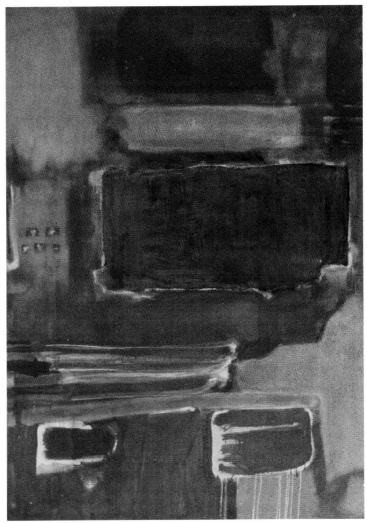

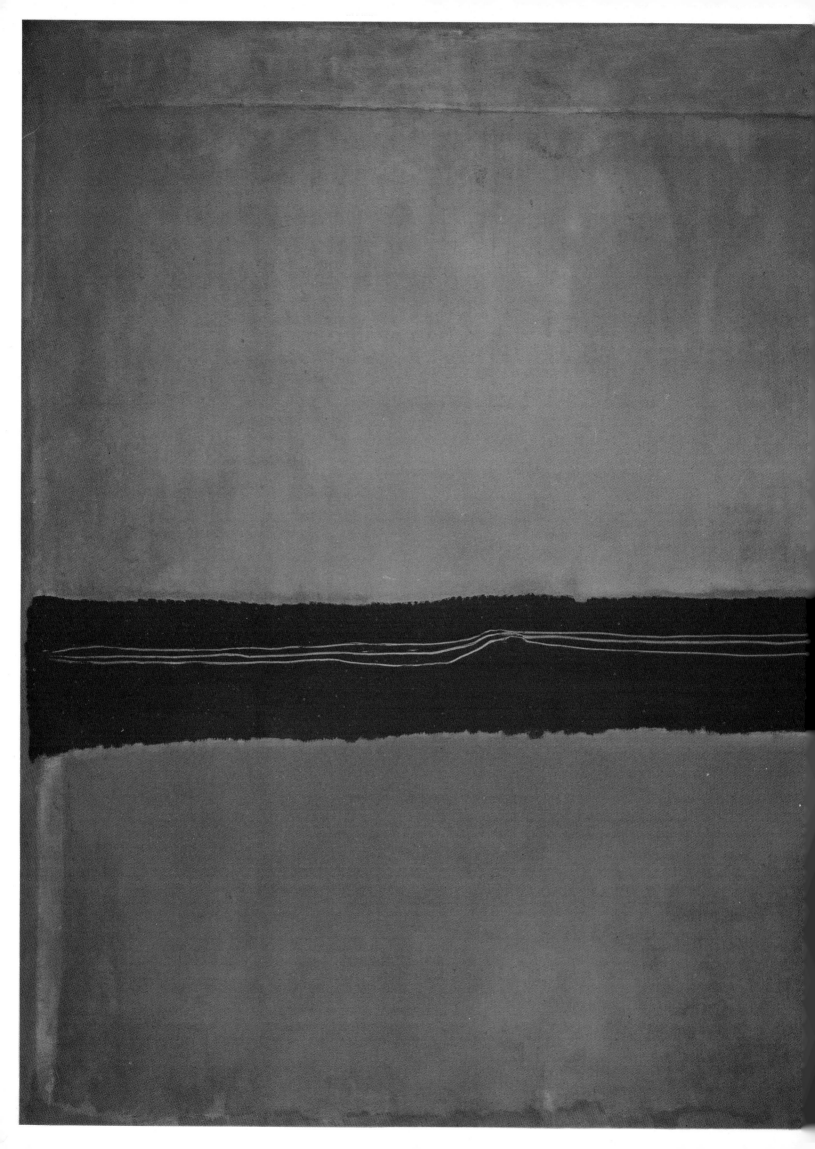

Left: *Number 22*: oil on canvas,
118″ x 107″, 1950 (Museum of Modern
Art). Above: *Homage to Matisse*:
oil on canvas, 106″ x 51″, 1953 (McCrory
Corporation, New York).

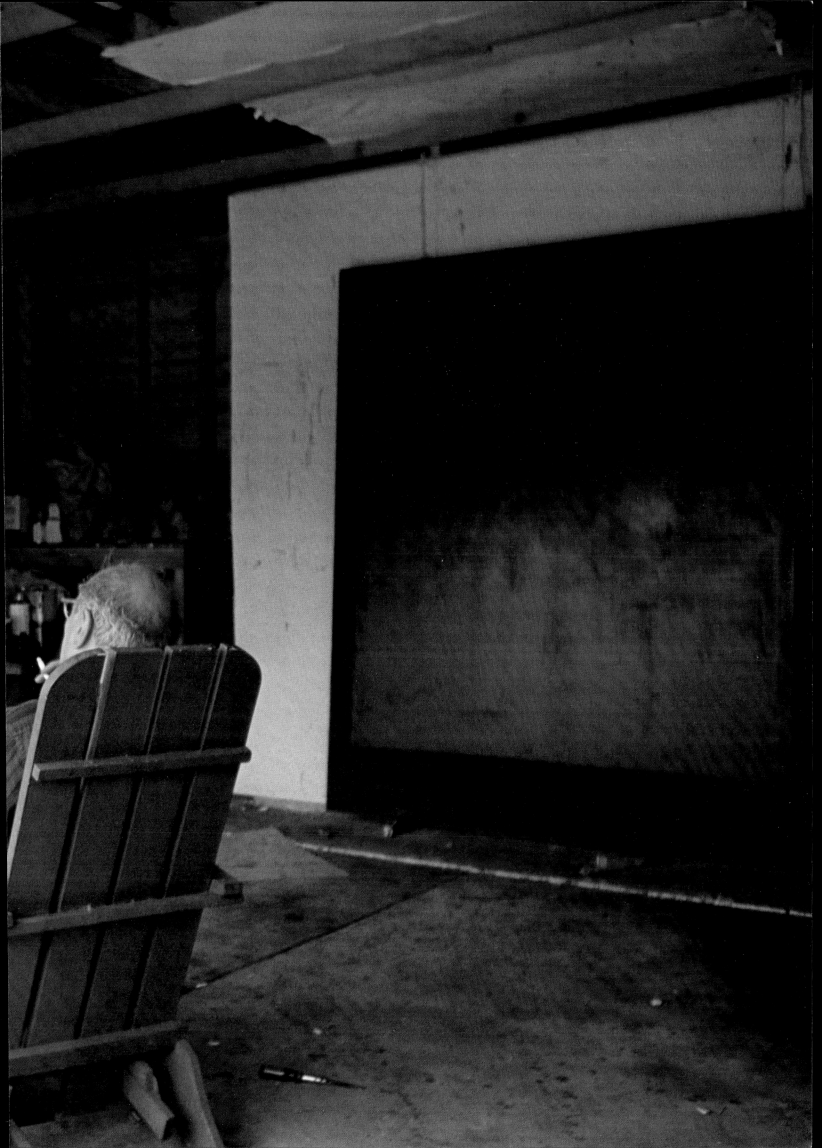

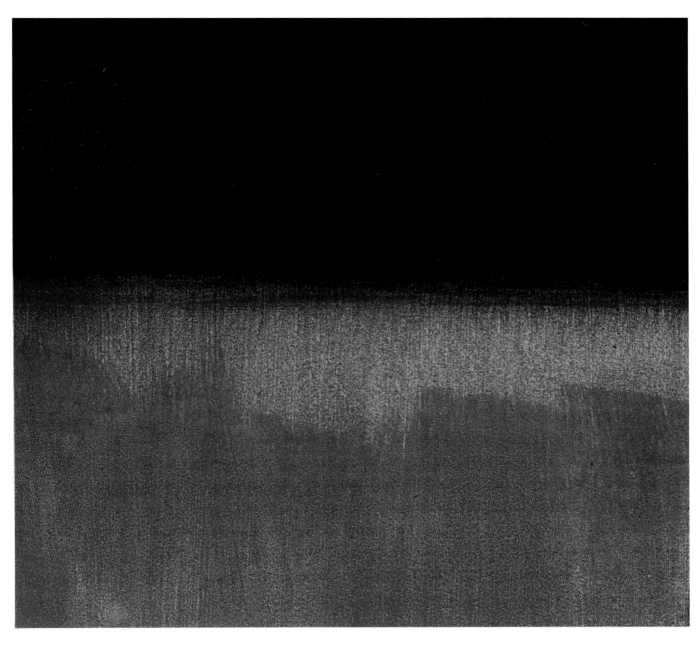

Preceding pages:
East Hampton, 1964.
Right: *Black on Grey*:
acrylic on canvas,
68″ x 64″, 1970.
Above: Detail.

The most aggressive aspect of Rothko's pictures derives from this dilemma of repetition. A strong case can be made that he experienced it in Kierkegaardian terms, to the point where it is followed "so far psychologically that it disappears before the eyes of psychology as a transcendency, as a religious movement by virtue of the absurd, which comes to pass when it has reached the borders of the marvellous." Maybe it is this that gives the pictures their fundamental mood, even though moods can be shown to vary from the somber and tragic to the sensual and almost playful. (Indeed, in one 1968 series, a variety of mood which Rothko referred to as "Shakespearean" was his declared intention.)

These many moods surely represent newness trying to destroy repetition, and the urgency with which this is experienced varies from picture to picture, depending on the quality of Rothko's color and light. It is also connected with the escape from time ("the true repetition is eternity"—Kierkegaard). Rothko's handling of the dilemmas of repetition might lead us to expect that his escape would have been complete. But it was not. (When it is complete his pictures tend to enter the timelessness of academia rather than Arcady.) What made his escape incomplete was his tentativeness, his organic preoccupation, and the intrusion of recollection, which, disrupting the hard energies of repetition, brings us to the loss Kierkegaard spoke about.

That loss had, in Rothko's case, a Faustian cast. It was really a kind of guilt, since guilt, like loss, is certain of itself; and it serves to introduce a moral or ethical element into art, and so, distantly, the tragic. For if tragedy is inevitability in the future, recollection and guilt are inevitability in the past. And by being projected into the future, these latter can mimic the tragic. Thus the obvious immediacy and transcendence of Rothko's work is compromised in a very specific manner. Recollection introduces a temporal blurring into Rothko's harsh world of repetition.

When Rothko's pictures are present, they overwhelm recollection. When absent, one recalls a somewhat nostalgic element in the pictures. Nostalgia gives a sense of exclusion and loss, and though it is in search of infinity it is temporally agonized. In memory one can experience Rothko's pictures very closely, but at the same time one is aware of an isolation the actual paintings tend to cancel. Yet one brings the memory of this to the pictures, so the apprehension of a Rothko is not so simple as it would seem. Nostalgia and yearning, which are the past and future of loss, donate their elliptical assurances of timelessness through varying cycles of recollection. These appear to be connected with the isolation of the figure before the picture, who stands for the possibility of an audience.

The Rothko literature shows how the work elicits in the western observer a sort of synopsis of European culture. This recollection, while it flaws the immediacy and transcendence of the work, allows Rothko to claim an audience, even though that audience is in the past. At the same time, insofar as the paintings' immediacy dominates, it interrogates the observer. The interaction of repetition and recollection, while threatening stasis (and academicism), allows the artist to include more—though in a somewhat illusory sense—while ostensibly being engaged in large rejections. This highly sophisticated process—modernism's last strategy for providing itself with a subject—is Rothko's most insistent habit. What transfers itself from picture to picture is this emphasis, this insistence. Though moods may vary, this fundamental mood made up of bundles of hope and regret intersecting at an illusory timelessness, does not. This mood, then, is preserved by, and experienced through, what seems to erode it. What would happen if it were experienced more directly?

V

In 1969 Rothko made a radical departure from his mature style, a style that had remained constant for twenty years. As in all such breaks with the past, it seemed at first sight to fracture continuities which, as time goes by, tend to be reaffirmed, but in a way that changes all that has gone before. Repetition has been disturbed, insistence altered. Changes have occurred that reverberate outward from the pictures to the farthest reaches of Rothko's pictorial universe.

Though they are called the black paintings, there isn't much black in them, simply deep brownish and greenish shades, and creamy, often streaky yellows and ochers. Color, his most powerful means, is reduced to a point where its effect is, to say the least, restrained. This is only one of a series of reductions.

Of the paragraphs and rectangles only two remain, the lighter area always below, the darker on top. (Otherwise the association with sky, earth, and horizon would become firmly established.) As always, the exact square is avoided. In most of these paintings, the light and the dark areas are about equal. A few reduce the lower rectangles to a familiar paragraph at the bottom.

For the first time Rothko abandoned the tonal background or underpainting and painted directly on the white canvas. The dark area above tends to be opaque, the degree of painterly process minimal. Much more turbulence (Rothko's word) is visible in the lighter area below. Deprived of a tonal resonance underneath, this painterliness is somewhat acerbic and harsh. We have mentioned that at the beginning Rothko's brush-strokes were beautifully studied, then, in the largest work, escaped more and more into vagueness. The brushstrokes in the dark paintings seem to belong to another category. They are not studied or particularly random. They seem calculated to advance a particular quota of painterliness, that is, to produce an effect, which they do—but having done so they do not, as previously, withdraw from one's attention. They just remain there and impress one as being more than anything else impersonal.

The most remarkable change, however, is the way the image is located on the canvas. A white, sharp border surrounds the image, as in a snapshot. So the two rectangles are not, as previously, placed in a painted setting where they hover ambiguously. They simply end where the masking tape has been stripped off, a half inch to a few inches from the real edge of the canvas. This, added to the diminished color, leads to less urgent effects, and a flatter, more conceptual surface.

The hard edges merely mark, without much fuss, the limit of the painted surface. They simply define the area of effect, of "psychological" scale as it were, and no more than the edges in the Houston Chapel murals do they advance an idea of absolute containment or composition. The origin of this border is the series of watercolors and oils on paper of the previous summer and fall, done after the Chapel murals. First they were framed conventionally with a surround. This removed the characteristic "object" sense; as sheets of tinted paper in a frame, the loss was evident. Removing them from the frame, Rothko mounted the paper on canvas, turning its edges around the stretcher to recover the object idea. As he continued painting he began using masking tape to hold the sheets of paper up. When it was removed, there was a white border. As with many artists, a "mistake" became the logic of the next phase.

There was, I think, one other important result of the works on paper, which were virtuoso performances, both ravishing and vulnerable in terms of mood. Generally, they were color-moods qualified and inflected in series. Some were dark, and one of these had an odd effect. Though the same size as the others (about three by four feet), it seemed much larger, indeed grander. When Rothko's attention was drawn to this he said that such was his intention. Why it occurred in this picture and not in the others was not obvious. But it was obvious that one of the themes of these paintings, which seemed such a romantic indulgence, was scale. Previously, only large size made intimacy of effect possible, but here this was reversed. It had something to do with the "conceptualizing" and flatness given to the image by the white border. That border also served to separate the painting from its surroundings—contrary to Rothko's habitual invitation to the surrounding atmosphere to contribute to the effect. The new sense of scale was carried over to the dark pictures, and along with it a different conception of the figure in front of them.

They are very bare pictures. The only indefinite edge is that separating the two rectangles. It must bear a lot of emphasis since, much more than the sharp edges, it defines the character of the rectangles. While sometimes rubbed into painterly indistinctness, it is often a

summary, almost careless demarcation. Though this makes for a sharper, more pungent mood, it brings the pictures very close to failure, a failure further threatened by the way the two areas behave.

All these losses—of tonal blandishments and subtly paragraphed rectangles—lead to a single question. An art that had absolutist ambitions, and had achieved them through the most discreet dialectical equivocation, now poses the dialectical question in its simplest form, in terms of two contiguous areas, one dark, one light. There is impatience, indeed violence, in this confrontation. By such emphasis the dialectical method is questioned. By laying claim to absolutism more directly, absolutism is placed in jeopardy. As a result these pictures are very close to nothing. That this was a conscious risk is attested to by one larger painting (lacking the white border) in which the two areas are brought into a more convincing single image. But though the form is new the mood is not. It is the other pictures—more interesting, if not the "best" by conventional standards—that display hesitations and puzzlement in the way the two areas are made contiguous. These pictures can appear both expressionist and impersonal at the same time. They seem at once to utter that word with which we began and to prevent us from hearing it.

Though they have abandoned the sensual, they are neither transcendental nor tragic pictures, but have elements of both. By confronting all his previous concerns and abandoning most of them in favor of his urgent question, Rothko does away with recollection, with nostalgia, with the audience located in the past. By impatiently locating yearning, or hope, in the present, he does away with the future. The result of this is that the quest, which was connected with hope, is superimposed on the void, and so is fulfilled, but at a cost. That cost is failure, which is of course the romantic way of succeeding. Caught between so many dilemmas, experienced abruptly and harshly, these last works are somewhat intolerable pictures, not the least because they abandon the idea of a future and of an audience.

RAUSC

CHENBERG

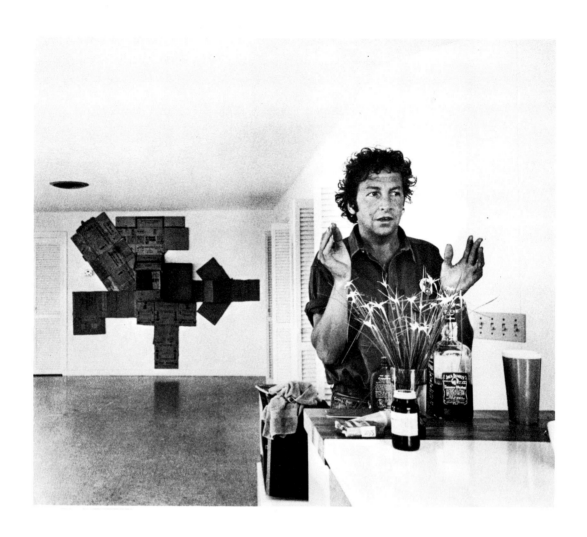

Robert Rauschenberg: The Sixties

The power of numerology is nowhere clearer than in the way we persist in giving a decade an identity, as if history could be a series of linked carriages, each distinguished by its passengers and paraphernalia. Or in the fairly constant time lag we require before a decade becomes an object of nostalgia; that takes at least a decade, too. The forties admired the twenties, the fifties the thirties, and the seventies make hay with the fifties. Such is the usual metabolism of fashion, which diligently rescues the past to offer us an image of the "new," fashion's version of the future.

Fashion's future is, of course, supposed to titillate but not to frighten, to reassure but not to let attention go to sleep. Fashion teeters along this thin line, with its contradictions—absurdities, if you will—covered with the thinnest of surfaces, style. Style, the gloss on an age's self-image, barely manages to give a sense of continuity or meaning—and all you need of meaning is just enough to get by. This may not do much for our sense of history, but it contributes to something more superficial and elusive, our sense of period.

Even before the sixties were out, people knew, as they had in the twenties that they had lived through something unusual. When the seventies came in, the fifties were, predictably, restirred, but the sixties became something of an instant period. They had everything that periods require for mythological success: a force feeding of possibilities that seemed to announce a new age, a growing connoisseurship of media and drugs, Rock Utopianism, pantheons of celebrity-heroes, a glamorous sense of license and excess, irresponsibility as a demanding pose and revolution as a creative plaything, a state of mindlessness sustained by ignoring brutal contradictions or parodying them, a high surface polish. No one knew that somewhere in the background Middle America was standing by with an extinguisher full of moral foam.

Rauschenberg's and Warhol's identification with the sixties—they are its most typical figures—is the key to their art. Both are, increasingly, period artists—which is what eventually happens to everyone anyway. But it happened quicker to them since they lacked the strategic distance from the moment that most of their colleagues were careful to maintain. From less strenuous times, their trip on the sixties' Zeitgeist seems a bit irresponsible. It will, however, seem less so in the future. As with all powerful and influential figures whose achievement is blurred by celebrity, the period they helped define now confines them. In effecting an escape their art must make a liaison with something they both rejected, history—history, of course, being the checklist scored at the exit of the sixties supermarket. How many cans of formal contribution? Social relevance? Any political content? Green stamps for future influence? Warhol has done much better here because he has, before this historical checker, pleaded innocence: He didn't know about history, never heard of it. His "naif" posture cleared his art of all "art-history" references. His exact neutrality, which now looks like inspired timing, encouraged Mary Josephson's reading of him as a "medium"—all things passing through him, and altered in the process, while he remained unchanged.

Rauschenberg's neutrality was of a different order and his identification with the moment far less flawless. At the height of his powers in the early sixties, his marvelous effervescence dispensed with any historical delays as he rode his wave. Yet his ebullient commitment to art as a short-term venture never quite disposed of the fact that he was an educated artist, confirmed by a number of gestures which staked out his territory. This made him vulnerable. He made no secret of his feeling that both criticism and museums were irrelevant to art; but the smart critical money doesn't like being left out of codifying an artist's contribution, especially if that contribution undercuts criticism itself. Warhol understood this perfectly. Rauschenberg did not, and his reputation has suffered because he failed to "curate" his inspired folly into the historical dialogue.

Rauschenberg's career tells us more about the New York art community in the sixties than that of any other artist. For the art community did not care then—nor does it now—for sunny figures whose innocent imperialism lies open. Rauschenberg's careless plenitude was distrusted as ambition, his generosity earned him not the

Pages 188–189 and left: Captiva Island, Florida, 1971.

affection of others, but inclusion in their self-hate. His flirtations with the media—accepted in Warhol's case because his art was so obviously based on them, and anyway you couldn't expect Andy to know any better—were condemned for a number of familiar reasons. First of all, Rauschenberg actually seemed *interested* in them. Lichtenstein, for instance, was also interested in some aspects of the popular media, but his attitude was benignly anthropological, mildly amused—in other words, intellectually respectable. Celebrity, when it came, was something to be suffered rather than courted. But Rauschenberg's ecumenical attitude toward the *means* of art—he would include whatever happened to be around—extended to media, people, everything.

He opened art to entry by a motley crew: engineers, socialites, All-About-Eve assistants, politicians, trade unionists, dancers, instant collectors, Utopians, scientists, foundation swingers, art groupies, and heaven knows what else; all rubbed shoulders with less success than the incongruous elements in his art. This rich mixture seemed to confirm the desire populists always have: that the boundaries of art are breaking down, as if the resulting stew could be gulped all at once. They forget that the boundaries are reformulated as quickly as they are broken down, and that this does not involve any progress. Though all this gained Rauschenberg a trendy rabble of followers, it did not endear him to the hardcore New York art community.

For this trafficking with the outside disturbed the hierarchies of importance in the closed artist-dealer-critic-collector circle, hierarchies maintained by high moral seriousness. Power is in turn threatened. Rauschenberg ran across all this with a suicidal blitheness. The politics of exclusion is the major weapon of an élite which constantly reassures itself by turning away from the gross values of the masses. Rauschenberg carried the day when fashion forced the art community to go along with him—until that moment in 1964 when he won the grand prize at the Venice Biennale. This popular success released the furies and marked the end of Rauschenberg's career as a dominant and untouchable figure. The preceding year Rauschenberg had pioneered in another quasi-lethal success: the museum retrospective for the artist not yet forty.

At the time this was adjudged a phenomenon, but it was simply the first of a series of retrospective exhibitions that, inexorably through the sixties, summarized potentially major careers and disposed of them. Such ostensible tributes, in the weird climate of the sixties, were symptoms of a crisis that for a while remained comfortably masked: the entrance of museums into competition with and for the media; the emergence of the curator as shaper of taste rather than its codifier; the abortion of the artist's contribution out of the historical process in which, at mid-career, it was still engaged, into the frozen compounds of premature myth.

Traditionally, the retrospective comes at the close of a substantial career or, like Cézanne's in 1907—the first of the great modernist retrospectives—immediately after the artist's death. It examines the moment's historical priorities as much as it pays tribute to recent or current eminence. In attempting to establish continuities with the past and offer guidelines for the future, retrospectives are fundamentally conservative, and they have implicit in them a rather simple theory of history. By presenting the full range of an artist's work, they show the early artist constructing his view of the past by ghost-painting it, and so equipping himself for the present. He adds to the past by developing his own independence from it, which in turn—according to the retrospective's scenario—offers points of departure for new artists. All this involves some idea of progress, that the successful artist leaves art more "advanced" than he found it. He may leave it with more or fewer options, but mythology, as we have seen, demands the rhetoric of the "advance." Rauschenberg's 1963 retrospective at the Jewish Museum in New York short-circuited this process in ways that can now be clearly read.

A glad personality combined with irrepressible bursts of eccentric creativity made Rauschenberg an influential curiosity. Setting up this somewhat legendary and unfocused figure for examination was a coup on the part of the Jewish Museum's curator, Alan Solomon. With a few shrewd gestures, Rauschenberg had ac-

cepted the task of breaking away from the heroic generation of the late forties and early fifties. Indeed, most of that generation saw him as an errant son, who, though he lowered the emotional pressure intolerably, preserved enough connections with the older art to make him acceptable. At the same time, his amiability diverted much of the hostility shown to any deviation. The amiability, however, was exaggerated by his critics into a lack of that seriousness so essential for major success in New York.

So Solomon presented for accounting an artist who summarized many Abstract Expressionist concerns, rehearsed them with frequent parody, "quoted" them extensively, and pointed new ways of escaping them by reducing absolutism to paradox, by bringing high art into everyday discourse. This gave an impetus to the slightly younger Pop artists who secularized art completely and who were otherwise untouched by his art but not his attitudes. They institutionalized Rauschenberg's irony, which he tended to leave open and "innocent"—a matter of coincidence as much as intention—by eliminating process and presenting a façade of subject matter. Subject matter, which Rauschenberg had clearly shown was not incompatible with aesthetic discourse, was the Pop artist's mask. When the subject matter was the everyday object, the irony was built into the surface. It was not just the object that became subject matter but the use of commercial design as subject matter. The fact that the design was contemporary was one of the things that made Pop revolutionary.

Pop's idealized avoidance of any sign of usage—the *newness* of everything—eliminated any identity such mass material always gains in its human transactions; after all, the impersonality of mass culture is a bit of a hoax. But Pop's subjects were always prepurchase, before, never after. Behind this mask of newness was a neutral zone into which one could project, according to one's sophistication, speculations that could be nuanced and replicated to an unprecedented degree. For Pop was the first occasion—after the hierarchies of modernist painting had been established, with abstraction firmly at the top—which donated to subject matter the richness

and ambiguity of abstract painting. This, to my mind, was Pop's greatest contribution.

In hauling subject matter into an area of aesthetic discourse that mimicked the issues abstraction had raised, the artists were clearly as ambitious as any other "fine" artist with designs on history. They were not surfers on the sixties, mod swingers or visual jokers, though they may, in one way or another, have taken advantage of what was there for the taking. The mask of subject matter allowed each one to develop a firm persona and a myth which interacted amusingly with the public reception of his work as it was recycled into the popular media, that is, became just subject matter again. The circulation between high art and public media is still an unexamined theme of the sixties. It would include a history of fashion, a study of mediation and of the Pop artists' myths. Unlike theirs, Rauschenberg's was never firmed up. His myth and his persona are both highly labile.

II

Since his art collected the scattered impressions of the individual on his own Bloomsday, one could imagine Rauschenberg tuning into any future or past age with equal enthusiasm—his major weakness and strength. This sense of the artist in the midst of process, not just art process, but the process of living, was aborted by the Pop artists at the level of commodities. Their idealized subject matter withdrew their art from the everyday and casual, putting it more in the precincts of Poussin than of popular art. Repetitions, spacing, and distancing make their work seem more classical every year, especially as changes in commercial design alter their subject matter, underlining not its campiness but the classicism of their transformations. Their personas, like brand names tied by the sixties to their aesthetic goods, obscure this and, in the case of the best of them, detain their work in a period it should transcend.

As the individual in the midst of life, and happily distracted by it, Rauschenberg was another kind of creature. For Rauschenberg's presence, the way he occupied the New York scene, was as influential as his

art. In the early sixties particularly, his excited, toneless voice, his ebullient laughter, his verbal playfulness, his physical energy, seemed everywhere. He was larger than life. He even looked larger than he was. It was a groundbreaking personality, in the spotlight and at ease in it. Its uncanny magnetism did a lot toward creating a climate favorable to change. Rauschenberg made it easier for those more quietly engaged in taking different ways out of Abstract Expressionism.

The retrospective's influence in New York was more by permission and example than by any formal promptings. As Bryan Robertson commented, it opened up not so much possibilities, as lots of things to do—the opposite of an artist like Mondrian, who convinces you there's nothing more to be done. Even people who weren't artists felt this at the time, and it is important to understand why. Denied familiar images in art for so long, museum-goers now found them in an art receiving the kind of praise hitherto reserved for the mysterious realm of abstraction. The man from the street was allowed to bring into the museum everyday feelings his wife had always told him he had to check at the door.

By bringing together the common images of the day, week, month, year, decade, Rauschenberg did a service usually performed by poetry, one of the functions of which still can·be to verbalize states of feeling and so make them accessible. This used to be one of the functions of art, though words, of their nature, do this trick better. The pictures in Rauschenberg's works were an image *and* a word, and Rauschenberg converted them into a kind of language with a missing syntax that is always standing by when objects become implicated in art. Take for instance a conjunction of two news photos: an athlete winning a race and a space capsule. The sports photo, depending on who's looking at it, can say: running, sports, winning, losing, Ryun, track, Olympics; the space photo: astronaut, weightlessness, capsule, race, Apollo, winning, moon. Each word can function simultaneously as noun and verb, leading to multiple readings depending on the viewer's state of mind and that of the Zeitgeist looking over his shoulder.

One can press this language idea too far, but at the time such conjunctions described an open situation very precisely; to some extent, Rauschenberg's best works still do. What viewers felt, I think, was not just a recognition of images, but a recognition of a familiar state of feeling that has to do with "informational overload," a part of daily life everyone more or less learns to ignore. "The show didn't help me to understand the world, but it helped me to understand my puzzlement about it" was the response of one viewer. While this was a substantial achievement, it gave up almost as much as it gained.

The work instructed the public on tolerating discontinuities, but only by maintaining the neutrality of the open situation. The art was chockablock with comments about art, some good, some not so good, but its comments on public affairs were negligible. The images were like headlines that just happened to be around, the casual information of the man who scans the paper, gathers fragments of news on television and radio, flips through an art book now and then. Public issues, this art seemed to say, are too complicated to understand or to take positions on. In art the open posture can look, especially to literary people, quite dumb. There is some of this philistinism in Rauschenberg, mitigated by the fact that his was not primarily a literary but a visual idea, and as such had its own pedigree and precedents.

The Pop artists made dumbness stylish, while at the same time burying deep in their art a hostility honed by numerous ironies. This hostility was completely absent from Rauschenberg's work, and the gains purchased through the open, neutral position were compromised by his enthusiasm, amiability, and lack of critical posture toward his subject matter. There was a sort of Whitmanesque plenitude in Rauschenberg's reaction to life at that time, and it shared some of the same vulnerability. Rauschenberg's uneasy tenancy of process, where consciousness and self-consciousness deliver a number of checks to each other, remains one of the central issues of his art, one which he himself recognized, and to which he had his own answers.

The distinction between Rauschenberg and his Pop colleagues is clearly underlined by two gestures: Lichtenstein's frozen portrait of a brushstroke and

Rauschenberg's rubbing out of a de Kooning drawing. The former represents the classicizing of process, the latter its continuation. As Rauschenberg extended process into a life style, programmatically ignoring distinctions between art and life, his work became performance and his life became art—that is, voice and myth attempted to fuse. Even now a mention of "the young Rauschenberg" calls up a kinetic personality, ebulliently presiding over the late fifties and early sixties, an image that has cannibalized the artist's later self. This fusion of Rauschenberg's life and art covered up contradictions in his art and attitudes that later became quite clear. By turning his work into quasi-performance—long before his actual stage performances—he forced it into a kind of limited duration. For one of the ways he legitimized his conception of art as a short-term by-product of an ongoing process was by accepting the rapid depreciation of his work's visual effect. His major pieces of the late fifties and early sixties have changed greatly within the short history of their existence. To a degree all works of art side-collect a history of vision, a provenance of perceptions. Rauschenberg's are blurred by a series of perceptual histories that still hinder their proper appreciation.

This idea of art diminishing into irrelevance through a brief series of half lifes was, of course, an attack on "permanent values" and the rhetoric of museum-broken art. Rauschenberg fully accepted his own premises here. He was careless of museum recognition, which, despite his great reputation, did not come as quickly as it should have, partly because he put his art in the position of a Trojan horse within museum walls. He tolerated, indeed welcomed, whatever accidents interfered with his work, and like a good host tried to make them at home. He was continually open to any environmental promptings, and would use any material once he got the idea, and indeed the notion of a jackdaw *collagiste*, drunk with detritus, is often called up by his performance. And he was completely careless of his own works, often allowing them to collapse back into the continuum from which they had been plucked, like a sentence falling back into a dictionary. Once he had finished a piece, it no longer held his interest. But usually artists who share this feeling develop a respect for their own histories. Rauschenberg ignored his past work, except for a few talismans that he kept around, like the erased de Kooning drawing. Indeed, he seemed to forget many of the things he had done, and Rauschenberg's lack of "memory" is an important clue to his art. During the great years between, say, 1957 and 1964, Rauschenberg needed a scrupulous historian, a kind of living footnote, to follow on his track. His carelessness in this regard has not helped his art or his reputation. The critical chameleons, ever anxious to take their cues from their subject (victim?), began to feel that if Rauschenberg didn't pay much attention to his past, maybe it wasn't that important.

This Duchampian idea of art's effect being limited to a short duration (and of the museum as mausoleum) was fully adopted by Rauschenberg, who also found much of Duchamp in de Kooning. How Johns and Rauschenberg received Duchamp, whose work and person they both appreciated at a time when this was considered trafficking with the enemy, is crucial to sixties art. That his influence could produce two opposite artists, whose work at first glance looked much the same, is a typical Duchampian irony. Rauschenberg showed how Duchamp's personality and ideas could be *performed* in public, with art an incidental part of the performance. Johns showed how the retiring and enigmatic side of Duchamp's personality could be withdrawn into the art work itself, thus feeding his ideas into a somewhat stagnant mainstream.

Formalist criticism, now somewhat too much the butt of its apostates, has overemphasized the paternity of forms to the exclusion of the paternity of ideas. But Duchamp's pervasive "infection" of twentieth-century art, one which spreads as the century goes on (or breaks down) must be recognized when it pops up in the most unexpected contexts. Tracing it requires a prestidigitorial historian who will follow Duchamp's secret histories with Vonnegut-like leaps in time. For Duchamp left behind a minefield of past actions, signified mainly by objects, which the present stumbles across and

explodes. With extraordinary prescience, he mined the future; some of his work remains mysterious because history hasn't yet tripped over it. Duchamp's genius, and it is genius, was to see the modernist era from the *outside, while in it.* Thus its myths, energies, and rhetoric lie open to a sympathetic understanding of their absurdity, since, like life itself, they progress nowhere. The strenuous searches for pure form, the egotisms of "expression," the pseudo-exploration of "advancing," the bourgeois desire for fame, the presumptiveness of initiating social change from a canvas, the smugness of aesthetic moralism—all these could hardly be matters of life and death to one who found life and death a pair of misunderstood trivia. Modernist history won't let Duchamp in, because he spoiled the fun it had in taking itself seriously.

I don't know whether anyone has made the analogy between history and chess, but Duchamp's sense of history was remarkably analogous to that game. Chess is a game of deadly wit; it plays as many jokes as life. Its arbitrary moves present an image of different powers bumbling along until a situation releases their danger. Even a pawn can kill a king. It encourages odd alliances between different pieces conspiring to undermine their counterparts, and little histories are aborted and re-formed by a single move. Its process opens up a variety of futures, predictable according to memory, foresight, and the psychology of one's adversary, which must be read on the board. Its balances of power after losses construe different equations, and its surprises leap out of a situation one thought was fully understood and covered. It is, like American football, a perfectly satisfying work of the imagination, because its extremely structured form underlines the unexpected; both games cultivate the study of disorder from a very ordered base. In chess the possibilities that recede into the future, while potentially understandable, add up to chaos. By his moves against the modernist adversary, Duchamp made modernism reveal its inner process and thus to an extent made it predictable. He opened the way for a fever of game playing that signified the end of modernism in the visual arts. History became "history," a game, and thus manipulable. Johns intuited this lesson perfectly and squeaked in just before the modernist door slammed shut. Rauschenberg literally didn't have time for this.

For Rauschenberg was always on the run, sentenced by his idea of short-term art to be a brilliant hare in front of the perceptual hounds. As with most artists of a didactic nature, visual conventions, habits of perception were Rauschenberg's material. His aim was to jog these conventions, affording a fresh glimpse, a momentary escape from habit. He worked in the gap between a new perception and its organization into a convention. He was delighted at the public's obvious response to his retrospective, a feedback necessary to his process. The retrospective provided so many new glimpses that it seemed to announce a new vision. What it announced was something far more perishable: brief new modes of seeing, uncodified perceptions as yet unfiled. This was Rauschenberg's way of revealing something of great importance to him, and from which he drew his marvelous energies—the plenitude of reality, the possibilities of which, he seemed to be saying, are infinite. His careless generosity was based on this plenitude. He believed then, I think, that the game could go on forever, that his past was as disposable as his future was available. He forgot, or didn't know, that there are historical and perceptual limits to this process.

Continually feeding on ways to make people realize their environment, Rauschenberg was caught in a tautology. As the audience gets used to the manner in which the new perception is glimpsed, it becomes more fragile and brief. As each unconventional glimpse is more quickly conventionalized, the time span gets shorter and shorter. The hounds, in a perceptual Zeno's paradox, draw closer to the hare, until both appear to be hunting together. The way becomes littered with past perceptual promptings. Passing them once again, these artifacts recall, like old newspapers, the history of the chase. His work of the late fifties and early sixties was a kind of inspired visual journalism, affecting people for a few days, then losing its efficacy, like old news. And like old news, the future of such work is in rumor and research. The museum, if one follows through

Rauschenberg's short-term idea, becomes a library of documents which have collected the perceptual history of how they were originally seen and how they are seen now.

At the point where Rauschenberg's reflexes became part of his pursuers' habits, his work developed a "look." No matter how elusive his performance, his modes of surprise were, if not anticipated, expected. His art between 1957 and 1964 afforded a heady, exhilarating glimpse before it was abridged by history. Perhaps his partial abandonment of painting and his entry into performances were prompted by an awareness of this, and by the fact that he had been too careless in the way he had spent himself—not only in making art, but in the generosity of his person, which gathered people to him, infused them with energy and spun them off. Also, for one who bases his existence on performance and ideas, the New York scene has an avid appetite. And for a time it seemed that Rauschenberg might give the monster indigestion. Added to all this were the art world's responses to the retrospective and the prize. He had had enough, the scene was clearly saying, and was to be allowed no more. No more, that is, beyond the pleasures of rehearsing his past, an intolerable position for one who based his future on forgetting his past, and whose sense of the present, and of himself, depended on perceiving an open future.

At that stage Rauschenberg became not the pursued, but the pursuer of ideas, of performances using art-like conventions, and of such dreams as art and technology. The results have been relentlessly downgraded, though some were remarkable. After mixed success and frequent failure, Rauschenberg, around 1969, became resigned to being "merely an artist making art," which he has been doing since then in a way that gives his career a distinct motif. To do so, he had to discover his own past and consent to an identity he had always avoided. In discovering his past, Rauschenberg, at this third stage in his career, became both pursuer and pursued. The first stage had been an extraordinary attempt to become an all-encompassing genius. Its program was to prod and urge people to see, not just art, but their environment for themselves. It thus had some social orientation, but in a somewhat diffuse way. As propaganda for nothing more than perception—to see the world fresh—it had an Emersonian innocence, a Whitmanesque exuberance. Among its many paradoxes was an attempt to make art unnecessary, to reduce it to a visual aid and then transcend it, but by using art. The inevitable happened when his means made the artist prisoner and firmly tied him to art and history, within which he must consent to perform, or become something other than an artist.

III

If the early Rauschenberg tells us a great deal about the New York scene in the early sixties, the later Rauschenberg tells us a lot about how we receive art and what our conceptions of art history are. Rauschenberg had deposited visual conundrums in the past which had, according to his ideas, been drained of their didactic relevance and now had the status of relics. They had served their purpose. But as documents they were—are—raw material for history. As such they are defenseless against the iconographic appetite of historical scavengers. So at this stage of his career, Rauschenberg is being asked to cooperate in his own interment, to encourage readings of his pictures which his aesthetic at the time prohibited. Finding out exactly *who* the athlete running through the tape really was may keep graduate students off the street; its relevance to the picture, or to understanding Rauschenberg's work, is not only minimal, but misleading. And the reading of little scenarios into groups of photographs in a painting, no matter how imaginative, is similarly misguided. The images were chosen not for the content they could unload on each other through juxtaposition, but for their nonspecificity. Watching Rauschenberg select old photoengraving plates at *The New York Times* in 1962— he had called and asked if he could have some—it was clear that this nonspecificity was in his mind. Incidents residing easily *in their categories* of events caught his attention. Indeed, he chose categories rather than incidents and showed no interest in the specific

occasion depicted within that category, or at least in its documentation. Occasionally he even blanked out faces, à la police photos, to withdraw specificity further. Rummaging through trays of obsolete photoengravings at the *Times*, he selected nonspecific images to be put later in nonspecific relationships. This neutralization worked both ways. It minimized content and encouraged numerous readings of it. I've always been struck by how people in the early sixties thought Rauschenberg's work was specifically addressed to them.

It is the quality of these images' disengagement, not only from each other, but from orthodox associations traditionally sanctioned by art history, that is at issue. Their description of reality, at the time they were made, depended on this dissociative rather than associative effect. His art encouraged what could be called the city dweller's rapid scan, rather than the art audience's stare. Cultivating this speedy effect, it's no wonder Rauschenberg didn't want the pictures exposed to the museum-goer's chew-the-cud regard. Rauschenberg's early work as a window designer for Fifth Avenue stores has been held against him as evidence of his ability to wring unexpected chic out of his talent for tastefulness. But it was in fact a public theater to test his ideas. Window dressing could not be more consistent with his aims of provoking perception, of jogging attention and measuring its decay. This was more Rauschenberg's subject than his ostensible subject matter—the objects, etc., in his work. Which is a way of saying that *process* was his subject; and that objects, photos, brushstrokes, etc., were simply categories within it. Since we were made aware of their temporal as well as spatial situation—as a result of Rauschenberg's perceptual urgency—a Rauschenberg of the early sixties was an upsetting and marvelous glimpse of lapsing histories, half-chewed processes, sputtering feedback from nutty dissociations, all contained in the crowded arc of one rapid perception.

Looking at these works at the Jewish Museum retrospective in 1963 gave you the feeling of crossing the street. You wanted to look over your shoulder to see if you were going to be run over. The work wouldn't

let me settle down, and I remember feeling uncomfortable that I'd brought my street reflexes in with me. Rauschenberg had introduced into the museum and its high-art ambience not just the vernacular object but something much more important, the *vernacular glance*. While this could be played down as an episode in the history of perception, I believe it was an important moment in the history of sixties art, which, more than most art, made modes of perception its subject and their history its art history.

The sixties made us aware of a history of *seeing* pictures, and Rauschenberg was the first to make this an issue by forcing his idea of perceptual decay. Traditional ways of seeing pictures could roughly be fitted into two categories: the additive and the overall. The additive relates part to part in larger and larger units which eventually add up to the entire painting (a classical and academic habit previously referred to as part of de Kooning's subject). Systems of checks and balances inflect each other until the "right" moment halts the process and freezes the picture. The general effect—the additive synthesis—then clarifies the picture, within which little pictures happily reside. Instructed by the parent picture, the eye is invited to make its own compositions within, finding pictures within pictures, details within details, before withdrawing to lock everything in again with the full glance at the parent picture. Nineteenth-century academic discourses are full of discussions of detail and effect, the split-level perception of academic art. "How-to-see" books, an academic hangover dressed up in educational finery, litter the first half of our century, crowded with diagrams and arrows guiding the visual traffic on everything from Cézanne to the Old Masters.

But also in the nineteenth century, the effect rather than the detail was the subject of a tenacious quest, arising out of the aesthetics of the sublime. The overall field (and Caspar David Friedrich seems to have had a vision of this) emphasized effect, as various excuses—distance, atmosphere, light, time of day—are used to blur detail, eliminate relational perception, and present a single, immediate experience. It was Miró as much as

Matisse who later translated atmospheric and tonal subterfuges into areas of pure color and immediate response, thus putting the habits of additive perception out of work and in need of the reassurance Cubism still gave them. From this we can trace a history of a certain mode of perception, or at least the consciousness of it, becoming included in aesthetic discourse: Pollock, Rothko, Newman, Louis, Noland, Olitski—at which last point the marginal detail is introduced not to suggest any additive future, but to check the overall glance— now codified as a mode of making art as well as of perceiving it. The marginal inflection of the overall field also avoided one of the sixties' most interesting blind alleys, the monochrome canvas, which failed to enter the historical dialogue in any effective way because it limited options to two major alternatives: total isolation of the canvas when displayed—to protect its absolutism; and a heavy emphasis on facture and staining. The problem here was to delay perception, as Ad Reinhardt learned to do. Another way out was to develop canvases in series, a return to additive perception of a sort.

All through the sixties perceptual matters were high on the agenda. The theme of invisibility—literal or by inference—cut across such diversities as conceptualism and painting. The urge to it, encountered around the same time (middle sixties) in many parts of the art world, derived from a complicated impulse. Absolutism, impatience with the condition of art, drugs, and mysticism, a hostility toward the audience and toward the perceiving organ, the eye itself, as well as a radical anger at closed options, were all part of it. This impulse, at large in quite contradictory quarters, gave rise to the idea of the death of painting, the irrelevance of tradition, the end of art. Or perhaps one might say such matters donated energy to the desire for invisibility. Whatever about this, modes of perception became as codified as styles of art. In fact, perception developed its own "styles," or the facts of style included the modes of their perception. As one of the first in the sixties to make perception his major theme, Rauschenberg had an interesting relation to all this, although his most upsetting efforts were over by the time the theme became manifest in the larger scene.

His early black-and-white series touched on the themes of abrupt perception in the offhand way of someone in rapid transit who sees opportunities he doesn't have time to take. But he did tag them. He didn't detain himself long enough to give them the kind of serious certification the New York scene demands from an artist assembling a history. In the mid- and late fifties Rauschenberg's mind leaped around with such preposterous ebullience that it was, for the rest of the art community, like living with an ocelot. It leaped on everything from garbage to grass. He planted grass in a box, exhibited it, watered it every day. The seventies, which use the real world to describe art instead of the other way around, have made such daftness prescient, though the results hardly build an imposing edifice on his insights. But when Rauschenberg shuffled his signposts the fallacies of the future were still hidden.

His white canvases were more "airports for the lights, shadows, and particles," as John Cage said, than formal forecasts of the aesthetics of minimalism. As palimpsests of the fluctuating environment, they have a kind of short-term function, something done "to see how it would work," and for no further purpose. This vulgarizes the idea of formal aesthetic inquiry, and there has always been a cheery vulgarity about Rauschenberg's work that hasn't helped, since it isn't intellectualized vulgarity, but a genuine liking that is as suspect as his good taste. That his is a coarser and more ardent sensibility than Johns' has led to unfortunate judgments based on Johns' superb accomplishments. But Johns, it should be added, has everything that Rauschenberg has not: a reflective sense of his own history, a brilliant ability to turn aesthetic meditation into provocative formal enigmas, a more cultivated gift of paradox creating internal rather than external systems. In other words, Johns provided everything the New York critical intelligence requires to requite its own narcissism. It would be irresponsible to use either of these two artists to expose the flaws in the other, but they have too often been paired in a way pejorative to Rauschenberg. Partly this is because Rauschenberg's work doesn't need

criticism the way Johns' does. Johns' work takes the critic very seriously. In the early sixties, Rauschenberg made no secret that he thought neither criticism nor its practitioners very interesting. Indeed, the critic's grim orders of priority, pursuit of intention, fabrication of "issues," and so forth, are shadows cast by a self-consciousness Rauschenberg's temperament can't bear.

For these reasons Rauschenberg's vulgarity and facile taste have been misinterpreted. To the window dresser, whose material is fashion—that is, modes of perception bizarrely jogged—vulgarity and taste are matters to be flirted with. He levels hierarchies by bringing in worthless chunks of the secular world—rocks, twigs, junk, objects of nostalgia—and giving them equal importance to the dress or object they surround. A fruitful comparison can be made between the language of Fifth Avenue window dressing and Rauschenberg's assembling habits. And windows are seen not by the museum public, but by the man in the street with the casual, vernacular eye.

Rauschenberg's aesthetic of the unrepeatable glance—the second time you look, the work has changed —is connected to the kind of instantaneous, overall perception clarified later by a vastly different kind of art. But once the work broke down, that is, on the second glance, it lapsed into a kind of additive dementia. The only time it held together was at first glance. It took years to put it together again for the museum audience, and of course the past decade has more or less accomplished that. Works such as Rauschenberg's thus have a lost mode of perception buried in them, as the aesthetic of "museum perception" instructs academic modes of looking quite alien to the original. Every work, of course, is cued differently by succeeding ages, but Rauschenberg's art of the early sixties called these processes of perceptual codification into question, or at least made them part of the issue.

The task for anyone writing about Rauschenberg now is to construct from the museum-broken residues of his work and intentions a rationale that does not ignore this perceptual history, but which does ignore the myth of careless superficiality that disqualifies his work from the strenuous examinations of high seriousness. This will not be accomplished here, for the way must first be cleared of numerous misconceptions. It must be done without the cues usually given by artists eager to assist their work into the historical dialogue. Some artists have a gift for this and some don't, just as some are good at conning curators and some are not. Rauschenberg has been unwise in assisting iconographic examinations of his work which put it on the art historical couch and plumb matters irrelevant to its function. So we find ourselves in the peculiar position, unthinkable with, say, Johns, of acknowledging the artist's original intent and ignoring him as a faulty witness thereafter.

The artist's myth is also a form of "witnessing" the work, of inducing reactions to it consistent with the artist's ambitions, if not always with the work. Apart from the early rhetoric of delight, followed by puzzlement and withdrawal, one has difficulty discerning in Rauschenberg's myth any focus—and myths to be effective must focus disparities into a single state of feeling that can be easily recognized, if not necessarily understood. In Rauschenberg's case there is a kind of failure of self-interest, unique in the New York art world, which leaves his career dispersed. Though the attitudes and ideas Rauschenberg has held to with undoubted consistency—the collaboration with materials, animate and inanimate, as part of a continuum of activity—are still interesting, they are somewhat outdated through acceptance. This happens to all "original" thinkers, but the outdating has negatively affected the way Rauschenberg's work is historicized.

Though Rauschenberg anticipated many of the newer ideas which have displaced his, no strings have been tied to his work that would pull them into significance now. Yet consider how much Rauschenberg contributed to these subjects: perceptual history, the uses of photography, cross-media insemination, the nature of objecthood, replication and duplication, permutation of images, the use of language, organic literalism, collage, disposability, the body image and kinesthetics, lithography, the limits of museum culture,

process, popular culture, the vernacular glance. Considering this wide swath of territory, now much inhabited, one can only conclude that Rauschenberg's spendthrift attitude showed little understanding of the ways in which the New York scene processes historical contributions. This is further confirmed by his innocent transgression of "permissions"—the limits of what an artist is allowed by his colleagues to do, a subject hardly spoken of among artists.

The extension of his activities into dance, performances, and theater—and his happily obtuse ambitions in these areas—lost him former friends. Indeed, the mid-sixties are a distinct benchmark in Rauschenberg's career, when the permissions he had transgressed reformulated themselves to define the territory to which he had to confine himself. Again, one cannot avoid reading Rauschenberg as one who donated to others his own lack of envy, who presumed, as idealistic social reformers do, that programs for the greater good would be welcomed by everyone. He did not realize that members of the art community frequently act against their own interests, are thus unpredictable, and that this whimsy is connected as much to self-destruction as to personal definitions of freedom. For this innocence he paid dearly. He misunderstood the power of the system of checks and balances that obtains in any scene where the stakes are high—whether it is Florence in the 1450's or New York in the 1960's. It takes time for work to survive not just its period, but the limits a scene places on it, which is why art history is subject to continual revisions. Long-term history is usually more generous than we have a right to expect, seems indeed to have a bumbling sense of fair play. Rauschenberg will, I believe, eventually dominate the sixties in a way that seems unlikely now. Maybe the reasons will be wrong—historical reasons often are—but that is part of the hazard of a work surviving its contexts, part of what we are pleased to call its "many-sidedness."

Rauschenberg's work now includes, as part of its content, the mode by which it was originally perceived—the vernacular glance. It can still tell us a lot. The vernacular glance is what carries us through the city every day, a mode of almost unconscious, or at least divided, attention. Since we usually are moving, it tags the unexpected and quickly makes it the familiar, filing surplus information into safe categories. Casually self-interested, it accepts the miraculous as routine. Its self-interest becomes so habitual that it is almost disinterested. This is the opposite of the pastoral nineteenth-century "walk," where habitual curiosity provoked wonder, but found nothing except ugliness in the city. The vernacular glance doesn't recognize categories of the beautiful and ugly. It's just interested in what's there. Easily surfeited, cynical about big occasions, the vernacular glance develops a taste for anything, often notices or creates the momentarily humorous, but doesn't follow it up. Nor does it pause to remark on unusual juxtapositions, because the unusual is what it is geared to recognize, without thinking about it. It dispenses with hierarchies of importance, since they are constantly changing according to where you are and what you need. The vernacular glance sees the world as a supermarket. A rather animal faculty, it is pithy, shrewd, and abrupt, like slang.

Its directions are multiple. Up and down (elevators, overpasses, bridges, tunnels, activity above the street and below it) are as much a habit as side to side. The one direction it doesn't have is distance, or the perspective distance gives. Everything is close up, in transit. Its disorder needs no order because it doesn't require thinking about or "solution." What relationships it perceives are provisional and accidental. The vernacular glance is dumb in terms of what it can't do, but extraordinarily versatile in dealing with experience that would be totally confusing otherwise. It can tolerate everything but meaning (the attempt to understand instead of recognize) and sensory deprivation (voids and absences). It is superficial in the best sense. It is very appropriate for looking at Rauschenberg's work.

Indeed, it is possible to see all Rauschenberg's work as a vernacular continuum. The chair, the goat, the tire, the ladder, the eagle, the Statue of Liberty, Kennedy, the Rokeby Venus, the helicopters, the birds, the keys, charts, diagrams all stutter by like scenes from an

201

unedited day. For the fundamental emphasis in Rauschenberg's work is process. Its implicit, often explicit, medium is time, an emphasis that increased as his work gained maturity around 1955-1956, leaving behind the early sense of a diary (orthodox collage of personal material) for lumps of information, globs and drips of paint, and common objects, which remain open, refusing to close the psychological gestalt. It is this lack of closure that indicates process. The slight discomfort in perception, refusing to settle, is exactly what deposits the work in its most appropriate context—something one scans, sorts, recognizes, briefly wonders at, and moves on from. What museum display does is check this process by modes of what we can call museum perception; the history of Rauschenberg's work in the past decade is the wrestling match between the modalities of vernacular and museum perception.

One accepts anything in a museum because one sees it with one's glance, as it were, in quotes. Specimens of past perceptual shock are fossilized, not because they are in a museum, but because of the fallacies of fifty years of art education. The problem in a museum now is to see disparity, disorder, varieties of order, that is, the conventions of "art display," as clearly as we see those of the individual work. We used to be instructed in the etiquette of vision, on how to purge ourselves of the everyday to become sensitive to the dialectics of form. Indeed, this idea of "purification" is carried through in the immaculate spaces of the modernist gallery. Returning to life, outside the museum door, we could become aesthetes manqués by civilizing the raw with our perceptual idealism. Now this mode of perception, inevitably connected with social and aesthetic élitism, has been mugged by the competing modes of vernacular perception: movies, television, advertising, etc. Rauschenberg's work attempted to bring these modalities of perception into the museum, and he couldn't get them very far past the door. The museum took on all the "swinging" trappings, but maintained its essential conservatism. Not that that was a bad thing. But that is another issue. The point is that more than most art in a museum, Rauschenberg's work

requires a strenuous effort for recovery.

But this is simply part of the task of recovering art for each generation, the perpetual salvage without which neither history nor the present are properly served. That this is not fully understood draws on museums a lot of criticism, but then museums hardly understand it themselves. There's nothing fundamentally wrong with the idea of a museum; you have to keep things somewhere. Caught in the midst of this process, however, Rauschenberg's works reveal predictable paradoxes and some unpredictable themes. Unrewarding to full contemplative regard, they are best apprehended by the casual glance. Seen that way, their internal relationships hardly exist, though the museum-trained eye invents these relations when given time. As the first glimpse is lost, the work unashamedly begins to proclaim its Cubist origins, and at this point formalist interest begins to wane.

But the unresolved images and objects begin to force a struggle against this reading, for they refuse to reside easily within the Cubist context. The images and/or objects do not suggest propositions to be solved, but appear as aspects of process. They contain, or indicate, no solutions, engender no enigmas. Nor are they absorbed into the picture as shapes or forms; indeed, they continually resist any such transformation. They force a steady back pressure against the Cubist readings in which they reside. We are presented not with a criticism of a style, but its relegation to just "doing something," like the nail holding the picture up. Cubism is as cavalierly treated as the objects themselves. It's just to hold the picture together. This is just as much a demythification of a high style as the far more frequently cited demythification of Abstract Expressionism. Abstract Expressionist facture here just "does something" too: It inserts the literal signatures of process, cueing the objects, linking up with their dissociative version of process, its drips frequently locking in components of the surface in such a properly mundane way that Jasper Johns calls them Rauschenberg's "hinges." In a dissimilar but related way, Davis also gave Cubism this vernacular accent.

Rauschenberg's usage of Cubism signifies a theme we have been unwilling to recognize. Formalist history is based on the persistence of Cubist readings. But it is virtually impossible to use multiple forms without putting one thing in front of another, or at least setting up figure-ground relationships. After the achievements of color-field painting, this issue is no longer an urgent artistic "problem." Problems in philosophy and art share this: They remain problems only as long as they are a rewarding source of energy. They lose their influence not because they are solved—they never are—but because they go out of date. Cubism, as a point of reference in "relational" painting, no longer, as Irving Sandler pointed out, carries the rhetoric it once did. It has simply been absorbed as an art historical "given," and the modes of perception it encouraged are somewhat anachronistic when applied to much post-color-field art. Rauschenberg's handling of Cubism remains one of the most important hidden aspects of his work. Just as the museum-broken eye ignored the modes of vernacular perception his art introduced, it remained blind to the fact that the same vernacular had been extended to Cubism itself.

IV

The charges brought against Rauschenberg's art all have some truth in them. It is a fundamentally conservative art in its forms; but is conservative still a pejorative judgment? It is sometimes too tasteful, taste being an obstacle the artist hasn't always successfully got around. The "warmed-over Schwitters" accusation is more difficult to dispose of. But the weakness of all these charges is that they are made from an aesthetic base the work implicitly questions by its cheerful existence. For it does not "ask" such questions with the sensitivity to "issues" that certifies the works' seriousness. Nor does it use the proper conventions to which we have become accustomed in entering a dialogue concerning matters of ideological moment. This is an essential of modernist deportment. Big questions should be asked with the proper high seriousness.

The glee with which the Schwitters charge was made is a parable of the jealous desire to devalue Rauschenberg's work. Rauschenberg had already provided a model of the occasion in the two "identical" paintings *Factum I* and *Factum II* (1957) showing how different things can look the same and similar things can differ. The differences between Schwitters and Rauschenberg are at least as remarkable as the similarities. Schwitters' work resides with perfect ease within the Cubist dialectic of which it is an exemplar. The common objects are carefully transformed through placement, painting, and juxtaposition. One sees the total work first and last. Within this suave general resolution, the tickets, print, images, etc., are released slowly. The entire work is in transit in an opposite perceptual direction from Rauschenberg's. The consistent, close-up reading that is encouraged after the work has superbly legitimized its materials tends to be a separate experience that informs the first, until one eventually withdraws again to savor fully the legerdemain. There is a clear sense of scale in this process. Parts relate to the whole in ways that clearly articulate its Cubist framework. The sense of process is mostly halted, apart from intermittent runs of wit, which include punning with Cubist language in a way that is high style and epigrammatic—and very different from Rauschenberg.

The scale in Rauschenberg's work is imparted by the categories of image and their size, and also by the quota of action or process they contain. The relation within and between these categories also monitors the scale: The mosquito is as big as the helicopter, the Statue of Liberty may shrink to smaller than a key. The watcher is wrenched by near and far, by up and down and upside-down. The first glimpse is succeeded by reading, and the reading, like a movie, switches intimate detail to infinite distance in a flash. Thus, depending on which convention of looking the viewer subscribes to, he has to choreograph a kind of abrupt, discomforting dance, or keep the picture at a distance, forgetting his body. The first is museum-watching; the second movie-watching. It is part of Rauschenberg's strategy to mix these conventions of looking and make

them part of his subject.

Tellingly, the pictures without photo-derived images are rather flat emotionally and seem uncertain of the viewer's size or posture. They don't allow Rauschenberg to conduct his highjinks with something that, for all his apparent clowning, he believes in profoundly: the integrity of the picture plane. His ways of breaking it with a deep image, or of transgressing the edge with a stuffed bird instead of a shaped canvas, disguise profound formal insights. Similarly, his way of connecting the wall with the floor, through a chain, rope, even a chair (not too successful), shows a wily sense of surface—the floor which the flatter pieces push against, submerge in, or glide along. Again these formal statements are made with deprecating informality.

But it is through the shuffling of categories, the redealing of sequences, the sloppy permutations and apparently careless interference with the individual images that his works retain their energy. The categories, as with a TV game show, can be continually reshuffled and reread to cut across each other. Athletics: football, running, swimming; Flying: mosquito, helicopter, bird; Space: rocket, nose cone, parachute; Art History: *Rokeby Venus, Venus with a Mirror,* the profane side of *Sacred and Profane Love*; Celebrities: Kennedy, Khrushchev, Statue of Liberty; Personal Effects: hat, newspaper, letter, key, tie; Domestic Objects: ladder, oranges, chair, Coke bottle, lamp, glass, clock; Animals: goat, hen, eagle; Transport: truck, clover leaf, sailboat; Tracking and Locating: radarscope, charts, diagrams, calendar, dials, arrows, directions, hand taking a pulse.

Cross-referencing these categories can imply themes, and the best work does this. Work that confines itself within a category makes its theme too obvious, as, for example, in *Express*. Cuts across these categories create not problems for iconographical solution, but a certain dissociative tone enlightened by wit, whether formal or verbal. Rauschenberg's wit, a large subject, is more sprightly than brilliant, but it has its modest epiphanies. The "One Way" sign in *Choke* obviously comments that one direction is as good as another (a point brought home by the two signs going in impossible directions), or on the fact that this is one way to make a picture, and shows that one way can be, indeed has to be, ignored, bringing in the sense of stopping short, or choking, as the word goes, under high pressure, or speeding up by pulling out the choke, as in a fast start. This kind of thing goes on interminably. A kind of staged vaudeville, it is the most accessible and least impressive aspect of Rauschenberg's wit. It can be read across categories in the work, and such occasions insist on process.

These themes, which run through Rauschenberg's work, are brought home in the *Dante* illustrations. The thirty-four drawings of the *Inferno* are his only sustained series. Significantly, they are about a journey through a nether world between the spiritual and the secular. As Dore Ashton points out, it is proper that the poet who wrote "In Praise of the Vernacular" should be illustrated by the artist who used the daily newspaper to find his cast of characters. Dante, the witness and narrator, is always in scale, measured by the charts that abound in Rauschenberg's work. The face is often, in typical Rauschenbergian fashion, occluded to encourage the nonspecificity that denotes the only available identity in his universe. Virgil is more labile, switching from a baseball umpire's uniform to a spaceman's. The remarkable reading Ashton proposes for these works— again the film and montage analogy is put to work— gives perhaps our clearest insight into Rauschenberg's "process" thinking.

Themes are carried through, relationships established, the sensorium coded and literalized, multiple events cross-referenced horizontally and vertically in a way that doesn't transgress Rauschenberg's dissociative principles. This series suggests similar kinds of reading for his other work, which could, in my view, be overdone. The value of the series in Rauschenberg's history was that it disciplined the somewhat capricious nature of most of his previous enterprises. It kept his inventiveness literally within bounds, within the picture plane, forcing more testing solutions. It also forced a continuity of multiple themes—or categories of image—which can

be followed through all Rauschenberg's work, as well as within each picture. Again we are returned to that conflict between the filmic and the pictorial. In *Barge* (1963), this confusion was brought to a head, and so offered for examination. At six-and-a-half feet high and over thirty-two feet long, *Barge* refuses to submit to the single glance, but encourages a reading from left to right, like a vast sentence or, more accurately, a filmic series, which the images themselves, grainy, gray and black and white, obviously invite. Most of the images, traveling from right to left, encourage this, as does the empty space at the start. The super-Cinemascope format can be read as a well-stuffed continuum, an image of the process from which Rauschenberg clipped numerous individual pictures. It contains many of his categories of image: the box, a sign for space, city, sky, sport, a shower of paint, boat, clover leaf, truck, Rokeby Venus, radar, nose cone, water tanks, bird, ending, humorously enough, with a key.

The conflict between filmic and pictorial space is clear, I think, in the radar/clover-leaf area, where too much is going on, leaving the surface confused. This is a conflict between process and image, even if one grants that the images have dispensed with any hierarchy of importance, and don't need to be "justified" by composition. Situated halfway between spatial and temporal conventions, between two aesthetics, *Barge* illustrates a crisis in Rauschenberg's thinking, from which he retreated back to painting rather than forward to performances and literal time. The pressure against pictorial conventions occurs intermittently in Rauschenberg's career until 1965. Despite the hubbub to the contrary, he deeply respected these conventions, had indeed an ingrained conservatism that has not been understood. One might have expected him to abandon the picture plane for environments far earlier in his career, but his objects never got too far away from it. This powerful, ambiguous, often reluctant fidelity to the picture plane as an arena whose conventions defined his departures from them, identifies the picture plane as the central fact in Rauschenberg's career, as central as for any of his "pure" painting contemporaries.

Before continuing with comments on the picture plane in Rauschenberg's work, one should acknowledge that since 1965 Rauschenberg's achievements have been compromised by an unfortunate liaison with art and technology, between which the gap is, if not wider, certainly more uncomfortable than between art and life. But Rauschenberg's performing career is full of remarkable moments, and it has been cruelly downgraded in the hostile atmosphere of the post-Venice success. The kinescope of *Linoleum*, a 1967 performance, consummates one aspect of Rauschenberg's thinking. It is also one of the great films made by an artist; most unfortunately, only a fragment of it survives. Without cataloguing them, multiple processes, with different rates, are juxtaposed, superimposed, and separated, profitably blurred by the grainy kinescope surface. These processes, themselves confined within a process situation, engage in mutual definitions which, encouraging the fragility and flatness of the shadowy image, begin to recall some of the pictorial conventions left behind. In terms of "mediumizing" between art and life, to use Mary Josephson's idea, it is one of the most consummate of Rauschenberg's achievements, all of which are defined by temporal signatures. Mediumizing of its nature glides and stumbles across temporal conventions; it attempts to escape them by inventing delays, speed-ups, lapses in process, but always ends up defining itself. Most but by no means all of Rauschenberg's confusions disappear when one realizes that mediumizing leaves the work open to the future—indeed, depends on it, not for completion so much as for energy. This openness, this invitation, has not been acknowledged or met in Rauschenberg's case because it causes a slight reversal in that drift of the work toward "art," that is, its historical completion. It is the tropism toward life-experience rather than toward art-experience that keeps the readings open. More than most work it will have its ups and downs, depending on what's going on outside the museum doors. It is like a quasi-classic book that depends on the social situation to get it off the shelf.

This understanding of openness, medium, and process is necessary if the most important—and hidden

(continued on page 225)

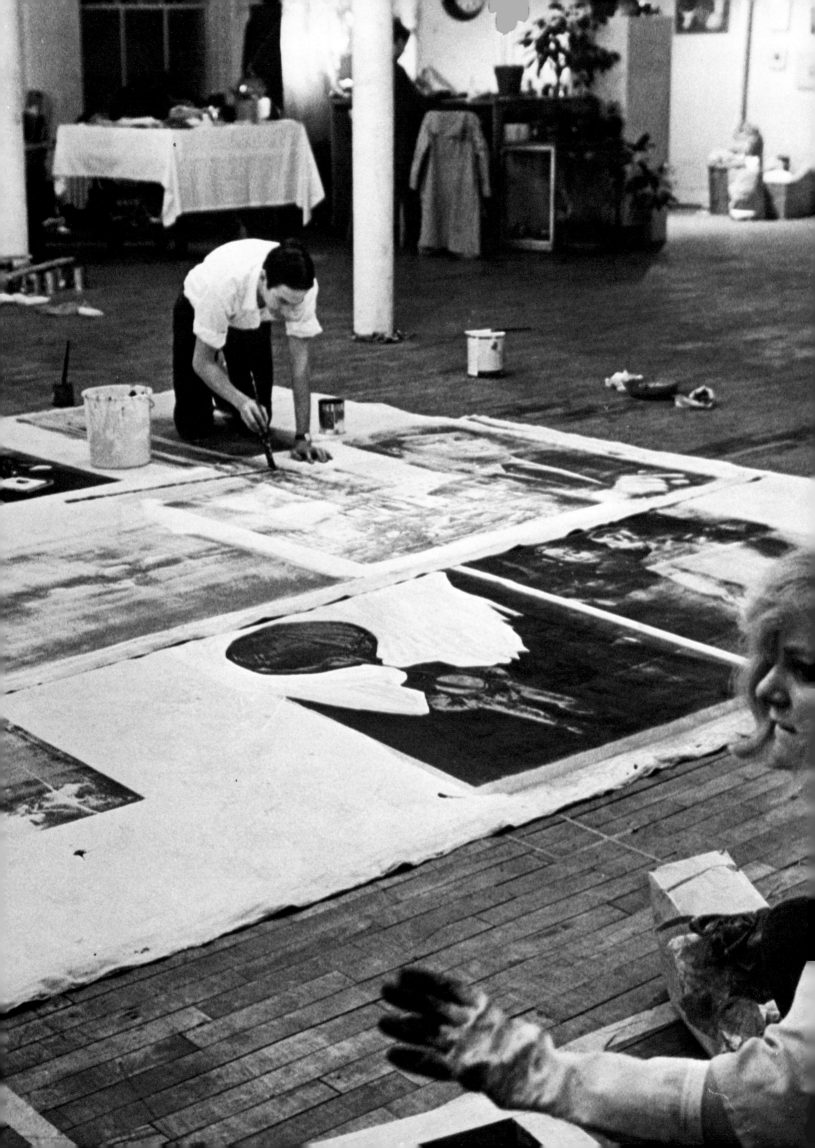

Studio, New York City, 1963.
Above: In studio, *Stop Gap*: oil
on canvas, 58″ x 40″,
1963 (Anonymous collection).

207

femme triste

RAUSCHENBERG
XXXIV DRAWINGS FOR
DANTE'S INFERNO

Preceding pages: Studio wall, New York City, 1963. Appearing on page 208 (top to bottom and left to right): Sue Weil and (to its right) Christopher Rauschenberg (age 5), Oyvind Fahlstrom, Frank Stella; sketch for first alphabet painting by Jasper Johns, Willem de Kooning, John Cage score, Magritte drawing; Jim Dine, Magritte gouache, Elaine Sturtivant. On page 209: Magritte, Merce Cunningham advertisement, Rauschenberg (*Listening Sound Piece*); Magritte lithograph, Rauschenberg (two); unidentified, Jean Tinguely sketch for self-destructing machine. Right: Performance with dancer Alex Hay, Surplus Theater, New York, 1964. Below: Backstage, "The Construction of Boston," New York, 1962.

Opening night, Jewish Museum show, New York, 1963. Bottom left: Profile view of *Canyon*, a combine painting. Bottom right: Part of *Monogram*, a construction.

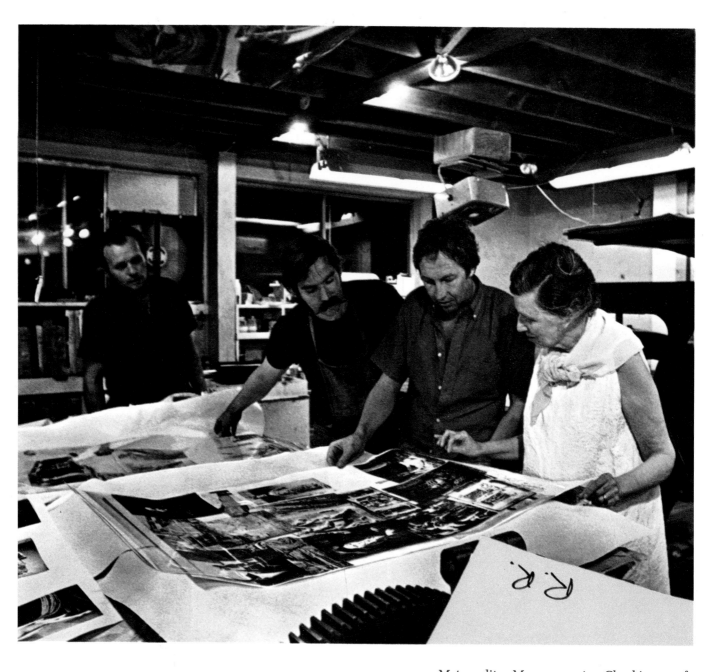

Metropolitan Museum poster: Checking proofs
with Zigmunds Priede and Tatyana Grosman, Islip, New York,
1969. Right: Inspecting lithographic film.

At Tatyana Grosman's, 1969. Above: Rauschenberg's press, Captiva, 1971.

Captiva, 1971, with Hummingbird Takahashi. Right: *Cardbird (Plain Salt)*: cardboard and plywood, 80½″ x 37″, 1971 (Martin Peretz). Page 218: *Yoicks*: oil and collage on canvas, 96″ x 72″, 1953 (Whitney Museum of American Art). Page 219: *Interview*: construction, mixed media, 66″ x 49″, 1955 (Count Panza di Biumo, Milan).

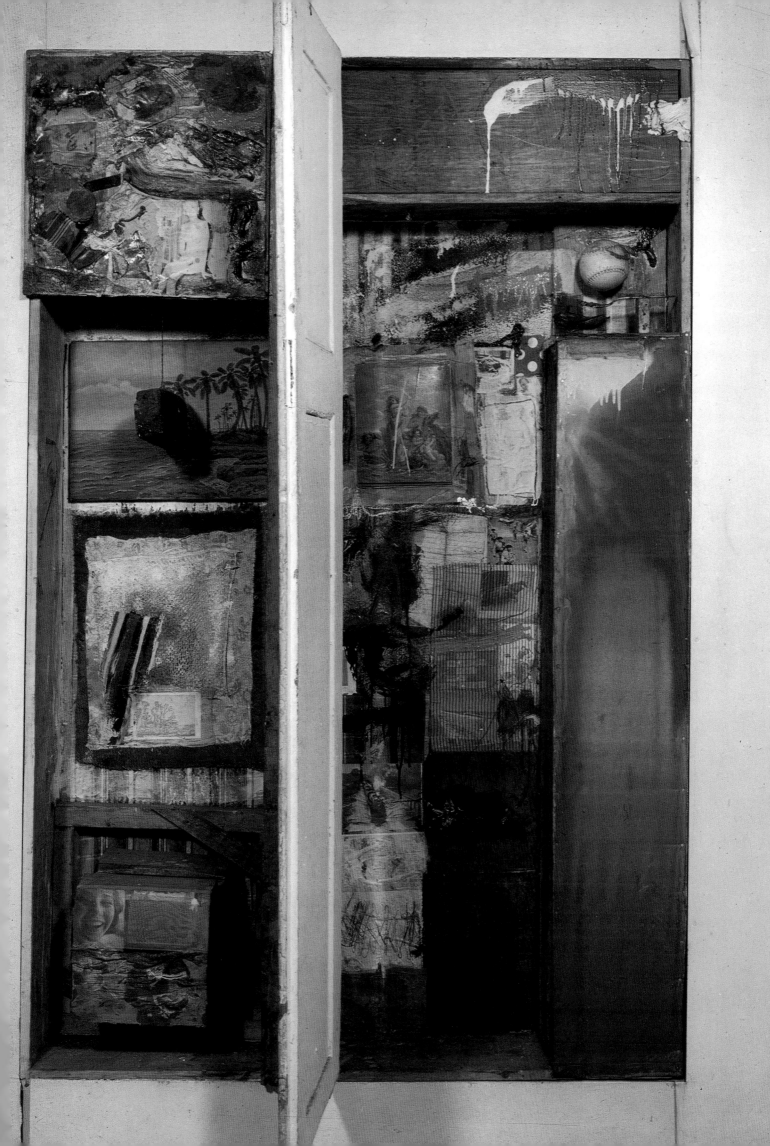

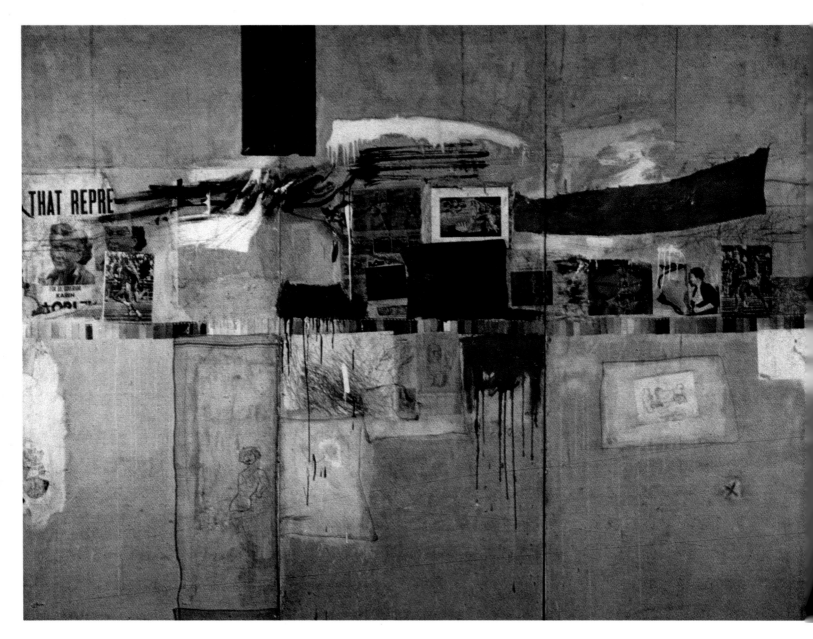

Rebus: combine paintin
94″ x 144″, 1955 (M/M Victor Ganz
Right: Bed: combine paintin
74″ x 31″, 1955 (M/M Leo Castell
Overleaf: Charlene: combi
painting, 89″ x 112
1954 (Stedelijk Museum

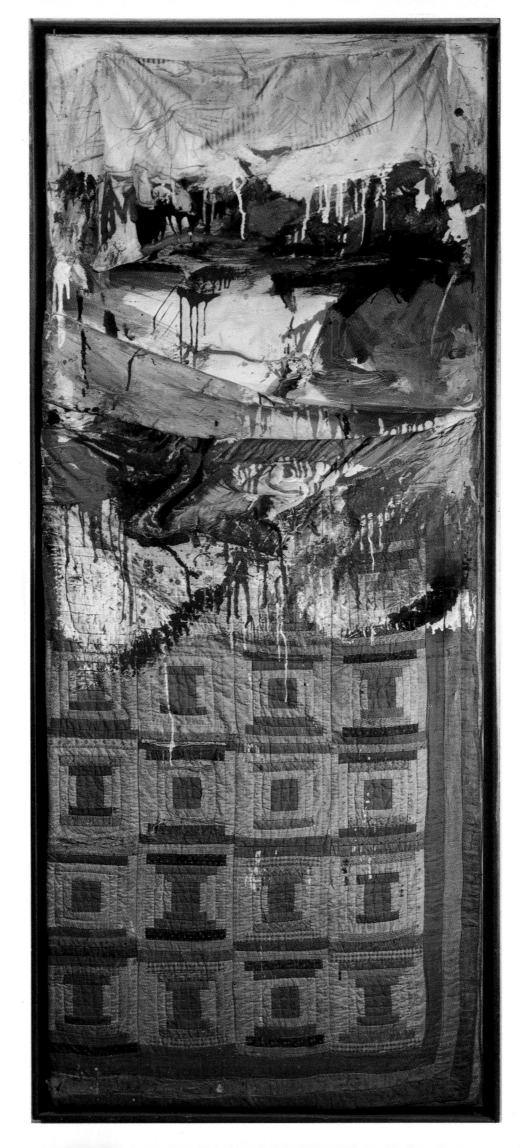

221

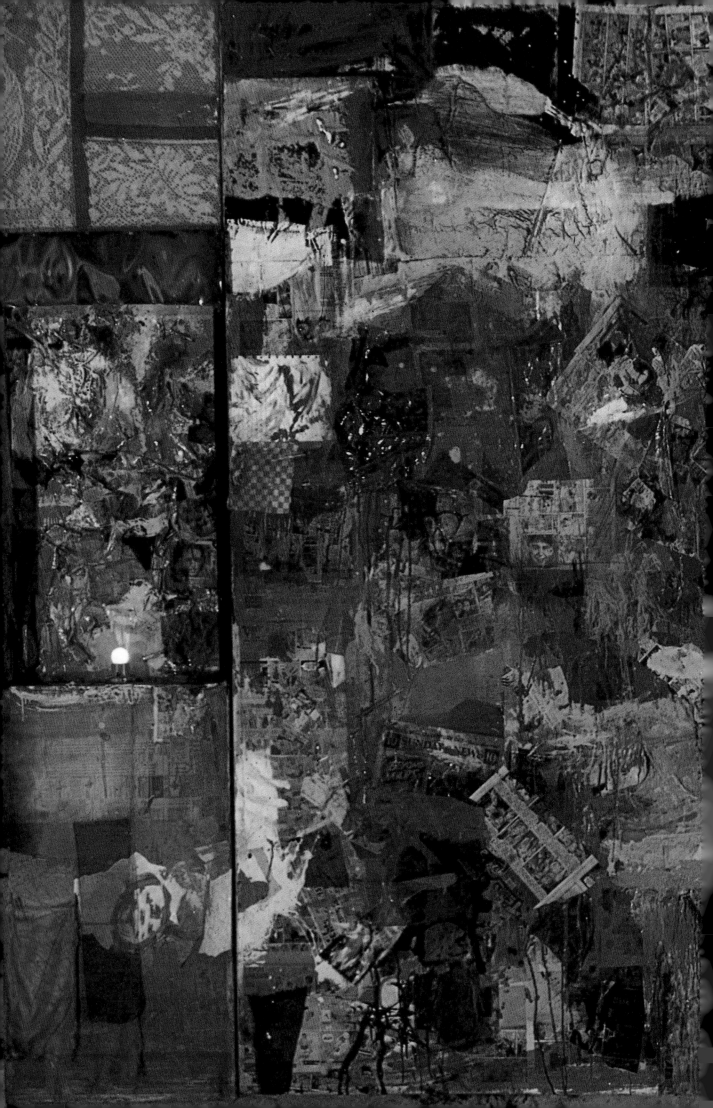

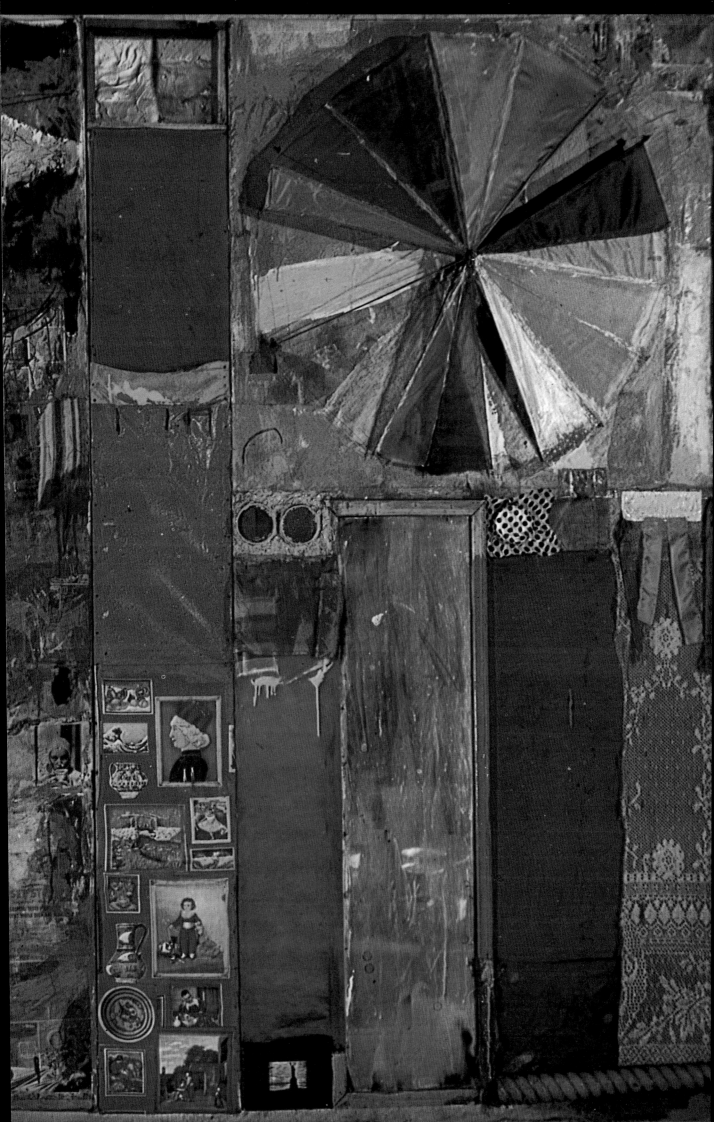

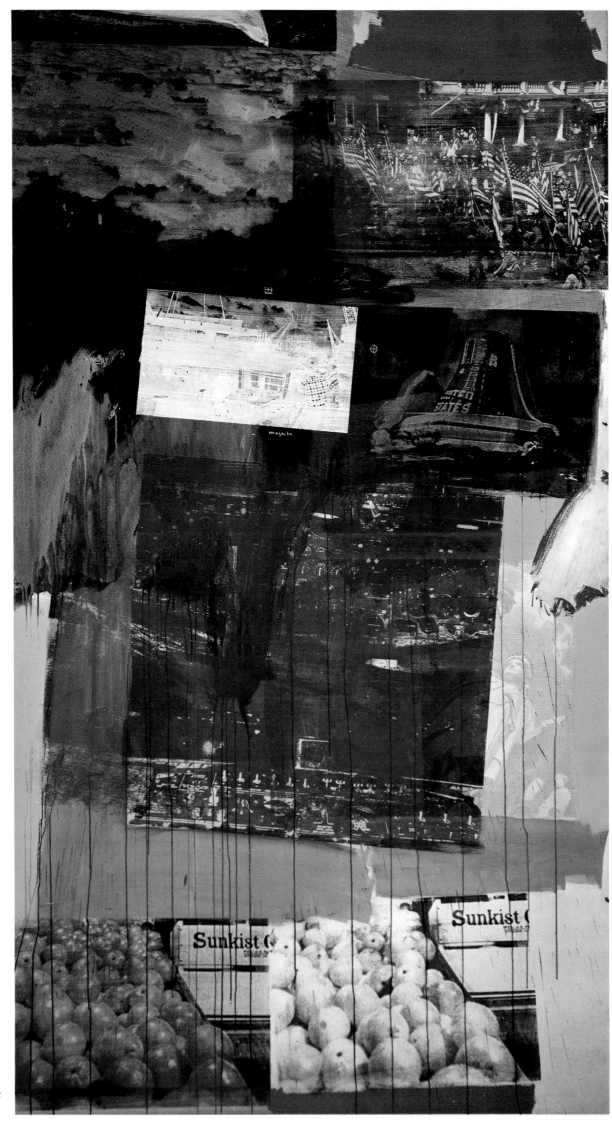

224

—aspect of Rauschenberg's great period between 1955 and 1965 is to come into focus. The picture plane has already been described as the locus where processes are halted, indicated, displayed in images that range in their manner of presentation from the literal to the altered, to the mediated. This mediation, by the way (photograph, newsprint, silkscreen, etc.), is usually taken as an opportunity, obligatory in the sixties, to discourse on distancing, checking the steps from the original "reality." This misunderstands the nature of what we are pleased to call reality, which, because of the pervasiveness of mediated images, is no longer the point of stable reference. Reality itself mediates these images rather than the other way round. They look more real every day, reality less so. Our perceptions, trained on such mediations, now find *them* the norm.

This truism means that the vernacular eye, despite the conservative mood of the seventies, is still our main visual guideline in looking at Rauschenberg's work. So all those mediations, transfers, reversals, etc. in that gorgeous rainbow color of the silkscreened paintings (1963-65) become matter-of-fact—literal, immediate, sudden. If reproductions can so cosmetize the old masters that the originals can't compete, then these paintings can compete with four-color glories and locked-in fine tuning. Obviously this mode of perception loses us some discriminatory subtleties, but Rauschenberg's and Warhol's pictures are the only major art that acknowledges its existence, and as such will have to keep on coping with the misunderstandings of popularity. But how does all this relate to the picture plane?

It confirms that Rauschenberg's images are all literal; symbol and metaphor are not their mode of existence. Things shuttle in and out of the picture, break the surface, poke over the edge, drop onto the floor, as if the picture plane were a kind of flophouse, in its evocations of drawer, window, closet, cupboard, door. But all these are old-fashioned analogues of the picture plane, despite the cluster of major images Rauschenberg extracted from them. When the flat silkscreened picture plane, with a similar energy, chews up and disgorges a glut of images, it sets in train another series of analogues: front page, poster, magazine, movie screen, and, in its blithe ignorance of moral content, TV. It is a space that so mutates and changes one forgets the picture plane for the analogues that replace it. The dialogue between the conventions of these image givers and those of the picture plane traps the main content of his work. In the midst of the unceasing literal images, the picture plane is the only rhetorical presence. It is the only metaphor—an extremely powerful one—in all of Rauschenberg's literal universe. This again bears Rauschenberg's work toward life.

This places Rauschenberg's work on an interesting historical watershed. For the picture plane is displayed not as literal fact—the main line of modernist thinking—but as supreme fiction. This both celebrates and destroys it, makes it disposable, but also renewable. How exactly opposite from Johns, who literalizes the picture plane, so that the marks and objects on its surface can echo and re-echo in myriad systems of allusion that ventriloquize its modernist pedigree; while Rauschenberg, with vulgar energy, sets all his facts on a metaphor, a fiction of other places, other times, many of them clearly in the future.

Johns' voice is at least *there*, accessible even in its voids because modernism has so rehearsed our perceptions that we can track him anywhere he goes—not because it is easy (it is very difficult), but because we know the borders of his territory. But in Rauschenberg's case, literal process—time passing—blocks those "art" allusions and by virtue of that powerful metaphor throws our pursuit back out into the real world. Rauschenberg's voice is inaccessible to formalist pursuit, and its transmission is almost obliterated by noise. Like the gapped voice from the sound track of one of his performances, it is self-occluded. If the voice is so dispersed, what of Rauschenberg's myth? Despite his celebrity, that fabulous personality of the late fifties and sixties never engendered an effective myth. Perhaps it awaits us in the future, when the conventions of the media that compose his single metaphor are displaced. How could he have a myth, when what he presents to us so overlaps our secular existence?

Whale: oil on canvas, 108″ x 60″, 1964 (Joseph H. Hirshorn).

WYETH

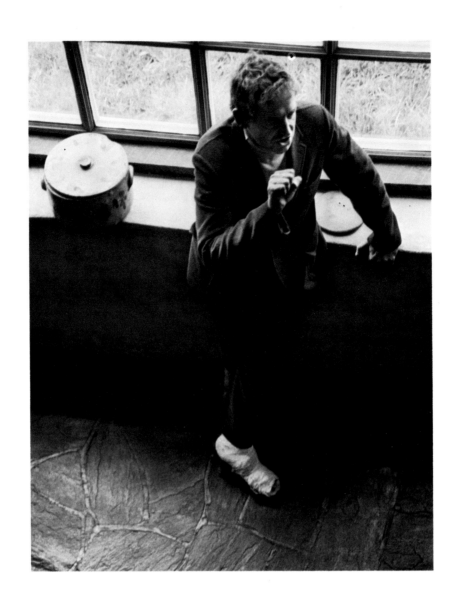

Andrew Wyeth: Outsider on the Right

As Andrew Wyeth became as much a celebrity as Henry Fonda (who admires and imitates his work), his reputation as an artist declined to the point where writing about him was an eccentricity requiring explanation. For most of us, his stardom has cannibalized his art to a degree unprecedented by any other artist with pretensions to seriousness. Informed opinion, when it thinks about the matter at all, has removed his art from its genteel inheritance of Eakins and Homer, and relegated it to the company of such an amiable myth-monger as Norman Rockwell.

Not all this is due to disenchantment with the art itself. Wyeth's prices have been engineered to extraordinary heights. Reproductions have saturated our tolerance but not the market. Every aspect of his life has been endlessly celebrated and whatever he has to say has been written down and turned into best sellers. Perhaps this is nothing more than the media testing his commercial viability, as they do with every successful artist. That viability depends on what public expectations the artist can confirm.

Wyeth's success, within which he apparently resides easily enough, arouses in the "genuine" artist a contempt that is obligatory if he is to maintain his intellectual respectability. The artist-hero is expected to be so troubled by his success that he reinforces his myth by rejecting it—thus raging, as it were, against the bars in that zoo to which American society generally relegates its cultural activities. Success cuts off careers in America for a very sharp reason. It makes the artist part of what he has based his art on rejecting: the values of the majority and the commercial engines supporting them. The divided mind and the aborted career usually have been attributed to the crassness of American society or some such easily apprehended generality. More acutely felt by the successful artist or writer, however, may be the closing of the ranks among his colleagues, and an exclusion, prompted by envy and intolerance, that amounts almost to an expulsion. While some American writers have exhibited an appetite for the sillier aspects of superstardom, or have been ill-equipped to deflect it, we have underestimated the

attrition caused, not just by the public, but by colleagues. To succeed in America may demand more toughness of spirit than to fail. Few manage to have careers both successful and long.

If Wyeth is an industry, who are the consumers? In those precincts where the products of the Picasso industry are *de rigueur*, Wyeth incunabula are something of a social liability. Those who share Wyeth share values we can identify with some confidence. For the members of this community—it is nothing less—the concept of "nature" is still a living force. Admiring stability and order, they are suspicious of the new, distrusting unorthodoxy but not eccentricity. Subscribing to a belief in human goodness, they can be dangerous when that belief is threatened. Along with nature, religion and morality are real forces in their lives, and a great deal of their energy is devoted to sustaining all three as values which should monitor the evolution of the social order. They maintain a firm belief in the future, and this optimism is as powerful a force in conserving their traditions as is the past. Evil tends to be rationalized as a failure to live by the letter of these beliefs, and so reinforces them. They are not unlike Wyeth himself.

While the gap between the avant-garde and the public has accustomed us to amusing kinds of leap-frog and acculturation by myth, no such gap exists between Wyeth and his audience. Though his community's values appear to many to be, like Wyeth's visual conventions, obsolete, we must look for the energy sustaining an "obsolescence" that is taking such a long time to go away. The source of this energy is in the powerful resistance to change, in the fierce conservation of the values that give meaning to existence. In its stability Wyeth's audience could be called, no matter how sophisticated its members, *primitive*. It shares superstitions, beliefs, icons, a circumscribed world-view, and ritualized modes of releasing violence. It is in fact a primitive community within, or side by side with, a progressive-destructive one, and appropriately it is served by an artist who, no matter how sophisticated his means, is primitive in his thinking. Wyeth's

communication with this audience is so instantaneous that it makes the McLuhanesque idea of viaticum via media seem a little forced.

Wyeth's art, then, functions socially in a way that both avant-garde art and Russian realism might envy. At the Wyeth retrospective at the Whitney Museum in 1968, one of the sights was not the art, but the audience entering the museum with the same settled expectancy as crowds about to view Lenin's tomb. Watching the members of that audience communicate with the pictures and with each other, it was obvious they were rehearsing the values by which their lives were lived. In this context, the individual works of art became icons for a way of life. Insofar as they assemble the parables of the faith, Wyeth books assume a certain sanctified character in the homes of this audience. At the root of this is a nineteenth-century idea of nature as a moral force, identified with nationalism, and providing a Holy Book, as Barbara Novak has called it, for meditation and interpretation. This ideology, implicit rather than explicit in Wyeth's art, is what provokes such hostility from the aesthetically sophisticated audience, in exactly the same way his audience responds to avant-gardism.

So Wyeth communicates with his audience, numbered in millions, with an ease and fluency that amounts to a kind of genius. Sharing their beliefs, he is able to inflect them endlessly by giving the audience, like Billy Graham, a sense of community *and* individuality, stimulating a buried imaginative life while leaving the surface undisturbed. By fulfilling a communal need while being faithful to his own interests (in a context of shared beliefs), Wyeth's voice and myth echo each other in a way unknown in modernism. Truth to experience is the audience's criterion, checked by reference to nature, and if the experience itself is banal it remains undisturbed by the art. What the audience sees is not process or formal deftness, but an image, all at once. In this sense, modernism's increasing narcissism with respect to its own means measures the break-up of a community and the rising arc of the artist's alienation.

Wyeth and his stable community, sophisticated primitives sharing their transcendental populism, arouse prejudices rooted in a conflict underlying more obvious skirmishes—the conflict between two ways of life, the rural and the urban. Modernist art is urban art and it has incorporated the pastoral idea in various disguises, often hiding in its abstract facade a nostalgia for landscape. In modernism the landscape has been painted by urban creatures knowing nothing about it or the rural life. Impressionist landscapes are as neutral as Cubism's guitars. Nature becomes a perceptual laboratory in which light and color disengage themselves from representation to become the chief actors. The landscape—even Expressionist landscape into which violent emotion is projected—is drained of *its* violence. The Darwinian struggle is transferred from the landscape to the city, and this transposal of the rural mythology is an unexplored part of the urban mind. That mind, however, while it accepts the urban view of the landscape (from Fairfield Porter's sunny idealizations to Hopper's bald realism), will not accept the rural view—nor is it equipped to read it, or perceive in it anything more than clichés identified with forms of nationalism troubling to the liberal spirit.

Thus Wyeth, the only genuine *rural* artist of the slightest consequence, is attacked with a violence far beyond the usual etiquette of critical disagreement. The hatred of Wyeth in informed circles is matched only by his audience's identification of abstraction with communism. For this reason we can couple two artists who epitomize urban and rural mythologies—Warhol and Wyeth. The two Andys, though separated by a Grand Canyon of irony, traffic in great images rather than paintings. Both tell more about the urban and rural milieus than any other American artists. Both arouse a violent prejudice aborting them out of art history into social history and legend. Both, totally obtuse, share mirror-image varieties of innocence: Wyeth is a sophisticated primitive; Warhol, like Jarry, a primitive sophisticate.

Wyeth has inherited in his oblivious way a nineteenth-century apparatus that one need not trace further than Constable in painting, Coleridge in literature, transcendentalism in philosophy, and the *einfühlung* of

Theodor Lipps in aesthetics. Nature attitudes, of course, have become a shrunken repertory of clichés. Wyeth uses them as if he had never heard they were clichés, and thus—in a way different from, but almost as effective as, ironic quotation—he forces us to acknowledge the truth they inter. Very offensive to modernist sensibilities, this.

Modernist art is placeless—a state of mind knowing no borders, communicating with ease through formalist Esperanto. Rural art is inseparable from place, and there is pathos as well as country cunning in Wyeth's devotion to two small reservations, Chadds Ford in Pennsylvania and Cushing in Maine. These reservations (surrounded by neon and superhighways) have an air of preservation that makes nature artificial, and Wyeth exists in a milieu as sealed in its way as a Cornell box. He is primitive and ideographic in a way unacceptable to those who dote on Grandma Moses; and at the same time a provincial—that is, one baffled by the idea of progress. Thus his art resists a development it appears sometimes to seek. The luxury of "periods" is denied it. This lack of progress, however, is a way of coping with the outside—urban—world that would destroy his raison d'être. Similarly, his rigid curatorship of the two areas that authenticate his work, and his fear of moving outside them. When the subject of realist art disappears, it becomes less understandable than the most rigorous abstraction.

To judge Wyeth, then, in terms of progress, change, invention, self-consciousness, is to look for an artist who isn't there. "The convictions to which he clings with naïve integrity keep him from engaging with the variousness of life, and his art tends to become a vehicle for rehearsing settled values. His skepticism shares in the qualities of village faith; his belief as to the unavoidability of loss becomes a simplistic inversion of Victorian optimism. The corroding ironies, the scathing assaults on untested convictions, the playfulness and deviousness of mind we have come to expect in modern art—these are not here at all—not here at all." This is Irving Howe on Thomas Hardy, with "art" substituted twice for "poetry," and the comparison is

valuable. Wyeth and Hardy both know country life. They match up in rural attitudes and in their awareness of a rural world under stress from outside.

They have most in common in matters of description, especially when Hardy's reports have the tang of rural observation: "At the door, the wood-hooped pails, sodden and bleached by infinite scrubbage, hung like hats on a stand upon the forked and peeled limb of the oak fixed there for that purpose . . . the large leaved rhubarb and cabbage plants slept too, their broad, limp surfaces hanging in the sun like half-closed umbrellas." Both emphasize age, textures, and clear focus. Like Hardy, Wyeth tinkers with animistic associations to bring home a description. In describing landscape, both move from close-up to distance abruptly—and back. Traces of human and animal passage (roads, cart tracks) frequently populate bare landscapes; and both return to the country problem of recognizing the familiar disguised by light or distance. A comparison between the famous description of Egdon Heath in *The Return of the Native* and Wyeth's *Hoffman's Slough* exactly underlines their similarities and differences. The feeling, the atmosphere, is remarkably similar, but Wyeth refuses the implications of total desolation by safely sticking a house, like a humanistic thumbtack, into the distance. The pungency of Hardy is inaccessible to Wyeth's comparatively lightweight adventures, but both are extremely sharp observers of rural characters. And under his surface optimism and sentiment, Wyeth's vision is not always settling. As Mark Rothko said: "Wyeth is about the pursuit of strangeness." "But," he added, "he is not whole as Hopper is whole."

Indeed, if one can accustom oneself to Wyeth's sentiment as a form of surface politeness, one can learn to read the sizable brutalities it hides: the casual insertion of deathly signs, the horror as well as the humor in country quirkiness, the panic in empty spaces that point attention to a kind of listening. One becomes sensitized to the scenarios behind open doors, cupboards, windows, simple objects. A pair of boots outside the door: Is he in or out? Has he been hunting? Any sign of dead game? No smoke from the chimney. Has he gone out

again? Where's the dog? That silence. Hope nothing's wrong. Couldn't be. I'll leave a note. Is the door open?

This kind of deductive fugue is a language in which country people are perfectly versed. The voice in their ears is their own. They are accustomed to reading people, objects, sky, and above all strangers, who do not realize that indifferent eyes conceal a hubbub of observation and conjecture, assisted by a silence that prompts the uneasy visitor to reveal more than his speech betrays. This is a protoliterary form that presents itself *visually*—and a closed book to urbanites. How closed is known to anyone who has tried to open it to city eyes. All the events in the country are flashes. The glimpse of red is missed; even when seen it is not recognized as a fox. Eventually the subliminal activities that he cannot see provoke in the inexperienced observer the idea that he is being watched, and this slight threat may sharpen his sight.

What is most true about Wyeth's art is its fidelity to this way of looking, to this internal stream of deductive language country people listen to as they move around. (Indeed, Wyeth's art is a kind of record of that movement. Like country life it is full of the rhythms of *walking*, of perspectives changing slowly with approach and withdrawal, of sudden details switched into distance with a glance.) Unlike any of the other artists in this book, in whom the *idea* of the voice is a significant convention, this rural voice in Wyeth's work is closest to an actual voice, a mode of reading the landscape to oneself from the point of view of a dweller in it. Intimately connected to a way of life, this voice, when deprived of its referent, drops out of the picture, leaving cliché behind. Thus Wyeth's audience is made up of city dwellers who like the clichés, and country dwellers who read his pictures as they read nature and find them true.

So if we speak of Wyeth's voice, it is not just the artist's personal discourse, but a kind of dialogue with objects and nature which his rural audience overhears and recognizes perfectly. At this point one begins to doubt if Wyeth is painting *pictures*, and in a way it hardly matters. For this voice is what makes Wyeth the only genuine rural artist in contemporary art; indeed, in the history of art there are very few. Ludicrous though it sounds, the only time one finds onself listening to this kind of voice is on certain occasions when the Gothic imagination is clarified by Renaissance observation— with Brueghel, for instance. Wyeth's innumerable followers, many of them infinitely more skilled than he, present the simulacrum of nature without the voice— clichés lovingly reinterred. Wyeth thus leads an army of dead men bent on repealing modernism and restoring moral health through the trinity of nature, nationalism, and godliness. Wyeth, who shares their political views, is an outsider aligned on the right against the modernist conspiracy.

Rothko's phrase, "the pursuit of strangeness," catches the key element in Wyeth's voice, the discourse between the observer and a situation that is a form of *expectation*. In the country such expectation encourages intense projections. Each extended sense monitors itself and the others. Seeing becomes a kind of listening. A smell can become a kind of hearing. "I am sensible of a certain doubleness," wrote Thoreau, "by which I stand as remote from myself as from another." Overactive in that country silence, one's senses crawl over and inhabit everything. Strings of association prompt hypotheses, and hypotheses test strings of associations. Identity is somehow translated into the landscape. One becomes all eyes and ears. Such animal-like empathy is also encouraged by what Wyeth chooses to paint: carefully assembled sounding boards for sensations both familiar and unfamiliar, or rather unfamiliar in a very familiar way. The tracks and traces cue the voice in the work, exciting those crackles and rustlings that, for anyone raised in the country, forcefully inhabit Wyeth's pictures, and indeed often stimulate him to paint them.

All this is a rehearsal, in another arena, of Jasper Johns' art, silly though it sounds at first, since Wyeth's nonkosher status disqualifies him from such comparisons. But Wyeth inhabits his art and his landscape in a comparable way to Johns' tenancy of sixties art. And Wyeth engages the rural community in a way not dissimilar to Johns' engagement of the modernist com-

munity. Each questions and watches his own senses, Wyeth in a natural context, Johns in an aesthetic one. Both put the feedback from other senses to work, for Wyeth's traces are not dissimilar to Johns' handprints, scrapings, and echoes of process. Each games with his identity to hide his lack of one. Wyeth's impersonations are often actual as he roams his reservations to find the situation that will respond to his disguise and so remove it. Johns roams the modernist landscape rehearsing its genres of process. Wyeth eventually disappears into the silence of old-fashioned transcendentalism, Johns into the silence of modernist exile. And both are intimate artists who love objects equally well. Despite Johns' formidable sophistication, there is something almost juvenile in his choice of images: maps, drawers, flags, rulers. Formalism has blinded us to the fact that they are often schoolboy souvenirs. Indeed, Johns used modernist process to legitimize his love for them, to make them viable as subject matter.

Objects report on their experiences by showing wear and tear. Wyeth's objects clearly report on country usage, anthropomorphosed by repeated involvement in intimate living habits. Infused with the animism unavoidable from contact with nature, objects develop a physiognomy. When deprived of usage, such objects are defenseless against nostalgia (savoring the past all at once and without effort) and are, except for the most sophisticated kind of quotation (Joseph Cornell), artistically unusable.

For the textures of usage, Johns substitutes the textures of process—modernism's short-term version of history—and thus makes them available for aesthetic instead of casual usage. In their narrow oscillation between objecthood and process, Johns brings his works to a troubling half-life where they are described by self-referential systems establishing an uneasy sense of *place*. Of course, no such sophistication ever touches Wyeth's depicted objects; they are firmly set in place in the rural ethos which assigns to objects hierarchies and categories perfectly understood by the rural mind.

Such a comparison points up the difference between an art in contact with and shared by a society, and art that is not. Wyeth, though not without self-consciousness, is without irony, while Johns' process is mediated through ironies necessary to bring his work into its fragile existence. The question arises whether irony is not a sign of weakness in art, the habit that consumed modernism while providing it with its last energies. (Johns seems to be conscious of this; since the mid-sixties his art has attempted to dispense with irony, thus encountering another set of difficulties.)

However, Wyeth's reportage on textures and appearances, while part of country language, betrays his inability to grasp things though he describes them well. For instance, the beech tree in *Corner of the Woods* is simply a textured curtain behind the figure, remarkably similar to some American primitive paintings. It has no solidity at all. The great boulder in *Far from Needham* has no solidity either, but he has filled in on every dotted line the record of the object's history. He is the object's genealogist instead of its possessor. Though crawling with its past, it is not physically present. The ectoplasmic results can be read as the primitive's conceptual frustration of the provincial's effort to perceive solidity, a conflict that gives at least an interesting tension to such works. The object is situated halfway between solid existence and an ideograph, though that halfway state is disguised in highly sophisticated techniques, and this perilous condition can have a case made for it in, inevitably, literary terms. One is reminded of Rilke in *Les Cahiers*: "... there is almost no space here; and you feel almost calm at the thought that it is impossible for anything very large to hold in this narrowness." More immediately, one thinks of Emerson's "spirit is matter reduced to an extreme thinness." Emerson, of course, is very obliging where Wyeth is concerned.

II

It seems a long time now since *Art News* took Wyeth seriously enough to report on how he painted a picture. Or since George Plimpton interviewed the Sage of Chadds Ford. In those days Wyeth was tentatively indulged as one who might make realism respectable

again, after the aggressive philistinism of American Scene painting and the bitter failure of social realism and the American left in the forties. As an artist with no education in ideas, no ability to handle them, and full confidence that what he does is "better," Wyeth is still a provincial. His celebrity makes it hard to believe, for instance, that when a passage from Wordsworth was quoted to him, he was struck by the passage, but had never heard of Wordsworth. As Lloyd Goodrich has pointed out, provincialism is a valid but not necessarily fatal charge against some American artists. "Many of the strongest, most vital contributions," he wrote, "[have] been made by native artists with no relation to advanced trends abroad. In comparison with these advanced trends, much of this native contribution [has been] limited in artistic concept and language." In the importation of these advanced trends, there were "time lags of a generation or more."

As a rule, the provincial artist functions unquestioningly within limits he has inherited from defunct traditions. It never strikes him to question assumptions he takes as gospel. Part of the pathos inherent in provincialism is watching the provincial "modernizing" what is out of date into something that is also out of date. Wyeth's obvious connections with the nineteenth century are typical of the provincial artist. Copley, whose early work in the eighteenth century derived from seventeenth-century models, is a possible precedent. Intrinsic to this provincial delusion, of course, is a strong dose of sincerity, very irritating to the less simple-minded. Provincialism, as George Kubler has pointed out, is related to replication, and the replication tends to be improved only rarely, "as when a talented pupil improves upon his mediocre teacher's exercise." Wyeth's teachers are in the nineteenth century. He is replicating their example from an illusory base, since the eternal (rural) verities which support his art are highly artificial, preserved in a kind of rural museum which Wyeth preserves further by avoiding the subjects—tractors, reapers, binders, milking machines—that would destroy his convention. He proves that defunct traditions, under certain extraordinary circumstances, are capable of an odd resuscitation.

Wyeth's techniques are uniform and unsurprising, and as Lloyd Goodrich has suggested, may have been grounded in the Pre-Raphaelites he saw at the Winterthur Museum as a boy, as well as in his father's intense training. His limited education did not foster the self-criticism that would have brought all this delicate, obsolete machinery to a halt. The temperas and drybrush—his best work—hold on, with the aid of uniform textures, to the surface of the picture, to the two-dimensional certainty. What are varied are his modes of exciting feeling, of carefully stage-managing his metaphors. But though the approach often appears empirical in terms of feeling, it is accommodated to formulae, particularly of composition. In this we can again see his provincial side coming into conflict with strong primitive traits.

The primitive is incapable of development; the provincial sees his ties clearly enough to the preceding period, and is partly aware that he should conduct some sort of dialogue with it. That is, the idea of development enters here. A further complicating factor is that Wyeth, as a sophisticated primitive, conducts a limited dialogue with the art immediately around him, but in an obtuse kind of way. Its influences are innocent, but not involuntary; for example, the painting Brown Swiss and the study for it colonize Kline's powerful strokes with natural details. This kind of genial assimilation ("Abstraction is the best thing that happened to realism" —Wyeth) is also extended to photographs, where composing is partly a matter of cropping and viewpoint, with empty spaces brought into rather obvious dialogue with off-balance points of psychological focus—though, as Max Kozloff remarks, Wyeth seems to have been influenced by bad photography. But whatever about this, the character of his work receives its definition from the conflict of provincial with primitive traits, and he tries to work out perceptual problems (the provincial's awareness of the "modern" tradition) in a primitive, conceptual way.

So this traffic between the provincial and the primitive, between natural fact and the idea of it,

(continued on page 247)

Chadds Ford, 1964.

Top: Mrs. Betsy Wyeth.
Above: Jamie Wyeth. Right:
Home, Chadds Ford, 1964.

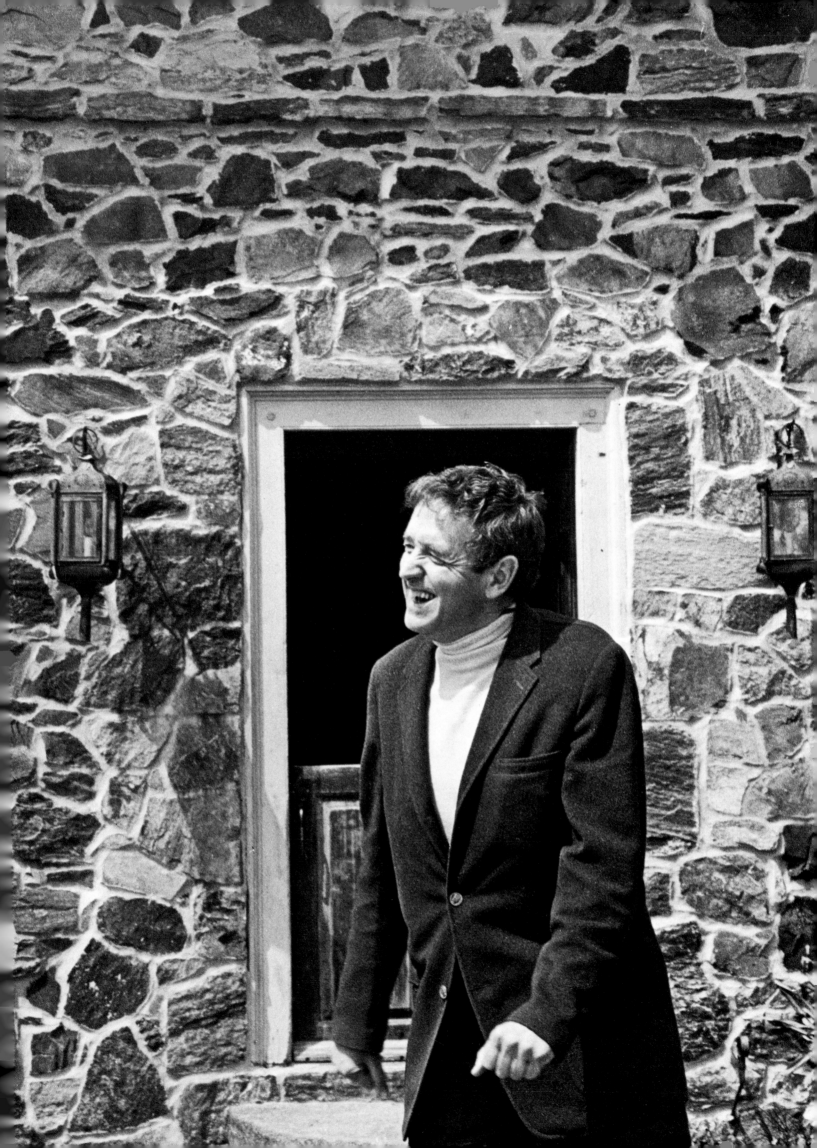

Chadds Ford, 1964: With
Andrew Wyeth's *The Trodden Weed*
(above) and *Brown Swiss*
(top right), and N. C. Wyeth
illustration, *Preparing
for the Mutiny*, from
Scribner's 1911 edition of
Treasure Island (right).

Chadds Ford, 1964: With
Marsh Hawk. Right: *Northern
Point*: tempera, 36″ x 18¼″,
1950 (Wadsworth Atheneum,
The Ella Gallup Sumner and Mary
Catlin Sumner Collection).

Pages 242–243: *Wind from the Sea*:
tempera, 19″ x 28″, 1947
(Professor and Mrs. Charles H. Morgan).
Above: *Hay Ledge*: tempera,
21″ x 45″, 1957 (M/M Joseph E. Levine).

Christina's World: tempera,
32″ x 48″, 1948 (Museum
of Modern Art). Above: Detail.

prompts him to poke through the surface to accomplish his declared aim of grasping the object "out there." Since his surface is obstinately two-dimensional, he pushes painfully at this thin tissue, stressing it enough so that his primitive space occasionally looks quite modern, as his abstract ideographs subvert the realism of his subject. Such a modern "look," however, is coincidence.

He escapes this spatial anxiety by using close-ups, which eliminate the problem of deeper planes. In some of these details he achieves a surprising solidity, coming close to the idea of that "neutral style" posited as a constant response to reality in widely separated situations—the usual example being Dürer's *Piece of Turf.* A comparable Wyeth detail is flatter, its conceptual separation of parts more extreme. Similarly, when the subject itself provides ready-made planes, for example, interiors, he attempts to preserve them like so many cardboard layers and has difficulty making transitions between them. They tend to telescope together, prompting us to read depth into them. Some of his more popular works confuse even these guidelines. In *Chambered Nautilus*, for instance, the planes at the near and far sides of the bed lean into each other, warp the space into incoherence, and turn the picture into an illustration of a mood—one definition of sentiment. The placing of the shell, which is highlighted to attract attention and make its obvious psychological point (the hush of double enclosure, room and shell), is completely insensitive for a provincial and overly naïve for a primitive.

But there are certain moments in Wyeth's oeuvre that show him overcoming his limitations, or at least holding them off long enough to justify the peculiar situation in which he finds himself. Most often these are pictures in which rural structures arrange the oblique trajectories of light on a number of planes, and so present themselves as abstract experiences to be read into the third dimension—pictures with some welcome difficulty in them for the spectator. These include *Mother Archie's Church* (the light-filled, hard-to-read geometries of the ceiling), *Toll Rope, Garret Room,* and particularly *Hay Ledge.* These works approximate ideas of originality and invention we've been presuming Wyeth can't have. Things are rarely pure, however. The fine compositional stroke in *Hay Ledge* is eroded by a cautious investment in the picturesqueness of the hairy beams above, depicted stroke by stroke, an illustrational device brought in to mitigate spatial doubt. In these pictures, the subject isn't a device for setting up compositions with the photographer's eye, but it is refined on abstract terms that bring it to a more visionary threshold. All of them tend to be two-dimensional in a confident way.

But something else qualifies this provincial-primitive dilemma. Wyeth's watercolors are painterly, sophisticated, and without primitive anxiety. His success with his first show (all freely-brushed watercolors) frightened him and he abandoned them as his main mode, deliberately seeking a medium (tempera and drybrush) that would emphasize his primitive temper by introducing those difficulties (so familiar in American painting) that would serve to insulate his art from change. Wyeth's painterly facility suggests that his directions may not be so obvious as they seem. A number of American artists of sober accomplishment, including Eakins and Hopper, rejected a painterly facility to which they had full access. Why such a mode should be identified as inappropriate, indeed—one is tempted to think—irresponsible, is an open question. But it may be associated with a desire to possess what is painted, bringing into play those conceptual habits which interrogate and sometimes confuse the data presented by the senses. These three artists aspired, in their different ways, to an image that would declare itself to the mind directly without the interruption of sensory delights, an image stamped with the imprimaturs of knowledge. "The laws of moral nature," wrote Emerson, a favorite of all three, "answer those of matter as face to face in a glass." Eakins appears to wring these laws from his subject matter, Hopper to pursue them relentlessly into silence, Wyeth to represent them as part of a natural order, realizing, to quote Emerson again, that "the whole of nature is a metaphor of the human mind."

Indeed, it is from living within this metaphor that Wyeth derives what strengths he possesses. He trusts it implicitly and it donates to his work a coherence inaccessible to modernism, traditionally dissociated from and critical of a fractured social order. For his work bears the imprint of the social order as a glove retains the shape and imprint of a hand. Wyeth, to quote the ubiquitous Emerson again, "shows us all things in their right series and progressions"; everything has its place—as distinct from modernist placelessness—and thus his objects' vocabulary, completely codified by their *place* in country life, is accessible to his audience, which is aware of its function and context.

Indeed, the most profound aspect of Wyeth's work is his organization of this rural vocabulary into a transcendental system that displaces the self outward through a series of environments which, at each relay, are saturated with association. An early Wyeth statement deals in unexpectedly sophisticated, Emersonian terms with the elimination of the self. "My aim," he wrote, "is to escape from the medium in which I work . . . to dissolve into clear air all impediments that might interrupt the flow of pure enjoyment." His self-portrait is disguised in light and not very successful. Partly this can be read as the countryman's inability to introspect, resulting in a curiosity about other people which relieves itself with gossip; indeed, Wyeth is a kind of tireless visual gossip. But his portraits are often natural philosophy of a shrewd country kind, in search of the detail or habit that betrays character.

Direct confrontation with the sitter, however, brings out an evasiveness in Wyeth, as if he didn't want to betray himself while thinking badly of anyone. In the famous *Karl*, the cruelty is displaced from the face to the hooks above. He is uneasy, as country people are face to face—a situation they go to devious lengths to avoid. But to unlock one's gaze is to suffer the nakedness of leaving one's face open for inspection, and there is something embarrassing about Wyeth's portraits that has nothing to do with aesthetic discontents. *Maga's Daughter* and *The Patriot*, vulnerable in this way, are exceptional records of character; I don't think they are exceptional paintings.

As he moves around and behind his figures (*Christina with Cat*) he finds more room for expression. So his art offers discreetly turned backs and Emerson is again at hand: "I conceive a man as always spoken to from behind and unable to turn his head to see the speaker." Wyeth would like to do without figures altogether, and like Hopper feels that subtracting the figure from the landscape should intensify the feeling, that Christina's world would be complete without Christina. This transcendental reductiveness happens to coincide with some modernist thinking.

So when people are replaced by clothing and objects his insights sharpen. Details, clarified by such absence, are less illustrational. Intimacies so intensely observed filter associations and thin the atmosphere. One is reminded of another situation in which objects and their associations are similarly conceptualized and possessed: Cornell's boxes, in which the captive air seems more rarefied than that we breathe.

From intimate objects that receive physical and psychological scale from departed figures, Wyeth moves to doors and windows where, as Gaston Bachelard wrote, "The dialectics of inside and outside multiply with countless diversified nuances." To this traffic Wyeth brings a great deal less sophistication than Hopper, who grasps both inside and outside in one powerful act that neutralizes the obvious dialectical situation. Hopper's windows are, like the artist, a kind of medium. They mediate without drawing undue attention to themselves, so that even when we cannot see through a foreshortened window, we gain an impression of vast space outside. Wyeth's windows clearly frame intimacies or point to escape outside. They cue the observer as clearly as exit or entrance signs, and sometimes, indeed, the traffic jams.

Passing through doors and windows, Wyeth looks back on walls, barns, houses—which, miniaturized by distance, offer themselves for possession as intimately as a detail. Moving out farther, foregrounds drop away (*Northern Point*). Finally he ascends to the deserted bird's-eye views that are his version of the sublime

(*River Cove*). At this climax of his transcendental system certain art from the past comes to mind, particularly that of the luminists who, as John I. H. Baur wrote, "living at a time when pantheism was a genuine force, found in nature a presence and a spirit. Like Emerson, they became before her 'a transparent eyeball.' " Such a release however is retarded by Wyeth's tempera technique. Its teeming minutiae impede the flow of mind through the subject.

This regulated displacement of the self outward, powerfully supported by what used to be called natural law, gives Wyeth a closed analogical system shared by an audience conversant with every link. Each object has its place, each nuance its receptive echo. These rich, organic correspondences make a living envelope for thoughts alien to the urban mind. Animism, superstitions, shrewd observation of man and beast offer to Wyeth's art a life its worn conventions would seem to deliver to us stillborn.

III

It is now time to return to the key element in Wyeth's art, which brings many of these comments into clearer focus. While we have little doubt in our mind that Wyeth has not produced great pictures, he has undoubtedly invented a number of great *images*. *Christina's World, Wind from the Sea, Distant Thunder*, and half a dozen others announce themselves with a shock of recognition to the eye and mind. Process is minimized to facilitate the transfer of content; the image is all content, as in pornography. But what is recognized? Not just an image "out there," but a gestalt of feelings that, like the image, is recognized whole. The image, then, unlocks a pre-existing and somewhat unchanging body of feeling. Wyeth's master images put the viewer on intimate terms with himself by stimulating sensations the privacy of which give him an illusion of his own uniqueness. These sensations have usually been consigned by his rural audience to childhood, where feeling and its expression are more admissible. So adults, particularly rural adults who would not otherwise condone such familiarity, are given access to themselves. His

master images, then, legitimize introspection and have the purgative function of enabling his audience to deal with emotions they are often unable to acknowledge. The flush of feeling is instantaneous and complete. One is reminded of Balzac recalling how he cried his eyes out at plays not worth a sou.

Or of a patriot looking at the flag, which is always and never seen. For an image that performs such a function—encouraging ideas of individuality by releasing tensions through shared common experience—is iconic. The image presents a bagful of notions in a form understood by the community whose presiding values it calls forth, summarizes, and announces, a recognition that tends to militate against formal quality.

By virtue of the previously described system he and his audience share, Wyeth possesses his community on magical or charismatic rather than aesthetic terms. This is unique. Modernist ambitions are mocked by an audience they cannot summon but still desire. Rothko's yearning for an audience, and Wyeth's happy possession of one, are poles apart but prod speculations on the unity of opposites. Rothko's art, like Wyeth's, is based on intimacy. Both artists' audiences first recognize the transfixing image, bearing a cargo released according to the audience's capacity to handle it. Wyeth's audience shares a single complex of rural sensations; Rothko's a singular feeling with a definite tone. Members of both audiences feel reassured of their uniqueness in a way that establishes a bond with others. But while Wyeth's audience communes easily through master images, there is something secretive about the members of Rothko's audience, who avoid trespass on each other's sensibilities. For Wyeth's audience the communal nature of their appreciation authenticates the values by which they live.

While the master image can be a work of quality, it can also be the opposite. *Her Room*, for instance, is a master image and an indifferent painting. Yet even a fine picture tends to be somehow alienated from its quality on becoming a master image. Modernism's aesthetic system, like Wyeth's rural system, turns certain images into icons through sophisticated superstitions.

Modern art picture books codify well-known works so thoroughly that they are turned into emblems illustrating the idea of history. By forcing them to certify the myth of history, their uniqueness is withdrawn and their voice submerged in that myth. On most of the major ornaments of modernism, this historical blindness has been deposited. So Wyeth's transcendental system equals modernism's historicism in that both do a lot of our thinking for us, giving us equivalents for experience rather than the experience. Within these systems our feelings stir into a banal but convincing life.

Watching some of Wyeth's audience at the Whitney retrospective of 1968, I was reminded of similar kitsch epiphanies witnessed before Matisse's *Red Studio* at the Museum of Modern Art. It would be easy enough to write a history of the master image in European art— from Cossa's *Allegory of Harvest* through El Greco's *View of Toledo* to Whistler's *Arrangement in Black and Gray*. All deliver a sudden cargo of emotion that seems to place us in touch with large verities. On reflection, however, much of the work is done by deeply ingrained cultural reflexes which are indeed associated with immodestly large matters—woman's fructitude, our visionary desires, and aged motherhood, in the three examples cited above. But such large ideas are easily trivialized, and it is the capacity of the master image— whether good or bad art—to renovate them, however temporarily, for re-experiencing. Their magical and talismanic properties are due to the fact that they abruptly reacquaint us with the familiar. This is why they are so close to the cliché, which indeed often claims them.

If there is a mystery about how master images accomplish their effect it is not very deep. For their very power tends to militate against innovative means, though they usually maintain a certain formal decorum. Just as a familiar body of emotion is renewed, so are formal effects combined or recombined in ways made familiar by advertising, which is based entirely on the master image. This conjugation of an easily accessible and somehow sanctified emotion—sanctified even when about the most secular subjects—with adequate formal

discretion, but without any radical challenge, is what defines the master image. It is mostly a repackaging job. Augustus John's *Madame Suggia*, for instance, is a perfect example of brilliant formal insight repackaging our feelings about high musical culture, conveying arrogance, drama, passion in much the same way as the cheapest bullfight poster, but at a highly acceptable aesthetic level. The master image rarely reaches the formal brilliance of El Greco's *Toledo*.

In American art, once one accepts the idea of Wyeth as a master-image-maker, one quickly recognizes a kind of American master image to which his work strongly relates. Indeed, the pursuit of a great image rather than a great painting is a theme of regional American art. Grant Wood, the most iconic American painter before Wyeth, usually cut both ways with his audience. Some of it identified with the subjects of *American Gothic*; for others the price of admission is a certain patronizing contempt. *Daughters of the American Revolution*, delivered into the same zone between two levels of sophistication, lacks master-image status. Such art derives much of its strength from recognizing shared values which become the artist's medium to inflect and influence. In this way, art, like advertising, becomes a kind of brokerage and remediation of shared values. Wood, who negotiated his way through loaded "national" imagery, is a more interesting artist than his "regionalist" colleagues. Benton's hillbilly baroque, which attempts to tap a shared feeling about America by way of a vernacular, setting visual forms to country music, never succeeded in striking the great image, whatever its other triumphs. Curry, whose pursuit of the master image is even more obvious, illustrated his ideas —see his *John Brown*—instead of giving them that instantaneous master-image status. A lax formalism sends many potential master images into the heavily populated region of illustration.

Two American artists of the second rank, though superior to those mentioned, including Wyeth, strike the master image often enough to give their art, like Wyeth's, a well-loved status. Georgia O'Keeffe's best images all bear a kind of southwestern imprimatur, but

they preserve sufficient acquaintance with modernist thinking to maintain their respectability. The way they are painted, however—their process—manages to be both flaccid and mechanical, so that her work is better in reproduction. And Ben Shahn's close observation of city life resulted in some images that have irrevocably colonized the way we see some aspects of it; the boys playing handball in a recreation area, the distant child playing baseball against a towering wall are superb master images and very respectable art. Their impact is not lessened by reproduction.

Indeed, reproduction brings us closer to a definition of the master image. The image takes such precedence over its manner of presentation that reproduction is a clarification rather than an impediment. *Christina's World* works just as well in a postcard, so well in fact that the original is a bit of a disappointment. The change in scale doesn't damage the image. To the contrary. Most reproduced master images can shuttle through vast changes in scale without diminishing their impact. Master images are thus scaleless, appropriate for their use as coinage through which a community conducts some basic emotional transactions. Indeed, it is only through photography that great works of sculpture become master images. The popular eye seems to fix repeatedly on a single viewpoint, giving us, as with Michelangelo's *David*, one aspect of a multiform image, which is then forced to conform to the conditions of painting. Can the reverse ever happen? Can an icon be turned into a complex private image? Perhaps Jasper Johns' flags are anti-master images. He makes a publicly owned symbol like the flag into an arcane counter in an exclusive aesthetic game.

Sentiment is never very far away from the master image, even when the sentiment, as in a great painting like Cossa's *Harvest*, is of the noblest kind. As active social currency, master images are of course easily sentimentalized, and Wyeth's have suffered this fate, despite the fact that his work deals with such perennial country matters as superstition, casual brutality, and necessary executions. His art recognizes rural life's habitual cruelties, but its main defect is that this view

is not clarified without sentiment. However, this makes it acceptable to country people who recognize sentiment as a form of politeness making unwelcome truths acceptable. Wyeth's apparently simple and banal art is the locale for far more than we allow it, and it has, in fairness, suffered from more than its share of art-world snobbery. The issues it raises go far beyond aesthetics to social and, as I have pointed out, ideological conflicts between one of the oldest of incompatibles—the city and the country.

Since his art depends so heavily on a subject rapidly becoming extinct, it hardly seems fair to leave Wyeth without acquiring some knowledge of the two major subjects with whom his life was and is involved, two types and characters, both very interesting, soon to be obsolete.

IV

The way to Karl Kuerner's house passes a railway station at a crossing where a large sign reads STOP-LOOK-LISTEN. Here, in 1945, a car driven by Wyeth's father, the illustrator N. C. Wyeth, cut out while straddling the tracks. An oncoming train killed his father and his brother's two-year-old son. Wyeth's pre-occupation with Kuerner owes something to this. Kuerner's place has been the scene of more than ten paintings. In *Young Bull*, Wyeth moved Kuerner's Hill to the left, shaved it bare of trees and pulled in the corner of the house from the left. Following his habit of flattening his space by means of a high horizon, he worked squatting down before the long whitewashed wall, looking up at the scene.

After getting out of the car, he squatted to demonstrate, then rose to his feet to wave at Kuerner, a blocky figure wearing a peaked cap and gray golf jacket, coming out the front door. To the left, near the hen runs, a German shepherd barked and plunged on a rope. Karl came down the slight incline, hands in pockets, smiling. His square, powerful face is as ruddy as Wyeth painted it.

Inside, the house, like many country houses, was slightly smaller in scale than its occupants, so it easily

appeared crowded. The antimacassar neatness was due to Karl's sister-in-law, who came over from Stuttgart when his wife became strange. A thin woman, curtsying, dressed in black, hair gathered in a bun above her nape, she greeted Wyeth in German. Sitting in the twilight of the slightly unused living room, drinking champagne-like apple cider, Wyeth pointed to the window in the dining room from which he had painted *Ground Hog Day*. Kuerner kept passing his cider, matured in casks set on stone flags over a subterranean stream. Later, outside, he showed me a small stone grotto with a locked wooden door. Inside was a natural icebox, cool even in midsummer, and walled with dim clusters of casks.

"Once there was a great explosion," he said, back in the living room. "I looked at the back of a fermenting barrel and it had split this heavy barrel right up the back."

"It's strong stuff," said Wyeth, laughing. "Karl's place," he said when Karl briefly left the room, "could be Bavarian or Austrian—particularly in the wintertime. You might find a carcass of a deer freezing in the corner. That's my origin," he said seriously. "Swiss-German."

Kuerner had recently returned from his first trip to Germany—near Nuremberg—since coming to America in 1930. On Wyeth's recommendation he had been to Dürer's house. "He was as bad as you are," he told Wyeth. "He painted everything."

Kuerner led the way up the narrow stairs, around corners cut off by oblique walls, to the attic where Wyeth had painted him. Up there he also painted a rifle hanging on the wall, which Karl had brought back from Germany. Wyeth's paintings of Karl have a latent violence, just as his paintings of Christina have a painful tenderness.

By one of those coincidences that happen to people who accept them as manifestations of hidden meanings, he and Karl were in the attic with a rifle the day President Kennedy was shot.

"Karl was showing me a high-powered rifle with a telescopic lens."

"I felt like Oswald," said Karl, smiling briefly. "It was unbelievable. It really hit me."

The whitewashed attic is shaped like a large, truncated pyramid, the ceiling furnished with hooks for hanging herbs and drying seeds to restock the garden. On the way downstairs a few deer heads jutted from the wall, the antlers like dusty coral. "When he was painting me," said Karl, coming down, "he only came over on dull days. No sunshine."

"I started thinking about Karl a few days after my father's death," said Wyeth, as he drove out the avenue toward Kuerner's Hill and the crossroads. "Karl believes very strongly in the supernatural. That always interests me. How a person as hardboiled as this. . . . I've seen him slaughtering the animals. He can be brutal and sentimental. He's very cruel, you know. He told me how he mowed down a line of Americans in the First World War, then lowered the sights of the machine gun and went over them again. Then in the springtime he sometimes comes over to give us the first snowdrops. He didn't like the portrait I did of him. He wanted snowdrops in the background."

* * *

Christina Olsen lived in the clapboard house her great-grandmother, a Hathorne, built out on Hathorne's Point, near Cushing in Maine. Once it was an inn used by the crews of the clipper ships coming down from Newfoundland. One of them brought her father, a Swede born "just outside Göteborg." He settled down after he married Christina's mother—also a Hathorne—and sailed on a schooner out of Rockland.

Christina and her younger brother Alvaro—the last of the Hathornes—lived in the family home. Al, a small witty man with a large nose who posed for *Oil Lamp* and refused to pose again, made a living from blueberry farming. The blueberries grow almost wild in low rug-like tangles in the fields that slope away from the house.

Christina sat stiffly, leaning back, facing the landward window. She rested one arm on a table piled with household trivia that looked infrequently moved. Behind her was the black range Wyeth had painted. Al sat inconspicuously between the range and the seaward window. The light was dim, the air pungent, the interior crowded. The colors were dun, ocher, and black. Chris-

tina's strong hair was reddish-gray, her eyes deeply brown, her flowered print dress a faded blue. "Christina's house," wrote Andrew Kopkind, "contains the anonymous leavings of years of confinement. The smell of burning oil, charred wood, fat cats and old cloth fills the air." This was her environment since an early attack of polio reduced her locus of activity.

Christina's voice completely wiped out the half-pitiable aura of a spirit straitjacketed into immobility. She spoke in a practical countrywoman's voice, with just a hint of self-pity, following what she had to say with a shrewd look from her brown eyes. She had a force of character that made any condescension to her paralysis an insult. Wyeth did more than a dozen studies, watercolors and temperas, of Christina and her environment, making her the most famous model in American art. Which of Wyeth's paintings did she prefer? Half-turning in her chair, she pointed to a stained cardboard box, bound with cord, surmounted by a cat. The cat was dislodged, the box handed to her. She opened it slowly, went deliberately through a collection of reproductions and selected *Christina's World*. Rummaging deeper she brought out some photographs of her family: sunlight, bright faces, Edwardian clothes. She lingered over a strapping young woman standing beside a bearded man in a wheelchair, then pointed a firm finger. "That is me—and my father."

Betsy Wyeth knew Christina from childhood and remembers playing around Christina's father's chair in which he sat, arthritic and immobile. As a girl she got into the habit of regular visits to Christina, cutting her hair, cooking, doing small jobs for her. The first time she met Wyeth—on his twenty-second birthday—she took him to see Christina.

"Christina didn't make any impression on me then," said Wyeth. "Just the house. It's strange, I wasn't conscious of her personality. As far as painting people goes, it didn't mean anything to me until after my father's death. That's why Karl's portrait was so important to me."

Christina became, like Karl, a focus for many of Wyeth's feelings. He painted in his favorite lair, an up-stairs room, listening to Christina occasionally stirring below. Sometimes she called him for pie, and a hand pushed the pie onto the bottom stair. He would wait until the sound of her dragging body had receded before going to get it. Going home, he would leave his unfinished painting behind "soaking up the atmosphere." Some of his pictures still faintly exhale the burnt-wood odor of Christina's house.

He painted most frequently from the second-story window in the southwest gable. In *Wind from the Sea*, the frayed curtains lift as a puff of air enters the stagnant room. Looking out that window across the declining field he got the idea for *Christina's World*. Legend has it that he saw Christina pull her way across the field after visiting the family graveyard near the sea. "The picture was all a dream," said Wyeth. "I never saw her there."

The painting took two months, during which he made close sketches of Christina's hair, body, and hands. Mrs. Wyeth posed for the figure, which was the last thing he put in. "The pink dress," said Wyeth, ". . . like a dried lobster shell."

"I can work for months on a single background," he went on, "if I know there's something going over it that is fleeting." He feels now he could have got the same effect by leaving out Christina.

Down in the blueberry field, looking back at the shingled barn and desolate house, one can see how Wyeth simplified the scene. House and barn are closer together in the painting, the hen runs are gone, along with some trees that broke the design. The field has been combed free of detail. "Wouldn't I like to go down there and pick blueberries," said Christina to her brother Al. "If she could," he said later, "she wouldn't want to."

Seen from the blueberry field, the house is gray, weathered, in want of repair. The windows are partly covered with old flour bags, their torn edges hanging in pennants. Turning and taking a few steps more, one comes on a dead gull with a bloody neck hanging from a stick, a warning to the berry-hungry gulls above. Wyeth painted that, too.

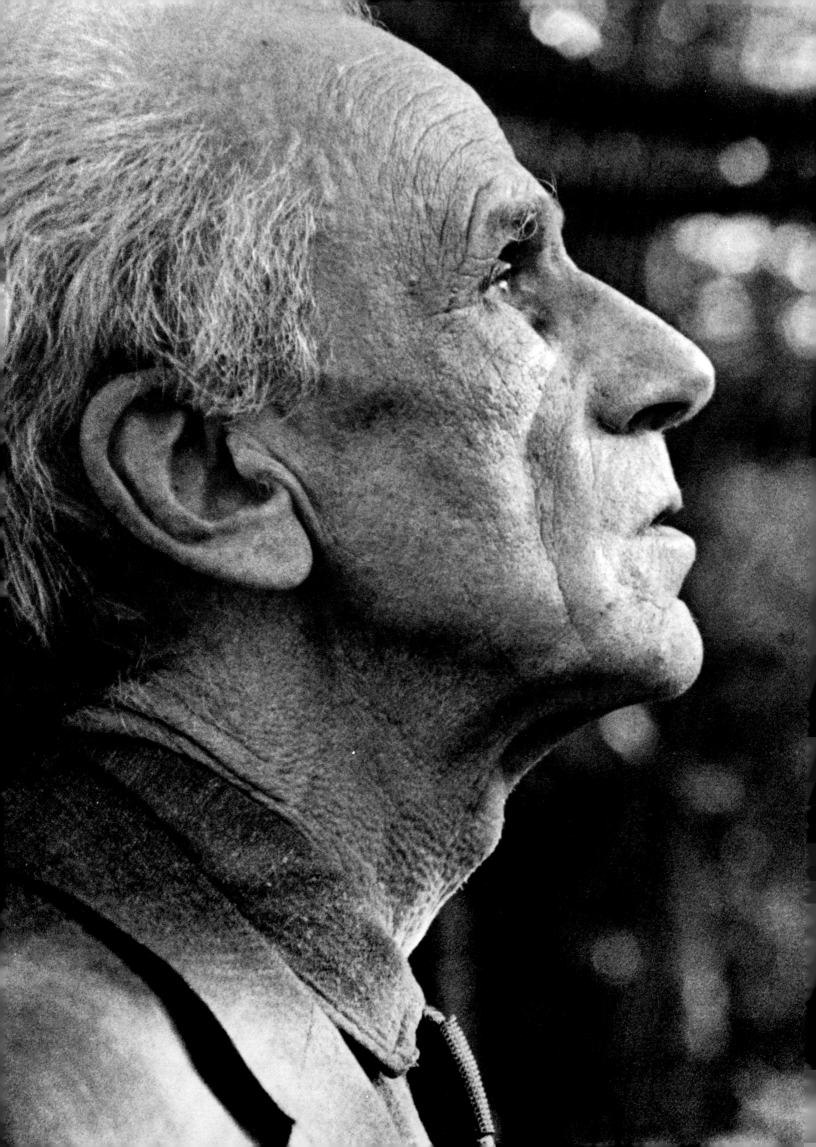

CORNELL

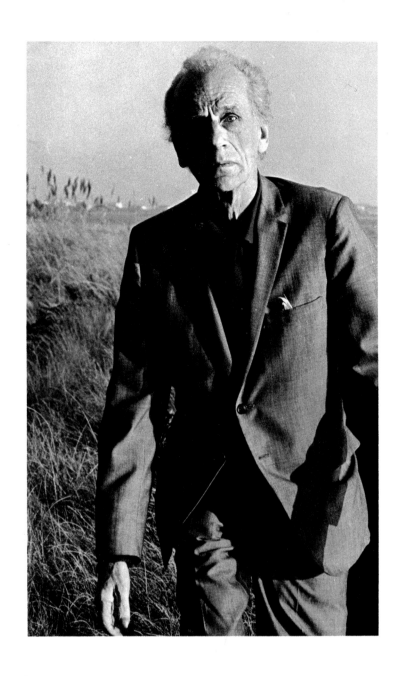

Joseph Cornell: Outsider on the Left

Themes of innocence and the vernacular, of voice and myth, of Europe and America, of, indeed, Europe in America, offer themselves so plentifully in Joseph Cornell's work that they can obscure the reading of its quality. For this marvelous art is perhaps the most perfect any American artist has produced. It is fitting that he should end this book, not only because its themes course directly through his art, but because history and the vagaries of myth have nudged him to one side, while others contend over their places in the mainstream.

Cornell is as much a major figure as his contemporaries, Rothko and de Kooning. He is presented here as their peer, a figure large enough that history must inconvenience itself to rearrange its priorities. Not that Cornell has been neglected. Among American artists he is perhaps the greatest stimulant to "poetic" art writing. Everyone has done his exquisite Cornell paragraph, to the point that putting writers in boxes is one of his involuntary specialties. Serious attempts to place him in twentieth-century art are few indeed, and his isolation seems to survive his critics' best intentions. Lacking the aggressiveness of the historicizing thinker, he has come to stand for all that is marginal and eccentric. Once so relegated, he can be patronized like some obscure violin maker of inexplicable genius.

As an outsider of a peculiar kind, like Ryder and Poe, Cornell had a sense of European culture that is one of his art's strongest underpinnings. In the larger historical picture this will eventually bring him, as it has them, to the center of attention. He is one of those rare artists whose universe is, like theirs, so imaginatively authoritative that it corrects the narrow views we accept without question from the official "art scene" itself. Certain Americans, without ever seeing Europe, have re-enacted it in a way central to American experience; not only Europe but its fabulous culture which, in Cornell's case, narrows down to a part of it so intensely understood—Symbolist France—that it becomes a lens through which all the rest is seen.

Mallarmé, de Nerval, Rimbaud, Verlaine are, to this mode of thinking, not names but sources of energy and light, stars as it were in the firmament of culture—stars, vulgar and otherwise, being objects of Cornell's reverence. Yet this reconstruction of Europe has the most mundane grounding in present experience. Most of it is re-enacted through trivia: objects, clippings, words, toys, maps, glass, mirrors, jars, jacks. Cornell's objects offer no language accessible to modernist readings (à la Rauschenberg and Johns); for their symbolic content, how they can be placed to replace themselves with that content, was his concern. He was, along with Ryder, the greatest of American symbolists, the spiritual kin of his French brethren, who found similar epiphanies in the vulnerable and banal.

The range of territory covered by Cornell's art—epicurean and vulgar, sacred and profane—is astonishingly matched by the fact that his art includes all the others. Music, dance, theater, visual art itself, are incorporated not out of some Wagnerian desire to fuse them into an imperial synthesis, or from some modernist itch to conquer realms of experience inaccessible to particular arts, but by virtue of the most discreet modesty, which also extends itself to his means. His genre—the box which is not collage, not sculpture, not painting—seems to have evolved from a desire simply to give his objects room to breathe, so that they can etherealize space, make it purely metaphorical, and give to it the elasticity of the imaginative faculty.

Perhaps the most literate of the eight artists presented here, Cornell fed not so much on the energy of the New York scene, with which he was well acquainted, but on the community of tradition, the spiritualism—if we may call it that—of culture. Communication is the key word in his universe, but his attempts to link present and past are devoid of the least competitiveness, of that egomaniacal self-assertion that is one of modernism's afflictions. Lacking any desire to subdue culture, Cornell makes the New York scene seem small in its range and grubby in its ambitions. Laughable though it may seem at first, Cornell bestrides American culture in a way none of his colleagues did. Six of the seven other artists in this book seem to fall within the scope of his interests: Davis and Rauschenberg in their

Pages 254–255 and left: Westhampton, New York, 1971.

orientation to the city and its vernacular; Wyeth in his pursuit of intimate sensations in a transcendental rural context; Hopper in his relentless tracking of fugitive echoes through the stage sets provided by the deserted city; de Kooning in his obsessive connections between past and present—though in terms of mastery; above all, Rothko, whose desire, not just for an historical position but for an ideal culture, is similar to Cornell's.

But what Rothko sought through a welter of painful contradictions, Cornell found accessible in the most natural way. Rothko used to recall how Cornell would come around to his studio and talk and talk until Rothko couldn't bear it and broke off the contact. Both artists were extremely sensitive. For Rothko these monologues must have had some of the frustration of listening to one who had discovered the secret of time travel. But Rothko couldn't use it. Cornell could use almost anything. His boxes contain such imaginative energy that a list of his library, like a poet's—like Blake's or Yeats' or Eliot's—was disposed according to its magnetic field: *Folklore and Symbolism of Flowers, Plants and Trees, The Meaning of Meaning, Stars of the Salons, Actors on Acting, Finnegan's Wake, The Concerto.* The library became, in one of Cornell's favorite words, *matériel*, from which could be extracted the facts to which he was scrupulously faithful before giving them imaginative valencies. The range of Cornell's interests and knowledge, and the graceful movement of his ideas, made him perhaps the most civilized man I ever met. This was somewhat belied by his tentative and remote voice, and the distance he placed himself from one when talking. The space between was always too wide, so that one had to listen very closely to hear what he was saying, since usually it was unassisted by any gestures. Yet this remoteness did not preclude intimacy, but made it slightly formal, a matter of etiquette. He talked, with frequent silences, of ideas, people dead and alive, genealogies, books, other artists, and, with delicacy, of remote and recent gossip. He had trouble maintaining a face-to-face gaze, which betrayed him into occasional stares. The meeting and slipping of glances paralleled his verbal discourse and remained somewhat separate from it. The voice, high, deliberate, and without much variation, was of one heavy with responsibilities. Gradually he came into focus as a kind of curator of culture, and his house on Utopia Parkway a bureau of which he was trustee, director, and staff.

Indeed, behind its very ordinary front, the "agency" kept up a busy traffic. Crammed with books and files cross-referenced to keep him in touch with distant places and times, it was antagonistic to the American myth of culture as adversary. According to this myth, many American—the most "American"—artists and writers abort themselves out of history, challenging it to acknowledge and eventually include this defection. Prompted by the desire to begin again, American "geniuses"—as we saw with Pollock—favor nature rather than culture. This use of the present as a club to belabor the past and suppress its lessons now seems connected to the less attractive aspects of American optimism. To this primitivism, Cornell counterposed the immense richness of the past, a desire for contact with a community of minds. History interested him, not so much as sequence, development, and process, but as a way in which the continuity of past and present could be mapped out if sufficient connections—or linkages, as he called them—could be established. After reading and gathering material to cultivate the ambience he desired, he would wait for the link that gave him access to it. It might come from the most unlikely quarter: Anita Bryant or Hedy Lamarr; Belmondo once gave him access to Taglioni.

Once the contact was established—with a performance, a movie star, a ballerina, a musician—he could voyage back. Culture was so glamorous to him that he expended all his energies making it less remote, and having captured it—if that is not too strong a phrase—he was happy to possess it, but careful not to analyze or otherwise destroy its enigma. Once in its aura he could gratefully inhale its atmosphere. In describing these voyages and connections he could have been discussing the timetable of the trains from Grand Central. And high culture and the vernacular were never far apart in his conversation or his art.

Movie glamour is, of course, also an aura, and it was transfigured in his eyes, as his films show, to an appetite for the inaccessible, and so could be connected to the auras of remote figures, whether Debussy or Bronzino. Like Edward Hopper, he watched movies a lot, indeed, loved everything about them. One of the stories told about him—and retold by Duchamp—is how he fell in love with a movie cashier in an Art Deco box, returning night after night until she complained and he was ordered away.

Meeting someone face to face was a mixed blessing for Cornell. He had a great understanding of the inaccessibility of persons, of their buried and remote life. Meeting them might later provide material for what he called an exploration, or even provide an unexpected and sudden link. I feel he would have agreed with what the young Samuel Beckett said to a friend after Beckett's girl had gone away: "Now I can really think about her." This process Cornell applied to movies particularly. The shadowy afterlife of extinct stars put him in touch with intense nostalgias, which were not sentimentalized ("The dialectics of nostalgia really intrigue me"), but part of his major theme, which in box after box is a kind of extended fugue on time, mortality, and the infinite, experienced almost entirely in terms of culture, itself a symbol for surviving temporal decay.

And Europe, of course, was synonymous with culture. Again it is a Europe that could be experienced only from a distance. Americans, who glamorize Europe and its culture, make hopeful connections with origins in thousands of journeys each year, triumphantly storing Kodak epiphanies for future memories. Such banal rehearsals of the past are in the tradition of something Robert Motherwell connected to Cornell's journeys: the Grand Tour, with its sketches, mementos, and souvenirs that the Victorian era made into fetishes. The Grand Tour and the democratic Cook's tour are all about culture. The Cook's tour enacts on a vulgar level what Cornell enacts on the level of symbolist poetry: a profound American myth, the dream of culture. This dream seems to lead to the left and liberalism, whereas the dream of nature seems to lead to the right and con-

servatism. Just as Cornell represents the former, Wyeth represents the latter to a degree approached only by one other artist, Clyfford Still. But the dialectic of American art and literature is profoundly implicated in this polarity between the natural and organic idea of beginning anew, and the cultural notion which makes connections with tradition. Both tend to define themselves by their awareness of the other, and by the way they see each other as antipathetic.

Cornell's most American characteristic is to see the survival of culture as an urgent matter to be accomplished through the most pure and transcendent obsession. It is a supremely civilizing task, usually attempted only by major gifts. Cornell's summary of European culture as endlessly rich—one vast salon crowded with those memories of great performances that are the very perfume of culture—betrays his American origin. Just as de Kooning's unquestioned celebration (in an art that questions everything else) of a certain myth of America—its energy, vulgarity, contradictions, possibility—betrays his European nature. In his nostalgia for European culture, Cornell is intensely American, further confirmed by his posture of exile.

If Europe represented culture to Cornell, it had to be pursued and reconditioned in every way possible. Obviously, the Surrealists who came to New York by necessity before and during the war gave him the practical means to realize his desire, as well as access, through their presence, to their symbolist predecessors. Everyone who knew the younger Cornell remarks on the tenacity of his pursuit of information—or linkages—that he needed to furnish his mansion of European culture. He haunted—and for once the word is apt—studios and artists, including one in particular who represented the epitome of all he was searching for: Duchamp. Duchamp suffered Cornell's haunting humorously enough, but without much pleasure. Cornell, he said, talked endlessly and was a bore. Their meetings have a comic aspect. For Duchamp, culture was a series of fossils to be prodded with a very unimpressed and very French wit. For Cornell it represented a sacred emporium of spirits living and dead. Duchamp was not in search of

(continued on page 273)

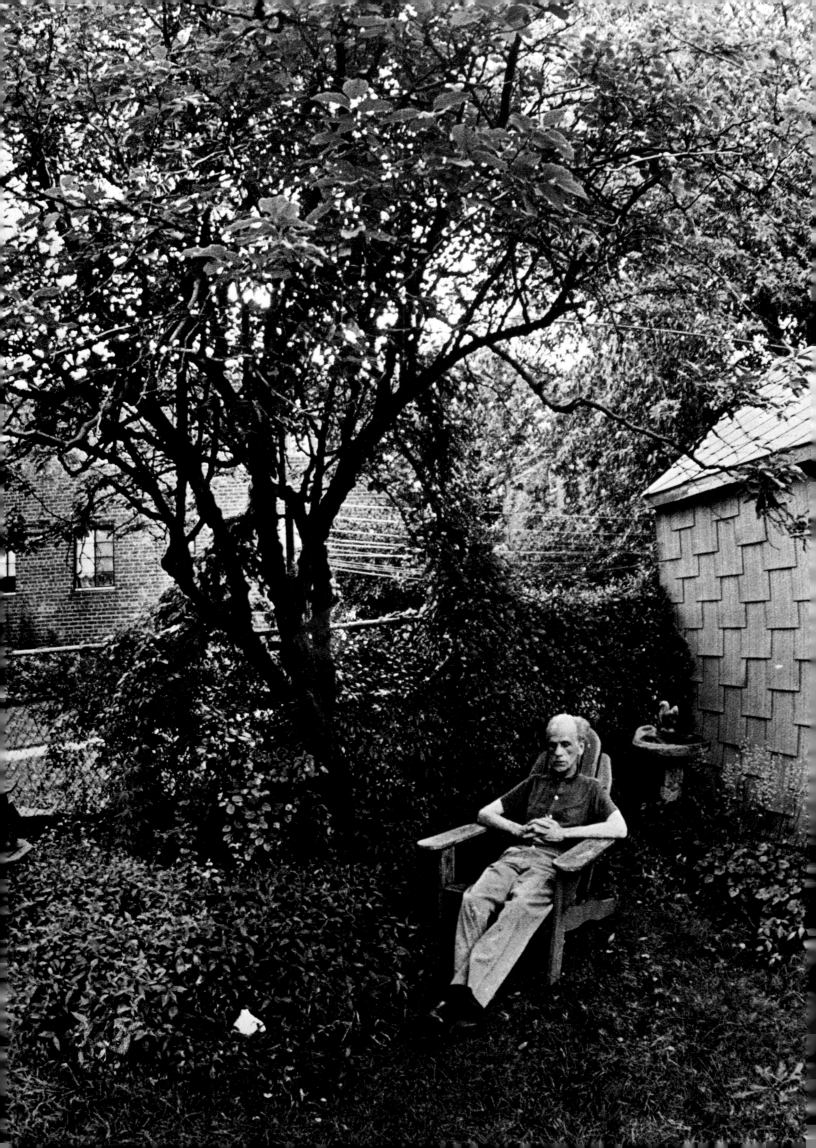

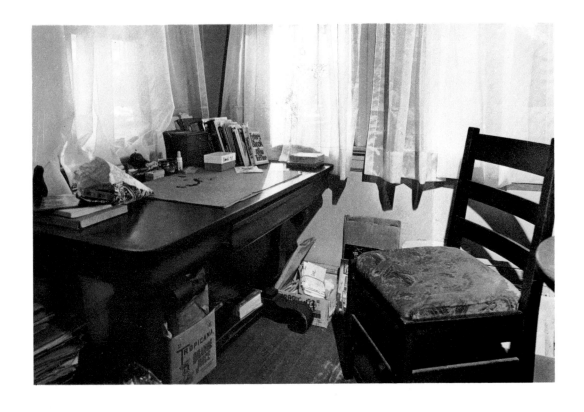

Utopia Parkway, Flushing, New York: Backyard, 1969, and interiors, 1973.

Studio, Flushing, 1969.

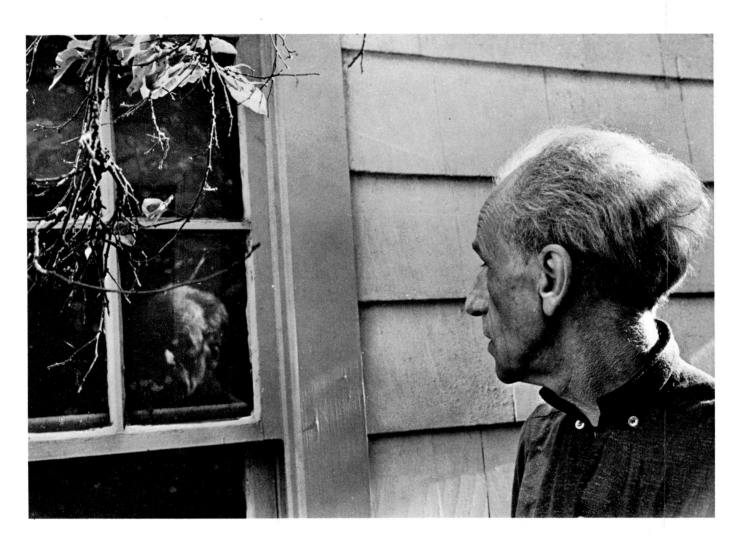

Flushing, 1969. Right: Unidentified construction in
"dovecote" series, photographed in studio, 1969.
Following pages: Studio, with work in progress, 1969.

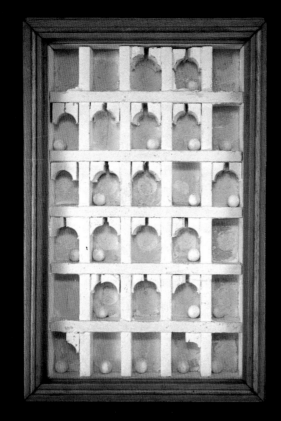

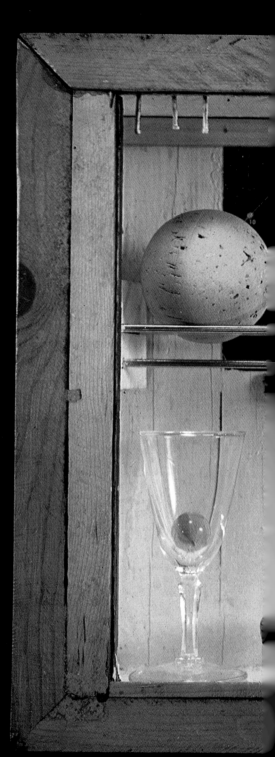

Left: *Dovecote—American Gothic*: construction, 17⅝″ x 11⅝″ x 2⅝″, mid-1950's (Collection of the artist). Right: Reverse side of box construction, with paper montage and mirror-image signature. Below, left: *Parrot*: construction, 19″ x 11⅞″ x 4½″, early 1950's (Collection of the artist). Below: *Sun Box*: construction, 10⅛″ x 15¼″ x 3⅓″, c. 1956 (M/M Alvin S. Lane).

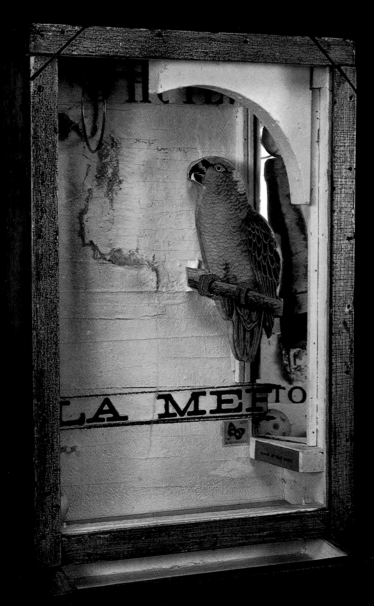

LA MER TO

Opposite: *Medici Slot Machine:*
construction, 15½″ x 12″ x 4⅜″,
1942 (M/M Bernard J. Reis).
Above: Details.

culture, he *was* culture, and Cornell's pursuit of it must have seemed to him juvenile, which, indeed, was his judgment on Cornell.

Cornell's desire to make Duchamp the avatar of his dream of culture could hardly have escaped the man who handled and directed other artists with an almost demonic charisma. Cornell didn't have much humor, and Duchamp, like Rothko, found his elevated level of discourse fatiguing. Duchamp didn't much care for committed spirits, and Cornell's lack of irony must have been a trial for him. The meeting of these two extraordinary creatures, each of whom often prompted the description of saintly, makes one realize that the worst thing that could happen to saints might be to meet each other. "What's the noun for sardonic?" Cornell suddenly asked, when talking about Duchamp. "Sardonicist?" He didn't care much for Duchamp either, but he needed him. He must have seen Duchamp as a traitor to culture, as well as to good behavior. Cornell was very concerned with etiquette, and Duchamp's acrid and aristocratic ironies were a closed universe to him. Cornell behaved as he thought aristocrats might, with perfect good breeding, appropriate to one who bore major responsibilities as a curator of culture. Though Cornell complained about the "latrine language he'd push at you in mixed company," Duchamp was still the direct route to one of his heroes, Raymond Roussel (the only person I ever heard Duchamp acknowledge a major debt to). But Cornell had his revenge in his dreams, in one of which Duchamp figured prominently. After a reference to "the strong mystique of parallel biography I've had," which I took to mean his double life—one on Utopia Parkway, the other in the realm of European culture—he recounted "a dream I had about Duchamp, wanting [him] to get the handkerchief of Delacroix for me. I was saying to Duchamp that Delacroix was alive and he wouldn't believe me. Then, when I shifted the locale to Paris, he believed me."

Delacroix's *handkerchief*—with Duchamp as messenger boy! Through such emblems Cornell built up the transit system by which he could conduct his voyages. In pursuing connections between things, his is exactly the opposite of late modernist practice. In a fashion now almost academic, late modernism seeks to dissociate objects from their function and from each other, to cultivate gaps and silences, and to demythify any rhetoric that might allow the work to refer to precedents that would disengage it from the present. To cultivate this literal "now," and to experience its confusions with the greatest clarity, is the most characteristic property of widely diversified late and postmodernist styles. Indeed, this demythification has contributed greatly to undermining not only history, but the art system which derived from it. The interruption of historical continuities and the breakdown of the avant-garde motor that sustains them causes the art system to lapse into pieces. Quotations from the past, when used, are more often hostile than not and reinforce the present, which succeeds in objectifying the past not as a history of styles with which to make connections, but as a trove of subjects, mainly abstract. Thus, the best art of the seventies is that which attempts not to spend the past to buy the present, but to renovate itself by making connection with traditions it does not consider defunct. So in this decade good art tends to have a somewhat conservative cast. This attempt to establish connections tends to transcend formalist continuities now seen as too narrow. Because of this, Cornell's art seems more relevant now than it did in the sixties, though relevance is hardly the word to apply to an art that has amply demonstrated its transcendence of whatever issues aesthetic politics declare fashionable.

For Cornell's associative graces are exercised to preserve culture against its natural and inevitable destruction. He found no need to engender the chaotic or negative; they continually threaten his universe from the outside. His sense of the detail and passage of time is as sharp as in metaphysical poetry, and it fuses with a Victorian nostalgia, as well as with the gliding fragility of symbolist thinking. Nor are his means self-reflective in the modern manner, but simply the equipment to enable him to undertake his very personal voyage of survival. As Alexandra Cortesi put it: "He conjures his own self-preservation out of memory." Indeed, a formal

Top, left: *Portrait*: construction,
15¾" x 12" x 3⅞". mid-1950's
(Estate of the artist). Top right:
L'Egypt de Mlle. Cléo de Mérode: Cours
Elémentaire d'Histoire Naturelle:
construction, 7¼" x 10⅝" x 4¾", 1940
(Private collection). Bottom:
A Swan Lake for Tamara Toumanova:
construction, 9½" x 13" x 4", 1946
(Private collection).

inquiry into his means seems to lack civility, and the high poetry they engender tends to blind one to the remarkable conjunction of ideas, sympathies, aesthetics, histories, interests, and practices which, as much as his objects, is the raw material of his art.

Without Surrealism, Cornell would have lacked the means whereby to conduct his somewhat fictive existence. His boxes could hardly exist without the Surrealist tradition of the "poetic picture," so significant in dissolving Cubist structure with atmosphere. That atmosphere, so liberating for Rothko's generation and for Rothko's work in particular, sensitizes *all* the surface, and gives it an intense metaphorical potential. In its all-overness, that atmosphere acknowledges the surface as flat, yet makes an infinite depth accessible. In this peculiar combination of literalism and illusion, it partakes of the character of Cornell's space, in which every particle is equally potent.

The shadow boxes containing their assorted objects tamed into congruity are also derived from the tradition of collage as altered by the Surrealists into psychological scenarios whose subject and object is enigma, whose syntax is dislocation, whose temporal context is a dream. And with collage, objects and words are never far away; the relation between the Surrealist collage or shadow box and Surrealist poetry is obvious. But Cornell's boxes are paralleled not by Surrealist, but by symbolist, verse. Cornell found in Surrealist techniques the syntax of symbolist poetry, and developed it to a degree of flexibility and allusiveness inaccessible to those artists we officially call "symbolists," with the outstanding exception of Redon. This paradox is at the heart of Cornell's method. Surrealism enabled him to become the last great symbolist poet. Cornell was not alone in his symbolist interests in the forties. And in translating Surrealist enigma into symbolist yearning, Cornell shares with Rothko an emotion for which they found vastly different means of expression.

Even more than forms, moods are subject to devaluation, and Surrealist enigma was quickly vulgarized into a matter of taste. But in Cornell's case Surrealist switches in scale, poeticizing of objects and escapes from time into states of bemused puzzlement, are appropriated by a vision that comports itself with perfect tact. Indeed, the tact Cornell brings to his work is like that of a modest courtier in the palace of culture who feels keenly his sense of privilege. Cornell's freshness graces the most tired of clichés, and his purity of spirit renovates whatever it touches with a kind of adolescent wonder. The purity of the innocent, however, doesn't imply an invincible innocence. Cornell's intense idealism—about culture, women, and past time—was seasoned and wise; he knew what he was doing. But he also knew he had to pay for it. For this idealism was maintained by an energy that refused to admit the malevolence of human nature—matters that would have demanded complex moral judgments—into his poetic discourse. Indeed, this preservation of adolescent idealism was one of Cornell's profound struggles; news of brutalities disturbed him to an inordinate degree. He compensated for his lack of stewardship of everyday affairs by worrying a lot about catastrophes, before which he felt helpless, and by extending a large, unfocused, and tender sympathy to the underprivileged, who confirmed his idea of the flawed material world and the purity of the spiritual realm which it imperfectly reflected.

II

Cornell's sympathies, like his work, remind us that he was both a symbolist and a Victorian. Victorian association was, of course, one of Surrealism's primary materials. For dissociation could only articulate itself through an accepted vocabulary of sentiment, generally attached to objects. Many Surrealist and Victorian clichés overlap—driftwood, postcards, shells, starfish, butterflies, reliquaries—all used, incidentally, by Cornell. Surrealism found much of its material in the bourgeois French parlor, and it seems at times as if that parlor—with its memorabilia, toys, theatrics, games—was the nub of the Cornellian universe. For Cornell was the recipient of a number of informal traditions that, in one way or another, resided there. He inherited not just the subjects of Victorian sentiment (hair of the beloved

plaited over her recessed photograph), but its forms—shadowboxes, frames, reliquaries for shells, acorns, dried flowers. These and other fragments, reminders of journeys and past time, were drenched in nostalgia and democratize the picturesque. An eighteenth-century aristocratic aesthetic becomes a bourgeois comfort. In the same way, the aristocratic diabolisms of the eighteenth century become comfortable appendages for the Victorian bourgeoisie. In the Victorian parlor large themes survive in quasi-superstitious amusements—Religion in spiritualism, Fate and Destiny in astrology, Chance in games, and behavior in Phrenology, all of which spiritualize materialism.

But the toys and games of the Victorian parlor are one of that era's most fascinating accomplishments. Science had opened up wonders which quickly became recreations infused with the "mystery of the universe," and inextricably connected to the grand design of Victorian science and religion, in which everything had its place and function. The mystery of science and the mystery of religion intersect in the Victorian parlor, giving a kind of halo to miniature exemplars of natural phenomena. That parlor, with its ornaments and oddments, often under bell jars, its mementos and photographs, was the arena of games that trip the apparatus of Cornell's cosmology. There were chemical amusements (Artificial Petrifactions, To Mimic Frost-work, Crystallization of Insects, Flowers, Mosses); there was The Beauty of a Soap Bubble, the thickness of which did not exceed "the 2,500,000th of an inch"; games with electricity and magnetism included Magnetic Swans. There were Magic Squares and Musical Glasses, Balloons, Geographical Plays, Perpetual Rotary Motion and optical amusements such as Rays of Light Crossing Each Other, Myriamoscopes, Cosmoramas, Multiplying Theaters. Miniaturizing was a passion. (Even the child was a miniature adult and "manly" a compliment.) All these and others were open to the Victorian child in *The Boy's Treasury of Sports, Pastimes and Recreations* (1852), plus games that ran, like most games, through simple numerologies and fairly sophisticated structuring of chance. Many of these could be construed as ances-

tors of the trapboards and slot machines which contain almost every formal device Cornell used later, though contact with other artists may have emphasized certain aspects of their structure.

All this "culture" of the Victorian parlor has a far from fully acknowledged afterlife in modernist art of a certain kind. But it receives its purest codification in Cornell's imagination. It is spiritualized in a way that recalls a Victorian invention, half practical, half mystical, which, because it is fictitious, serves as a medium for the operation of his imagination: the ether. The ether was supposed to fill the upper regions of space and to facilitate communication (telegraphy); it became identified in the popular mind as an imperceptible substance, taken on faith, signifying all that was rarefied about distance and communication. Its remoteness invited icy projections, its translucence, crystalline metaphors. It becomes an apt image for Cornell's compressed, magical, and infinite space—that is, symbolist space crowded with bodiless allusions. Through this ether his mind could undertake its journeys, both waking and sleeping—dreams, which he entertained with Surrealist propriety, being a major part of Cornell's existence. Cornell's world then, refines nineteenth-century science through the ambience of the Victorian parlor. As he wrote in 1948 of his Soap Bubble sets: "Shadow Boxes become poetic theaters of setting wherein are metamorphosed the elements of a childhood pastime. The fragile shimmering globules become the shimmering but more enduring planets—a connotation of moon and tides—the association of water less subtle, as when driftwood pieces make up a proscenium to set off the dazzling white of seafoam and billowy cloud crystallized in a pipe of fancy."

The full powers accessible to Cornell through his apparently innocent methods are nowhere better described than in Diane Waldman's account of his box *L'Egypte de Mlle. Cléo de Mérode: Cours Elémentaire d'Histoire Naturelle:* "The interior, with its rows of bottles and side compartments, recalls the display cases of a museum or a department store. The box, a Victorian oak writing or strong box, contains a piece of glass

mounted about one and a half inches from the bottom, which acts as a supporting rack for the bottles. Underneath the glass is a layer of red sand with a few broken bits—a small piece of comb, slivers of plain or frosted glass and a porcelain doll's hand broken at the elbow. Much of the interior is covered with an ivory paper delicately marbled in brown and blue and framed by bands of marbled paper in blue, blue-grey, ivory and orange spots. A description of one of the bottles gives some idea of its contents: *Sauterelles* (grasshoppers or locusts) contains a cut-out of two camels, and bedouins from an old photograph of the Pyramids and a small green ball, both set in yellow sand.

"Cléo de Mérode was a famous ballerina of the 1890's. The goddess Hathor, pictured on the inside lid, is the goddess of love, happiness, dancing and music, also goddess of the sky. Cléo in the title is also Cleopatra of Egypt. The composition of the box can be paralleled to the Egyptian involvement with the tomb and the afterlife, to the customs of securing in the tomb the articles most required by the deceased in his life after death, as well as a description of the individual's life as he lived it on earth. It suggests, as well, the structuring of life into registers on the wall reliefs of the tombs. Simultaneously, the objects offer clues to the essence and mystery of Woman, whether Cléo de Mérode or Cleopatra."

III

An imagination so ingenuous, so rich, so vulnerable, and a method so gentle, aristocratic, and elusive obviously foster isolation. Cornell's hold on passing time was insecure, so that he found everyday matters, unless intimate and routine, painful. The powerful myth he inevitably engendered, though not totally inaccurate by any means, was experienced by him as an inconvenience that prejudiced his options and showed a deep misunderstanding of his nature on the part of those who confined him within it. Since the symbolist aura of things and persons was his medium, he was very concerned that his own aura—how he survived in the rarefied world of symbolist communication—would send out unwarped signals. This made him extremely sensitive to the motivations and sensibilities of his visitors.

"The notion that I am unseeable," he wrote, "is a wrong notion, a canard in fact." "People writing about me," he said, "don't bother to get the crudest kind of fact straight." He referred to their "out-and-out Trojan-horse tactics" of befriending him and then betraying him in print. "This notion of a recluse gets trotted out by people who should know better," he said, for his was "not the run-of-the-mill temperamental or [stand] offish thing." He had reason to fear visitors who, by and large, saw nothing but their preconceptions confirmed, and he spoke of "trying to break down some of the adjectives used with the work and me—eccentric." Cornell found meetings that made him the subject of inquiry and the object of observation severely discomforting. Though he was always delighted to see women, particularly girls, on whom he would project a radiance in which he could then bathe, he simply didn't want to see a great many people.

The reason, for anyone who knew him, was clear. In his way, Cornell accepted everything as material as fully as Rauschenberg. Servicing his complex communications with the past, connecting it to the present to resuscitate dead areas of experience, kept him so busy—and frequently so enervated—that he simply couldn't keep up with new experience, especially experience he could not control. One who operated such a giant switchboard could hardly see himself as a recluse. Also, since he spent his time among the most exceptional spirits, he cared little for those with only pretensions to this realm. Though he liked meeting exceptional people, his preference for humble objects was matched by his affection for humble people. But whatever came to his door had to be dealt with, and soon after meeting Cornell one became aware of a certain distraction in his presence which, with further acquaintance, could easily be traced. As a kind of secretary to his own history, he watched himself watching everything, and the resulting slight displacement appeared as a remoteness. His politeness often seemed a kind of apology for his partial absence.

This slight unfocusing was at the center of Cornell's consciousness, and a key both to his modes of thinking and his method. As one who wished to conserve all his experience, to remember everything, the process of time was an extremely complex experience for him, and it entered his conversation directly or indirectly a great deal. Just as dreams were his greatest solace, keeping up with the present was his greatest anguish, and appropriately he sometimes cited Zeno's paradoxes. The displacement arose, I think, from the fact that he was trying to experience each encounter as not occurring in the present, but as part of the past, where it could be experienced as memory. With the present thus attached to the past, the meeting was actually in advance of the present, and was not really allowed to occur. Dividing the present so that some of it was in a spurious future, and the rest of it in a premature past, lent one's communications a rather unfixed air. At times, Cornell, whose precise and deliberate voice betrayed these tensions, would drop out of the conversation into a reverie, from which he would return to unfocus the present again. These tensions were diminished, or at least became manageable, when his body was absent—a state he, like Mallarmé, apparently desired—that is, when his voice came over the phone. Over a period of years he called repeatedly, prefaced his conversation with a formal announcement, like a visiting card, and then, free of urgencies, would converse for hours.

So one had to cancel immediate plans and make preparations for a voyage. Silences and pauses were a considerable part of the discourse, but his temporal anxiety was sufficiently lessened so that he could savor what was said with some degree of leisure. The sense of loss could be coped with as a material, discussed as a problem. ("I feel that with my work there's something that will get lost, just as marvelous dreams get lost. If [only] you could get them up to the light, but maybe this is illusory.") Sometimes, when the conversation grew complex or touched off a surge of memories he had difficulty sorting, there was a sense of strain and the pauses, as distant rustlings betrayed, were

being filled by note-taking. The secretary had taken over. ("Diarying," he called it, "which has expanded beyond the conventional sense.") Since he referred to previous comments and conversations, inquired about the status of things liable to change, and kept up with numerous developments with perfect accuracy, I found myself taking notes also. A new conversation would sometimes telescope those anterior. At one point, both parties at each end of the phone found themselves taking copious notes, the silences stretching, the sense of responsibility overwhelming and of impasse, acute.

The paralysis invited by Cornell's relentless attempt to construct an historical present was never far away. ("I have to put a blank line down for that state when I'm writing.") This obsession with documenting experience before it had happened effectively pre-empted the present and perfectly excluded experience—except by proxy, that is, by memory and speculation. Things didn't become real to him until they were past; that was as real as they could become. So his experience remained somewhat artificial and fictitious. Sitting with him in his garden near the quince tree his mother had planted, some skeins of Christmas sparkle catching the light in the bushes, this sense of unreality—a courteous unreality—was shared. There was a curious impression of living backwards, of everything drenched in lucid nostalgia, yet infused with hope or yearning, which are of course nostalgia's future. With his past pre-empting his present and his future consuming his past, he was Kierkegaard's Unhappiest Man—who happened to be an artist and who had become the connoisseur of his condition. He could only live through a form of expectation, codified by habits of retrieval, that is, practically speaking, he could not begin to live at all. As Hilton Kramer put it, his was not "the pathos of experience, but the sentimental reverie of an innocent dreaming of experience." "His heart was broken and mended so many times," said Rauschenberg on one occasion, "he should have got used to it."

He was caught at a crossroad where reality was unhooked from the present and made fictional, and the past was retrieved with an energy that gave it a very

real complexion. His existence, as the locus of this traffic, was somewhat immaterial and could be said to approach the condition of symbolist poetry itself. He became a voice—which the telephone emphasized—with echoes replicated so widely that they served to emphasize his material absence. A natural result of this posture was the familiar symbolist idea of a soul too rare for life, for whom, by implication, living is somewhat vulgar. This ethereality was rectified in Cornell's case by tiny things—a piece of cake, a toy, some gossip could draw a jet of interest until overtaken by his curatorial habit. His conversation often centered on the implications of this exquisite neurasthenia, whose vernacular parallel was the Victorian maiden's "decline." Its themes were time, the body, dreams, memory.

IV

"There's a certain time state of Kafka-like terror.[1] Do I have any right to be making notes in such a state? It will pass, this bouleversement will be changed into such a different state of mind—I cannot deal with the other. I had an experience two years ago of being in the throes of this nothingness. My notes were so incoherent. But as long as I live, I would like [to continue making them]. Just take that clock itself per se. The puzzlement it gives me. At some times the hands will terrify me, they are going so fast, and sometimes the opposite. Remember that incident in Proust? He's in this dark room. He's lying in bed and he sees the light under his door, and being in this negative state we've been talking about, in a nightmarish way, he thinks it's the sun. And this means a new birth, the arrival of a new day. Then he hears the butler approaching and [he] turns out the light and he realizes there is an eternity before him.

"I have these waking nights of rampant hallucination. In one dream last week a snake and a leopard in very prosaic circumstances [in] a neighborhood yard. I've had dreams in the erotic realm. Marvelous dreams of nudity in a very pure sense. I just have to write down the dream processes, [dreams are] so meaningful, so deep, so prolific and complex. I have a need to transfer them. I just dream about people once, very vividly, and not again. Aftermath of waking up from dream of Duchamp after he died, and talking [with him] that Delacroix was alive. It was morbid, but it had a certain inscrutable significance [open to] anyone who is concerned with the mystique of the objects beyond Surrealism in everyday life. Dubuffet had an exhibition of this [kind of thing] outside Surrealism. I had a marvelous dream of an equilibrist doing a tightrope up in the sky. I tried to relate this to Dorothea [Tanning], a box whose legs were made up of flowers—Condensations à la Freud—of writing down a dream again and again, never sui generis. Hallucinatory dreaming for three years now. Had a very bad dose last night. I had a good awakening this morning. I have noticed myself walking in and out of time, so to speak, of contradictory mental states. If it were too pronounced I just wouldn't hold together in one piece. When you can experience eternity instead of time . . . when you get the eternity of waking up in the night, and then look at the clock, and five minutes have passed instead of an hour, it's a mockery of eternity.

"I welcome them as mystiques, these hot and cold days. Bring back things that only come back with this kind of torture. Fifty-eight summers have gone and they still are redolent: running a nail into a foot, the hot air in the doctor's office, the shining light on the silver. There's a satiety about these things. Unless you're a master it's just scribbling. In a hopelessly frustrated, benumbed kind of situation I've grasped at these straws in libraries. I've had very good insight into Joyce in [doing] collage work. I have scattered throughout this year and last some notes on collage. Joyce has the sense of collage in that method of his. The diarying that can't be gotten into. The mystique has expanded beyond the conventional sense of it—frustrating but intriguing. I have a record of Joyce. I play this ever so often, instead of getting lost in Finnegan's Wake. Michaelson, Valéry, Piero della Francesca; these [collages] come very naturally, very spontaneously. I get the idea they'd be intrigued if they were looking over my shoulder.

Memory and beauty are strong in Indian summer. I have this enlargement of our forty-year-old quince

[1]These quotations are taken from many conversations, nearly all of them over the telephone, between 1965 and 1972. Since he returned to the same themes frequently, comments on them have been grouped together. Conversations were often a form of reverie for Cornell. The movement of his thinking from one subject to another is represented fairly accurately.

278

tree. It blossoms and is very beautiful in spring. My mother bought this little plant in Bloomingdale's forty years ago for sixty-nine cents. I had this blowup of a fragment of the tree tinted a deep brown. The sunburst behind the branches. This had been a reject for months, until I picked it up again in the cold cellar. Here it was, lying on the floor. And I picked it up just because it was in the way. I took a brush, went round it with this brown and it knocked me out. There's a form there like Camelopardalis, the Camel, near the Bear—done in this impromptu and casual way. This has always been the content of the boxes: memories united with certain artists along the way . . . no method. So many of these things piled up and not realized . . . inability to verbalize these problems. These things are the most meaningful to me, and also the most frustrating. My atelier just hasn't been functioning for a long time now. I go into it and my stomach turns upside down— a morbid, almost hostile feeling. I'm not adjusted. I find it embarrassing to go back and see these things unrealized.

"Things were done in a kind of Sunday spirit, not in a conscious, atelier 'exchange-of-ideas' aspect. Cancel out the remote aspect of things and keep oneself out of the picture. Thirty years [of] drawing feeling from people. Above all, the very amateur standing of making things without any thought or expectation of exhibiting —morbillia, autographed letters, old books. You can imagine how much precious loot was lost in the London blitz. Mine comes from the stinking bustle of the city, and it was this kind of thing that gave it its intent [?]. Some of the finds are just incredible. I have a Rimbaud find here. Nearly twenty of these explorations. They were a kind of escape from the hideous impingement of the mercantile [Depression]. Always the rapport with something for which one has nostalgia, realizing that they were probably as banal in their time as things are at the present, now. Can't hold these wonderful thoughts and ideas. So much gets by me all the time in trying to hold onto things. One thing I make up for in this area is the all-night shows—Long John Nebel and Barry Farber—some people don't dig him.

"Cuvier's theory of reconstructing a dinosaur from one bone. I remember showing it to Duchamp and he said, 'It's a romantic vapor.' Some Tuesday mornings— Tuesday is special—detonate a chain reaction like this . . . Proust. . . . I've been in a strange physical state with regard to traveling into town. Quite wonderful rapport in the time [before this] all my life. It may be the time. Terrible things going on in the world. The inspiration came from being out and around. I've found very striking incidents that have affected me in a biography of Debussy—a father complex. Ravel had a very strong strain of naïveté, innocence—I've had this. The Romain Rolland concentration of these people. The work may require a dedication and solitariness—then they use that to club you with. I felt that before I died I wanted to know somebody who had known Debussy. I could have spoken to him and the chain would have been established. I can go along with de Nerval better than I can with Roussel or Lautréamont. Lautréamont, a balloon of [?] hovering over the head of a child in its coffin. I don't dig Surrealism in the manifesto sense.

"Portfolios—état brut—explorations—as much potential as the boxes. The spectator can apply this to his own modus operandi. If domestic circumstances had been different, I'd have liked to get into teaching. The spectator can, if he likes it, go out and do his own picking. This teeming obsession that I cannot help having, of benefiting aged people and handicapped children—boxes I have kept purposely in état brut—a kind of metaphysique of exploration that anyone can do—this kind of thing has a potential for the young blood instead of the museum kind of thing. I feel I've missed a great deal by getting so unconsciously pulled into this arcane kind of thing. If I had to do it all over again, I would have been for communicating it more. I do get this feeling from time to time."

V

Nearly all of this came over the telephone, which, by virtue of what was passing through it, slipped into an image in Cornell's domain. The sense of a wire, a connection, a thread, as Cornell's voice carefully picked its words, was inescapable. French words inserted

in a somewhat archaic way: *atelier, matériel, conversation,* indicated how much of France Cornell was conserving in America. Some mispronunciations were carefully cultivated: arcane became *arcan,* dichotomy *dishotomy.* The phone encouraged an intimacy that tended to vanish when the static of physical presence was substituted. In these conversations Cornell would report on the state of his body, which usually was engaged in discreet insurrections of various kinds, once speculating that this might be due to the equinox.

He was, however, more tough-minded than this would suggest. Offered a description of Valéry "in a state of neurotic fibrillation, unable to work," he gravely considered Valéry's condition but did not identify with it in the least. Indeed, one of the pleasures of these conversations was gradually becoming aware of a mind that suffered its harassments with great dignity, rejected superstition, and made one realize one's unconscious condescension with unfailing courtesy, disposing of it without irritation. The implicit or explicit subject of most of these conversations was connections, messages, deciphering, all in the context of his larger subject, time. Behind all this lurked the idea of a grand design. According to the organic Victorian world view, every particle had its use and purpose, and this belief, far from the brutalities of post-Darwinian science, was the basis for his systems of retrieval and the predominant images they employ. These images have to do with time as traveling, as Fairfield Porter made brilliantly clear in an essay Cornell often referred to with gratitude and delight. ("Cornell's nature is an abstract matrix through which journeys the cabin of the mind.") Cornell's art is a diagram of the organic universe, endlessly allusive, joining in a single emotional tone the distant and dissimilar. Science is the source for the poetic metaphor which effects these communications; and science, which introduces the mathematical, the astronomical, the chemical, the quantifiable, abstracts the organic and preserves it by a mineral petrifaction. One of Cornell's earliest works is a text for this: A mounted fly is set among crystals. "The end of every creature," wrote Flaubert in *The Tempta-*

tion of Saint Anthony, "is the liberation of the celestial ray shut up in matter." This crossing of an Arcadian mood—organic and warm—with the mineral perfection that insulates it against time is a particularly symbolist strategy and it shows in Cornell's choice of subject matter. Of two ballerinas, Taglioni is chosen over Fanny Elssler, romantic ice over romantic fire.

The house on Utopia Parkway, like de Kooning's studio in Springs, was not just an abode, but an image of the artist's methods, dilemmas, and quests. The basement workroom was crowded with filed materials for boxes, and boxes in progress, which Cornell was happy enough to demonstrate, slipping in false backs and glass and objects, then angling them to one side for the proper effect. The front room upstairs was crowded with books, and a filing system that looked sloppy and haphazard but was not. But the most extraordinary thing about that room was that it was blue (blue walls, blue curtains), a powdery blue one sometimes sees in the Middle East or Spain. Like the blue glass over some of the boxes, or the blue filter through which his movies were projected, it enhanced distance, dissolved the walls of the house into that "azur" Cornell seemed to need for many of his most ambitious voyages. Occurring within his boxes as powder and sand, it seemed a temporal deposit, an accumulation of infinite particles. Cornell's images are entirely unoriginal, even banal, which measures exactly the degree of his extraordinary transformations. This image of time, however, in which space (distance) and infinity (accumulation of particles) are precisely notated, is accompanied by one other predominant master-image in Cornell's cosmos—light. Time, light, and a sense of a grand design converge in each of Cornell's boxes and collages.

The grand design exalts degraded material in proper symbolist fashion. It presumes for it a place in a scheme of things if that place can be discovered. The past is full of voices seeking to ventriloquize themselves through what the present provides. In divining that past, Cornell engaged in voyages of retrieval through his "chains" of communication. As time passed, however, more data accumulated, heaped up on the

past until, like an archaeologist, he had to dig through layers of time and layers of memory.

The decay of memory is a preamble to death, and Cornell's intense temporal anxiety is caught between holding time and letting it slip by. Time is the medium that assists and frustrates his voyages, is thus ambiguous and the locus of struggle. In that his work is about losses and lost connections pursued beyond the capacities of any single mind, his boxes are, in the largest sense, about mortality—not individual mortality, but an individual's meditation on the decline of collective memory. Light is the image that bears information from the past, and light and time become identified. Stars and constellations become a network identified with the past, their light traveling toward the present, including light from stars extinct and dead. Receiving this light across vast distances is Cornell's deepest poetic image. It is an image of memory itself, one that applies itself naturally to his conception of the present, to his idea of retrieval, to his very presence in his blue room where, instead of someone unable to begin to live, one could now see living memory—that is, one who was dead already, prematurely posthumous.

So the sense of distance Cornell maintained when one met him was more than etiquette. It was a sentence under which he cultivated an existence he might have had, which he was always in advance of, or detained by. At the heart of Cornell's universe was this system of equations: celestial bodies = light = time = memory = decay = nostalgia = grand design = common objects = celestial bodies. And along the way are implicated those avatars of the symbolist slot machine: glasses, bubbles, pipes, sand, birds, butterflies, dancers, glitter; in turn setting off the themes of isolation, innocence, enigma, transcience, absence, traveling, voyages, women; and finally the media of these discourses: ether, azure, night, water, dream space, reverie, sentiment. Cornell, the easiest of artists to apprehend, quite transcends his historical moment, and brings to a consummation that dream of Europe he set out to re-enact. He takes his place as a major artist, but it is far from irrelevant to inquire why this status has been denied him.

The charges against Cornell go something like this: His work, small in scale, is essentially marginal if not trivial. His childlike innocence recalls a charming but rather naïve Hans Christian Andersen. His wonder is unguarded by any of those ironies that certify modernist maturity, and his poetics, which are those of a sentimental provincial yearning for the centers of culture, are far from the strenuous world of real aesthetic issues. His unique status is understandable, and rather than guaranteeing originality, accentuates his eccentric role. His formal adventures are far more limited than his content, which gains access to comfortable intimacies without any great sign of effort, or of that anxiety which reassures us that we are in contact with ambitions that challenge our problem-solving habits. His myth, which summarizes much of the above idea of a naïve, accidental genius, is a pretty fair reflection of his real place.

These judgments interest us not so much in themselves as in their assumptions about the nature of the modernist enterprise, which has been dominated either by Faustian dramas or absolutist quests that inhabit the *means* of art as if they were a Romantic slum. By and large, these occasions add up to a theme: the disappearance of overt content and its transference to the means, now as populated with subjects as any academic canon. Large ambitions of course—essentially *museum* ambitions—are quickly synonymous with the fallacy of large size. That Cornell's works are, like Emily Dickinson's, small in scale calls up, in reciprocal fashion, the judgment of "minor art," although every student is taught to speak learnedly of tiny "monumentality." Symbolist work does not lend itself to large scale. It can be sustained only through modes of addition within a large theme. In this sense, Cornell's boxes are like a series of linked carriages. Their paradoxicality lies in the fact that their scale is perfectly adjusted to their ambitions. Just as Rothko's canvases are large to achieve intimacy, Cornell's are tiny to compress space and render it, as Gaston Bachelard writes of the poetics of "intimate immensity," infinitely elastic. The scale is one that removes all bodily static and turns us into a pair of eyes, leaving, as Mallarmé's poetry does, the body care-

fully deposited elsewhere. European art is sufficiently populated with major figures who work small—Vermeer, Klee, Jan van Eyck, even Duccio, whose largest works are made up of small panels—that the question betrays not Cornell's deficiencies, but the rhetoric of modernism and the snobbism of the loft space.

Nor is eccentricity/uniqueness a disqualification, when one thinks of such singular geniuses as Piero di Cosimo, Monzu Desiderio, El Greco, and de Chirico—all visionaries, one notices, and in the case of the first two, remarkably underrated. This prejudice betrays the modernist passion for mainstream thinking which is now parodied in much post-modernist art. Dialectical succession, as we have found, narrows the limits of art's inquiry and eventually leads to academic self-perpetuation. At such a point of exhaustion, an artist of a scope that transcends formalist manners looks larger than ever before, and in the seventies Cornell looks very good, indeed. Succession, of course, leads to the very bourgeois idea of followers, something that modernism, which mimics so many Renaissance habits as seen through the nineteenth-century academy, paid lip service to. Here we come to an area where the record is virtually blank: Cornell's influence, which has been subtle, graceful, and pervasive, can be read, like Mallarmé's, far outside the immediate precincts of imitation. For the major eccentric becomes not an unstable element in the artistic firmament but a constancy, whose light, though it may wax and wane, remains a fixed point of reference.

The childlike and naïve charge would be more impressive if American innocence were not a matter for admiration in the context of modernist ambitions. Innocence has become a qualification to be picked up and worn (Warhol), or something to puzzle over along with the observer—a form of sophisticated narcissism (de Kooning). Cornell's innocence is more in the area of Rothko's vulnerability, leading to an acute sensitivity. Both Rothko and Cornell suffered from an innocence (an inability to learn from experience or, indeed, in Cornell's case, to experience) that they could hardly avoid recognizing as part of their make-up The issue of

maturity lies in how they—and their work—handled this given. Cornell had a passionate interest in childhood and innocence, and indeed the iconography of innocence in his work is formidable. It was the interest of one who associated innocence with an ideal immortality, and thus with an acute nostalgia for a future to which the past gave him access, but no assurance. Cornell's naïveté—its terrors, its poetics, its insights—finds its closest parallel in Miró, whose "elfishness" became a part of his myth for years, and could be supported by his imagery. Miró's childlike myth was disposed of only when he invoked large scale and more formal color problems. In painting the *Constellations*, in which birds are a predominant image, Miró, like Cornell an admirer of the symbolist poets, said, "I felt a deep desire to escape. I closed myself within myself purposely. The night, music, and the stars, began to play a major role in my painting." Such "poetic" postures invite harsh judgments in the "tough" climate of modernism, which makes cynicism a kind of entrance fee to serious discourse. One might hazard that irony is the modernist counterpart of innocence, indeed, a version of it, insofar as it insulates and prohibits experience by the same mechanism of which innocence is accused.

Finally, to lack of irony, cultivation of innocence, smallness of scale, is added the charge of formal orthodoxy. Just as modernism's diminishing content is the result of a rearguard action that now seems far less heroic than it once was, its formal emphasis has disguised the few spirits whose universes have remained uncompromisingly large. In this sense, Picasso, the epitome of modernism, who refused to abandon content, is the truest antimodernist. Cornell's large achievement is muffled by his largest virtue: his pure and easy metaphysical reach, in such perfect consonance with its means that not only formal striving, but the artist himself disappears, in proper Mallarméan fashion. "The pure work," wrote Mallarmé, "implies the elocutionary disappearance of the poet, who yields place to words [read objects?], immobilized by the shock of their inequality; they take light from mutual reflection, like an actual train of fire over precious stones, replacing the

old lyric afflatus, or the enthusiastic personal direction of the phrase." Cornell's warmth has a somewhat arctic crystal at its center, and its Arcadian exhalation is eventually chilled by infinite distance. Cornell's objects, whose discord is submerged in a powerful mood, are far from the modernist inquiry into the ethics of the means. Cornell's objects *express* something. They are not subjects of inquiry, but immensely learned and allusive carriers of meaning. They support a vision, a major theme approached with a full sense of its fragility, and that theme resides outside of modernism, but it is the very theme of culture—a theme too obvious to name. As Fairfield Porter said, "His content has something that has not been seen in works of visual art since the Renaissance, and that gradually disappeared from them during the seventeenth century, which is an inclusion within itself of references to the highest reaches of the human spirit, without pedantry, artistically and imaginatively. However, the Renaissance was triumphant and extrovertive, while Cornell is on the contrary introvertive and melancholy, and includes the spectator in his awareness." His mood is of the company of Giorgione and Watteau. In such a case, the Cartesian split which modernism made into a subject is irrelevant, and forms reside naturally within their universe of discourse. Their radical nature is so disguised and inaccessible that it has to be delivered, as it were, with high forceps. Diane Waldman has best summarized Cornell's formal intelligence and made cogent claims as to his precise contribution in an area which for him held little interest in itself. What survive such inquiries, indeed transcend them, are the allusive reverberations of a vision expressed in objects as common as words.

Cornell's myth, however, cannot be dismissed as a fiction. It has its own energies and truth, and must be corrected insofar as it lessens the critical stringencies by which he is judged, and therefore gives praise a somewhat conditional premise or cast. Cornell's myth does not run counter to the voice in the work. The only distortions are those of amplification and vulgarization. As we have seen in this book, artists' myths are, for the twentieth-century artist, a problem, sometimes a subject, composed of paradoxes which illuminate public necessities and private self-consciousness. But Cornell's myth has a particular relevance to his work. He himself foresaw this, and was uneasy about the vulgarization of his work contained in his myth. With those whose voice and myth are mainly consonant, the crucial point is at what distance one receives the message. At the limits of popular necessity, the myth is used to reassure the public need for "genius"; yet the same public protects itself by inflicting stigmata such as "innocence and naïveté," which have enough condescension to assert mass superiority over the exceptional.

As one approaches, the voice begins to assert itself and the work begins to reverberate with its somewhat miraculous purity. Eventually, as box after box passes before us, the name Cornell begins, like those of the symbolists he admired so passionately and with whom he spent his imaginative existence, to exhale that ether which surrounds some names in the history of culture like a rare perfume. This is where the trouble starts and ends. For "Cornell" is a name that now has a magical reverberation in the museum of culture. Thus, the noun gradually transfers itself into an adjective, "Cornellian," and so begins to signal a bundle of rarefied emotions, which, insofar as they define a kind of aestheticism to which coarser spirits are denied access, are a form of snobbery, a translation of "class" into aesthetics that Cornell would have detested. Many who know exactly what the adjective "Mallarméan" means know nothing about Mallarmé. This is symbolism's burden, the dead weight of the "refined." But Cornell's name now is set in that symbolist firmament as an exile repatriated. He has become part of the vision of culture he enacted in Utopia Parkway. This is Cornell's odd, delayed position: Along with Redon, he is the greatest symbolist artist and, of course, one of the major American artists.

Acknowledgments

For persisting in extracting this book over a period of ten years, and for the most generous treatment and consideration any author could receive, I am grateful to my friend, Jerry Mason— the president of Ridge Press—as I am to my editor, Adie Suehsdorf.

There are numbers of others to whom I owe a great deal: Roselle Davis for her cooperation in making Stuart Davis' papers available to me; Lee Krasner for talking with her usual clarity and insight about her late husband, Jackson Pollock. I particularly want to thank Bryan Robertson for his generous and eloquent support during a difficult time; I am also deeply grateful to Irving Sandler, Peter Schjeldahl, and William C. Seitz for reading the manuscript and giving me the benefit of their thinking. I welcome the opportunity to tell Morton Feldman how much our many conversations have meant to me.

My thanks to Jim Fitzsimmons, editor of Art International, *who published earlier versions of the chapters on de Kooning (December, 1968) and Rothko (October, 1970). An early version of the Hopper chapter appeared in* Art in America *(December, 1964).*

Nancy Foote cheerfully took time out from her own work to help me in mine; and Claudia Kern and Carolyn Betsch did some necessary research, for all of which I am thankful. Moira Duggan's meticulous reading and editing helped clarify passages that needed it. Harry Brocke and Albert Squillace deserve my thanks for making the design of the book what it is. I am also grateful to the museums and collectors who gave permission to publish pictures from their collections.

Hans Namuth, my collaborator, provided me with many insights through his photographs, which complement the text perfectly. Barbara Novak's contribution went far beyond the precincts of conjugal support. Her ideas often stimulated sections of this book, and much of her thinking is included here, I hope not misinterpreted. Her determination to make the book happen was unfailing, and always gave me confidence.

It is entirely proper for me to thank the artists, seven of whom I know or knew, and some of whom were and are close friends. I thank them for what they added to me by being there.

—B.O'D.

Selected Bibliography

GENERAL

Blesh, Rudi, *Modern Art USA. Men, Rebellion, Conquest, 1900–1956.* New York, Alfred A. Knopf, 1956.

Greenberg, Clement, *Art and Culture.* Boston, Beacon Press, 1961.

Hess, Thomas B., *Abstract Painting, Background and American Phase.* New York, Viking Press, 1951.

Hunter, Sam, *American Art of the 20th Century.* New York, Harry N. Abrams, 1972.

Rose, Barbara, *American Art Since 1900: A Critical History.* New York, Praeger, 1967.

Rosenberg, Harold, *The Tradition of the New.* New York, Grove Press, 1961.

Sandler, Irving, *The Triumph of American Painting: A History of Abstract Expressionism.* New York, Praeger, 1970.

EDWARD HOPPER (1882–1967)

Campbell, Lawrence, "Hopper: Painter of 'thou shalt not.'" *Art News,* LXIII, October, 1964.

Edward Hopper Retrospective Exhibition. New York, Museum of Modern Art, 1933. Articles by Alfred H. Barr, Jr., Charles Burchfield, and Edward Hopper.

Goodrich, Lloyd, *Edward Hopper.* New York, Whitney Museum of American Art, 1964.

————, *Edward Hopper.* New York, Harry N. Abrams, 1971.

Hopper, Edward, "Charles Burchfield: American." *The Arts,* Vol. 14, July, 1928.

Lanes, Jerrold, "Edward Hopper." *Artforum,* Vol. 7, October, 1968.

Mellow, James R., "The World of Edward Hopper: The Drama of Light, the Artificiality of Nature, the Remorseless Human Comedy." *New York Times Magazine,* September 5, 1971.

O'Doherty, Brian, "The Hopper Bequest at the Whitney." *Art in America,* Vol. 59, No. 5, September–October, 1971.

Pène du Bois, Guy, *Edward Hopper.* New York, Whitney Museum of American Art, 1931.

Robertson, Bryan, "Edward Hopper." *New York Review of Books,* Vol. 17, No. 10, December 16, 1971.

Seitz, William C., *São Paulo 9, Edward Hopper, Environment U.S.A.: 1957–1967.* Washington, Smithsonian Institution Press, 1967. Includes essays by William C. Seitz and Lloyd Goodrich, and memorial statements by Brian O'Doherty, James Thrall Soby, and John Canaday.

STUART DAVIS (1894–1964)

Arnason, H. H., *Stuart Davis.* Minneapolis, Walker Art Center, 1957.

————, *Stuart Davis Memorial Exhibition.* Washington, Smithsonian Institution, 1965.

Blesh, Rudi, *Stuart Davis.* New York, Grove Press, 1960.

De Kooning, Elaine, "Stuart Davis: True to Life." *Art News,* LVI, April, 1957.

Goosen, E. C., *Stuart Davis.* New York, Braziller, 1959.

Kelder, Diane, ed., *Stuart Davis, Documentary Monographs in Modern Art.* New York, Praeger, 1971.

O'Doherty, Brian, "Stuart Davis: A Memoir." *Evergreen Review,* Vol. 10, No. 39, February, 1966.

JACKSON POLLOCK (1912–1956)

Gray, Cleve, and Du Plessix, Francine, "Who Was Jackson Pollock?" *Art in America,* Vol. 55, No. 3, May–June, 1967.

Greenberg, Clement, Review in *The Nation,* CLVII, No. 22, November 27, 1943.

————, "The Jackson Pollock Market Soars." *New York Times Magazine,* April 16, 1961.

Hess, Thomas B., "Pollock: The Art of a Myth." *Art News,* LXII, January, 1964.

Hunter, Sam, *Jackson Pollock.* New York, Museum of Modern Art, 1956.

Jackson Pollock. New York, Malborough-Gerson Gallery, 1964.

Jackson Pollock: Black and White. New York, Marlborough-Gerson Gallery, 1969.

Kozloff, Max, "The Critical Reception of Abstract-Expressionism." *Arts,* XL, December, 1965.

Kramer, Hilton, "Jackson Pollock and Nicholas de Staël: Two Painters and Their Myths." *Arts Yearbook,* 3, 1959.

O'Connor, Francis V., *Jackson Pollock.* New York, The Museum of Modern Art, 1967.

O'Hara, Frank, *Jackson Pollock.* New York, Braziller, 1959.

Poli, Bernard, "The Hero in France and in America," in A. N. J. Den Hollander, ed., *Diverging Parallels: A Comparison of American and European Thought and Action.* Leiden, E. J. Brill, 1971.

Robertson, Bryan, *Jackson Pollock.* New York, Harry N. Abrams, 1960.

Rosenberg, Harold, "The American Action Painters." *Art News,* LI, December, 1952. Reprinted in Harold Rosenberg, *The Tradition of the New.* New York, Grove Press, 1961.

————, "Action Painting: A Decade of Distortion." *Art News,* LXI, December, 1962.

Rubin, William, "Jackson Pollock and the Modern Tradition." *Artforum,* V, February, March, April, May, 1967. Also, correspondence between Harold Rosenberg and William Rubin in the April and May issues.

WILLEM DE KOONING (1904–)

Ashton, Dore, Introduction, *Willem de Kooning.* Northampton, Smith College Museum of Art, 1965.

De Kooning, Willem, "The Renaissance and Order." *trans/formation,* I, No. 2, 1951.

————, "What Abstract Art Means to Me." New York,

Museum of Modern Art Bulletin, XVII, No. 3, Spring, 1951.

Hess, Thomas B., Willem de Kooning. New York, Braziller, 1959.

————, Willem de Kooning. New York, Museum of Modern Art, 1968.

O'Doherty, Brian, "De Kooning: Grand Style." Newsweek, LXV, No. 1, January 4, 1965. Reprinted in Brian O'Doherty, Object and Idea. New York, Simon and Schuster, 1967.

Rosenblum, Robert, "The Abstract Sublime." Art News, LIX, February, 1961.

Sylvester, David, "Content is a Glimpse . . ." Location I, No. 1, Spring, 1963. Excerpts from BBC interview broadcast, December 30, 1960.

MARK ROTHKO (1903–1970)

Goldwater, Robert, "Reflections on the Rothko Exhibit." Arts, XXXV, No. 6, March, 1961.

————, "Rothko's Black Paintings." Art in America, Vol. 59, No. 2, March–April, 1971.

Kozloff, Max, "Mark Rothko's New Retrospective." Art Journal, XX, No. 3, Spring, 1961.

O'Doherty, Brian, "The Rothko Chapel." Art in America, Vol. 61, No. 1, January–February, 1973.

Robertson, Bryan, Preface, Rothko. London, Whitechapel Art Gallery, 1961.

Rothko. Venice, Museo d'Arte Moderna Ca'Pesaro, 1970.

Rothko, Mark, "The Romantics Were Prompted." Possibilities I, No. 1, Winter, 1947–48.

————, Statement in "Ides of Art." The Tiger's Eye, I, No. 2, December, 1947.

————, "A Statement on His Attitude of Painting." The Tiger's Eye, I, No. 9, October, 1949.

Selz, Peter, Mark Rothko. New York, Museum of Modern Art, 1961.

ROBERT RAUSCHENBERG (1925–)

Amaya, Mario, Pop Art . . . and After. New York, Viking, 1965.

Ashton, Dore, Rauschenberg: XXXIV Drawings for Dante's Inferno. New York, Harry N. Abrams, 1964.

Forge, Andrew, Robert Rauschenberg. New York, Harry N. Abrams, 1969.

Lippard, Lucy, Pop Art. New York, Praeger, 1966.

O'Doherty, Brian, Introduction, "Robert Rauschenberg." Catalogue of the VI Exposition Internationale de Gravure. Ljubljana, Yugoslavia, 1965. Reprinted in Brian O'Doherty, Object and Idea. New York, Simon and Schuster, 1967.

Robertson, Bryan, Preface, Robert Rauschenberg: Paintings, Drawings, and Combines, 1949–1964. Whitechapel Art Gallery, London, 1964. Essays by Henry Geldzahler, John Cage, Max Kozloff.

Rose, Barbara, "The Value of Didactic Art." Artforum, Vol. 5, April, 1967.

Rubin, William, "Younger American Painters." Art International, Vol. IV, No. 1, 1960.

Seckler, Dorothy Gees, "The Artist Speaks: Robert Rauschenberg." Art in America, Vol. 54, No. 3, May–June, 1966.

Seitz, William C., The Art of Assemblage. New York, Museum of Modern Art, 1961.

Solomon, Alan, Robert Rauschenberg. New York, The Jewish Museum, 1963.

Steinberg, Leo, "Other Criteria," in Other Criteria. New York, Oxford University Press, 1972.

Swenson, G. R., "Rauschenberg Paints a Picture." Art News, LXII, April, 1963.

ANDREW WYETH (1917–)

Corn, Wanda, Andrew Wyeth. Greenwich, Conn., New York Graphic Society, 1973.

De Kooning, Elaine, "Andrew Wyeth Paints a Picture." Art News, XLIX, No. 1, March, 1950.

Jacobs, Jay, "Andrew Wyeth—An Unsentimental Reappraisal." Art in America, LV, No. 1, January–February, 1967.

Mongan, Agnes, Introduction, Andrew Wyeth: Dry Brush and Pencil Drawings. Cambridge, Fogg Art Museum, 1963.

Plimpton, George, and Stewart, Donald, "An Interview with Andrew Wyeth." Horizon, IV, No. 1, September, 1961.

Richardson, Edgar P., Andrew Wyeth. Philadelphia, Pennsylvania Academy of the Fine Arts, 1966.

JOSEPH CORNELL (1903–1973)

"Americana Fantastica." View, Series 2, No. 4, January, 1943.

Ashbery, John, "Cornell, The Cube Root of Dreams." Art News, LXVI, Summer, 1967.

Cortesi, Alexandra, "Joseph Cornell." Artforum, Vol. 4, No. 8, April, 1966.

Kramer, Hilton, "The Enigmatic Collages of Joseph Cornell." New York Times, January 23, 1966.

Myers, John Bernard, "Cornell: The Enchanted Wanderer." Art in America, Vol. 61, No. 5, September–October, 1973.

Michelson, Annette, "Rose Hobart and Monsieur Phot: Early Films from Utopia Parkway." Artforum, Vol. XI, No. 10, June, 1973.

Porter, Fairfield, "Joseph Cornell." Paris, Art and Literature, No. 8, Spring, 1966.

————, Introduction, An Exhibition of Works by Joseph Cornell. Pasadena, Pasadena Art Museum, 1967. Organized by Walter Hopps.

Rosenberg, Harold, "Object Poems." The New Yorker, Vol. 43, No. 15, June 3, 1967.

Waldman, Diane, Joseph Cornell. New York, Solomon R. Guggenheim Museum, 1967.

Index